Landscapes of Memory

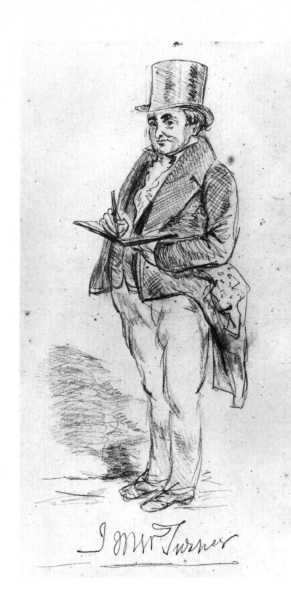

J M W Turner

Landscapes of Memory

Turner as Illustrator to Scott

Gerald Finley

University of California Press
Berkeley and Los Angeles

University of California Press
Berkeley and Los Angeles

Copyright © Gerald Finley, 1980

Library of Congress Catalog Card Number: 80–5956

ISBN: 0–520–04436–3

Designed by Ray Carpenter

Printed in Great Britain by The Scolar Press
Ilkley, West Yorkshire

Frontispiece
Charles Martin,
J.M.W. Turner, R.A. Pencil.
13¾ × 9½ in; 34.9 × 24.2 cm.
National Portrait Gallery,
London.

Contents

To the memory of my mother and father,
Winifred Margaret Mackenzie Barker and Frederick James Finley

List of Plates

Photographic Acknowledgements

Christie's 35
Courtauld Institute of Art 104
Fine Arts Society, London 27
John Freeman 4, 7, 10, 12, 27, 41, 43, 45, 53, 57, 63
Hawkley Studio Associates 24
Helga Photo Studio Inc. 71
Sydney W. Newberry 22, 23, 32, 34, 42, 46, 64
Philadelphia Museum of Art 56
Charles Prosser 28, 29, 30
Royal Commission on the Ancient and Historical Monuments
 of Scotland 78, 108
Tom Scott 1, 21, 54, 58, 61, 95, 97
Sotheby and Co. 65
Stearn and Sons (Cambridge) Ltd 87

Preface

An abundance of legendary material survives concerning the life and art of J.M.W. Turner. There are innumerable anecdotes and reminiscences which have been used to reconstruct the artist's character and to shed light on his art. No doubt, the imminent publication of Turner's correspondence will correct, broaden and enrich our knowledge of his life and art.

However, the discovery of a considerable body of documents connected with Turner's employment as illustrator of publications by, or about, Sir Walter Scott between 1818 and 1838 has provided further important information that is remarkably complete. This material, in the National Library of Scotland, is in the form of correspondence between Scott and his associates – in large part between the author and his latter-day publisher, Robert Cadell (1788–1849). But by far the most significant documentation concerning Turner's role as illustrator to Scott is contained in the journals of Cadell, and these diaries furnish the only sustained record of the artist's continued employment as illustrator of Scott's works after Scott's death in 1832. They also record Cadell's methodical procedures and his shrewd and accurate observations, which provide an eminently readable, and historically illuminating, account of the publisher's dealings with Turner the illustrator.

The major aim of the book is to establish, through this fresh evidence, the significant outlines of the collaboration between Turner, Scott and Cadell, and to fill in as precisely as possible the

nature of their association. The illustrations chosen and discussed are generally those that bear specifically on Turner's relationship with his Scottish employers.

That a book has actually materialized from this investigation is to some extent fortuitous and unexpected. My original intention was to prepare a series of articles on aspects of Turner's associations with Scott and Cadell, and several of these have already been published. However, when papers were added to the Cadell Collection while these articles were in preparation, it seemed that a complete re-assessment was in order and, indeed, a wealth of new facts emerged which served to knit the contents of the studies already published and those in preparation into a sustained and cohesive account of Turner's role as illustrator to Scott. For this reason, then, it has seemed desirable to draw together in a single book both the published and unpublished materials, since, in this way, it is possible to illuminate more fully the relationship of Turner with his employers, and to determine with some confidence the significance of the Scott illustrations.

This book, prepared over a period of several years, has required the co-operation of many institutions and individuals, and for this reason my list of debts is long. I should first mention Professor Adele M. Holcomb, who was one of the first scholars of recent years seriously to consider Turner as an illustrator; see especially her article on Turner's association with the poet Samuel Rogers in the *Journal of the Warburg and Courtauld Institutes*, XXXII, 1969, pp. 405–10. Her paper, 'Scott and Turner', read at the Scott Conference in 1971, was published under the same title in the *Journal*, XXXIV, 1971, pp. 386–97, and subsequently, with revisions, appeared in a volume of selected papers, read at the Scott Conference, entitled *Scott Bicentenary Essays*, edited by Alan S. Bell, Edinburgh/London, 1973, pp. 199–221. Dr Holcomb's *Journal* article was not known to me until after my first article on the subject had been submitted for publication; this was published in the *Journal* in 1972. The documents mentioned by Dr Holcomb were also those to which I referred. However, as I scrutinized the relationship between Turner and Scott on the basis of a body of documents not known to Dr Holcomb, I reached interpretations and conclusions that differed from those presented by her.

I wish to acknowledge the aid of several institutions during the preparation of this book. Foremost the staff of the National

Library of Scotland, especially that of its Department of Manuscripts. The Assistant Keeper of Manuscripts, Mr Alan S. Bell, has been most helpful. He first directed me to the Cadell Papers and has kept me informed of additions to the collection. Equally deserving of thanks is the staff of the Department of Prints and Drawings of the British Museum, especially Mr Reginald Williams, whose assistance and sympathetic interest have made the publication of this book much easier. I also wish to acknowledge the assistance of Mr Martin Butlin, Keeper of the British Collection at the Tate Gallery, whose counsel on several points has been most valued. I am also under obligation to Mr R. E. Hutchison, Keeper, and Dr Rosalind K. Marshall, Assistant Keeper, of the National Portrait Gallery of Scotland for answering many of my questions. Further, I am grateful to Miss Catherine Cruft of the Royal Commission on the Ancient and Historical Monuments of Scotland for her assistance over several years. In addition I wish to thank the staffs of the British Architectural Library (Royal Institute of British Architects), the Witt Library and the British Library and the librarians of the Victoria and Albert Museum, whose services during my research have been much appreciated. I should also like to express my gratitude to Mr Evelyn Joll of the firm of Thomas Agnew and Sons Ltd, who at the outset of my research provided me with information concerning the whereabouts of many of the watercolours which I have discussed in this book and who kindly arranged for the photography of a number of the Turner watercolours in private hands. The book has been published with the help of a grant from the Canadian Federation for the Humanities, using funds provided by the Social Sciences and Humanities Research Council of Canada. Further, I gratefully acknowledge the financial assistance of two other bodies, the British Council and the Queen's University Advisory Research Committee, which has allowed me to undertake research and purchase photographs.

The editors of the *Connoisseur*, the *Burlington* and the *Journal of the Warburg and Courtauld Institutes* have kindly allowed me to incorporate material which first appeared in articles in these journals. I am especially grateful to the editors of the *Journal* for allowing me to republish in this book portions of my articles. The passage from C. R. Cockerell's diary (1824), quoted in Chapter 4, note 4, is reproduced by kind permission of the British Architectural Library, Royal Institute of British Architects.

I owe a major debt to private and public owners whose Turner watercolours I have examined. Some of these owners wish to remain anonymous, but others are identified in the captions to the plates. I am particularly grateful to the private collectors, many of whom welcomed me into their homes and, at considerable inconvenience to themselves, arranged for their watercolours to be photographed. Their generosity and kindness have made the writing of this book possible and eminently worth-while.

Many others have assisted me. While I have attempted to acknowledge (in the notes) individuals who have given me assistance on specific points in the text, here I must thank those whose aid is of a different sort. Chief among them must be Mr Charles Prosser, who, during the summer of 1975, motored me to most of the sites visited by Turner in 1831 in Scotland and northern England. Mr Prosser's keen observations concerning Turner's interpretation of landscape were suggestive, and have been helpful to me in preparing the discussion of Turner's sketching methods in Chapter 8; he has also generously allowed me to publish his photographs of the Greta and Tees. Further, I must thank Mr W.F.E. Morley, Special Collections, Douglas Library, Queen's University, for his aid, and Dr J.D. Stewart, who first suggested the idea of this book to me. Mrs Patricia Maxwell-Scott, OBE, has been most hospitable and helpful and kindly introduced me to Dr James C. Corson. I have profited from a conversation and from correspondence with Dr Corson, who has also generously lent me material from his remarkable library of published material about Scott. I have also benefited from my association with the late Mr Kurt Pantzer, whose collection of Turner watercolours and whose generosity have been known to all students of Turner, and who, during the last few years, has shared with me his enthusiasm for the artist. From the outset of this project, he provided me with constant encouragement and support.

Another obligation is to those who, under the pressures of their own responsibilities, took time to read the typescript of this book in whole or in part. I am indebted to my wife, Helen, who persevered in reading through some rather rough drafts and whose criticism and support during the writing have been greatly valued. I am also grateful to Dr Adele Holcomb for her willingness to read Chapter 2, and for her valuable suggestions

for improving it. Yet my chief debt must be to Dr Allan Hartley and Mr Evelyn Joll, who devoted much time to reading through the entire typescript and whose critical appraisals have given me a much better perspective on the study and have helped me to improve it in a material way.

My final but not least debt is to the editorial staff of the Scolar Press, and, at the last stages of preparation, especially to Mr Michael Graham-Dixon, whose questions, care and skill have also helped to make this a better book.

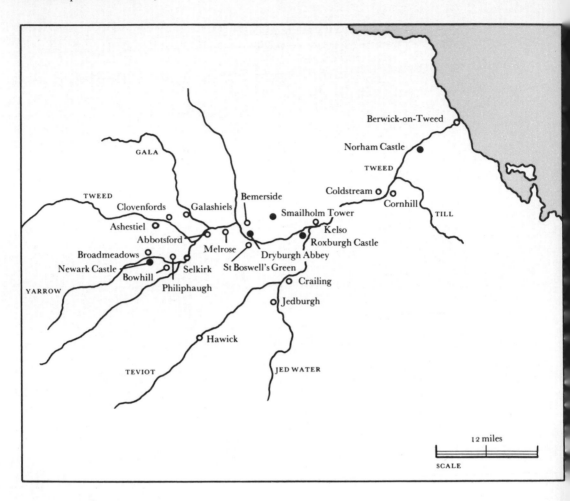

Turner's visit to Abbotsford
and Berwick-on-Tweed, 1831.

Turner's tours of Scotland in 1818, 1831 and 1834.

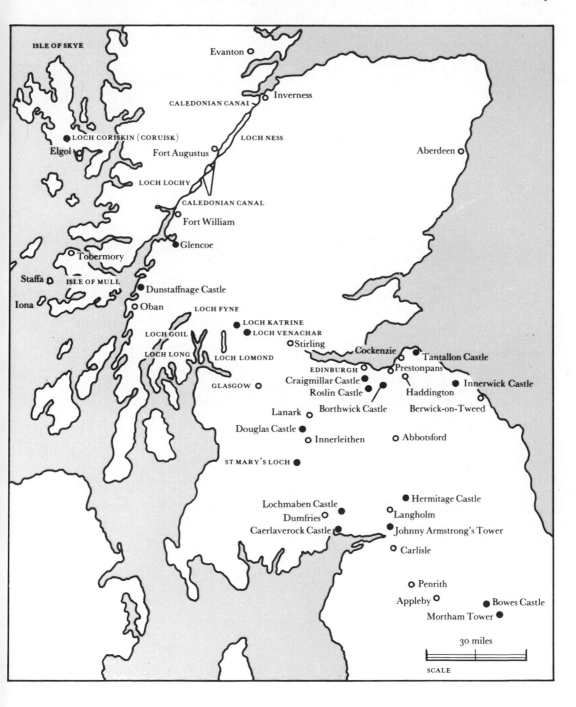

ISLE OF SKYE

Evanton

Inverness

CALEDONIAN CANAL

LOCH NESS

LOCH CORISKIN (CORUISK)

Elgol

Fort Augustus

Aberdeen

LOCH LOCHY

CALEDONIAN CANAL

Fort William

Glencoe

Tobermory

Staffa

ISLE OF MULL

Dunstaffnage Castle

Iona

Oban

LOCH FYNE

LOCH KATRINE

LOCH VENACHAR

LOCH GOIL

Stirling

Cockenzie

Tantallon Castle

LOCH LONG

EDINBURGH

Prestonpans

LOCH LOMOND

Craigmillar Castle

Innerwick Castle

GLASGOW

Roslin Castle

Haddington

Lanark

Borthwick Castle

Berwick-on-Tweed

Douglas Castle

Innerleithen

Abbotsford

ST MARY'S LOCH

Lochmaben Castle

Hermitage Castle

Dumfries

Langholm

Caerlaverock Castle

Johnny Armstrong's Tower

Carlisle

Penrith

Appleby

Bowes Castle

Mortham Tower

30 miles

SCALE

I Introduction:
Turner, Scotland and Scott

When France declared war on Britain in 1793, travel to the Continent virtually stopped. British tourists who normally went abroad now swelled the ranks of those who had discovered the fascination of their own country. Travel guides to various parts of Britain were published to satisfy the growing demand of travellers who wished for information and direction; some writers of this kind of literature considered matters pertaining to soil, crops and industries, while others were more interested in describing attractive aspects of the countryside. Sometimes books of the latter kind included engraved plates of maps and landscapes which had been introduced specifically to enhance the written descriptions of places, and to direct travellers to particular views.

The travel tours of William Gilpin, first published in the early 1780s, did much to stimulate an aesthetic interest in nature. What Gilpin did was to teach the traveller to appreciate scenery in terms of art, and this relationship formed the basic ingredient of Gilpin's aesthetic doctrine, the Picturesque.

One of the most fascinating parts of Britain, and one believed to possess picturesque potential, was Scotland. It was considered so because of the rich variety of its scenery, ranging from the gentle, rolling slopes of the Border country to the dramatic and dour peaks of the Highlands. The terrain of the latter, with its hills of gloomy bulk and impressive barrenness, especially attracted the visitor's attention and suggested descriptions in

Ossian; to those versed in the doctrine of the Picturesque, the landscape recalled the dark, foreboding paintings of Gaspard Dughet or Salvator Rosa. Gilpin published his 'Scotch tour' in 1789,[1] and this, with its descriptions and aquatint plates of Scottish landscapes, did much to feed the growing demand for books and views, thus reinforcing the strong, broadly based interest in Scotland that was rapidly developing. Many English artists visited Scotland specifically to make sketches of the picturesque countryside for private patrons, for commissioned illustrations or in the belief that a potential market for these views existed.

As a proponent of the Picturesque, Gilpin did not consider Scotland's scenery its sole attraction. Its history, he believed, added enormously to any aesthetic evaluation of its landscape: 'The constant quarrels between the Scotch and English which were generally decided in Scotland have made it a fertile scene of military events; to which several have been added by rebellions since the union. In fact you can hardly ascend any elevated ground, without turning your eye over the scene of some memorable action.'[2] A knowledge of these historical associations Gilpin therefore believed essential to any appreciation of the country's terrain.

However, Scotland's cultural traditions were also important in this respect. In speaking of its rivers, he noted that almost each one along the Border was 'the subject of some Scotch ditty, which the scene [raised] to the memory of those . . . versed in the lyrics of the country'.[3] In 1830, Sir Walter Scott echoed sentiments similar to those of Gilpin: 'every valley has its battle and every stream its song'. He made this observation shortly before Turner was engaged to prepare illustrations for the author's *Poetical Works*.[4]

The literary, historical and pictorial associations connected with Scottish topography generally stimulated interest in the country. They intensified the patriotic fervour of Sir Walter Scott and undoubtedly roused the curiosity of the young Turner.

Turner's interest was stimulated also by first-hand reports of the country's picturesqueness brought back by artists. Thomas Hearne, Edward Dayes and Joseph Farington, all Turner's associates in London, had visited the northern kingdom, the last named to prepare illustrations for a projected but never realized 'Picturesque Scenery of Scotland'. Indeed, it may have been

Farington who urged Turner to make his first Scottish tour, for he had become Turner's good friend and had probably spoken of his earlier Scottish visits in 1788 and 1792.

Turner himself first visited Scotland in 1797. The tour was a short one. His prime purpose had been to make sketches not in Scotland, but in the northern parts of England; many of these were to be used as the raw material for commissioned topographical views. But he found time to visit the Scottish Border country, and his interest was certainly whetted by this visit. In 1801, when the opportunity presented itself, Turner did not hesitate to undertake a second visit to Scotland, one that took him deeper into the country. While again there appears to have been no specific commission behind the tour, he must have concluded that the Scottish landscape possessed qualities that he wished to capture on paper and canvas. He may also have been encouraged by his friend and colleague, Thomas Girtin, who had been there the year before. In any event, on 19 June 1801 Turner informed Farington that he was to leave for Scotland the next morning, accompanied by a Mr Smith of Gower Street, London. Farington, already familiar with Scotland, had promised to supply Turner with directions to particularly picturesque places before the young artist departed. But apparently something went wrong. Because of Turner's 'indisposition' the trip was delayed, and it seems that when he eventually left, he left without Mr Smith,[5] and the tour, originally planned for three months, was completed in three weeks.

This visit of 1801 was highly significant. The many sketch books which Turner filled are a thorough record of the places he visited, and include a wide variety of landscape subjects. Indeed, the contents of these sketch books inspired the artist to prepare, immediately he returned to London, a series of large, elaborately finished drawings of Scottish scenes of which the London artistic community, according to Farington, 'much approved'. Farington also observed that Turner thought Scotland a more picturesque country to study in than Wales, and added that the artist believed 'the lines of the mountains were ... finer, and the rocks of larger masses'.[6] The 1801 tour, then, must be considered the one that truly awakened the artist to the rich aesthetic potential of the Scottish landscape.

Turner was to make four further visits to Scotland, in 1818, 1822, 1831 and 1834; and it is these that provide the basis for the

1 Sir Francis Chantrey,
Sir Walter Scott. Marble, 1820.
Height: 30 in; 76.2 cm. The
Abbotsford Collection.

present book. All were undertaken while he was in the employ of
Sir Walter Scott or in that of the latter's Edinburgh publisher,
Robert Cadell. That Turner should have decided to accept his
first commission from the author in 1818, for views to embellish
the latter's *Provincial Antiquities and Picturesque Scenery of Scotland*
(1819–26), at a time when he himself was already overburdened
with commissions, was due as much to his admiration for Scott
as to his interest both in Scottish scenery and in financial gain.
Turner had long admired Scott's work. At least as early as 1811

he knew of and possibly had read some of Scott's major poems, such as *The Lady of the Lake, Marmion,* and the *Minstrelsy of the Scottish Border*.[7] He therefore welcomed the opportunity to meet Scott and collaborate with him as illustrator.

These two eminent Romantics of such different backgrounds (Scott (**1**) was the son of a solicitor, while Turner was a barber's son) probably met briefly when Turner arrived in Scotland in November 1818. At that time Scott was at the height of his fame; his production of the 'Waverley Novels' was progressing rapidly, and he hoped that they would bring him a sustained income.[8] Turner was also by then well established. He had a considerable reputation and a comfortable income from the sale of his paintings and watercolours, as well as from investments. During Turner's Scottish visit, Scott was fully occupied, indeed pre-occupied, with the building of that castle of attractive profile and domestic proportions on the Tweed – Abbotsford near Melrose; and Turner, for his part, was heavily engaged in preparing sketches of places to embellish the first volumes of Scott's *Provincial Antiquities*. While he may have wished for an opportunity to get to know Scott, his immediate concern was to complete his sketches and hurry south to visit his friend and patron, Walter Fawkes, of Farnley Hall, Yorkshire.

When Turner next visited Scotland, in 1822, he was still sketching for the *Provincial Antiquities*. It is probable that he encountered Scott again, but still did not get to know him well. However, on the visit Scott formed an opinion of the artist that was decidedly unfavourable. Indeed, it was not until Turner's next visit to Scotland, in 1831, when he came north to gather sketches for a new edition of Scott's *Poetical Works*, that Scott's impression of the artist changed for the better. While Turner was on a short visit to Abbotsford that year, the two men had their first opportunity to become properly acquainted. It was a critical year in the lives of both. Scott, still endeavouring to free himself from the bankruptcy into which he had plunged in 1826, knew that he was seriously ill and would probably die before his debt was liquidated; and this gravely worried him. Turner likewise had forebodings of death. He had recently been unwell and in 1829 he had suffered the loss of his father; only a year later, his good friend Sir Thomas Lawrence had also died.

During the brief period when the two men were together at Abbotsford they discovered that they had interests in common.

For instance, at an early age both men had been nurtured on the cult of the Picturesque and thus they responded to nature in similar ways. Perhaps, in discovering such shared interests, they began to recognize in each other additional affinities that they had previously not noticed, or had been inclined to overlook. The kinship that began to develop between them was one that Turner was to cherish long after Scott's death in 1832. Their association on these two projects, the *Provincial Antiquities* and the *Poetical Works*, provides the setting for the first eight chapters of this book.

After Scott's death, Turner became closely associated, between 1832 and 1838, with Scott's former Edinburgh publisher, Robert Cadell. It is this association which forms the last two chapters of this book. After completion of the posthumous publication of Scott's *Poetical Works*, Cadell launched into a new edition of the collected, non-fictional, *Prose Works* and began planning a special edition of the successful 'Waverley Novels'. For both projects Turner had been invited to contribute illustrations, but in the end, as we shall see, he only prepared designs for the *Prose Works*. Cadell also commissioned him to complete designs for an edition of the projected *Memoirs of the Life of Sir Walter Scott*, to be written by the author's son-in-law, John Gibson Lockhart. Turner's illustrations for the *Life* were the last concerning Scott that he was to undertake.

All of these later projected illustrations were commissioned immediately after Scott's death and before 1834, when Turner made his final Scottish visit to prepare the sketches. During preparations for designs to illustrate these publications Turner was still undisguisedly sensitive to the very special relationship that he had begun to form with Scott, and the remembrance of their relationship probably accounted for the particular way in which he approached some of the illustrations for the *Prose Works*, and especially those which were to embellish Lockhart's *Memoirs of the Life of Sir Walter Scott*.

2 The Background to Turner as Illustrator

Turner's success as a book illustrator was due both to his talent and to the market for illustrated books which had developed during the later eighteenth and the earlier nineteenth centuries. By this time reading tastes had widened, and there was a growing demand for illustration not only to embellish topographical guides, tour books and popular historical writing, but also poetry and fiction. Many of these publications were undertaken as speculative ventures in the hope that they might capture the imagination of the reading public, thereby resulting in handsome and sometimes spectacular profits for investors.

Illustration was certainly one way of increasing the popularity of a publication, and, indeed, by the 1820s it was increasingly evident that illustration sometimes determined the success or failure of a book. By this time, Turner was not only highly skilled as an illustrator; he also thoroughly understood the processes of engraving on metal plates and of monochrome printing, and occasionally practised them (particularly mezzotint and aquatint, which are tonal methods). Although he normally entrusted his book illustrations to professional engravers, who usually engraved them in line (a process whereby lines are cut into the surface of the metal plate), because of his considerable knowledge and experience he was able to advise them and thus assist them in achieving the engraving effects that he desired. His special skills and high standards did not go unnoticed. That Turner was in constant demand as an illustrator is a tribute both to his success

in this genre and to the shrewdness of publishers, who realized that his designs contributed materially to their prosperity.

Turner's watercolour illustrations differ from his exhibition watercolours in several ways. The latter were conceived mainly as independent and self-contained entities, whereas the former always related to a text. Because of this, the illustrations served also as complements to the printed page and thus display a more palpable picturesqueness than do his exhibition watercolours. This is especially noticeable in those designs that take the form of the vignette: an oval or, more rarely, circular pictorial shape normally only used in book illustration. Further, illustrations, unlike exhibition watercolours, demanded the support of other illustrations. That is to say, in books, illustrations were often connected with each other by subject matter and meaning. Since Turner normally executed his designs in groups, they possess strong stylistic similarities as well. Yet, despite the distinctive qualities which Turner's watercolour illustrations display and the function they perform, most of those executed before 1826 are mainly regulated by the general evolution of his style; for instance, watercolour illustrations share certain qualities with his contemporary exhibition watercolours and oils. Undoubtedly many borrowings, both unconscious and deliberate, occur in Turner's constant shifting from one medium and venue to another, and it is likely that technical, stylistic or conceptual innovations blossoming in one medium sometimes enhanced another. From 1826, some of his illustrations, especially those designed for steel engraving, assume a quite independent character. The latter are miniscule in comparison with his illustrations made for copper engraving and exhibit a compression and complexity of form, and a richness and density of colour, that are distinctive; further their finely hatched brushwork is unusual and reminiscent of that of portrait miniatures.

Turner's book illustrations are of two general types. There is the full-page rectangular illustration and the smaller vignette, a form characterizing much of his later illustration. The full-page rectangular illustration either served as the frontispiece, as in Robert Stevenson's *Account of the Bell Rock Lighthouse* (1824), or, as in the case of Dr Thomas Dunham Whitaker's *History of Richmondshire* (1823), was interleaved with the text. The vignette form, a survival from the eighteenth century, is smaller. Sometimes it served as the frontispiece, as in John Bunyan's

Pilgrim's Progress (1836), and occasionally it was incorporated with the printed page, as in Samuel Rogers's *Italy, a Poem* (1830) and in Thomas Campbell's *Poetical Works* (1837); but more usually the vignette functioned as a title-page embellishment, as in *Turner's Annual Tour – The Loire* (1833), being small and of a shape and character which could be combined sympathetically with the engraved lettering of the title. In publications where the vignette is the title-page illustration, it is often balanced by a frontispiece of rectangular design.

Turner's illustrations can (like his other works) be conveniently divided into two main phases. The first, from *c*.1795 to *c*.1826, may be labelled the 'descriptive' phase, since in many landscapes (prepared for copper-plate engraving) dating from this period the artist sought to intensify naturalistic effects. Books which contain illustrations of this phase include W. B. Cooke's *Picturesque Views of the Southern Coast of England* (1814–26) and Whitaker's *History of Richmondshire*. The second period, from *c*.1826 to *c*.1840, at the end of which Turner gave up illustration, may be referred to as the 'expressive' phase. During this period Turner's designs executed for engraving on steel are smaller and more abstract in character, such as those vignettes which embellish Samuel Rogers's *Italy, a Poem* and *Poems* (1834).

Not all of the illustrations can be said to fit convincingly into these categories. When they fail to conform, however, the exceptions can often be explained in terms of a special intention on the part either of the artist or the publisher.

Arbitrary as such categories must be, they do provide a useful framework in which to consider the function of the illustration, and particularly those examples prepared for works by or about Sir Walter Scott. For instance, the first series of illustrations which Turner prepared in this context were those for the *Provincial Antiquities and Picturesque Scenery of Scotland* (1819–26), and they clearly fall within the first, or 'descriptive', phase. On the other hand, all of the 'expressive' illustrations, of the second phase, were executed for the *Poetical Works* (1833–4), the *Prose Works* (1834–6), George Newenham Wright's *Landscape – Historical Illustrations of Scotland and the Waverley Novels* (1836–8) and Lockhart's *Memoirs of the Life of Sir Walter Scott* (1839).

During the 'descriptive' phase the illustrations increasingly mirror the sensuous qualities of nature and natural effect, and the first notable thrusts in this direction occurred in the late 1790s

and are apparent particularly in the oil paintings and watercolours prepared for exhibition. By studying the landscape paintings of older masters as diverse as Richard Wilson, Rembrandt and Nicolas Poussin, Turner began to comprehend the rich potential of natural effect in painting. Varied as the landscapes of these artists are, they share one thing in common on which Turner centred his attention: the remarkable softening, blurring and dramatic effects of light and shade.

Turner's persistent quest for natural effect continued in his work during the first two decades of the nineteenth century, though it began to lessen by the middle of the third, with the initiation of the 'expressive' phase. His illustrations of those first two and a half decades most clearly display his growing understanding of, and sympathy with, nature. Yet it would be misleading to call these landscapes truly naturalistic, even though they have their origins in his experience of nature. Unlike John Constable's landscapes, Turner's are at once less immediate, and display an artifice, a 'certain synthetic or composite tendency', which Lawrence Gowing, in his introduction to A.J. Finberg's *Turner's Sketches and Drawings* (1968), rightly notes is characteristic of Turner's landscapes in general.

A comparison of two views (**2**, **3**) of the junction of the Greta and Tees – one from *c.*1817, prepared for Whitaker's *History of Richmondshire* (1823), representing the first, 'descriptive' phase, and the other from 1832, for Scott's *Poetical Works* (1833–4), characteristic of the second, 'expressive' phase – provides evidence of some of the essential formal differences in Turner's approaches to the same subject.

Turner's clarity of vision and careful observation are striking in the earlier of the two illustrations. The landscape is heavy with a variety of leafy growth; it is impregnated by a moist, luminous atmosphere, and its water surfaces glisten with sunlight. Because of the normal eye level which the landscape suggests, the spectator seems intimately connected with it. Ruskin, who owned the watercolour, was smitten by its immediacy and by its natural effects of light and shade: 'It . . . may be well to note of it at once', he remarked, 'that in the painting of the light falling on the surface of the Tees, and shining through the thicket above the Greta, it is an unrivalled example of chiaroscuro of the most subtle kind; – obtained by the slightest possible contrasts, and by the consummate skill in the management of gradation. The

2 J.M.W. Turner, *The Junction of the Greta and Tees at Rokeby*. Watercolour, *c.*1817, engraved for Whitaker, *History of Richmondshire* (1823). $11\frac{3}{8} \times 16\frac{1}{4}$ in; 29.0 × 41.4 cm. Ashmolean Museum, Oxford.

3 J.M.W. Turner, *Junction of the Greta and Tees*. Watercolour, 1832, engraved for Sir Walter Scott, *Poetical Works* (1833–4). $3\frac{1}{4} \times 5\frac{3}{4}$ in; 8.3 × 14.6 cm. Private collection.

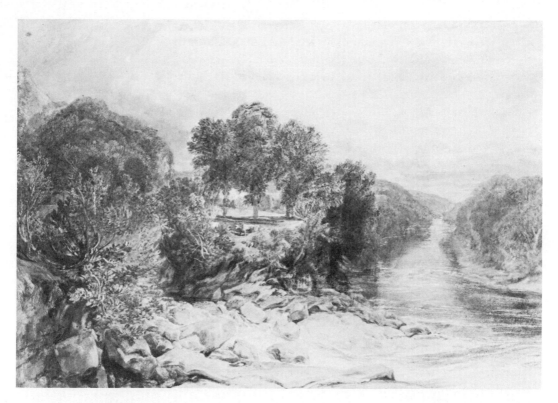

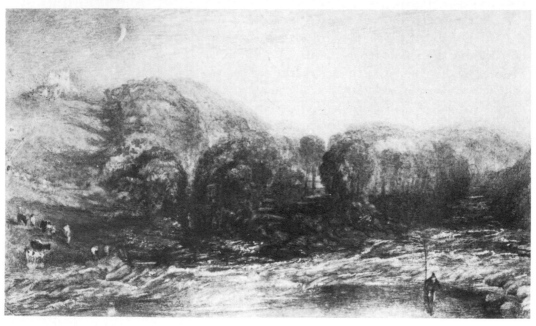

rocks and stone drawing is not less wonderful. . . .'[1]

The second landscape watercolour has fewer of the naturalistic effects of the first. It is smaller in size, although it is enhanced by a stronger, more assertive design. The landscape forms seem compressed – I shall suggest later (pp. 91–3) that the on-the-spot panoramic sketch for this watercolour is not an accurate representation of the place – and the trees and bushes display, individually, less formal variety. Also, the subtleties of chiaroscuro, present in the earlier watercolours, are missing. Further, the vantage point has been raised to allow a more extensive view of the Greta and Tees, but one which makes the viewer's relationship to the landscape less intimate in consequence.

While these two watercolours differ in these fundamental ways, they do share general chiaroscuro and atmospheric effects which enhance the landscape's mood. That Turner was particularly interested in capturing the particular mood, or spirit, of landscape is supported by those poetic fragments which often accompanied the entries of his paintings in the Royal Academy catalogues. By including verses, the artist not only demonstrated that equivalent moods existed in poetry and painting, but that such lines were capable of evoking images and an atmosphere that might reinforce those of a painting.

During his 'descriptive' phase (at least, between c.1808 and c.1811), Turner was prepared to accept only a limited connection between the arts of poetry and painting, since at that time he believed that the intention and means of the painter and poet were fundamentally different: '[the] contrariety of their [the painter's and poet's] means underlies [and] separates Poetry from Painting tho [sic] drawn from the same source and both feeling the beauties of nature, but selection is as different as the means of conveyance diverse. Their approximation is nearest when the Poet is description [sic].'[2] Elsewhere, Turner observed that while the artist's aim was description, the poet's purpose was description to which a further significance was added: 'The painter's beauties are defineable while the poet's are imaginary as they relate to his *associations*. . . . He [the poet] seeks for the attributes of sentiments to illustrate what he has seen in nature. ... The painter must adhere to the truth of nature.'[3]

By the time of his 'expressive' phase, however, Turner had become convinced that a more intimate relationship between

poetry and painting was possible and that his illustrations, if adapted, could participate more directly in the poet's vision. In order to achieve this end, Turner revised his approach to book illustration: forms were now made simpler and thus stronger, and colour was used more for its emotional than for its descriptive power.

This change ultimately led Turner closer to an abstraction which invested his landscapes with a new geometry and a new tautness of design; it also allowed him to invest his illustrations with a wider range of emotion and ideas than they had previously possessed. This fresh approach is particularly apparent in those designs which he prepared for poetry, which dominated his commissions for illustration during the 1830s: examples are those for Samuel Rogers's *Poems* (1834), John Macrone's *Milton's Poetical Works* (1835) and E. Moxon's *Campbell's Poetical Works* (1837).

That the most decidedly abstract designs prepared during this second phase were those done to embellish literature, and especially poetry, may not be entirely fortuitous. For, in a number of these, Turner employed devices equivalent to those found in poetry by which to strengthen the emotional content. Now, the artist, like the poet, is concerned not only with the objects of nature but also with his knowledge of, and responses to, them, and the fusion of these provides the basis for his creative experience. In poetry, metaphor is a means of giving expression to this experience, and of this Turner seems to have been well aware. It was for this reason that he appears to have superimposed elements of a literary structure on his art, notably in the 1830s and often in his illustrations. That is to say, in a number of his illustrations, natural objects function in a dual role, for they are given symbolic value, and, as in poetry, can be read on both a literal and a figurative level, providing vehicles of a richer and intenser mood. These symbols can function independently, but are mainly woven into the design's larger configurations of meaning. For example, in the watercolour *39, Castle Street*, (**101**) prepared for Lockhart's *Memoirs of the Life of Sir Walter Scott* (1839), the sculptured bust of the author, situated on the parapet of his house, has enhanced significance when considered in conjunction with the star in the sky immediately above it. As Scott inhabited this residence during some of his most creative years, the star hanging above the bust signals his achievement (see p. 224). While pictorial symbols can embody a clearly

established and parallel relationship between literal and figurative interpretations, on occasion the connection is as indefinable as it is efficacious. It might be said that the character of this relationship is comparable to that existing between two juxtaposed, complementary colours in a painting: that is to say, an association is established which, while not interfering with the integrity of either colour, serves to vitalize and splendidly enhance the quality of each. In Turner's illustrations, then, there exist certain constellations of symbols whose relationship is similar to that existing between complementaries, in so far as their independence is maintained while they interact. Indeed, they function much like the literary metaphor, wherein 'two thoughts of different things are active together and [are] supported' by a single image 'whose meaning is a resultant of their interaction'.[4] These metaphorical aspects in some of Turner's illustrations can be considered poetical, since they serve to amplify poetic mood.

Turner's shift, then, to a more abstract style was undoubtedly the consequence of a rigorous process of thought which resulted largely, but perhaps not entirely, from the artist's search for a more expressive mode. For this kind of development may also have been influenced by the fact that the engraving material for his illustrations changed from copper to steel.

Turner's sense of the potentialities of the engraving medium must have developed at an early period of his career. Indeed, his introduction to art probably took place through the medium of engraving. Prints after paintings were widely known and readily accessible, since they could be purchased for only pennies. Turner's first tentative steps in the direction of art, and an artistic career, seem to have been taken when he began colouring prints. A further step was taken when he copied them. One of his earliest surviving watercolour copies was made when he was only twelve, after a landscape engraved by J.B. Basire for the *Oxford Almanack*.[5] This copy, signed and dated 1787, apparently did not satisfy the young artist, for he soon made another which is much more tonally unified.[6] In this second version there are notable improvements in the consistency of the brushwork, in the translation of the hatched tones of the engraving into the fluid ones of the drawing, and, finally, in the greater unity of colour.

Turner's efforts in making these copies taught him much about pictorial structure. This is especially true of copies that he made

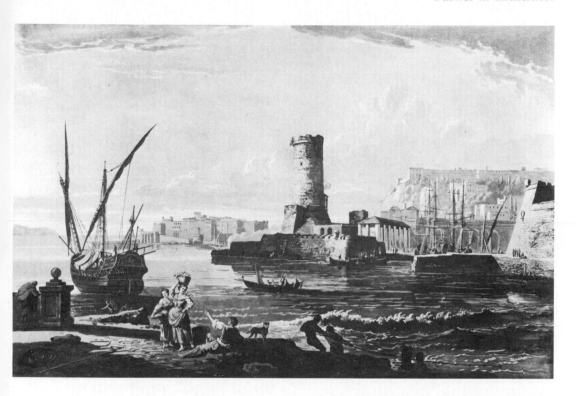

4 A. Fabris, *Part of Naples with the Ruined Tower of St Vincent.* Aquatint by Paul Sandby, 1778. $13\frac{1}{8} \times 20\frac{1}{8}$ in; 33.5 × 51.1 cm. British Museum, London.

after plates from Gilpin's guide to Cumberland, Westmorland and other parts of England.[7] These aquatints are possessed of three defined and simplified spatial grounds: a dark foreground, a light middle ground and a still lighter background. Through copying them, Turner absorbed the essentials of Gilpin's picturesque methods. When he later came to translate a landscape aquatint by Paul Sandby, *St Vincent's Tower, Naples* (**4**), the young Turner freely employed a similar system of spatial grounds.[8] He transformed the relatively realistic foreground of *St Vincent's Tower* into the dark, earthen abstract hump, so typical of foregrounds in landscape plates after Gilpin (**5**). Also, the more natural, energetic figures of Sandby's *St Vincent's Tower* are reduced in Turner's copy to the relatively lifeless, staffage embellishments of Gilpin. Finally, in his copy, Turner has rejected the rectangular format of *St Vincent's Tower*, preferring instead the oval, so characteristic of Gilpin's published views.

By copying or freely transcribing prints, Turner received a thorough grounding in the elements of pictorial structure, the better preparing himself to understand the nature and extent of

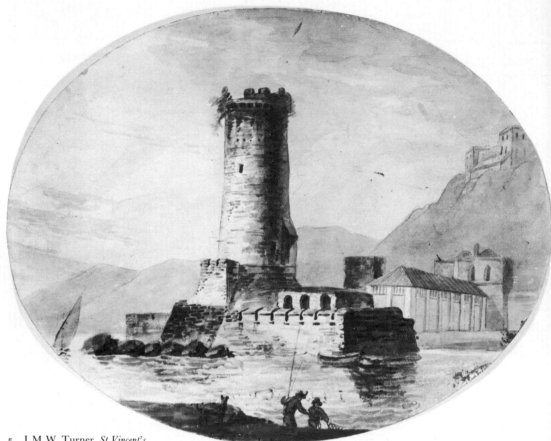

5 J.M.W. Turner, *St Vincent's
Tower*, *Naples*. Pencil outline
with washes of Indian ink,
c.1787. Turner Bequest, IE.
8 × 10 in; 20.3 × 25.4 cm.
British Museum, London.

the relationship between a watercolour and an engraving made from it. Such knowledge was undoubtedly consolidated after making further copies from the drawings of well-known topographical illustrators, such as those of Edward Dayes. By the time Turner was first engaged to prepare illustrations for a publication, *Walker's Copper-Plate Magazine*, to which he contributed between 1793 and 1798, he already knew the requirements of the engraver and his style was readily translatable into the medium of the print. That is to say, Turner's drawings were fundamentally linear, with simple tonal areas which the engraver could readily convert into line. Ironically, these same illustrations, apparently so admirably adapted to the needs of the engraver, were not at all well translated. The difficulty was basically due to the standardized engraving techniques which John Walker and his engravers employed (**6**). Their system of parallel and regularly hatched strokes translated the basic tonalities of the drawing, but did little more. Even these tonalities are translated in such a mechanical way that they appear both inert and monotonous. As a consequence, the tonal nuances and complexities of the artist's emergent naturalism have been mainly lost in the *Copper-Plate Magazine* engravings. But Turner was to find a more able engraver.

When Turner was commissioned to prepare views for the *Oxford Almanack* in the late 1790s, he became associated with John Basire, the engraver of landscape views whose work he had copied when hardly more than a child. Basire was a sympathetic engraver, far more competent than the engravers for the *Copper-Plate Magazine*. Under Turner's guidance, Basire was able to capture some of those characteristics of the artist's style which unhappily had largely eluded Walker's engravers. That Turner actively assisted Basire is borne out by the evidence of his notations on the margins of the trial proofs of *Almanack* plates.

Undoubtedly, the success of Turner's collaboration with Basire depended as much on the engraver's technical skill and adaptability as on the artist's inventiveness. Basire introduced many varieties of engraved line, not only to render the complex chiaroscuro effects of Turner's drawings, but also to approximate to the textural richness which was becoming increasingly evident in them.

This is not to say that the evolution of Turner's style posed no difficulties for Basire, because it did. Such problems are discernible. The earlier designs seem to have caused Basire little

6 J.M.W. Turner, *Bridgenorth*, for *Walker's Copper-Plate Magazine*. Engraving on copper by J. Walker, 1795. 4⅜ × 6¾ in; 11.1 × 17.2 cm. British Museum, London.

trouble, as the landscapes were clearly organized and the forms simply modelled. However, in Turner's later views for the series, a developing naturalism began to manifest itself in more complex arrangements of form, light and shade which made greater demands on the engraver's skill. Sometimes Basire's success was limited. For example, in Turner's *View of Oxford from the South Side of Heddington* [sic] *Hill* (engraved in 1808) Basire attempted to approximate to the subtle luminosity of the watercolour's cloud forms by burnishing and scraping them (**7**). While the effects he achieved, and the tonal relationships he established between sky and landscape forms, may have been deemed adequate by Turner, by comparison with those of the watercolour itself (even though now faded), they are deficient. Basire achieved a luminous sky, but at the expense of the landscape itself. The cloud forms are too complex and bright for the landscape, which in the engraving is inadequately illuminated. The basic problem which Basire faced was, in fact, the effective translation of Turner's naturalism. Turner himself came to this realization and was convinced that, if engraving were to serve as the medium of his imagination, it had to be sensitive to all the essential aspects of

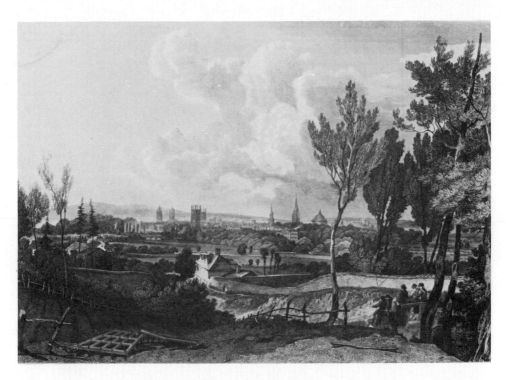

7 J.M.W. Turner, *View of Oxford from the South Side of Heddington Hill*, for *Oxford Almanack*. Engraving on copper by J. Basire, 1808. 12⅝ × 17⅝ in; 32.1 × 44.8 cm. British Museum, London.

his style. He further recognized that, in order to accomplish this, the engraver would require an expanded vocabulary of linear equivalents.

Turner's association with Basire on the *Oxford Almanack* made him conscious of the technical limitations of engraving. It also provided him with a fuller and more precise awareness of the nature and extent of the relationship existing between the illustration and the engraved impression made from it. He had long understood that engraving was only a means of translating the effects of a drawing or painting, never an instrument for reproducing them.[9] This knowledge, gained at least as early as his experience with engravings for the *Copper-Plate Magazine*, was greatly reinforced during his association with Basire. Turner fully realized that the engraving, like a sieve, sifted the essentials of the original pictorial statement. If the engraver's technical resources were limited, the screen of the sieve would be coarse and homogeneous in structure (as in those engravings for the *Copper-Plate Magazine*), and the subtleties and individuality of the artist's style would inevitably be lost. On the other hand, if, as a consequence of the engraver's greater knowledge and ability, the

screen of the sieve were finer and of more varied construction, then engravings, such as those of Basire, could preserve more of the original pictorial statement.[10]

Turner was convinced that he had found an even better engraver when he discovered the work of John Pye in 1810. At that time John Britton was undertaking the publication of the *Fine Arts of the English School*, a work which was to include a number of engravings after paintings. One of those works selected was Turner's oil painting, *Pope's Villa at Twickenham* (**8**). This, Britton commissioned John Pye to engrave. Apparently, when Pye took his first proof to Turner for correction, 'he was relieved to find the painter was from home, and he was thus enabled to leave the proof for his inspection'. A few days later, 'a gentleman ... on horseback, was seen at Mr. Pye's house: It was Turner himself. "This is all right," said he, "you can see the lights"! If I had had any idea there was any one in this country capable of doing that, I would have applied to him before."'

This was the first time that Pye had commercially engraved a painting by Turner, but it was not the first engraving he had made from the artist's work. He had encountered Turner's paintings as early as 1804, while apprenticed to the engraver, James Heath. He had spied a drawing of Inverary Castle which Turner had made for Joseph Mawman's *An Excursion to the Highlands of Scotland* ... (1805). Pye recalled, 'From this drawing I was destined to make an engraving,' but, as an amateur beginning, it had not been successful. Later, Pye spied 'in the shop window of a Bookseller an impression of the plate bearing the name of James Heath as the engraver'.[11]

Pye's success in engraving Turner's *Pope's Villa* was probably due to his study of the artist's means of conveying the effect of space, 'to enable the spectator to see through the picture into space' and to approximate to the effects of light that Turner had originally achieved. Indeed, the two 'cardinal points' to which his success was attributable were light and the management of it. Light, according to Pye, was an essential ingredient of landscape, but in translating a painting, this light required proper control.[12]

To create a convincing sense of space in *Pope's Villa*, Pye developed a carefully graduated tonality throughout the landscape, leading the viewer's eye from the strident darks of the foreground to the light and tender tints of the middle ground and background. But, as important as his sensitivity to the effects of

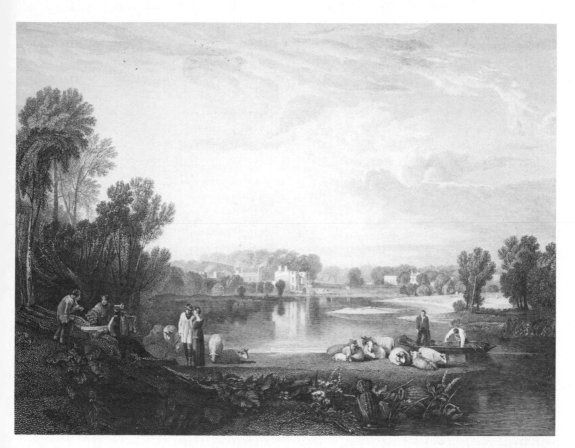

8 J.M.W. Turner, *Pope's Villa at Twickenham*. Engraving on copper by John Pye (figures by Charles Heath), 1810. 6⅞ × 9 in; 17.5 × 22.9 cm. British Museum, London.

space, and in some respects related to it, was Pye's creation of a landscape 'light' or luminosity, which is particularly notable in the middle ground of the engraving. It is a spreading, luminous aura, enveloping trees and other landscape forms and the sky.

Through his understanding of the artist's intentions, Pye was able to produce effects equivalent to those found in Turner's painting. And his success in this respect was in no small measure due to the sophistication of his technical methods. In the trees of the middle ground, Pye introduced a tone of vermiculated or granulated texture, composed of numerous tightly woven, meandering lines. These create a high degree of luminosity, which closely approaches Turner's original effects. But the light which Pye achieved is not restricted to the landscape itself. With consummate skill, he has been able to approximate to the sensuous lightness of Turner's cloud forms. He realized that, in order to translate Turner's clouds into light and luminous forms,

it was necessary sharply to distinguish them from the darker material forms of the landscape itself. While, in engraving the clouds, Pye, like Basire, employed the traditional method of cross-hatching, burnishing and scraping, he also used the fine hair-line of the drypoint needle to supply added textural distinction and to provide an added lightness and luminosity.

If Turner's exclamation, 'you can see the lights', is authentic, then it may document the beginning of his firm conviction that engraving could create effects equivalent to those of an original artistic statement.[13] It would also imply that he understood that the work of art and the engraving had independent existences. When Turner corrected Basire's trial proofs for the *Oxford Almanack* series, he was not merely achieving a tonality generally equivalent to that of the original: he was correcting the range of values in the context of the tonal range of the engraving. For example, when he insisted on a greater brilliance in certain parts of a plate, it was not that he wished the engraver to duplicate the specific effects of the watercolour, but that he believed that the modification was essential to the tonal integrity of the engraving. That he was later to ask his engravers to add figures or other details, or even to delete them, attests to his belief that the engraving could enjoy a considerable measure of artistic independence of the original, and was not to be considered merely a pale and mechanical reflection of it.

Turner was to put his knowledge of engraving to good use in his subsequent commissions for illustrations, when he was able to influence the technique of line engraving employed. Soon after the publication of *Pope's Villa*, he became associated with W.B. Cooke's series, *Picturesque Views of the Southern Coast of England* (1811–27) (9), for which he occasionally supervised the cutting and correcting of the plates. Cooke and his brother were the principal engravers, supported by several young and ambitious assistants. Although bitter arguments erupted between Turner and the Cookes over the years of their association, the painter's influence was profound and resulted in the formulation of a technique of copperplate engraving sufficiently distinctive to launch a 'school'. Indeed, this technique of engraving, with its rich textures and its sparkle and vibrancy of light and shade, which developed under Turner's guidance, became the best established manner by which his work was translated into prints. By this stage of his career Turner, when embarking on any new

9 J.M.W. Turner, *Lulworth Cove, Dorsetshire*, for W.B. Cooke's *Picturesque Views of the Southern Coast of England* (1814–26). Engraving on copper by W.B. Cooke, 1814. 5⅝ × 8½ in; 14.3 × 21.6 cm. British Museum, London.

commission, often had the opportunity to make recommendations concerning the engravers to be employed, and inevitably he selected those who had come under his influence and whose work he admired. For this reason, the particular technique of engraving developed on the *Southern Coast* series was to survive even in the latest of his great copperplate series, the *Picturesque Views in England and Wales* (1827–38). Indeed, as a mark of its phenomenal adaptability and success, the technique even influenced that of steel engravings made after his original work.

But the technique was not to be limited to engravings after Turner; it spread to such an extent that, by the late 1820s and 1830s, it was generally adopted in British copperplate and adapted to steel engraving. It survived and flourished because it had evolved through the early years of Turner's 'descriptive' phase of illustration, at a time when a technique of engraving was required which was both flexible and sensitive to the subtleties of the artist's naturalism.

Although the efflorescence of steel engraving did not occur until the 1830s, Turner's first illustrations for steel were those

which embellished W.B. Cooke's *Rivers of England* (1823-7) and *The Ports of England* (1826-8). However, these drawings were engraved in mezzotint, and not in line. W.B. Cooke, who financed this series, noted in the advertisement for the former that the medium of mezzotint on steel was 'peculiarly adapted to the powerful effects of light and shade in the varieties of twilight, sunlight, sunrise, midday and sunset'. While mezzotint on steel might have had some of the virtues that its proprietor proclaimed, technical problems, which beset the plates in the printing process, proved so overwhelming that the project was eventually discontinued.

Steel certainly had its shortcomings. It was much less tractable than copper, and it was probably for this reason that Cooke encountered so many problems with the mezzotint process – an intricate and complex method of engraving. Steel had other disadvantages, too: it was more costly to engrave, and cutting was more laborious than on copper, causing the edges of engraving tools to be rapidly blunted. Yet, in spite of such difficulties, the primary advantage of steel was significant: it had great resistance to wear. For this reason, steel was generally employed as the engraving medium for the much bigger editions issued during the 1830s. Also, since steel was harder, finer lines, and hence more subtle ranges of tonalities, were possible. On the softer copper such effects were not feasible. However, engravings on steel, because of their higher cost, tended to be much smaller than those on copper, and, since it was more economical to make watercolour illustrations the size of the intended engravings, those prepared for steel were normally much smaller than those for copper.

While there can be little doubt that Turner's transition from his 'descriptive' phase to his 'expressive' phase was to a considerable extent a response to his need for greater expressiveness and meaning, it was also to some degree the consequence of his change from copper to steel engraving. That a more abstract cast can be observed in Turner's watercolours prepared for steel than in his contemporary watercolours intended for copper is beyond doubt. This is due not only to the transition to the 'expressive' phase, but also to the reduction in the size of the pictorial image and the frequent use of the vignette form, especially for illustrations for poetry.[14] Both had the effect of reducing or subduing the naturalism of Turner's first, 'descriptive' phase, which had been

so fully developed in the rectangular illustrations, of generous size, which characterized the works engraved on copper. In these, and in the engravings made from them, naturalism had acted as a pictorially unifying element. But in the watercolours intended for steel engraving, which were severely reduced in size, Turner needed to discover or invent other means of unification. This he accomplished largely through a form of abstraction. By carefully regulating and compressing forms and superimposing on his landscape a strict and conscious order, he made the inner logic and abstract structure of his compositions much more conspicuous, and thereby reinforced the fundamental conceptuality of his style.

Turner's first major series of watercolour illustrations for steel were the vignettes executed for Samuel Rogers's *Italy, a Poem*, published in 1830. The tremendous success of this publication resulted in a series of commissions for literary illustration on steel which were to keep him occupied until the end of the decade and of his career as an illustrator. Among them were the steel engravings prepared for Scott's writings: the *Poetical Works* (1833–4), the *Prose Works* (1834–6), G. N. Wright's *Landscape – Historical Illustrations of Scotland and the Waverley Novels*, published by Fisher and Company (1836–8), and finally, Turner's illustrations for J. G. Lockhart's *Memoirs of the Life of Sir Walter Scott* (1839).

Since the engravings were a monochrome translation of the illustration watercolours, some mention must be made of the role of colour in the originals. Turner's first practical experience with colour in relation to engraving occurred in his early years, when he began to colour prints. The function of colouring here was simply to give the engraving the *semblance* of a drawing or painting. It assisted in differentiating forms and in providing naturalistic effect, or it could function simply as a cosmetic. But colour did little more than this. It was only when the young Turner actually began to *copy* the engraved image that the function of colour changed.

When watercolour is applied to an engraving, it is, at least in part, contained or organized by the linear skeleton of the engraving itself. However, if this framework is removed, as when an artist makes a copy of an engraving, the colour constitutents in the copy become of necessity more structural, serving as tonal as well as chromatic components of the composition. Turner's

development from colourist to copyist sharpened his awareness of
the distinction between engravings and original works of art and
also made him conscious of opportunities for colour experi-
mentation; in his illustration watercolours he discovered that he
was free to experiment with colour as long as he maintained the
tonal relationships necessary to guide the engraver in his
translation of tones on to the plate.

One cannot say that, during the 'descriptive' phase, Turner's
illustration watercolours, as opposed to his exhibition
watercolours, display any special colour characteristics. From
the early 1800s to the mid-1820s, much of his work shared a
certain limited naturalism of colour. That is to say, colour
functioned in a descriptive way; although, unlike John
Constable's colour sense, Turner's was developed not so much
from studying natural effects as from reflecting on them. From
1810, however, one is struck by a growing penchant in Turner's
work for more intense colours, and specifically for the three
primaries: red, yellow and blue. Although this emphasis is not
limited to illustrations, the first notable examples are those found
in the watercolours for the *Southern Coast* series. Turner's growing
interest in colour compositions in which the primaries figure
largely may be due to his struggles in attempting to understand
the nature of light.

From 1810, Turner, as Professor of Perspective at the Royal
Academy (1807–37), began to contemplate possible ways in
which pigment colour could more accurately emulate natural
appearances. He considered how to employ the principles of light
to heighten the naturalism of colour in paintings. This probably
explains the growing emphasis on the three primaries, which
seems to have culminated in a number of watercolours produced
in 1817 and early 1818.[15] But these ideas appear to have been
more fully developed in the early 1820s, and particularly about
1822–3, when he seems to have considered briefly the broader,
more complex nature of the spectrum in watercolours which he
prepared for the *Rivers of England* series. In a number of the
watercolours of this series, especially *Norham Castle*, the three
primary colours dominate, though Turner seems to have
introduced them in an unusual way. By means of a sophisticated
and systematic technique, he created a spectral richness which he
hoped would more accurately approximate to natural effects
than his work had done hitherto.[16] While he was never wholly

convinced of the success of this experiment, in certain respects it did succeed. For not only did it give him insight into the problem of spectral harmony, but it also enabled him to produce some of the most attractive and brilliantly coloured of his watercolours. That such chromatic experiments were carried out in watercolours for engraving rather than in those for exhibition is perhaps understandable. For what better place could there be for personal essays in colour? Again, in watercolours for engraving all that was necessary was that the colour employed convey the necessary tonal relationships to guide the engraver.

While the spectral richness of Turner's colour continues in his illustrations until the late 1830s, it is a richness in which there is a diminishing reference to local colour – that is, the colour of the object itself. Not that local colour was ever notable in his work, but in these late illustrations – especially those for steel, designed as vignettes – it is quite unimportant. In the watercolours for the *Rivers of England* of the early 1820s, while there is no vividness of local colour, it does exist beneath the surface of the prismatic skein of reflections and shadows with which the views of the *Rivers* abound. By the late 1820s, in many of the smaller illustration watercolours, Turner's colour becomes increasingly conceptual: that is, the conscious reference to local colour diminishes even more. Colour is thickened and becomes increasingly opaque (due to the use of body colour), losing its primarily descriptive capacity, although it retains its ability to indicate tonality and continues to guide the engraver in determining transitions in terms of light and shade. But it becomes abstract, and assumes an essentially expressive role. In these later watercolours, colours of objects are determined in some cases by reflected lights, exaggerated in strength, that sometimes function as local colour, but which, of course, are not. In other instances, colour is symbolically or intuitively applied. Such a change in Turner's attitude towards colour is parallel to, and consistent with, that which in the later 1820s resulted in a greater abstraction of landscape forms, and which has suggested that the artist's watercolours from the mid-1820s to about 1840 be considered as belonging to the second, 'expressive' phase of his illustration. The increasingly abstract nature of Turner's colour did not escape the keen eyes of the early twentieth-century Turner scholar, W.G. Rawlinson, who noted, especially in the vignettes designed for steel, their particularly 'exaggerated' and 'unnatural' hues.[17]

Turner's colour developed in the way it did because, paradoxically, he accepted both the interdependence and the ultimate separateness of watercolour and engraving. Colour might serve to guide the engraver in establishing tonal relationships, but it also became an essential component of the illustration as a work of art and saleable commodity. That Turner viewed his illustrations as investments is not surprising, for he possessed sufficient business acumen to know that, as colourful and attractive products of his brush, they had a valuable life beyond their services as illustrations for reproduction. Although initially expensive for a publisher to buy, they could be resold, reducing considerably his actual investment. Further, a publisher persuaded of their resale value might very well increase his order and thereby add to the artist's profit. Consequently, for Turner to consider his illustrations as independent works of art was the result of good economic sense.[18]

3 The *Provincial Antiquities*

Turner's initial contact with Scott occurred in 1818, when Scott invited him to contribute designs for the author's *Provincial Antiquities and Picturesque Scenery of Scotland* (1819–26). He was also asked to become a shareholder in the project. That Turner accepted the commission, with its particular responsibilities, and in spite of the fact that he could not claim to be the exclusive illustrator of the book, indicates something of the extent of his desire to become associated with Scott. In addition, at the time he was already heavily committed to other projects. He was engaged to prepare designs for several serials, including W.B. Cooke's *Southern Coast* (1814–26) and Whitaker's *History of Richmondshire* (1818–23), as well as designs based on drawings by the architect James Hakewill for his *A Picturesque Tour in Italy* (1820). Not until late October 1818 did Turner find time to visit Scotland to discuss Scott's proposal and to collect sketches, and then only for a period of about two weeks.[1]

Scott proposed this project when he realized that, over the years, he had collected much material on the history and archaeology of Scotland which he believed should be published. He was convinced that the work would benefit from illustration, since it was essential to make it as attractive as possible to the buying public. Like many such ventures of the period, the project was speculative, and for that reason the risk of publication was to be shared. Two of Scott's friends, Edward Blore, artist and architect, and the gifted amateur painter, John Thomson of

Duddingston, were invited both to prepare drawings and paintings and to become shareholders. Turner's invitation was identical, and three engravers, George Cooke, Henry le Keux and William Lizars, were also asked to provide their skills and to share the risk. All accepted the challenge. During the summer or the autumn of Turner's visit, four additional artists had been asked to contribute drawings, though not to become shareholders: H.W. Williams, A.W. Callcott, Alexander Nasmyth and J.C. Schetky. Of all the *Provincial Antiquities'* illustrators, Turner was considered the most eminent. He had been selected because Scott and his other shareholders were convinced that Turner's name and artistic contribution would be of inestimable value, both to embellish the book and to guarantee its financial success. As Edward Blore observed, 'We cannot too highly appreciate the advantages which his [Turner's] name is likely to confer on our work.'[2]

Fortunately, the *Provincial Antiquities* contract survives.[3] Defining the functions and responsibilities of the shareholders, it provides a useful background to the history of Turner's involvement in the venture. Scott was asked to select the subjects to be illustrated, around which he would develop his text. As he was to donate his manuscript, he was to receive 'drawings and paintings which his descriptive manuscript illustrates'.[4] Moreover, he was to have the privilege of 'demanding such numbers of copies of the work not exceeding six as he shall think proper two of which shall be on Indian paper. . . .'[5] Further, Scott and the other shareholders (the three illustrators, the three engravers and the publishing firm involved, Rodwell and Martin) were to receive one share each, 'according to which proportions the profits shall be divided'. And, in case the undertaking did not succeed,

the loss if any shall be sustained and in the same proportion the said parties shall relieve the Publishers of their advances, should that become necessary in consequence of a deficiency in the sale in manner after expressed each to the extent of one share only . . . and it shall then appear that a sufficient number of copies has not been disposed of to defray the whole expence [*sic*] that has been incurred the Whole Proprietors shall be bound to make up the deficiency to the publishers in the proportions before mentioned and in the event of the proceeds of the copies sold exceeding the expences incurred as aforesaid the balance

shall be divided among the proprietors as profit in the same proportions.[6]

The document also contains a valuable statement of payment to the three shareholders/illustrators, indicating the discrepancy between what was received in payment by Turner, and the amounts allotted to Thomson and Blore. Turner was to receive, for each drawing, a sum 'not exceeding Twenty five Guineas if taken on the spot and twenty Guineas if made from sketches'. Thomson and Blore were to receive only 'ten Guineas for each finished drawing or painting and ten [*sic*] Guineas for each slight one'. Blore was to be paid an additional sum for undertaking 'the trouble of superintending the progress of the work'.[7] Recognition of Turner's skills and reputation is undoubtedly reflected in the higher payment he was to receive. But the amount contracted was apparently greater than that originally envisaged, and it was only after hard bargaining by Turner that the fee was raised. At the outset, Turner's 'haggling', and what might have been thought an excessively generous payment, were considered an acceptable burden – if they guaranteed the publication's success. However, these manoeuvres proved to be only minor events in the much bigger drama that was to unfold as the *Provincial Antiquities* project proceeded.

Having signed the contract in London early in 1818, Turner prepared to leave for Scotland late in October. On the twenty-second he wrote a letter from London to his friend Francis Chantrey, the sculptor, who was then in Edinburgh, saying that he had wished to meet him there but could not see how a rendezvous was possible at this late date: 'I begin to fear that I shall not arrive before you leave ... though I hope to be in Edinburgh by this day week.'[8] Turner left London soon after writing this letter. He sped north by coach to Grantham, Lincolnshire, and then proceeded to York. From there he coached to Newcastle, and thence to Berwick and on to Dunbar. At Dunbar he stopped and made the first of his sketches for the *Provincial Antiquities*.[9] From Dunbar he seems to have taken the North Berwick coach, stopping to make sketches of the spectacularly situated Tantallon Castle and the nearby Bass Rock. From North Berwick he possibly staged through to Edinburgh.

While as yet little is known of Turner's movements during this Scottish trip, the three sketch books which he filled suggest that

CLXVII – 66

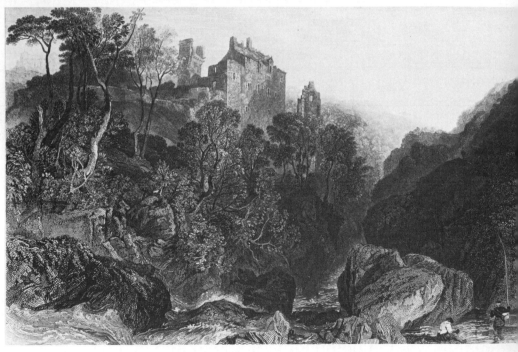

10 J.M.W. Turner, Roslin
Castle. Pencil sketch, 1818,
'Scotch Antiquities Sketch
Book', Turner Bequest,
CLXVII, 66. $4\frac{3}{8} \times 7\frac{1}{8}$ in;
11.1 × 18.1 cm.
British Museum, London.

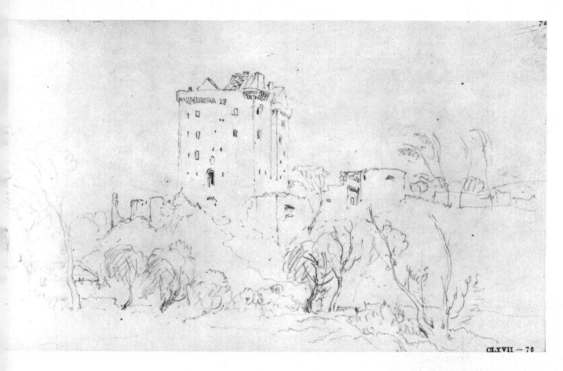

12 J.M.W. Turner, Borthwick
Castle. Pencil sketch, 1818,
'Scotch Antiquities Sketch
Book', Turner Bequest,
CLXVII, 76. $4\frac{3}{8} \times 7\frac{1}{8}$ in;
11.1 × 18.1 cm. British Museum,
London.

11 J.M.W. Turner, *Roslin
Castle*, for Sir Walter Scott,
*Provincial Antiquities and
Picturesque Scenery of Scotland*
(1819–26). Engraving on
copper by W.R. Smith, 1822.
$6\frac{1}{4} \times 9\frac{3}{8}$ in; 16.0 × 23.8 cm.
British Museum, London.

most of his time was spent sketching in Edinburgh, with brief excursions into the countryside. He travelled south-east from the city to sketch views of Crichton, Roslin and Borthwick castles, and west of Edinburgh for views of Linlithgow.

On some of these trips, both beyond Edinburgh and within the confines of the city, Turner may have been accompanied by the Reverend John Thomson, fellow illustrator of the *Provincial Antiquities*. Thomson, of almost the same age as Turner, was a devoted admirer of his work.[10] The two seemed to get on well together: on one occasion Turner visited Thomson at his home, the Manse at Duddingston, a village not far from Edinburgh. Hugh William Williams (an artist who, as we have seen, was also engaged on the *Provincial Antiquities* project) was there too. The three men set out to visit and sketch the remains of Craigmillar Castle, not far distant, since it had been selected by Scott for illustration in his work. On reaching the ruin, however, Turner sketched apart from his companions, and, when the time came to return to Duddingston, he apparently refused to allow them to see his studies.[11] When the three arrived at the Manse, Turner quite inadvertently left his sketch book on the lobby table, where it was spied by the good pastor's wife. 'This was an opportunity Mrs Thomson could not resist. She seized the book and ran off with it. But Turner saw it and gave chase, caught her, and took the book from her before she had time even to open it. No one saw what he had done.'[12]

Turner's secretive manner was also observed by another fellow illustrator on the *Provincial Antiquities*, John Christian Schetky, who informed his sister that Turner took 'sketches (**10, 12**) of Roslin, Borthwick and Dunbar Castles, but no one saw them except Walter Scott.'[13] For a man of known generosity and of established reputation, Turner's secretiveness in this minor matter is difficult to explain. Yet, this was not the only one of his traits that irritated his Scottish hosts. They also interpreted his natural reticence and his abruptness as haughtiness and as a demonstration of self-importance. Several Scots, with whom Turner was associated at this time, developed a marked hostility towards him in consequence. The Schetkys invited Turner to breakfast with them one day; but when he arrived, while they acknowledged that he possessed a certain graciousness, they found his manner so cold that they cancelled a special party which they had arranged in his honour. Schetky's sister later

related, 'finding him such a *stick*, we did not think the pleasure of showing him to our friends would be adequate to the trouble and expense'. On another occasion a dinner for Turner, arranged by the portrait painter William Nicholson, to which a number of special guests were invited, was spoilt when the guest of honour did not appear.[14]

Nor was Scott especially enamoured of Turner's character. On this visit, Scott had probably met him[15] and had already been aggrieved by reports of his haggling over the terms of the *Provincial Antiquities* contract. In the spring of the year following Turner's visit, Scott was to warn his close friend James Skene that 'Turners palm is as itchy as his fingers are ingenious and he will, take my word for it, do nothing without cash, and any thing for it. He is almost the only man of genius I ever knew who is sordid in these matters.'[16] Socially, then, Turner's Scottish visit could not have been entirely successful, and the impression formed by Scott on this occasion was one that was to be confirmed several years later while Turner was still collaborating with him on the *Provincial Antiquities*.

Turner's stay in Scotland had lasted about two weeks. From Scotland he coached south, stopping off to see his friend and patron Walter Fawkes at Farnley Hall near Otley in Yorkshire. Turner was apparently back in London by 1 December.[17]

Turner's sketches for the *Provincial Antiquities*, executed in 1818, are views of architecture, but architecture in relation to its general environment. When sitting down to make his studies, he was conscious that these initial, on-the-spot sketches would often yield the composition which would serve as an armature on which he would develop the final watercolour; he also regarded them as containers of specific topographical information which, similarly, he would later use in the preparation of the watercolour. That this specific information is presented in terms of line, rather than of colour or tone, was the outcome of a conscious and deliberate choice. Turner was anxious to record the essential details of the scene before him. Being pressed for time, he considered the use of colour or tone to be an unnecessary extravagance; such a procedure, he believed, could be most effectively accomplished within the confines of his studio.

Turner's finished watercolours for Scott's *Provincial Antiquities* are dominated by golds, browns, greens and blues. With their restricted palette, they are reminiscent of the contemporary

drawings which the artist executed for Whitaker's *History of Richmondshire*. Both groups of drawings exhibit a limited concern for local colour, yet they share an abundance of natural detail and effect. Further, they generate a poetic aura; this is especially strong in the illustrations for the *Provincial Antiquities*, and particularly in those that show architectural ruins. In these illustrations Turner has consciously juxtaposed ruined architecture with figures dressed in the costume of his own time, to amplify the temporal gulf existing between the present and the period in which this architecture displayed its full, pristine glory. In evoking a sense of the past, these illustrations served to complement the historical and archaeological nature of the text which Scott was writing as accompaniment to them.

The project began ambitiously. Sixty-five plates (mainly views) were to be issued in twelve numbers. However, in the end, only fifty-two plates were published in ten numbers. Many views were of architecture in and around Edinburgh, and most others showed subjects within a day's journey. Turner contributed twelve designs including a title-page vignette for each of the two volumes in which the collected work finally appeared in 1826.

As we have seen, Scott's text was intended to support the illustrations, rather than *vice versa*. He explained to Blore that 'the press ought certainly to give way to the convenience of the pencil and engraving tools in arranging the subjects of publication'.[18] Blore agreed, and was of the opinion that the first of the illustrations to have text prepared for them should be those by Turner, since these would attract the most attention and would therefore stimulate sales.

At the end of January 1819, Scott wrote to Blore in London that he had completed the draft manuscript of the text for the first number of the *Provincial Antiquities*, which contained Turner's illustrations of Borthwick and Crichton castles (**13**, **14**). However, Scott explained to Blore that the manuscript could not be considered complete until he had seen proofs of the designs and had rewritten some of the descriptive parts to fit. Indeed, Scott pressed Blore to arrange for proofs, since he argued 'before I can *finish* the article entirely I ought if possible to see the plates however rough & imperfect in order to get some account of the point of view and the particular object which each embraces'.[19] But, he added, 'if this should not be convenient please send to me an exact description of what each drawing includes & from what

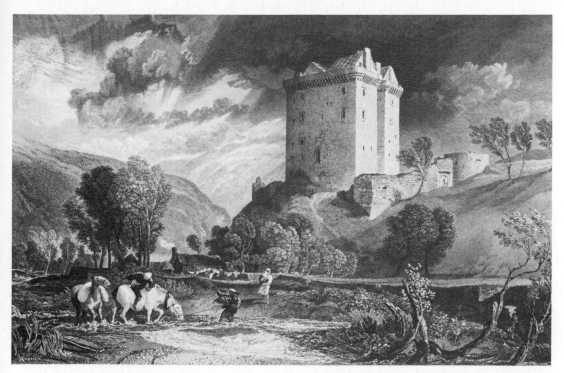

13 J.M.W. Turner, *Borthwick Castle*, for Sir Walter Scott, *Provincial Antiquities and Picturesque Scenery of Scotland* (1819–26). Engraving on copper by H. Le Keux, 1819. 6⅜ × 9¾ in; 16.2 × 24.8 cm. British Museum, London.

quarter it is taken & I will weave it into my letter-press the best I can.'[20]

Blore answered Scott almost immediately: 'I lose no time in forwarding to you our proposed arrangement in which we have as far as the style of execution and a wish to distribute the works of the different Artists as equally as possible through [*sic*] the numbers would admit.... [We hope to] have all the plates for the first Number in a sufficient state of forwardness to supply the proofs for the purpose of your description; but that no time may be lost I have annexed a slight sketch of Mr Turners view of Borthwick Castle....'[21] Scott was informed that Turner was about to begin *Edinburgh from the High Street*, a view which would embellish the second number (**15**). Blore noted that 'Mr Turner has made four sketches ... all equally interesting in a picturesque point of view. He ... begs to know what object you would prefer to be made the prominent feature in the view of the Street.'[22]

While little difficulty was encountered with the first numbers (published in 1819), in which the originally planned sequence of subjects to be illustrated was adhered to, Scott's system of developing an historical and descriptive text round an

illustration was to prove impracticable in later numbers, where the original sequence was altered, because of the erratic production of the paintings and watercolours and the length of time required to have the designs engraved. As a result, Blore now found that he could not co-ordinate the production of drawings, engravings and text, and by 1821, only three years after the project had been launched, he wrote, in depressed spirits, to Scott:

14 J.M.W. Turner, *Crichton Castle*, for Sir Walter Scott, *Provincial Antiquities and Picturesque Scenery of Scotland* (1819–26). Engraving on copper by G. Cooke, 1819. $6\frac{3}{8} \times 9\frac{3}{4}$ in; 16.2 × 24.8 cm. British Museum, London.

> You will perceive that in the two last numbers we have departed from the arrangement of subject … laid down and in the succeeding numbers it is probable for the convenience of the engravers we shall be obliged to submit to a still further departure from that arrangement, the consequence has been that subjects intended to appear together have been separated by the interposition of others which ought to have come after them.[23]

Because of these difficulties, Blore suggested that Scott should not wait for the proofs of plates, but proceed to prepare his text without illustration references to guide him. He realized the burden which this placed on Scott, and he was sympathetic: 'I

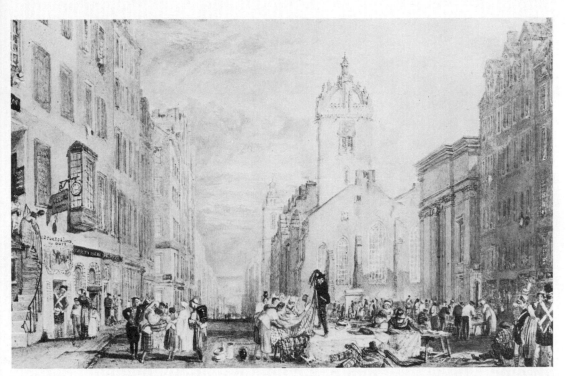

15 J.M.W. Turner, *The High Street, Edinburgh*. Watercolour, 1819, engraved for Sir Walter Scott, *Provincial Antiquities and Picturesque Scenery of Scotland* (1819–26). 6⅜ × 9⅝ in; 16.2 × 24.5 cm. Yale Center for British Art, Paul Mellon Collection.

am aware of how difficult it will be to prepare descriptions without either having the Drawing or Engraving before you at the time of preparing the letter press....' In order to lessen or overcome the problem, he advised Scott to make his descriptions general, and not to attempt any 'particular reference to the mode in which it has been treated by the artist....'[24]

Blore understood that a change such as this would reverse the relationship between plate and text that had been established. Instead of the text reinforcing the plate, the plate would be simply 'an illustration of the description'. As a consequence, while the drawing 'takes in a particular number of objects ... the description might thus be panoramic....'[25] In this way, Scott's text, because of its general character, could accommodate any illustration from within a fairly broad range. These changes in procedure were probably not entirely satisfactory to Scott, since he continued to ask about what viewpoints had been adopted; but there seemed to be no practical alternative. As I have mentioned, it was erratic production of paintings and drawings, combined with the length of time required to produce the engravings, that had created this state of affairs. Scott gave way

and prepared the more general descriptions asked for.

The shift from specific to general descriptions is apparent from a comparison of the texts which Scott prepared for Turner's illustrations before 1821 with those which he wrote afterwards. For example, for the artist's view of Edinburgh from Calton Hill (**16**), published in 1820, Scott's description is much more vital for its specificity and reference to the plate than those independent and more general descriptions prepared after 1821. The success of the former description was undoubtedly due to the fact that Scott's description of Edinburgh was coloured by his response to the illustration. He was probably unaware of Turner's exaggeration of features of the topography, of the compression in width and the extensions in height. Turner imbued the architecture of Edinburgh with a grandeur and eloquence that only such manipulation could provide. No wonder that Scott wrote so enthusiastically of the view which Turner captured:

The pencil of our celebrated associate Turner, has here given a daring representation of one of the most magnificent scenes in this romantic

16 J.M.W. Turner, *Edinburgh from Calton Hill*, for Sir Walter Scott, *Provincial Antiquities and Picturesque Scenery of Scotland* (1819–26). Engraving on copper by G. Cooke, 1820. $6\frac{3}{4} \times 10$ in; 17.2 × 25.4 cm. British Museum, London.

city.... The point which Mr Turner has selected for the view is precisely that upon which every passenger, however much accustomed to the wonderful scene, is inclined to pause, and with eyes unsatisfied with seeing, to gaze on the mingled and almost tumultuous scene which lies before and beneath him....[26]

The shift from this immediate and enthusiastic description to texts more general, and disassociated from the illustrations, could not have made the *Provincial Antiquities* more attractive to potential buyers. Indeed, the sales of the *Provincial Antiquities* had never been especially good, and they were in fact quite indifferent at least as early as 1820. In that year, one of the engraver shareholders, Lizars, wrote to Blore,

I have now the pleasure to congratulate you upon the publication of the new Number of the Prov[l] Ants – it certainly is very beautiful – your own one not the least so. The Grass Market is admirable and Turners is a great performance certainly.... But my Dear Blore ... I rather suspect from what you yourself wrote me and from what I have heard it is by no means paying so well as could be wished.... The truth is I fear the Work is too great and too expensive ... to meet the purse of the public....[27]

Turner's next visit to Scotland, in 1822, coincided with King George IV's state visit to the country. This suggests that, in order to stimulate sales of the *Provincial Antiquities*, Scott may have asked him to come to Scotland to prepare special vignettes for the book, in commemoration of the state visit. As early as 1819, Scott had recommended the inclusion of ornamental vignettes to make the publication more attractive. He had written to Blore,

It would be a great improvement in our plan were we to add either wood tail pieces or vignettes as in the manner in which coats of arms are sometimes engraved under prints, little sketches of peculiar ornaments or monuments concerning the castles or buildings to which the prints refer.... If these ornaments are cut in wood they can be worked off with the letter press and I think would add real value to the work which is so well supported by the names and talents of the most distinguished artists that I would wish it to be as complete as possible in the Antiquarian department.[28]

Turner arrived in Edinburgh a few days before the King, presumably because he wished to consult with Scott before the author became too deeply involved in the business of the Royal

17 and 18 J.M.W. Turner, compositions for a 'Royal Progress'. Pencil sketches, 1822, 'King at Edinburgh Sketch Book', Turner Bequest, CCI, inside end cover and 43a. $4\frac{3}{8} \times 7\frac{3}{8}$ in; 11.1 × 18.7 cm. British Museum, London.

receptions, of which he was in charge. Turner appears to have remained in Scotland for at least two weeks; he was there for the arrival of the King on 14 August and he probably remained to witness the last of the ceremonies over which the King presided: the knighting of the President of the Royal Scottish Academy, Henry Raeburn, at Hopetounhouse on 28 August.

If Turner had gone to Edinburgh only to collect sketches of the Royal visit to serve as the basis of illustrations for the *Provincial Antiquities*, he certainly left with much more ambitious ideas. While he documented the most important and impressive of the ceremonies in the two sketch books which he brought north with him, he began to see this pictorial record as the raw material for a grand series of history paintings on the Royal visit, a kind of 'Royal progress' in the tradition of Baroque pictorial triumphs.[29]

This grand scheme is outlined in one of the two sketch books and takes the form of two rows of extremely slight compositions across a double page (**17, 18**). It was from this series of designs that Turner eventually selected two to serve as title-page vignette illustrations for the *Provincial Antiquities*. Fortunately, it is possible to distinguish most of the subjects of the proposed cycle, and therefore to identify those events represented in the vignettes.

The vignette in Volume 1 of the *Provincial Antiquities* represents the King's procession with the Regalia to Edinburgh Castle (**19**), which took place on 22 August. Appropriately enough, this volume is introduced by Scott's essay on the history of the Regalia of Scotland. The vignette for Volume 2 is not, like the first, related to the text. Its subject is the welcoming of the King to Scotland by Sir Walter Scott (**20**). Turner depicts Scott being conveyed by barge to the recently arrived Royal Yacht, anchored off Leith. The clasping of hands below the landscape symbolically represents the Union and the accord between England and Scotland which the Royal visit strengthened, but it also heralds the meeting of the King and Scott.[30]

Although these vignettes are attractive, they seem to have done little to encourage sales of the *Provincial Antiquities*. And no one could have foreseen that a national economic slump would develop while the publication was still in production. In 1823, the future prospects appeared very bleak indeed, and, in June of this year Blore reluctantly informed the proprietors that money was now needed to keep the operation afloat:

[At] a meeting of the proprietors . . . [it was agreed that] the state of the

19 J.M.W. Turner, *The King's Procession with the Regalia to Edinburgh Castle.* Vignette, title-page of Sir Walter Scott, *Provincial Antiquities and Picturesque Scenery of Scotland* (1819–26), Volume 1. Engraving on copper by G. Cooke, 1826. 5 × 6 in; 12.7 × 15.3 cm. British Museum, London.

account [of the publishers] having been taken into consideration and the future promotion of the work being also considered, it was resolved that a call of £77 per share be paid into the hands of Messrs Rodwell & Martin on or before the 26th June. . . . It was further agreed on the part of those proprietors who have to contribute Drawings or plates for the ensuing Numbers of the work . . . to confine the work to ten Numbers by which means in the event of their not receiving a more immediate remuneration they may look forward to the Close of the work for that remuneration.[31]

20 J.M.W. Turner, *The Mission of Sir Walter Scott.* Vignette, title-page of Sir Walter Scott, *Provincial Antiquities and Picturesque Scenery of Scotland* (1819–26), Volume 2. Proof of engraving on copper by R. Wallis, 1826. 7½ × 7½ in; 19.1 × 19.1 cm. British Museum, London.

The possibility that the venture would be a failure came as a great shock to the proprietors. Scott was disheartened, but received the news stoically. When he heard from Blore about the need for additional funds, he immediately wrote to him, indicating that a 'remittance to Messrs Rodwell & Martin [would be made] as advised. . . .'[32] However, Scott was unhappy at being given what he believed was preferential treatment. He wrote to Blore,

If this shall eventually be a losing undertaking to the sharers I cannot possibly think of retaining the original drawings without making some compensation especially as they are greatly more valuable than any library [research and written] assistance I can render. I embarked on the concern mainly from a love of the undertaking & respect to the high talents employd but without any view of profit.

Yet Scott could not believe that all was lost, for he added optimistically, 'I have little doubt that after all, the work will come well through.'[33] What Scott decided about the drawings and paintings by artists other than Turner is not known; he certainly kept a number of them. Turner's watercolours he was to retain (with the exception of the vignettes) and eight of them were to hang at Abbotsford in a large oaken frame made from a tree on the Abbotsford estate.[34]

Scott agreed with the proposal to limit the size of the *Provincial Antiquities* to ten issues, rather than proceed with a series of twelve, as had been originally envisaged. 'I think it quite prudent to confine the work . . . because supposing that in bringing it to a period it shall be ultimately an advantageous concern nothing is more easy than to commence a new series and if unlucky there is to be any risque [*sic*] . . . the more that risque is diminished so much the better for all parties.'[35]

If Scott eventually accepted the news concerning the state of the *Provincial Antiquities* with equanimity, the Reverend John Thomson did not. He was greatly disturbed because he was unable to make the required payment of £77. Distressed, he wrote to Blore,

I certainly did not anticipate so considerable a loss as a result of the undertaking . . . it is with reluctance I say that at present my funds are so exhausted by the numerous calls I have had to answer in sending away our son to Demarara another to China and putting a third to school in a distant part of the country – that I know not how I am to advance the money required. All I can look to is the recovery of a large sum which has been locked up from my use for nearly three years and on which my resources all along depended. It is awkward to ask delay in a case like that in which we are engaged – but I have no alternative left. I am unwilling to forego my connection with the work and shall make every exertion to meet the demand as soon as possible. At the present moment I really have nothing to offer but my labours in the department assigned to me.[36]

In spite of his financial difficulties, Thomson seems to have made the required payment.

With Turner it was another matter. The painter either ignored Blore's request for funds or informed him that he would not pay. Blore was understandably furious. He was especially upset because, during the period of their collaboration on the *Provincial*

Antiquities, Turner had been far from co-operative. In 1821, Blore had written to Scott informing him that, because of Turner's unwillingness to communicate with him, he, Blore, avoided 'applying to him except when absolutely necessary'.[37] However, this final gesture of disregard was too much for Blore to bear. He wrote to the shareholder/engraver, George Cooke, with whom Turner had previously been associated, and vented his anger:

Turner evidently acts from the most selfish motives, he does not care what becomes of the Scotch work or how the proprietors may be affected provided his own interested views are best accomplished. I know that there are the most liberal intentions towards the work in another quarter [among the other shareholders] but as far as my influence goes it is my intention to confirm the benefit of such intentions to those who most deserve it. Mr T—r certainly will not be in the number.[38]

Without doubt, news of Turner's unwillingness to contribute his share of the expenses reached the ears of the other shareholders, including Scott.

Attempts to reverse the fortunes of the *Provincial Antiquities* were undertaken. In 1824, additional money was invested to 'extend the letter press in the last two numbers to four sheets . . . to increase the interest of the work'.[39] It is difficult to know precisely what arrangements were made to bring the project to a speedy conclusion. It did go forward to at least partial completion in 1826, though under a new publisher (J. and A. Arch of Cornhill, London), Rodwell and Martin having sold their share.[40]

As late as 1831, Scott was being hounded to make additional payments to the *Provincial Antiquities.* Thomson advised him against this, as 'the work stopped long ago tho [*sic*] not finished. . . . It [the *Provincial Antiquities*] has been a very ungainful concern I suspect to all parties.'[41] Thomson informed Scott that he had sold his own interest in the scheme several years before. Whether or not Thomson's decision to sell his share was influenced by advice from Turner is not known, but the latter was certainly responsible for the sale of Thomson's share in 1828, probably at the same time that he sold his own.[42] Thomson must have advised Scott to ask Turner for assistance, for in April 1831 Turner reported triumphantly to Scott that 'The Scottish Antiquities being now finally disposed of and divided 31 Copies (your share) . . . are at [the new publishers] Arch's Cornhill,' and,

anxious to please, he added, 'Can I do any thing [more] for you [?].'[43]

Therefore, contrary to generally accepted opinion,[44] the *Provincial Antiquities* project proved to be an unqualified commercial disaster. While Turner could not be held responsible for its collapse, his attitude towards the project had generated bad feelings, and Scott may have associated its failure to some extent with Turner's lack of commitment. These circumstances Scott was not soon to forget, and in 1831, when Scott's publisher, Robert Cadell, announced that he had secured the talents of Turner to illustrate a new edition of the *Poetical Works*, Scott, if not dismayed, was certainly apprehensive.

4 The *Poetical Works*

In 1807, at the age of nineteen, Robert Cadell entered the employ of Archibald Constable, the eminent Edinburgh publisher. By 1811, Constable had made him a shareholder and, in the following year, his sole partner. Cadell's future with the company seemed bright, especially when he married Constable's daughter in 1817. However, after her death in the next year, disagreements erupted between Constable and Cadell, even though they remained united in the belief that their success in business owed much to the continued publication of the works of Sir Walter Scott.

Constable and Cadell had little in common. The former, while resourceful, lacked many commercial skills. Cadell, on the other hand, possessed a number of the attributes of the successful business man (**21**). Cautious, shrewd and, when necessary, ruthless, he was known in later years as 'hard-hearted Cadell'. Despite these differences they struggled jointly to keep their operation profitable.

Yet, even with his business acumen, Cadell was unable to rescue the firm from failure during the economic depression of the 1820s. The collapse of the company also precipitated that of James Ballantyne (the printer of Sir Walter Scott's works), thus causing Scott's own bankruptcy in 1826, since all of their affairs were inextricably intertwined.

Scott was favourably disposed towards Cadell, who, as a result of investments by his brother Hew Francis and by George

William Mylne in a co-partnership, was able to establish the publishing house of Cadell and Company in 1827. Cadell, still an undischarged bankrupt because of his partnership in Constable and Company, could only participate in the new firm as a clerk. Yet Scott, who had faith in his ability, placed the publication of his writings in his hands, and later (in 1829) was largely responsible for securing Cadell's discharge from his creditors. In 1827, when Constable's creditors put up for sale copyrights in Scott's *Paul's Letters to his Kinsfolk*, the 'Waverley Novels' (from *Waverley* to *Quentin Durward*) and in the *Poetical Works*, Cadell realized that to possess them was to control publication of these works and thereby increase company profits. Scott favoured Cadell's proposal to purchase the copyrights and both agreed that, if the copyrights could be obtained, they would share all of them on an equal basis. They did buy the copyrights, due to the generosity and far-sightedness of Scott's trustees, who allowed Scott to apply profits gained from the publication of recent writings towards the purchase. By 1829, as a result of good management, Cadell had amassed sufficient funds to enable him to buy out his co-partners and thus to become the sole partner in Cadell and Company; in the following year he changed the name of the firm to 'Robert Cadell'.

Cadell soon showed his business acumen, and his reputation was assured when, after the purchase of the copyrights, he turned to the publication of a collected edition of the 'Waverley Novels', which was dubbed the 'Magnum Opus' and appeared between 1829 and 1833. This edition, completed in forty-eight small volumes, was illustrated with steel engravings (a title-page vignette and rectangular frontispiece beginning each volume) after works by well-known artists, as varied as Edwin Landseer, John Martin, Clarkson Stanfield, William Mulready, Robert Scott Lauder and Richard Parkes Bonington.

As a result of the acquisition of all the copyrights in the *Poetical Works*, and encouraged by the immediate and overwhelming financial success of the first volumes of the 'Magnum Opus', Cadell launched a new collected edition of the *Poetical Works* (or 'Poetry', as they were termed by Scott and Cadell). For its commercial advantage, the 'Poetry' was to be uniform with the volumes of the 'Magnum' edition. Scott would prepare notes for this new edition, and 'like a tailor', he observed, he would give 'the old coats new capes, cuffs & collars'.[1]

21 D.O. Hill, calotype of Robert Cadell (with head on hand). A photographic study for Hill's painting of the first assembly of the Free Church of Scotland, 1843. 4⅝ × 4¼ in; 11.8 × 10.7 cm. National Gallery of Scotland, Edinburgh.

By 1830, Scott was well advanced in the writing of the 'Poetry' notes and preface, and before the end of this year Cadell was preparing a format. Scott suggested that the *Minstrelsy of the Scottish Border* could be omitted, possibly because, as a collection of ancient ballads and legends, the work seemed to him more antiquarian than creative. But Cadell insisted that such a move would be highly undesirable: '*I would not leave out the Minstrelsy*, on the contrary I would take the bold course & place it at the head of the column of attack. I would illustrate it beautifully.' He firmly believed that this new edition should follow the novels; on 'the day, [and] month [that] the 48th or 50th Volume of the Magnum [is] ended, I would sail in Vol I of the Minstrelsy as Vol I of the Poetry and [therefore] give it all the advantages of the *current* [edition] *of the Novels*'. Buoyed up by the repeated successes of the novels, Cadell confidently announced, 'I will adventure many a good pound that I shall catch 10,000 of the Novel men the better to accomplish all this I would confine the entire issue of the Poetry to 12 Vols ... @ 5/- each £3 [the edition] – 15 months could be squeezed out of it.'[2] By the beginning of 1831, Cadell was sufficiently far advanced with the planning of the 'Poetry' to consider the illustrations.

In this respect, a happy accident occurred in January. Scott had received from his friend, the poet Samuel Rogers, a copy of the 1830 edition of his *Italy, a Poem*, to which Turner had contributed numerous illustrations and which had taken the public by storm. Scott wrote to Rogers, thanking him for his 'beautiful verses ... embellished by such beautiful specimens of architecture as form a rare specimen of the manner in which the art of poetry can awaken the Muse of painting'.[3] Even though he often remarked on his lack of knowledge of art,[4] Scott considered the work in 'every respect a bijou and yet more valued as the mark of your regard than either for its literary attractions or those which it derives from art although justly distinguished for both'. He urged Rogers to visit him at Abbotsford, so that together they could enjoy those places which, while 'not very romantic in landscape', are filled with history, for, he added, 'every valley has its battle and every stream its song'.[5]

Possibly the recollection of Rogers's work was with Scott when he visited Cadell in Edinburgh at the end of January, for it was on this occasion that he and his publisher were to discuss not only the format of the 'Poetry' but also the desirability of illustrations.

22 William Allan, *Sir Walter Scott*. Oil on canvas, 1831. 7½ × 6 in; 19.1 × 15.3 cm. The Abbotsford Collection.

Cadell had previously been considering the arrangement and distribution of poems through the volumes, which were to be issued monthly, one by one. After the meeting, he noted in his diary his advice to Scott:

[I] state[d] as clearly as I could that my plan with the Poetry would be to place the Minstrelsy first ... when placed first it had all the advantages of the wash of the high circulation of the Novels – if put last subscribers might stop when they had got the popular poems and not take it – my plan is to make 12 Vols of the Poetry [the] same size as [the] Novels [and] to follow the very next month after the Novels cease, if the Novels run to 48 Vols the Poetry will make the whole up to 60 Vols, if the Novels make 50 Vols the Poetry will bring the whole to 62 Vols.[6]

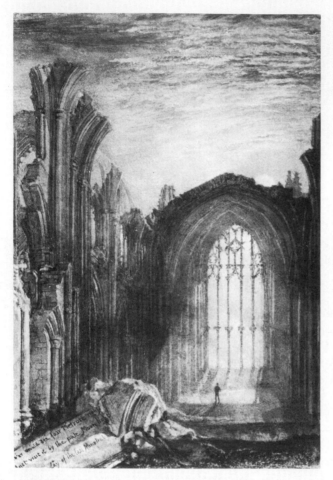

23 J.M.W. Turner, *Melrose Abbey: Moonlight*. Watercolour, *c*.1822. 7¼ × 5¼ in; 18.4 × 13.4 cm. Private collection.

Cadell believed that these volumes, like those of the 'Magnum' edition, would benefit from illustration. Scott was not as certain. However, at their meeting, illustrations were discussed, Turner's name was mentioned, and Cadell seems to have convinced Scott of the advantages of employing an illustrator of such eminence. Soon after Scott returned to Abbotsford, Cadell contacted a 'London friend' with whom he spoke of his resolve to employ Turner. On his friend's advice, Cadell wrote and posted a long letter to the artist on 24 February, describing the proposal which he had in mind for illustrating the 'Poetry'.[7]

Turner, of course, had always been fascinated by the relationship between painting and poetry, and he had demonstrated how financially successful the marriage of the two could be in his designs for Rogers's *Italy*. When Turner received

24 J.M.W. Turner, *Glenartney*. Watercolour, *c.*1822. 7¾ × 5½ in; 19.8 × 14.0 cm. Private collection.

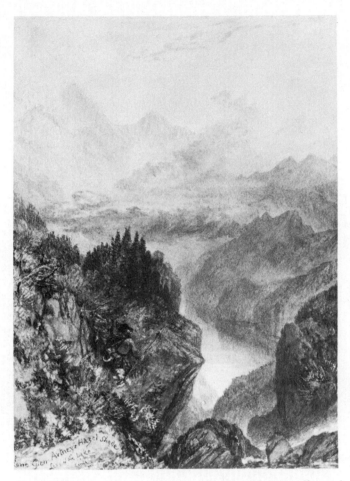

Cadell's letter, he was delighted, believing the offer to be both a challenge and a considerable honour. He had known Scott's poems at least as early as 1811,[8] and in the early 1820s had prepared for Walter Fawkes four landscape watercolours illustrating Scott's poetry. These were *Norham Castle*, inspired by lines from *Marmion*; *Melrose Abbey: Moonlight* (**23**), by *The Lay of the Last Minstrel*; *Glenartney* (**24**), by *The Lady of the Lake*; and a view on the Greta (**25**), associated with Rokeby.[9] Turner felt that he could not forego this new opportunity.

On 5 March, Cadell received a letter from Turner, 'acceding', he noted, 'to my views as to Scott's Poetry'.[10] Two days later, the publisher wrote triumphantly to Scott: 'I have much satisfaction in mentioning that I have succeeded in securing Mr Turner as the sole Illustrator of the Poetry.'[11] Cadell was also pleased to

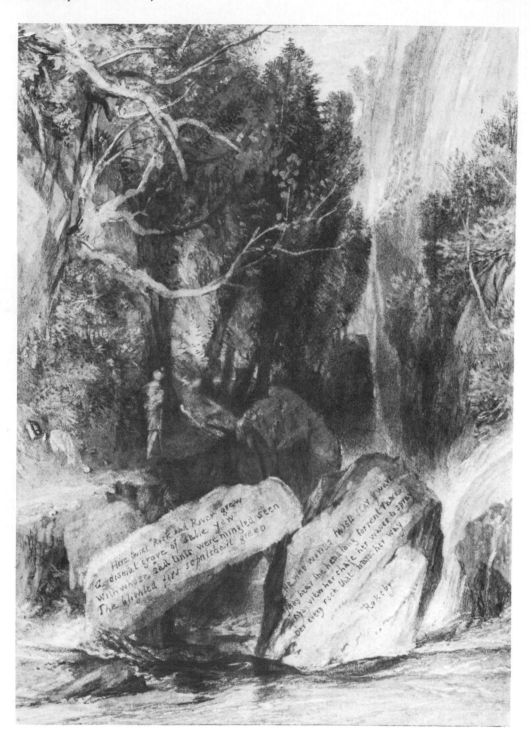

Here twixt Rock and River grew
A dismal grove of sable Yew
With whose sad tints were mingled seen
The blighted firs sepulchral green

... his waves
They hear the headlong torrent Tees
view her chafe her waves to spray
Oer every rock that bars her way

Rokeby

report that the artist's terms 'are fully under what I expected – 24 Designs at 25 guineas each I have accepted the terms, & will soon have to address you more at length for the benefit of your suggestions as to the views & scenes to be represented.[12] The Minstrelsy will puzzle me most,' but, he added, 'I have little difficulty about the scenes for the Great Poems.'[13] 'I am glad', Scott replied, 'that you have taken Mr Turner under your own management and that you have made a bargain with him which you think a good one.' Scott expressed his willingness to receive Turner in Scotland 'with all hospitality and conduct him to all the scenes most fit for the minstrelsy. . . .' Such a trip was no doubt a hardship for Turner, but it was also, he suggested, a burden for himself, since, 'though an artist of very great genius', Turner was hardly pleasant company.[14] However, Scott reaffirmed that he would welcome him, since who else could 'make him fix on the fit subjects' for the 'Poetry'?

Now that Turner had accepted the commission, Cadell's task was to search out subjects for illustration. Even before he wrote to Scott asking for suggestions, Cadell had begun looking through the poetry to see if he could locate passages suitable for illustration. Further, he had examined the Scottish subjects which Turner had prepared years before for the *Provincial Antiquities*, in order to determine precisely 'what Turner had done'. He also proposed to consult James Skene, antiquarian, topographical artist and friend of Scott, for advice on possible subjects.[15]

On 4 March, Cadell wrote to Scott, informing him that he was preparing a provisional grouping of the poems and noting down possible subjects for illustration. 'In a few days,' he wrote, '[I shall] send you a Sketch of what has struck me before I send it to Mr Turner, who asks suggestions.'[16]

By 17 March, Cadell had completed this preliminary arrangement and a list of subjects to be considered for illustration. He explained to Scott: 'In the Sketch of the mode of bringing out the Poetry in 12 Vol[ume]s with Turner's illustrations I have kept in View that after the Minstrelsy and Sir Tristrem, it is of the utmost importance to Head each Monthly Volume with a prominent poem. . . .'[17] He gave reasons for this: '. . . in the *First place* [it would] . . . insure an Introduction from the author to said prominent poem . . . [which would] commence the monthly Volume . . . in the *Second place* . . . the painter

25 J.M.W. Turner, *View on the Greta River*. Watercolour, c.1822. 7¼ × 5¼ in; 18.4 × 13.4 cm. The Trustees, The Cecil Higgins Art Gallery, Bedford, England.

[Turner] may have such [a] poem before him ...' for illustration.[18] In this way, Cadell remarked, one would be able 'to *fix upon Mr Turner's Illustrations*'.[19] Therefore, the illustrations were to be determined by the major poems of each volume. Cadell had commissioned Turner to prepare one frontispiece and vignette for each of the twelve volumes, and these were to illustrate the major poems.[20] Having prepared a list of subjects, Cadell's second task was to suggest the sequence in which the main poems for illustration were to appear. Of the twelve volumes which would constitute this new collected edition, the first four were to be assigned to the *Minstrelsy of the Scottish Border*; the fifth volume was to be devoted to *Sir Tristrem*, the sixth was to have as its major poem *The Lay of the Last Minstrel*; the seventh, *Marmion*; the eighth, *The Lady of the Lake*; the ninth, *Rokeby*; the tenth, *The Lord of the Isles*; the eleventh, *The Bridal of Triermain*. The twelfth and final volume was to be devoted to the dramas.

Cadell had planned to visit Scott at Abbotsford, in order to explain his proposals, show him the revised list of subjects, discuss the details, and get the author's approval, but ill health prevented him. He wrote to Scott, 'I have drawn up as clearly as I can, my views as to the Poetry, which I am so teasingly prevented from going over with you in person.' Scott received Cadell's list of divisions and subjects for illustration, made some modifications and then sent back the corrected list to Cadell, who thereupon made a new list incorporating Scott's changes, and sent it on to Turner,[21] probably posting it on 1 April. On this date, Cadell wrote to his London agent, instructing him to send Turner a copy of the *Poetical Works* (the 1830 edition) for examination.[22] Turner was to peruse the list and note the lines of poetry that specifically referred to the subjects tentatively selected for illustration;[23] he was probably also asked to comment on how effective they seemed to be, and to assess how well the descriptions suited the sketches he had on hand.

Cadell's initiative in establishing a list of subjects for illustration apparently annoyed and irritated Scott, who felt that he had not been adequately consulted. It was he, after all, who was the poet. Cadell, for all his abilities, was only a publisher and bookseller. Perturbed, Scott had written to Cadell, 'I naturally must know best what will be apposite to the subject[,] although in the point of the art in general I am a poor adviser....'[24] In addition, he observed, 'I have no fear of finding subjects if I have

time to recollect myself.'[25] Much later, he expressed regret for the haste with which Cadell had determined the subjects: 'It was my intention & I honestly think that it could ... [have been] settled otherwise that we should have taken the copy and comparing it with the subjects should have fixd the one to the other when I am convinced the whole would be fixd handsomely.'[26]

Turner had not yet decided whether to travel north: he had been in indifferent health and, moreover, insisted that he had previously made fifteen pencil studies of the twenty-four subjects suggested in the list which Cadell had sent him.[27] The remaining subjects he believed he could develop from sketches, or from prints after the work of other artists. Cadell and Scott were not pleased. The publisher complained to Scott that he had engaged Turner as early as he had so that the painter could 'have a summer before him in case his portfolio did not contain the necessary sketches'.[28] Scott now insisted that 'new' landscapes were essential.[29] If Turner 'confines his subject[s] to those already in his portfolio it will have a second[-]hand effect especially in the larger pieces to which I grant he can give interest, but not always that which is appropriate to the place or subject'.[30] Moreover, he could not tolerate in his publication those subjects that were in 'every Miss's album'.[31] Further, Scott maintained that Turner himself could only benefit from a trip to Scotland. For by doing so, he 'might make a great deal by filling his portfolio with subjects for future sketches'. If Turner was concerned about the time the Scottish trip would occupy, he could restrict his tour and not go further than Abbotsford,[32] and therefore 'a great many of those landscapes especially those for the Minstrelsy could be collected' in a single week.[33] Scott was fully prepared to transport Turner by 'Poney [*sic*] & Dog Cart' to 'about fifteen [subjects which] are within reach of this place [Abbotsford]'.[34]

However, if Turner did not come, then 'old' subjects, ones previously taken and published, would have to be employed, but, of course, 'very differently handled'.[35] Cadell agreed that, if it was necessary to accept views previously taken, and which were already familiar to the reading public, there was some consolation. He reminded Scott of the particular genius of the artist: 'There is about Mr Turner's pencil what there is in the pen of one other person only, that which renders familiar scenes more striking and lovely than before.'[36] Cadell also assured Scott that Turner's designs could not be copied: 'I have no alarm for

imitators, we have secured Turner – and no one can take the scenes – no one can take the descriptions of these scenes from the Lay – Marmion – Lady & Lord of the Isles.'

Scott became increasingly restive, and anxious that work on the 'Poetry' begin. 'The difficulty appears to me,' he wrote, 'to be in time. There is no fear of finding plenty of subjects but how we are to get time to engrave them so well as we wish seems doubtful. As it is novelty that men run after a small or minute subject a little exaggerated may sometimes be better than one which [is] hackneyd. When does Mr Turner begin his labours?'[37] Scott was convinced that production should be started as soon as possible. 'Time,' he noted, 'strikes me as valuable on many accompts.'

He was also worried that the successful illustrations of Rogers's *Italy* would have prompted others to produce similarly designed works. 'The success of Mr Rogers by dint of beautiful illustrations will not have escaped the Trade who will make eager attempts to imitate it & it is in such a race that the Devil catches the hindmost. If you agree with me in this measure you will start as soon as you can for the publick tire of illustrated books. . . .' Even now, Scott had not been completely persuaded that illustrations for the 'Poetry' were absolutely essential. 'Our illustrations however excellent in device and execution have not yet helpd us very much. I hope they will bring us up now.'[38] Cadell sympathized, and agreed on the need for haste: 'You are quite right, the sooner the Poetry is got done the better.' However, he warned Scott that the publication could not be rushed. It would be impossible to make 'great progress for a considerable time, as Mr Turner will not engage to give me the 24 designs for the Poetry within a year – and it will take a long time to insure their being thoroughly well engraved.'[39]

The longer Turner delayed making a decision on the northern trip, the more exasperated Scott became. By the end of March, no firm plans for a visit had been made, but by then both Cadell and Scott had decided that, if the 'Poetry' was to be a success, then fresh views were absolutely necessary, and that it was imperative that Turner come north. But the question still remained, would he agree? Scott's increased agitation over Turner's indecision is reflected in his letters to Cadell at this time. He had complained of Turner's penchant in his illustrations for the *Provincial Antiquities* for depicting 'highlanders in every Scottish scene', and hoped 'he will keep them to their own side of

the Line'.[40] He also expressed concern about Turner's current reputation as a colourist. While he 'is certainly the first of our artists going ... he has made some experiments of late in his colours which have attracted some censure'.[41] Scott wanted an assurance that Turner would not indulge in such 'violent' experiments and would be 'modest in his Colouring'.[42] Further, he was apprehensive that Turner's colours might appear in the line engravings for the 'Poetry', but, as if to reassure himself, noted 'there is no danger of this in our illustrations I suppose not being tinted.'[43] Scott wondered if Turner's illustrations might have the attractive and varied effects produced by the groups of figures in his designs for *Italy*.[44]

Cadell sensed Scott's agitation and his rising antagonism towards Turner because of the latter's resistance to the idea of a visit. He suggested that Turner might be persuaded if an invitation to Abbotsford, which Scott had earlier proffered, came from the writer himself. 'It occurs to me', Cadell wrote, 'that in place of my basely urging it now by letter, your kindly promised invitation to Abbotsford might come in *at this moment* with the best effect, it would, in all probability, decide him if he is wavering – which one would suspect ... and now is the time to fix him.' He ended his letter on an optimistic note: 'I anticipate many benefits to our project by getting him down to this country for the occasion. . . .'[45]

Scott immediately wrote to Turner and then informed Cadell that he had done so; 'I have written to him with all civility offering him all sort [*sic*] of hospitality & means of transportation.'[46] He noted in his journal that 'Cadell may giv[e] him some money [for expenses], this will more mitigate.'[47] But Scott was obviously still disturbed. Recalling his own experiences with the painter, he observed, 'I had my own private fears that the negotiation with Turner would have its difficulties.'[48]

Turner's hesitation had been interpreted by Scott as reflecting a lack of interest in, and concern for, the project. At one point, in frustration, he exclaimed to Cadell,

It is folly to attempt doing a thing of such consequence without [Turner] doing his utmost and taking the personal trouble of making the drawing on the spot I could rather far have John Thomson [the amateur artist] doing his best than Turner slurring it. It is right to humbug the publick if you can but after all they will not be humbugd beyond a certain extent. . . .[49]

But Scott realized that the planning had advanced too far for them to contemplate changing illustrators: 'I fear you must come into Turners terms however extravagant as they are now to be . . . To quit Turner now if it be possible to kick him would make an awful cry against the work. And I foresee that if he gives you his best he will make you pay for it. But as Turner goes it is worth the money. . . .'[50]

If Turner were not to accept the invitation to Abbotsford, Scott seized on a compromise which he believed acceptable. His friend James Skene, the topographical artist, might be brought in to assist. 'If he could be induced to take the trouble to reside a fortnight here [at Abbotsford]',[51] he could prepare sketches of the scenes needed and these could be forwarded to Turner to be worked up into the finished watercolours. Scott immediately put the plan to Skene, who expressed enthusiasm for it and proposed that he should visit Abbotsford to discuss it. After Skene duly arrived at Abbotsford, Scott wrote jubilantly to Cadell, 'Skene being here at this moment offers most willingly to supply Turner with such drawings as he wants. . . . He says that if Turner has a[n] exact outline of drawing he can use it as well as an[y] individual.'[52] Scott continued, 'If Mr Skene is correct we can avail ourself of Turners talents & popularity even though he cannot come down himself. . . .'[53] However, still anxious and agitated over the whole affair, he added, 'He [Turner] cannot complain of unfair treatment since he makes a bargain with his eyes open.'[54]

Scott's fretfulness over Turner's indecision was largely the outward expression of a growing inner panic. At the time he was labouring, with supreme difficulty, over his novel, *Count Robert of Paris*. He had become painfully aware of his diminished powers of invention and of an inability to write with his previous confidence and ease. This realization was frustrating and upsetting, and, indeed, was the prelude to a seizure.

It was on Sunday, 17 April, that Scott was suddenly paralysed by a stroke. He survived this, however, and by the following morning appeared much improved. James Skene had been with Scott when he was stricken, discussing with him the preparation of the preliminary sketches for the illustrations for the poetry. On Tuesday, 19 April, Skene left for Edinburgh to summon Scott's physician, Dr Abercrombie. After informing Dr Abercrombie of Scott's illness, Skene hurried to Cadell's office to break the news.

Cadell, learning that Dr Abercrombie was to leave for Abbotsford the next morning, resolved to go with him. Cadell recalled, 'I took a coach to Dr A[bercrombie]'s who most cheerfully agreed to take me as his companion.'[55] On the following morning, Wednesday, 20 April, at seven a.m. Cadell and the physician left the latter's residence at 19 York Place. The morning was extremely foggy and this slowed their progress southward to Melrose. Arriving at Abbotsford after four and a half hours on the road, they went in to see Scott, and Cadell has recorded his impressions:

We were much gratified to find . . . that Sir Walter was much better – he had been a good deal alarmed for himself the preceding evening, also those about him, but there was no good ground for it – he had been somewhat sick in consequence of some medicine he had taken. When I entered his Bed room – he said 'well friend this is a serious stop of the press' – I begged in reply that he would not think of the press 'but take care of his own health'. I sat down when he began to talk about Turner – the Illustrations to the Poetry – and all sorts of things . . . I did not encourage this in any way, rather contrary discouraged it, at last as I saw he would talk I rose and came away, as I had heard Dr Abercrombie forbid a Novel to be read out to him.

Cadell observed in conclusion,

Sir Walter was quite collected, but his speech bad – his tongue rolling as it were, in his mouth, however I understood every thing he said quite well – he said to me as I was about to leave him, 'I must see you before you go, you see I am quite collected, all the indiscretion the fellow can lay to my door is a single tumbler of porter.'[56]

Within a few days, Scott's condition had so improved that he was able to venture out of doors. In spite of an obvious speech impediment, he seemed in good spirits, being undoubtedly relieved to find that he was still able to think clearly. His spirits further improved when he received a letter from Turner (dated 20 April), accepting his invitation to visit Abbotsford.

It was clear from Turner's letter that he was flattered. Although he had on hand pencil studies of fifteen of the twenty-four subjects required, he must have sensed Scott's eagerness – indeed his anxiousness – for him to come to Scotland. He had already planned a sketching trip to the Continent for late July, if the weather were not too hot, but being anxious not to offend Sir

Walter, asked him how long he thought that he would need to prepare the necessary sketches. While the scenic prospects might be near by, Scott would be obliged to take into account his poor horsemanship, which would undoubtedly lengthen rather than shorten the visit. Turner proposed to make the Abbotsford stay brief, because he planned also to travel further north, and did not wish to return to London without having taken views of the sublime scenery of the Isles, 'Staffa Mull and all'. Turner knew of the steamer service to the west, which he believed would shorten the time required.[57]

Scott was elated by Turner's obvious interest in the visit, and especially by his enthusiasm for the scenery. As soon as he was physically able, Scott, his anxieties overcome, informed Cadell of the artist's intended visit: 'Mr Turner ... seems in excellent humour for our job ... I am quite pleased to see he is taking kindly to his oars and have no doubt the scheme is in good progress, and he & you will boat us over in safety....'

Scott could now begin serious planning. He had decided on specific criteria to guide the selection of views. He wished to have a geographically representative group. 'On looking at your list,' he wrote to Cadell, '[the] subjects [divide] naturally into three classes.' There were those within the reach of Abbotsford, those that lay 'just in his [Turner's] way [north] on the English road ...', and a third class: views of the Highlands.[58]

Scott was convinced that the choice of subjects should depend on their appropriateness to the context. 'If you have illustrations at all,' he warned, 'you must have them appropriate otherwise we shall be like "Our auld gudeman wha gaed down to the Merse/With his breeks on his head & his bonnet etc. etc."'[59] The designs were to illustrate architecture or landscapes which were either described or alluded to in the poetry, or were associated with Scott's life. In order to guarantee that the subjects were really suitable, Scott knew that, as the poet, he needed to maintain the closest control over their selection. Turner and Cadell, though they were to be fully consulted, were to be kept in line; otherwise, he noted, the illustrations 'will be void of that propriety which gives interest to an illustrated poem which I conceive to be the propriety of the union between the press and pencil which like the parties in a well chosen marriage should be well considered before hand'.[60]

A number of subjects selected by Cadell were considered

inappropriate by Scott, and as a consequence disputes often erupted during the process of selection. At one point, only a few days before Turner's arrival, Cadell wrote to Scott,

Poor me, I have done nothing but under your own express sanction. When I sent you the list of proposed designs, so long ago as March last you expunged many of my hints, and they were merely hints for you to be saved trouble by . . . you are King – Priest and Prophet of this matter from beginning to end.[61]

Typical of the wrangling that occurred was the dispute over the choice of illustration for the seventh volume of the *Poetical Works*: *Marmion*. Cadell had suggested that the frontispiece should be a view of Edinburgh: 'I have visited Blackford Hill early in the morning & am convinced that the view from it cannot be passed over;' it is 'glorious'. Scott concurred with this suggestion; but the vignette was another matter. For this, Scott had suggested a view of Norham Castle. Cadell knew that Turner had prepared a view of it for illustration earlier,[62] and reminded Scott of other views that the artist had already executed: 'Mr Turner has already done the Bass [Rock,] Tantallon Dunbar & others which I had counted on for Marmion.' For the vignette, Cadell initially suggested Lindisfarne; Scott favoured Norham. Cadell then mentioned the Till Bridge or Flodden.[63] Scott was strongly opposed to Flodden: 'I greatly question [if] our place [Flodden is] fit for a separate view Mr Turner will judge for himself. . . .'[64] Cadell doggedly persisted, but Scott was adamant. 'There is nothing to see', he explained, 'but a half cultivated braeside I doubt even Mr Turners talents could make nothing [? something] out of it.'[65] Cadell, unperturbed, continued to champion Flodden. 'My wish', he wrote, '[was] to indulge the Public with a View of it no matter how barren – no one cares for the gentle undulations of the field of Waterloo – what they want to see is the field of battle which decided the fate of Europe.'[66] Scott would not surrender and countered, 'I conceive you are still mistaken about Flodden of which you cannot have a view that will illustrate the text for you can from no corner see both the north & south side of the hill at once.'[67] When Scott turned down Cadell's suggestion of Twizel Castle, which Cadell had considered a reasonable substitute for Norham Castle, the publisher once more insisted that the function of illustration should not simply be to display the landscape's inherent beauty,

but to exploit its historical associations.[68] But Scott would not listen and refused to consider Twizel, referring to it as an example of bad 'modern Gothick'. More appropriate, he believed, were nearby Twizel Bridge[69] or Crichton Castle.[70] Cadell probably reminded Scott that Turner had drawn the latter for the *Provincial Antiquities*, reiterating that it would be best not to repeat too many subjects. Eventually, Scott suggested Ashestiel, his early residence near Abbotsford. Cadell agreed, and this was to be the subject of the printed vignette. (See Appendix 3 for an account of the discussions which took place over the choice of illustrations for the remaining volumes of the *Poetical Works*; they are highly illuminating.)

Cadell was now prepared to begin serious discussions with Turner about his visit to Scotland, and planned to meet him in London to discuss in detail the proposals for views. He had written Turner about his visit to London probably before the beginning of May,[71] but as the artist was out of town he did not receive a reply until late in that month.[72] As soon as Cadell heard that Turner would be at home during June, he made final arrangements to meet him, and to stop off at Abbotsford for a day or so on the way south.[73]

Cadell left Edinburgh by coach on 2 June at nine in the morning. Reaching Melrose Bridge, near Abbotsford, shortly before two, he left the coach and continued on foot. Walking towards Abbotsford, he encountered Scott's two daughters, Mrs Sophia Lockhart (the wife of John Gibson Lockhart, editor, literary critic and Scott's future biographer) and Anne Scott, who had apparently come to meet him. When they reached the house, Cadell found Scott seated before the entrance portal. Scott was in a sombre mood, and seemed to have forgotten that Cadell was coming to visit him, and was then to continue south to London. 'He asked', Cadell wrote, 'if I returned to Edinburgh or went on.' While Cadell noticed 'a considerable hesitation in his speech' and thought him 'dull', he regretted that he himself was not the best company, as he had 'nothing of moment to say to cheer him'. Yet Cadell observed that they 'had a good deal of talk about the usual topics . . . we talked of Turner – the London trade – & other matters'. Cadell noted that Scott 'eats little'. In the evening Scott and Cadell went to visit the Lockharts at their house, Chiefswood, on the Abbotsford estate. After seeing Sir Walter home and to bed, Cadell and Lockhart spoke about him

and agreed that, because of his deteriorating health, 'the less Sir Walter writes after this, so much the better – indeed it would be better if he were to write no more Novels.' Despite Cadell's rather pessimistic view of Scott's health, he did observe that on the whole 'Sir Walter [is] . . . considerably better than I expected to find him. . . .'[74] Cadell left Abbotsford the following morning, 3 June, bound for London, having promised to write to Scott after his meeting with the great artist, Turner.

Having made several business stops on the way, Cadell arrived in London a week after his meeting with Scott. The day after his arrival, he called on Turner at 47 Queen Anne Street. The two men had a 'long crack' over the subject of the illustrations for Scott's poetry, and Cadell was cheered to know that Turner 'was disposed to come to Scotland before he goes to the Continent'; he added in his diary, 'which plan I shall most pressingly enforce . . .'.[75] Cadell and Turner decided that their business would require another meeting, which was arranged for the following Monday.

Cadell had not met Turner before and was struck by his appearance. Turner was not the man he had expected; he had envisaged him as being tall and urbane and was astonished to find him 'a little dissenting clergyman like person [with] no more appearance of art about him than a ganger'.[76]

When the two met again on the Monday at the prearranged time of eleven o'clock, they soon settled a great deal. Cadell was agreeably surprised to find Turner, 'all ready with maps and road books, when we canvassed over everything & agreed that his best way is to come North by Steam to Edinburgh'.[77] From Edinburgh, Turner was to take the coach to Abbotsford. There, he was to 'get all that is necessary for the Minstrelsy and the Lay return to Edinburgh, & from thence to the Trosacks'; from the Trossachs he proposed to travel to Glasgow and from there to Skye.[78] The conference lasted for three hours; Cadell left pleased by Turner's co-operation, and well satisfied with all that had been accomplished.

He wrote to Scott full of enthusiasm for Turner and for the arrangements which he had made with the 'great artist'. 'After I had the pleasure of seeing you so well at Abbotsford,' he tactfully wrote,

I made a considerable round before I reached this place [London] and saw many of my country brethren & heard a good deal of their opinions

and views. I got here just one week after leaving you – the following day I saw Mr Turner and have just concluded a regular business revisal of the Illustrations of the Poetry. Mr Turner is willing to be directed in every thing – the [only] condition I made was originality so far as regards himself no copying himself – no new view of what Mr Turner has done before.

Cadell described the itinerary which had been worked out, noting that 'he [Turner] will be down with me in about a month or six weeks – he comes first to Edinburgh – from thence to Abbotsford, and if you will admit of my presence it might be as well for me to come out with him for a day. . . .' Confidently, Cadell concluded, 'I have no doubt [that he will] do the whole thing full justice. I found Mr Turner throughout very agreable [*sic*] – very much a man of business and in every way open to hints or suggestions. I cannot now doubt of all this going on right. . . .'[79]

Before Cadell left London he had a final half-hour 'jaw' with Turner on Tuesday, 21 June, when arrangements were reaffirmed for the trip north, which was to begin as soon as possible and before the proposed Continental tour. The plan was that Turner should leave London by 20 July. Cadell was back in Edinburgh by the end of June.[80] From there he wrote to Scott, solicitously asking after his health and informing him that 'a few weeks will bring this last named person [Turner] down to Scotland so as to accomplish the whole plan at a fine time of a fine season, and expressly for the Poetry'. Triumphantly he added, 'he throws aside all of the 15 sketches he had on hand'.[81] But Cadell was determined to see Scott once more before Turner arrived, to confirm plans for the visit. On Wednesday, 6 July he left Edinburgh at about six in the morning, arriving at Abbotsford well before eleven. He and Scott went over the plans concerning both the illustrations and Turner's visit.

Cadell thought Scott was 'looking very well, [and] considerably fresher' than he had looked five weeks earlier, when Cadell saw him while en route for London. He observed that his speech was still affected, 'but his conversation is more free – less general impediment'. Yet he was aware that Scott was not the man he once was. Deeply concerned, he had raised with Scott the subject of a trip abroad, which he believed might improve the author's health, but found Scott's own family 'had often and again urged the same thing'. He also observed that he 'had an

able assistant in Mr Lockhart in stating all the pros and cons'. Scott apparently admitted to Cadell that he 'made out a strong case'. Cadell then 'canvassed the matter in relation to the work [that] he [Scott] had in hand and could get through by October', and, to encourage him, offered to pay his expenses 'by the book of Travels his journey would produce'.[82] That the two men also discussed Turner's impending visit seems likely. At this time no word about a departure date had been received from Turner, although, only a few days later, on 11 July, Cadell, in Edinburgh, was given a note from him changing the itinerary previously agreed on. Turner said that he would not take a steamer north, after all. Instead, he planned to coach to Scotland in about a week's time, sketching a number of the scenes proposed for Scott's poetry on the way.

It may have been Turner's recent poor health that caused him to alter his plans. He may have decided that, as the sketching tour was likely to be strenuous, it would be better for him to travel by coach, take a number of views in and near Carlisle, and further north and west, on his way to Abbotsford, and eventually make a restful return trip by steamer from Edinburgh. Cadell, however, was upset, since Turner's new itinerary would necessitate a change in his own arrangements. Immediately (on Tuesday, 12 July) he wrote to Scott, indicating that he would try 'to divert [Turner] from this ... [so that he might] still come here [to Edinburgh] first, but I shall ascertain this and let you know as nearly as I can the precise day of his being with you....'[83] He would most probably arrive at Abbotsford on 26 or 27 July.[84]

Cadell, aware that Scott was somewhat impatient for Turner's arrival, also knew that as he was unwell he might find it difficult to cope with this celebrated visitor by himself. He therefore once more offered to assist. 'I shall keep myself disengaged', he wrote, 'in case you wish me to meet Mr Turner and in the meantime shall study the whole subject [of the illustrations] with great care.'[85] Scott, who had begun to share Cadell's excitement over the impending visit, informed him in a letter of Friday, 15 July that 'if Mr Turner by any accident is like[ly] to arrive before friday [22 July] or Saturday ... you must be so good as [to] drop ... a line when to expect you & him. But health excepted nothing else can make me absent.'[86] Turner did not arrive by 23 July; in spite of Cadell's entreaties, he had insisted on taking the slower land route, making sketches on the way. Cadell then received a

letter from Turner and on Monday, 25 July, wrote to the author,[87]

The visitation is now very near you . . . he cannot now be far off – for his letter, which I have just received, & which I ought to have got on Saturday [23 July] is dated the day preceding . . . and I fear from some other mistake, he will look for a letter from me at Penrith which is not there[88] – no matter . . . but I am not a little at a loss to know on what day he will be at Abbotsford as that after all will be the centre point of our operations.

Cadell continued, 'At present I do not see that it can be later than Wednesday [27 July] or Thursday [for] Mr Turner reaching Abbotsford. I shall not be far behind him.' He added cheerfully, 'the weather is now delightful & will I hope suit all our plans.'[89] Scott also wrote, with enthusiasm, on 27 July, 'Mr Turners arrival & yours . . . will give us great pleasure & I will be ready to transport our Draughtsman wherever he wishes to go.'[90]

But Turner still failed to appear. 'At present,' Cadell wrote on Sunday, 31 July, 'I do not see that Mr Turner can well be with you till the end of next week – the moment I am aware of his approach I shall be sure to come out and meet him so as to get through our business quickly. . . .'[91] Because Scott had not been involved in the discussions between Cadell and Turner, he was anxious that no decisions concerning the illustrations be made until he had the opportunity to consult with the artist. He wrote to Cadell on 1 August, 'It seems essential that we should lay our heads together' as soon as Turner arrives. And, he noted testily,

On the subjects . . . each has his particular province in which he will have an especial claim to be consulted. Mr Turner is unquestionably [the] best judge of everything belonging to art. Your opinion will be necessary with regard to roads travelling and the arrangement for distributing Mr Turner's time with the greatest regard to convenience and trouble. . . .[92]

Scott could not resist adding that he, the poet, was 'the fittest judge of the adaptation of the scenery to the composition'.[93] Also it was he who had 'knowledge of the locale [which] will supply not only . . . local subjects but point out the easiest way of introducing them to Mr Turner which he is very unlike[ly] to know by himself but which I have been thinking upon occasionally since we first spoke of this undertaking.'[94]

Turner, meanwhile, was making his way north in late July, not always remembering to keep Cadell informed of his progress, as the correspondence between the latter and Scott, quoted above, will have indicated. He was naturally preoccupied by his journey. Stage connections demanded constant attention, particularly as his route often bypassed the more frequently travelled roads. His sketches, too, required concentration. Subjects sometimes required the sketching of a number of views, to clarify the landscape contours in Turner's mind and on paper, and also to provide the kind of ancillary landscape detail that might be needed in the finished composition. Consequently, the infrequent letters that Cadell received from Turner during his journey contained little information and did not indicate when he would arrive. Scott, of course, was anxious to know when this might be and in his correspondence with Cadell repeatedly asked about Turner's expected date of arrival: 'I hope by your next [letter] to learn of Mr Turner's approach for like a carriage at a public place the affair stops the way & keeps me from attending to other things.'[95] But Cadell had had little news.

On 22 July, Turner was at Manchester. By the twenty-eighth he had arrived at Penrith. There he began to make the first of his sketches of places suggested for Scott's poetry in the two sketch books which he used on his way north: the 'Rokeby and Appleby Sketch Book' and the 'Minstrelsy of the Scottish Border Sketch Book'. Using Penrith as a centre of operations for a short period, he travelled to Ullswater, where he made a sketch of Lake Bassenthwaite, with Skiddaw looming behind. He also visited the strange henge of Mayburgh, sometimes called 'King Arthur's Round Table' (**26**). These subjects were being considered for *The Bridal of Triermain*. According to Cadell, Turner believed he could 'make something' of them. Then within forty-three miles of Rokeby and Greta Bridge, Turner decided, for the sake of the subjects proposed for *Rokeby*, to see and sketch the places he had visited long ago.

The sketches of the Greta and Tees rivers and Mortham Tower provide splendid examples of how Turner explored landscape pictorially. The location proved to be a difficult subject. Because of their spatial disposition, these landscape elements could not be included with accuracy in a single sketch. Consequently, Turner prepared a number of studies of separate parts and individual details of the location. He also fabricated an on-the-spot,

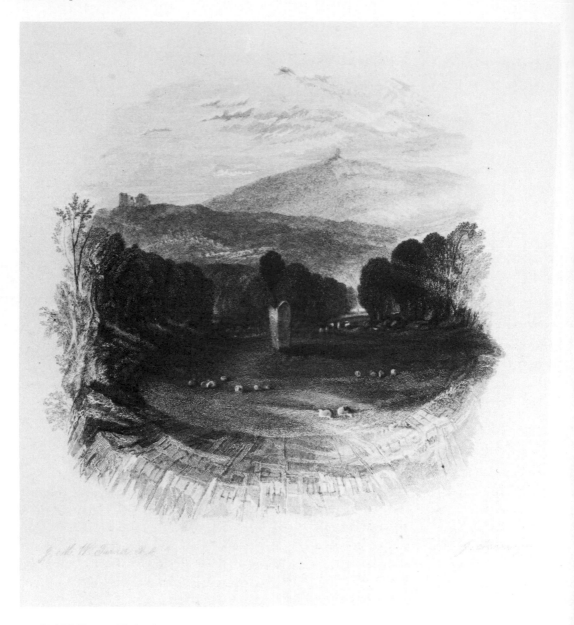

26 J.M.W. Turner, *Mayburgh*.
Vignette for Sir Walter Scott,
Poetical Works (1833–4), Volume
2. Engraving on steel by
J. Horsburgh, 1833. $3\frac{1}{2} \times 3\frac{1}{2}$ in;
8.9 × 8.9 cm. British Museum,
London.

panoramic view in which only very approximate spatial relationships could be established between Mortham Tower and the landscapes of the Greta and Tees rivers. To synthesize a view was no easy task, and, in order to 'create' one, he required an extensive knowledge of the topography of the place. To be able to depict it in this way, he needed to examine it not only pictorially, but also physically: to measure the relationship of one part to another and to note his responses to the volumes of the landscape's forms and voids as he experienced them (**3, 27–30**).

On his return to Penrith, Turner stopped to draw both Barnard Castle and Bowes Castle, also suggested for the *Rokeby* volume. From Penrith, he seems to have coached to Carlisle, where he made a number of studies of the city, a subject to be considered for the *Minstrelsy* (**31, 32**). From there he continued north and west, where he took views also proposed for the *Minstrelsy*: Caerlaverock Castle, New Abbey, Lincluden and Lochmaben Castle. Like the studies of the Greta and Tees, those of Lochmaben Castle demonstrate how important the physical experience of location was to the sketcher.

Lochmaben Castle was recorded by Turner in a number of sketches, including a series of tightly composed studies (**33–5**) which, made from different sides of the loch, indicate that the castle was ringed by trees. Turner presents the castle as if glimpsed through an obscuring screen of branches and foliage. Although he could not have seen more than the odd piece of masonry through the trees, Turner jotted down the ruin's coherent shape with some confidence. Other sketches suggest that he had previously examined the castle at close quarters, physically measuring its form and extent, and sketching it from differing points of view. When deciding on more inclusive views from across the loch, he mentally 'saw' the ruins without the full and immediate experience of them.

From nearby Dumfries Turner travelled to Langholm on 2 August, making a sketch of Johnny Armstrong's Tower on the way. The next day he coached from Langholm to Hawick, and on the morning of 4 August hired a chaise which took him south to the rather inaccessible Hermitage Castle (**36**). After making sketches of this ruin, he returned by evening to Hawick for dinner. After the meal he had planned to take the stage to Abbotsford, but, finding himself crushed 'out of all the

27 J.M.W. Turner, junction
of the Greta and Tees Rivers.
Pencil sketch, 1831, 'Minstrelsy
of the Scottish Border Sketch
Book', Turner Bequest,
CCLXVI, 35a–36. $4\frac{1}{2} \times 14\frac{1}{2}$ in;
11.4 × 36.8 cm. British Museum,
London.

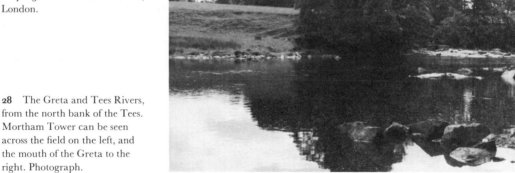

28 The Greta and Tees Rivers,
from the north bank of the Tees.
Mortham Tower can be seen
across the field on the left, and
the mouth of the Greta to the
right. Photograph.

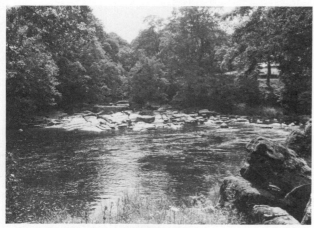

29 View up the Greta River, from the north bank of the Tees. Photograph.

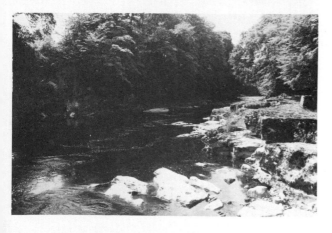

30 View of the Tees from the north bank. Photograph, taken a few yards west of the confluence to obtain the view round the bend, up river.

31 J.M.W. Turner, Carlisle.
Pencil sketches, 1831,
'Minstrelsy of the Scottish
Border Sketch Book', Turner
Bequest, CCLXVI, 41a.
$4\frac{1}{2} \times 7\frac{1}{4}$ in; 11.4×18.4 cm.
British Museum, London.

32 J.M.W. Turner, *Carlisle*.
Watercolour, 1832, engraved for
Sir Walter Scott, *Poetical Works*
(1833–4). $3\frac{1}{4} \times 5\frac{5}{8}$ in;
8.3×14.3 cm. Yale Center for
British Art, Paul Mellon
Collection.

33 J.M.W. Turner,
Lochmaben. Pencil sketches,
1831, 'Minstrelsy of the Scottish
Border Sketch Book', Turner
Bequest, CCLXVI, 59.
$4\frac{1}{2} \times 7\frac{1}{4}$ in; 11.4 × 18.4 cm.
British Museum, London.

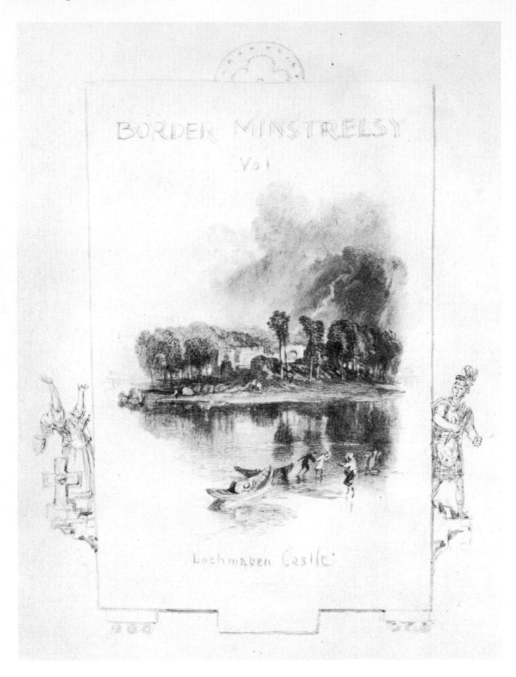

34 J.M.W. Turner, *Lochmaben
Castle*. Watercolour, 1832,
engraved for Sir Walter Scott,
Poetical Works (1833–4).
8 × 6 in; 20.3 × 15.3 cm. Private
collection.

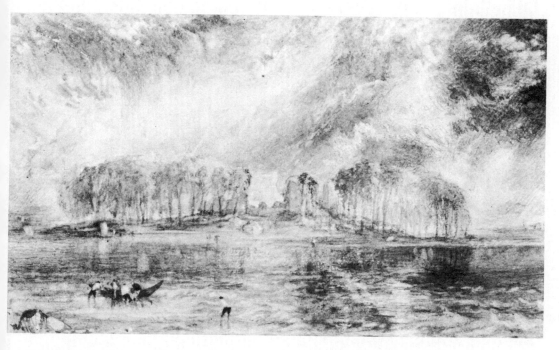

35 J.M.W. Turner, *Lochmaben Castle*. Watercolour, 1832; rejected design, originally intended to be engraved for Sir Walter Scott, *Poetical Works* (1833–4). $3\frac{1}{4} \times 5\frac{5}{8}$ in; 8.3×14.3 cm. Present location unknown.

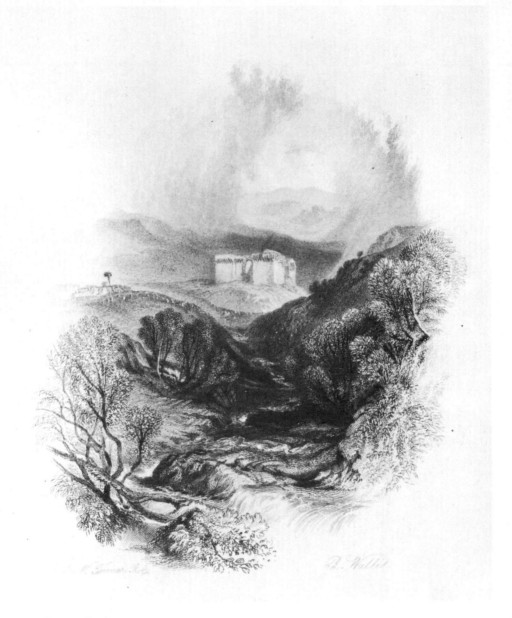

36 J.M.W. Turner, *Hermitage Castle*. Vignette for Sir Walter Scott, *Poetical Works* (1833–4), Volume 4. Engraving on steel by R. Wallis, 1833. $4\frac{1}{8} \times 3\frac{3}{8}$ in; 10.5 × 8.6 cm. British Museum, London.

Coaches',[96] hired a gig which was to bring him to Sir Walter Scott's door at eight o'clock.

While at Langholm, Turner had posted a letter to Cadell in which he stated that he would arrive at Abbotsford on 4 August.[97] As Cadell only received the letter on the evening of the third, he was forced to make hurried plans to leave for Melrose early the next morning. His attachment and sense of responsibility to Scott had increased proportionally to the writer's diminishing health, and he was deeply concerned that Turner's visit might exhaust Scott's limited physical and emotional reserves. For this reason, as I have mentioned, he had already assured Scott that he was willing to remain with him throughout Turner's visit, and he intended to be at Abbotsford in time for the painter's arrival. Cadell did not tell Scott that it was concern for his health that prompted his offer to stay with him: he merely said that he wished to ensure that 'Mr Turner's stay may trench as little as possible on your time'. Scott, however, was probably aware of Cadell's true motives. His apprehensiveness over the visit must have been at least partly due to awareness of his diminished physical and mental capacities. He probably wondered whether, in his state, he could cope with Turner, whom he believed to be a difficult man.

Much of Scott's anxiety was dispelled when Cadell arrived at Abbotsford early in the afternoon of 4 August. Cadell, having had no time to inform his host of his impending visit, found that Scott, alone in the study, was 'somewhat surprised to see me pop in but was right glad to see me before Mr Turner came'.[98] Cadell, who had not seen Scott since his previous visit at the beginning of July, was cheered by his healthy looks, observing his good complexion and detecting hardly a trace of slurring in his speech.[99]

After discussing their publishing ventures in the library, and particularly plans for the illustrations to the 'Poetry', the two took a long walk before dinner. Scott seemed more like his old self, but his appearance proved deceptive. The sanguine hopes which Cadell harboured were to be dashed later in the visit, and both he and Turner were to notice in Scott a marked change for the worse by the end of their stay at Abbotsford.

During dinner, business discussions were suspended as Cadell and Scott were joined by the author's two daughters. After the meal, the ladies retired from the dining room, and Cadell then began to question Scott about the probability of his going abroad

for his health. While in London, making arrangements with Turner for the illustrations, Cadell met the painter Sir David Wilkie, to whom he had spoken about Scott's condition. Wilkie mentioned how his own health had been greatly improved by a foreign voyage and expressed the view that such a trip would undoubtedly improve Scott's.[100] Although Scott's physician fully endorsed the idea of a voyage, Scott himself had resisted it.[101] Now, when Cadell asked whether or not Scott would journey to Naples, where his son Charles was attached to the British legation, Scott again demurred.

Too practical a man really to deceive himself, and yet seeking a way to delay decisions which would confirm the poor state of his health, Scott wished to avoid any discussion of the subject. However, when pressed, he reluctantly suggested possible routes to Italy that he might follow. The idea of a trip down the Rhine appealed to him more than a sea voyage. Whereas sea travel might be swifter and less taxing of his strength, Cadell had promised to advance him money for writing a journal on his trip, and this Scott could not accomplish if he went by sea.[102] Scott was still anxious to clear his great debt, and the money from the journal would ease his mind and the demands on his pocket book. After their conversation, the two men retired to the large drawing room, where they had tea with Scott's daughters. Scarcely had they seated themselves than the subject of the voyage to Naples was raised again, this time by Anne, who urged her father to commit himself to the trip. Despite talk about the planning of the voyage (to which contributions were made by Lockhart, who had now arrived), Scott was not prepared to decide until August or at the latest, the autumn.[103]

Turner's non-arrival had provided the assembled company with a diversionary topic. Heavy rains, poor roads and particularly low ground near Queen's [? King's] Moire were thought to have been responsible for the delay. Indeed, it was believed possible that he was 'bogged down'. But hardly had this discussion begun before the noise of a carriage was heard; moments later, Turner was at the door.[104]

Turner's Visit to Abbotsford in 1831

For a man who had been travelling by coach for almost two weeks, and constantly sketching, Turner must have been exhausted. Yet he exhibited little sign of it when he was welcomed by Scott. In the best of spirits, he was delighted when he learned that Cadell was there.[1] While waiting for his meal, Turner relaxed and 'talked & cracked' with the company. The party conversed on many subjects: 'of Caerlaverock of the Manchester & Liverpool Railway and every thing that came uppermost'. Turner was famished by the time he sat down at the table, and Cadell noted that he soon did full 'justice to [the dinner] after his long drive'.[2] After the artist finished his meal, Anne Scott and her sister Sophia talked to him about Abbotsford and showed him round the library. The company then retired for the night.

The next morning, Friday, 5 August, when Turner and Cadell came down to breakfast, they found Sir Walter, Laidlaw (Scott's secretary) and Anne already at the table. The conversation was mainly devoted to the illustrations that Turner was to prepare. After breakfast, Scott, Cadell and Turner retired to the study to confer on the matter of the designs. They spoke of the views that Turner had taken on the way north for proposed illustrations for the *Triermain* and *Rokeby* volumes. For *Triermain*, a view of Skiddaw from the lake was chosen to serve as frontispiece, while Mortham Tower was selected for one of the plates in the *Rokeby* volume. Scott mentioned that he had a print of the tower

upstairs, so the party 'adjourned upon this to Sir Walter's Bed room & from it through almost all the other bed-rooms in search of Views'.[3] It was then suggested that sites for sketching in the vicinity of Abbotsford should be considered. Ashestiel, Scott's former residence, was suggested for the *Marmion* volume, because it was there that he had written both *Marmion* and *The Lady of the Lake*.[4] Abbotsford itself was discussed as a possible illustration for *The Lay of the Last Minstrel*, and both Cadell and Turner stepped out on to one of the terraces to ascertain the best vantage points for the view. After examining various angles of the house, they decided that the most suitable viewpoints would be from across the river, and the two men planned to visit these spots early the next morning.

It was Ashestiel that was the subject of immediate concern, and, indeed, became the object of this day's sketching trip. Scott pointed out to his guests that the fine weather would not last, and that they should leave as soon as possible. He was somewhat disturbed by the delay, and when Anne informed her father that she planned to take their friends George Payne Rainsford James (the writer) and his wife in the carriage to Newark Castle as soon as he and his guests returned, perhaps suggesting haste, Scott became irritated. Cadell, quite innocently overhearing Anne's plans, remarked that the horses would be exhausted after their return from Ashestiel. 'Hang the horses,' snapped Scott in reply.[5]

Shortly after eleven, the Abbotsford party left in the carriage, driven by Peter, the coachman. They crossed the Tweed by the house, proceeded up through Galashiels, through Clovenfords, arriving at the approach to Ashestiel by a quarter past one. All the way, Scott had been in the best of spirits, entertaining his guests with ballads and poetry relating to the districts through which they passed. When Ashestiel (**37**) came into view, nestling on the crest of a steep bank which slipped into the Tweed, Turner asked that the carriage be halted. Alighting, he began an elaborate double-page panoramic view in a fresh sketch book (the 'Abbotsford Sketch Book'), with Cadell looking on. After completing this study, Turner returned with Cadell to the carriage, which then continued to a point almost immediately across the river from the house, where both house and bank were much more prominent features of the scene. Turner, once more followed by Cadell, found a spot on the bluff at the edge of the road, where he made a second elaborate double-page sketch.

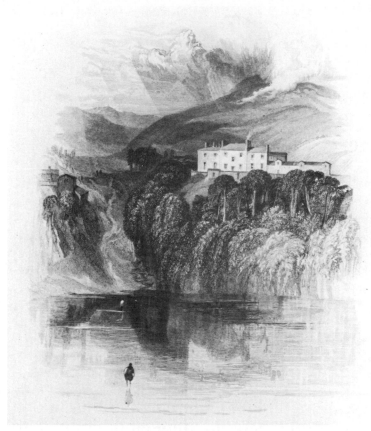

37 J.M.W. Turner, *Ashestiel*.
Vignette for Sir Walter Scott,
Poetical Works (1833–4), Volume
7. Engraving on steel by
J. Horsburgh, 1833. 4 × 3¼ in;
10.2 × 8.3 cm. British Museum,
London.

After this was completed, Turner and Cadell resumed their places, and the carriage then proceeded down the steep river bank, forded the river and bumped its way up a rough track on the other side to the house.

On arriving at the stables, Sir Walter instructed Peter to put up the horses and then led Turner and Cadell to the house, where they were greeted by the young Misses Russell, the daughters of Colonel James Russell, Scott's cousin. While Scott was being entertained by the young ladies, Turner, accompanied by Cadell and Peter, proceeded cautiously down the bank to the river, in search of a rowing boat to take them to the other side. Turner was anxious to discover a view of the house from a lower vantage point than he had found for either of his two previous panoramic sketches. They soon found the boat, but it was partially submerged. While Turner and Cadell waited for Peter to bail out, Colonel Russell, the owner of Ashestiel, arrived to introduce

himself and chatted with them until the boat was ready for boarding.

By the time the boat was afloat, and Turner and Cadell seated in it, the sky had darkened and the muttering of thunder was heard. With the assistance of Peter, their craft was launched into the middle of the stream. However, before they reached the opposite bank, the rain began and Turner was forced to sketch from the boat under the protection of the umbrella that Cadell dutifully held. After Turner had completed his study, the publisher rowed quickly back to the other shore. They disembarked and with Peter's assistance scrambled up the bank through the drizzle to the shelter of Ashestiel, where, in the company of the Russells, the Abbotsford party lunched.

Turner, Cadell and Scott were on their way home shortly before three o'clock. The weather had improved by the time they reached the Yair Road, for Turner asked if he might have a five-minute stop to take a view of the river, 'which he thought . . . pretty'.[6] Cadell again joined Turner as he sketched. Half a mile on, by a ford, the artist called for a further halt. Here again he made a very quick sketch of the river. The party reached Abbotsford shortly before five, approaching the house along the road to Galashiels, directly across from Abbotsford. Turner probably wished to examine views of the house from this side of the Tweed, since he had mentioned that he would take sketches here the next morning. But the carriage did not stop. Scott was anxious to return home, as there was to be a party at Abbotsford that evening and preparations needed to be made. The Lockharts had been invited, as had the Jameses, whose afternoon trip to Newark was cancelled because of the late return of Scott, Turner and Cadell. The three men must have been extremely tired, for Cadell noted that there was little conversation during the meal, and what was said was 'commonplace' and far from stimulating. Scott hardly spoke and Turner muttered only a word or two. Cadell expected quite a lively discussion from Lockhart and James, but even they had little to say.[7]

However, after the ladies excused themselves and a quantity of claret had been drunk, the company revived and became quite animated and jovial. Scott related a story about Captain Basil Hall, the writer, delivering his wife of her last child, an account which convulsed those present. After discussing the quality of their first bottle of claret, the men arose and retired to the

drawing room for tea, when Cadell joked with Turner, who appeared to be in good spirits. During tea, Mrs Lockhart entertained the company with airs on the harp, all of them Minstrelsy ballads. There was also a good deal of gossip, including a discussion of Samuel Rogers. Anne Scott mentioned the poet's great house in London, overlooking Green Park, with its collection of pictures and curiosities.[8] Turner joined in the discussion and so did Scott. Cadell thought that, since the dinner, Scott appeared much better. He had become increasingly animated and looked 'greatly improved by being dressed in good clean clothes'.[9]

Later, as the Jameses took their leave, Cadell accompanied Scott to the door to see them off and spoke of his plan to return to Edinburgh on the following day. Scott would not have it, and later Anne echoed her father's opinion. At nine o'clock, after Sir Walter had retired, the remaining company – Cadell, Turner, Mrs Lockhart and Anne – discussed the proposed illustrations for the 'Poetry'. Mrs Lockhart was especially interested in the subjects which had been suggested for the illustrations to *Minstrelsy of the Scottish Border*, and Turner took the opportunity to question her about the appearance of Ashestiel twenty years before.[10] When the ladies retired, shortly after ten, publisher and artist continued their discussion. Although Turner had been told by Scott that he would have a say in the choice of subjects, he told Cadell, 'Fix you and Sir Walter what you wish put in [and] I shall find it out.'[11] In the event, Turner was slightly more interested in the subjects than he indicated at this time.

Before retiring, Turner and Cadell must have made their plans for the morning. They had already discussed a view of Abbotsford for *The Lay of the Last Minstrel* and had proposed a number of vantage points from across the river. It was confirmed that they would cross the Tweed before breakfast, so that Turner could make several sketches of the house.

The weather on the following morning, Saturday, 6 August, was bad, and the proposal to make sketches of the house was thwarted both by heavy rain and by fog that obliterated the landscape. However, Scott, Turner and Cadell discussed plans in case the weather cleared. Scott was particularly interested in Smailholm Tower as a subject for the 'Poetry'. It was a childhood haunt for which he held a deep affection. The trio decided, if the weather improved, that a visit to Smailholm could be combined

with one to Bemerside, another subject considered for illustration. Fortunately, the skies began to clear. A lunch was prepared, and, accompanied by the servant James, the Abbotsford party set out for Smailholm Tower at about half-past eleven.

The day was now fine. Turner was delighted with the scenery, and when the carriage reached a bluff overlooking Melrose Vale, Scott called a halt. Turner asked him if the view before them, with Melrose Abbey, was contemplated for *The Lay of the Last Minstrel*, or was a more particular view of the Abbey to be used for this purpose. To Cadell's surprise, Scott seemed almost indifferent to the matter, for he replied, 'that he would leave that to the Painter'; so, according to Cadell, 'nothing was settled'.[12]

On the way to Smailholm Tower and Sandyknowe Farm (which was on the same property), Scott recounted the history of his family. Robert, Scott's grandfather, had been left this property, as well as £30 from an old shepherd, who had stipulated that this money (which was his entire life's savings) was to be used to purchase sheep stock. Robert did not heed the shepherd's instructions and used the money to buy a fine horse instead. This horse proved to be so excellent a hunter that he sold the animal at a profit and applied the entire amount to the purchase of sheep. Scott then told of being sent to Sandyknowe Farm as a 'feckless boy of two years old to die', of the 'nurse or Keeper contemplating the cutting of his throat' and of the occasion when he was 'on a rig during harvest and incurring danger from a Bull'.[13] Scott also kept his guests entertained by quoting excerpts from the ballads of the district. The Abbotsford party approached Smailholm shortly before two o'clock. From the road, Turner must have been struck by the peel tower's majestic appearance. On a hilly prominence, it dominated the rather flat surrounding countryside. The narrow road which led to it was a long one, and Turner would have been able to view the way in which landscape elements seemed to shift and reform themselves round the tower, as the carriage made its irregular pilgrimage to the precinct. From a distance, the farm and outbuildings of Sandyknowe seemed to hug the base of the tower, but, as the carriage drew nearer, they receded. The narrow road leading to the tower passed through the stable yard, beyond which it deteriorated into a rough track created by the hoofs of numberless generations of cattle.

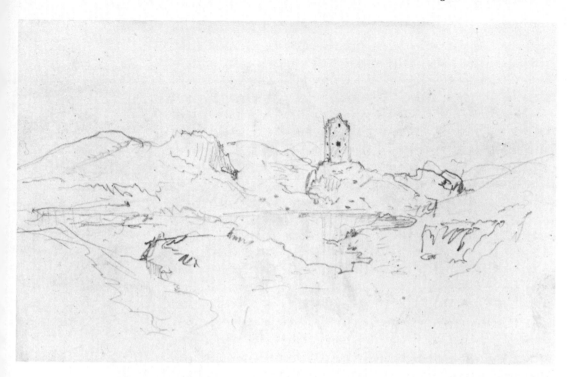

38 J.M.W. Turner,
Smailholm Tower. Pencil
sketch, 1831, 'Abbotsford Sketch
Book', Turner Bequest,
CCLXVII, 85a. $4\frac{3}{8} \times 7\frac{1}{4}$ in;
11.3 × 18.4 cm. British Museum,
London.

39 Smailholm Tower.
Photograph.

Approaching the peel tower from the farmyard must have been a moving experience for Turner (**39**). The sounds of the farm fade as one follows the track round a hillock and confronts the brooding form of the tower, looming before the spectator in splendid isolation. When Turner arrived on that clear August day, the tower would have been dramatically silhouetted against the brilliant light of the early afternoon sun and reflected in the unblemished surface of the pond spreading before it. On arrival, Turner began almost immediately to make drawings, both to the right and the left of the pond (**38**). It was while Turner was sketching on the left that he represented Cadell and Scott making their way along the rocky shore of the pond towards the tower, at a moment when Cadell was having 'some cracks with Sir Walter as he leant on my arm while Mr Turner made his sketches' (**41**).[14]

When Cadell and Scott returned to the track leading from the farm, servant James was laying out a picnic lunch on the grass. Cadell then went in search of Turner, who had positioned himself on a hillock behind the tower, where, from a crest, he had discovered a pictorially powerful image of the peel, to which the flat distances stretching behind served as a useful foil (**40, 42**). After completing his sketches here, Turner and Cadell returned to the other end of the pond for lunch.

After their meal, the Abbotsford party trudged back to the Sandyknowe farmhouse, where the farmer's wife, a 'tall stout fair haired good looking comely person', invited them for a second lunch at which they consumed quantities of 'whisky, gingerbread, cheese, nice bread and cool nice milk....'[15] The party was introduced to the others present, the wife's farmer husband ('a poor useless like deaf body') and a Miss Jordan ('a sister of Jordan [H.R. Jerdan] of the Literary Gazette [a weekly critical review] who afforded us much amusement, she was decidedly daft & raved about Sir Walter'). Scott, Turner and Cadell thoroughly enjoyed this visit, for Cadell noted, 'we sat I daresay half an hour, all apparently well pleased with each other'. And so, with considerable reluctance, they departed.[16]

It was about four o'clock when the Abbotsford party left Sandyknowe farm. The sun behind the tower, seen from a distance, once again provided a dramatic silhouette, which Turner sketched as the carriage departed (**43**).

Bemerside was their next stop. It was not far from Dryburgh Abbey and Scott's View, and they reached it shortly after five.

40 J.M.W. Turner, Smailholm Tower. Pencil sketch, 1831, 'Abbotsford Sketch Book', Turner Bequest, CCLXVII, 84a. 4⅜ × 7¼ in; 11.3 × 18.4 cm. British Museum, London.

41 J.M.W. Turner, Smailholm Tower, with Cadell and Scott on the right. Pencil sketch, 1831, 'Abbotsford Sketch Book', Turner Bequest CCLXVII, 85. 4⅜ × 7¼ in; 11.3 × 18.4 cm. British Museum, London.

58

42 J.M.W. Turner, *Smailholm Tower*. Watercolour, 1832, engraved for Sir Walter Scott, *Poetical Works* (1833–4). $6\frac{1}{4} \times 4\frac{1}{2}$ in; 16.0 × 11.4 cm. Private collection.

Scott seems to have been relieved that the Laird and his wife were absent, since a further social call would have impeded Turner's work and made them late for dinner. However, one member of the family was there: a daughter, Miss Mary Haig ('a bon[n]y little lassie'), who welcomed them. While Turner was making a sketch of the house, Mary Haig escorted Sir Walter and Cadell round the building to 'where the house is more prominently seen but not so picturesque, as where Mr Turner took his sketch'.[17] Apparently Turner was not enthusiastic about the appearance of the house and so decided to make only one sketch of it (**44**). This he took from the garden, in front of a large Spanish chestnut tree, so as to give this stark structure some visual relief. He also sketched a curious stone sundial which stood to the left of the house. Turner's studies took approximately thirty minutes to

43 J.M.W. Turner, Smailholm Tower. Pencil sketches, 1831, 'Abbotsford Sketch Book', Turner Bequest, CCLXVII, 83a. $4\frac{3}{8} \times 7\frac{1}{4}$ in; 11.3 × 18.4 cm. British Museum, London. See Plates 65, 99.

Orvieto

complete, after which the three men climbed into the carriage, bound for Abbotsford.

This proved to be one of Turner's most memorable days in Scotland. The weather had been good and Sir Walter was in buoyant spirits. He was pleased that Turner had made numerous sketches of Smailholm Tower, for he had set his heart on this as a subject for a 'Poetry' illustration; indeed, 'there was nothing he [Scott] had more anxiously wished than that he Mr T[urner] should do that tower'. Turner expressed delight with the landscape of the Vale of the Tweed and especially with 'turns of the Tweed about Old Melrose & Gladswood and . . . the view of the Vale of Melrose with the sun in the direction it now shone in'.[18] This last view in particular was so deeply impressed on the artist's mind that he returned later to make a detailed sketch of it.

Scott, Turner and Cadell made Abbotsford by seven o'clock, just before a storm broke. Colonel Russell was there and soon dinner was served. The conversation was cheerful and concerned the events of the day: Turner's sketches, descriptions of the farmer's wife at Sandyknowe who had so generously served them lunch, the farm's other inhabitants and the bonny Miss Mary

44 J.M.W. Turner, Bemerside Tower. Pencil sketch, 1831, 'Abbotsford Sketch Book', Turner Bequest, CCLXVII, 83. $4\frac{3}{8} \times 7\frac{1}{8}$ in; 11.3 × 18.4 cm. British Museum, London. See Plate 69.

45 J.M.W. Turner, Newark
Castle. Pencil sketches, 1831,
'Abbotsford Sketch Book',
Turner Bequest, CCLXVII, 79.
$4\frac{3}{8} \times 7\frac{1}{4}$ in; 11.3×18.4 cm.
British Museum, London.

46 J.M.W. Turner, *Newark Castle*. Watercolour, 1832, engraved for Sir Walter Scott, *Poetical Works* (1833–4). $4\frac{3}{4} \times 4$ in; 12.1 × 10.1 cm (sight measurement). Private collection.

Haig who had been so hospitable at Bemerside. Cadell was pleased that Sir Walter had such a memorable outing. However, he had noted that Scott's 'upper lip which was once so playful now appears to hang heavy and interrupt and check his conversation'.[19]

Scott retired at nine o'clock, but Turner was still in high spirits, and apparently gave little evidence of fatigue. He carried on a long and involved discussion with Colonel Russell on the subjects of phrenology and physiognomy, a conversation which Cadell found tedious and which he was relieved to see draw to a close shortly after eleven, when all retired to their rooms.

The next morning, Sunday, August 7, Turner and Cadell arranged to visit Newark Castle, but without Sir Walter, as it was Sacrament Sunday at Melrose. Breakfast was at nine, though Turner and Cadell did not depart until twenty minutes past ten. Cadell drove the phaeton, and it was arranged that Sir Walter's

47 J.M.W. Turner, bridge in Rhymer's Glen. Pencil sketch, 1831, 'Abbotsford Sketch Book', Turner Bequest, CCLXVII, 6. 4⅜ × 7¼ in; 11.3 × 18.4 cm. British Museum, London.

boy should accompany them on a pony. On the way to Newark, the gig was halted so that Turner could make sketches of Philiphaugh and Selkirk. They reached Bowhill just before midday, when the boy was sent to Ettrick Water with the ponies, while Cadell and Turner proceeded on foot to the grounds of the castle. Turner was struck by the turns of the Yarrow Water, and confessed that he 'could have gloated over the beauties of it for a

whole day'.[20] While he did not stop to draw them, he planned to make sketches on his return from Newark.

After Turner sketched the castle (**45, 46**), he and Cadell went back to Broadmeadows, where the gig was waiting to take them back to Abbotsford. Since they were expected for dinner at the Lockharts', who lived at Chiefswood on the Abbotsford estate, Turner did not have an opportunity to take views of the Yarrow Water, which had so much attracted him when he arrived. Indeed, because of the lateness of the hour, and the need to return as quickly as possible, Turner and Cadell were forced to eat their picnic lunch in the discomfort of a moving gig. Before losing sight of Newark, Turner made a number of additional quick sketches while the vehicle was in motion.

Cadell managed to make good time on the return journey, proceeding across the Ettrick by Sunderland Hall and reaching Abbotsford shortly after half-past three. When they arrived, they changed, and were soon seated in the carriage with Sir Walter and Anne. A few minutes later the party was in sight of Chiefswood. After the pleasantries of the introductions, several of the group suggested a stroll to the famous Rhymer's Glen, a subject proposed for illustration of the *Sir Tristrem* volume. However, this idea was overruled, 'on account of Mrs Lockhart's roast beef' which was ready to be served.[21] Turner was probably disappointed. He had his sketch books hidden away in one of his capacious pockets and was obviously looking for an opportunity to visit the Glen. After an interlude on the carefully manicured lawn which lay before the attractive wilderness of the entrance to the Rhymer's Glen, Sir Walter, Turner, Cadell and Anne accompanied the Lockharts into the house.

A pleasant dinner ensued. Sir Walter seemed in excellent spirits, repeating many of the old ballads and poetry. The meal was generously punctuated by 'fun and jaw', as was the period immediately after dinner.[22] Turner, who fully participated in the dinner conversation, seems to have broken away as tactfully as possible, sketch book in hand, to visit the Glen (**47**). He had probably hoped to steal away with Cadell, who showed no inclination to leave. However, Scott's daughters learned of Turner's intentions, and begged to be allowed to accompany him. Turner and the two ladies were away for a considerable period, and Cadell eventually decided to search for them, but lost his way, and was forced to return to the house. When Turner and

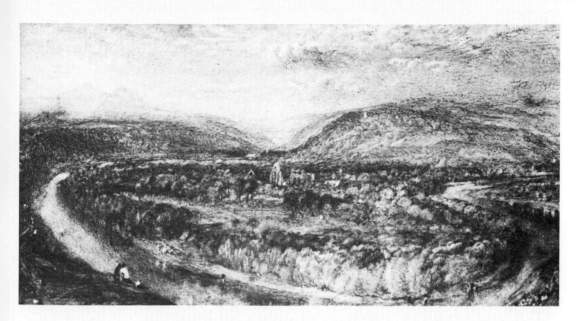

48 J.M.W. Turner, *Dryburgh Abbey*. Watercolour, 1832, engraved for Sir Walter Scott, *Poetical Works*, (1833–4). 3⅛ × 5⅞ in; 7.9 × 14.9 cm. Tate Gallery, London.

the young ladies finally emerged from the Glen, the painter was tired and his feet were wet. He had drunk a fair amount of wine during the meal and had apparently found it difficult to negotiate the rather slippery rocks of the Glen's rivulet. After being presented with a pair of dry slippers belonging to Lockhart, and after drinking a cup of hot tea, Turner was ready to leave with the other guests. On reaching Abbotsford, shortly after ten, Sir Walter took his nightly bowl of gruel and went to bed. Turner took a nightcap. He was not a little drunk and berated Cadell for having left him in the Glen in the company of the women. After this, Turner staggered off to bed, but not before accidentally lurching into a bedroom that was not his. Cadell, on reflecting on the day's activities, noted that whereas Scott was in good humour during the dinner, he had sulked immediately before. Cadell had also observed that Scott was silent on his return from Chiefswood, and concluded that his behaviour must have been the result of fatigue, for 'Sir Walter speaks less towards the evening when he gets tired.'[23]

The next day, Monday, 8 August, was to complete Turner's business at Abbotsford. Scott was not to accompany Cadell and Turner: apparently the round of activity and entertainment was proving too much for his by now delicate constitution. Cadell was up at half-past five, and, shortly after dressing, he was summoned by Scott. The author wished to remind him of a request that he had earlier made: that, if it were at all possible, Turner should

take a view of Coldingnose Castle, which had been proposed for the *Sir Tristrem* volume. Cadell was fully aware that Turner was against this subject, and noted in his diary, 'I did what I could to throw cold water on it . . . but promised to mention it', knowing full well that Turner would reject the suggestion.[24]

The gig was at the door by seven, and Turner and Cadell left fifteen minutes later, accompanied by Sir Walter's boy on a pony. They were to visit Archibald Todd's family at Drygrange for breakfast and then walk on to Dryburgh Abbey, which was within easy walking distance. At twenty minutes past nine the party arrived at the suspension bridge erected by Lord Buchan. From here, Sir Walter's boy was sent with the gig and horses to St Boswell's Green, where Turner and Cadell arranged to meet him at midday.

After a short but pleasant ramble to Drygrange, the pair took a short turn round the Todd property with the two young sons of the household, Jamey and Aleck. Breakfast was at nine, and by ten Turner and Cadell were on their way to Dryburgh Abbey, accompanied by the two boys. As they approached the abbey, Turner made a number of quick sketches. He then completed a number of closer views from different directions, which occupied him for about an hour. Meanwhile, Archibald Todd arrived and the two boys departed.[25] Todd, who knew the area intimately, guided Turner and Cadell round a high bank in the direction of Lesudden and Boswell's Green, where Turner made several more studies – one, in particular, was panoramic in nature and included the abbey within a loop of the Tweed (**48**). Todd left Turner and Cadell at half-past one.[26]

As Turner had hoped to draw Melrose Abbey and a view of the Vale of Melrose this day, he was anxious to be off. He and Cadell left to meet Sir Walter's boy and the gig at St Boswell's Green, where a lunch had been laid out for them. After a hasty meal, the party departed for Melrose Abbey, which they reached at a quarter past two. Here Turner made the most elaborate architectural studies of his tour (**49**). For three hours he laboured intently on three views of the abbey, taken from close quarters. One was taken from the stone seat near the 'entry to the foot of the path leading to the Village of Newstead'. The second was a 'South East View of the whole Pile' and the third and final drawing was a particularly elaborate study extending across a double page, looking towards the 'East Window in an angular

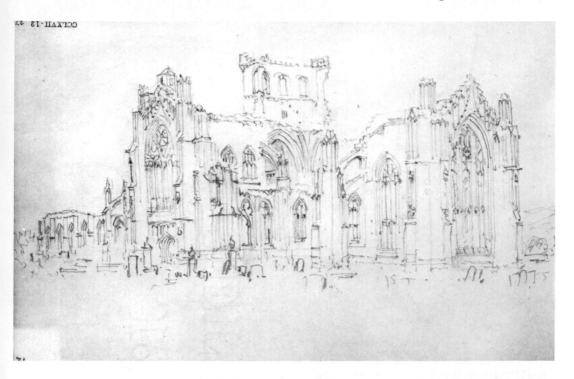

CCLXVII·12

49 J.M.W. Turner, Melrose Abbey. Pencil sketch, 1831, 'Abbotsford Sketch Book', Turner Bequest, CCLXVII, 12. $4\frac{3}{8} \times 7\frac{1}{4}$ in; 11.3 × 18.4 cm. British Museum, London.

direction looking South East'.[27] After completing these studies, Turner was now prepared to take the view of the Vale of Melrose, which had so attracted him on a previous occasion.

When they reached the familiar point overlooking the Vale, with Melrose Abbey and Lord Buchan's suspension bridge in the distance, Turner made a panoramic drawing, covering two pages of his sketch book (**50**). Cadell noted that this view was made on the Drygrange road, at the entrance to a track leading to a farmhouse.[28] But it seems that Turner climbed down through a field in order to find the viewpoint for the study from which the finished watercolour was derived. As soon as the sketch was completed, Turner and Cadell sat down to a picnic dinner: 'Sir Walter's boy attended us with a Basket of viands which all relished very much.'[29] Because of the difficulty they experienced in finding a place to ford the Tweed to make this sketch, and due to the long time spent over their evening meal, the group did not leave for Abbotsford until half-past seven.

However, as it was a fine evening, and since Scott and his daughter Anne had been invited to the Haigs of Bemerside for dinner, Turner and Cadell agreed to follow a more circuitous

CCLXVII-15 271

route home, and so came down at a point near Langlee, and travelled down a side road to the Gala, where, from a high bank, Turner made some sketches of Abbotsford, which could be seen from this vantage point. Because Turner was not especially pleased with this view, the party travelled down and across the Gala to a position much closer to the house and, indeed, almost immediately across the river from it. Here Turner made two additional brief sketches and then, proceeding to a point further west, near an ash tree, made a final study of the house. Having completed his views of Abbotsford, Turner, Cadell and the boy forded the Tweed, tired after being '12½ hours in the open air'.[30] Turner and Cadell sat down to eat at half-past eight. While they were still at the table, Sir Walter and Anne returned. Cadell was alarmed by the author's silence, but again attributed it to fatigue. Turner and Cadell soon followed their host upstairs to bed.

They were down to breakfast early the next morning, Tuesday, 9 August, as they were to leave Abbotsford at one. This was to be the beginning of an eastern tour along the Tweed, a journey that would eventually take Turner to Berwick, whence he would coach to Edinburgh. Before sitting down to breakfast, Cadell spoke to Scott of Turner's plans for sketching during the next few days, and attempted to explain why the painter did not

50 J.M.W. Turner, Melrose Vale. Pencil sketch (detail), 1831, 'Abbotsford Sketch Book', Turner Bequest, CCLXVII, 15. 4⅜ × 7¼ in; 11.3 × 18.4 cm. British Museum, London. See Plate 70.

make a sketch of Coldingnose, as Scott had wished him to do. However, after Cadell had made his explanations, he was surprised to note how well Scott received the news, for, according to Cadell, he now 'did not seem to care much about [it]'.[31] Cadell assured Scott that he would return to Abbotsford in a month to discuss Turner's ideas concerning illustrations, after the latter's return from the Highlands. Scott appeared to be in high spirits when he joined Turner, Cadell and Laidlaw that morning at breakfast, repeating snatches of ballads.

There is no doubt that Scott found Turner a different man from what he had expected. Turner was very co-operative and cheerful, and was thoroughly enraptured by the gentle, rolling countryside in the Vale of the Tweed. It is likely that Scott was taken with Turner's immediate and constant enthusiasm for scenery, whether it was a ruin, or the turn of a river. We may reasonably assume that, during their recent association, Scott had discovered that Turner shared with him a knowledge of the theory of the Picturesque, according to which nature was examined and ordered by the precepts of art: whereby a locality took on a character that ruled its mood. Also the theory established, as we have seen, that landscape was considered to be more than mere topography: it was the silent witness to the events of human history.[32]

That common interests such as this generated a personal sympathy between the two men seems likely, and is suggested by two letters written by Scott shortly after Turner's departure, but before the latter's tour of northern Scotland. First, Scott wrote to Cadell, who was by then in Edinburgh, 'My compliments to Mr Turner. Miss Mary Haig [of Bemerside] was quite disappointed at not finding him here yesterday. I trust Mr Turners journey [north] will be as successful as it has been, more so it can not be.'[33] And writing to his son, Major Walter Scott, about Turner's impending tour of the bleak landscape of the Highlands, Scott referred to the project in the most optimistic terms: 'I think he will make a superb book of it if he is not as Burn[s] sa[y]s "killd by highland bodies / And eaten like a weather haggis". For the plan if he goes to the Hebrides Staff[a] Skye and all that He seems [to] think it a queer place for he already begins to open his eyes & [? in] wonder.'[34]

Before bidding a final farewell to Sir Walter at Abbotsford, Cadell had spoken to both Laidlaw and Anne Scott, who had

agreed that Scott should take the trip abroad. By this time, both Cadell and Turner were certain that Scott was gravely ill. Laidlaw had mentioned to Cadell Scott's inability to write *Castle Dangerous*, and both men agreed that it would be a 'most fortunate circumstance if he were not to work any more – but this is too good to be at all likely'.[35] Cadell had come to the conclusion that Scott might not live long, and that if he went to Naples, he might never return. A little later, he was to observe,

Nothing can be more clear than that the great Baronet is a failed and failing man – he does not take care of himself – he drinks wine – he does not [w]rap himself up when he goes out – he is constantly meeting with accidents . . . in a word the Great Mind is sinking – there is a constant tendency to listlessness & forgetfulness – & I fear matters will not mend, they will get worse.[36]

At midday, Turner and Cadell bade farewell to Sir Walter and his family and set off on the next stage of their tour.

6 Berwick-on-Tweed, Edinburgh and the Northern Tour

Of the 'Poetry' designs, those associated with Turner's visit to Abbotsford were undoubtedly the most significant. There were, however, other important subjects for illustration to be sketched along the Border to the east, on the way to Berwick. From Berwick, Turner would return to Edinburgh and then begin the final lap: a tour to the north, where he would gather yet more material.

After leaving Abbotsford, Turner and Cadell coached first to Jedburgh, which they reached by three. This was to be their initial sketching stop, for the abbey had been chosen as a suitable subject for illustration in the *Minstrelsy* volumes. On this eastern lap, Turner was to continue to sketch in the 'Abbotsford Sketch Book', but would now employ it in conjunction with a new one, the 'Berwick Sketch Book'.

At Jedburgh, Cadell met by chance a relative and friend, one John Paton, who invited the two men for dinner at his home at Crailing. The invitation was accepted, but before they visited Paton's house Turner wanted to complete his sketching of the abbey, so that they might go direct from Crailing to their next destination. They therefore deposited their baggage temporarily at one of the Jedburgh inns and set out on foot for the abbey.

Turner examined its structure carefully and decided on possible views. Shortly after he began to sketch, Cadell left to return to the inn, and, after writing a letter to his wife, set out again to find Turner. Having met, the two men made their way

51 J.M.W. Turner, Jedburgh Abbey. Pencil sketch, 1831, 'Abbotsford Sketch Book', Turner Bequest, CCLXVII, 65a. 4⅜ × 7¼ in; 11.3 × 18.4 cm. British Museum, London.

52 J.M.W. Turner, *Jedburgh Abbey*. Watercolour, 1832, engraved for Sir Walter Scott, *Poetical Works* (1833–4). 3⅝ × 6 in; 9.4 × 15.4 cm. Taft Museum, Cincinnati, Ohio, USA.

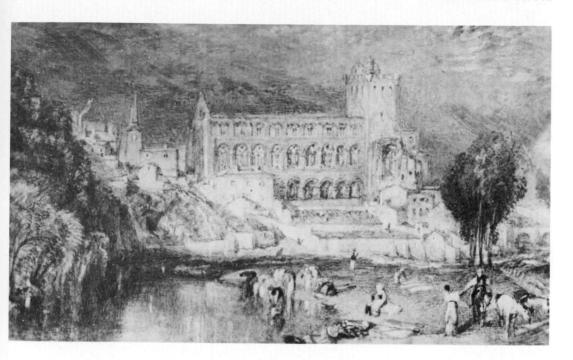

53 J.M.W. Turner, Kelso.
Pencil sketch, 1831, 'Abbotsford
Sketch Book', Turner Bequest,
CCLXVII, 19a–20.
4⅜ × 14½ in; 11.3 × 36.8 cm.
British Museum, London.

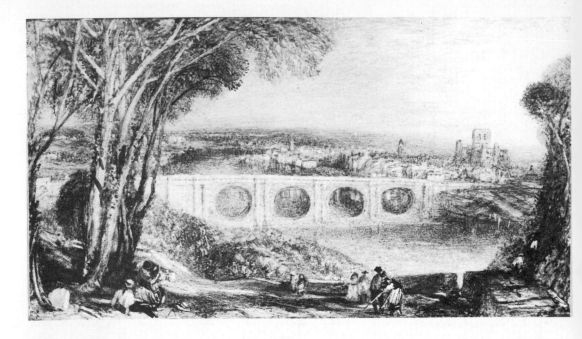

up the Jedwater, where, from a stone bridge, Turner made a careful pencil study of the town. The pair then retraced their steps to the abbey, where Turner made more drawings (**51, 52**) of the fabric; he ascended 'to the top & went all round and about it'. Suddenly Cadell realized that it was well after five o'clock and time to leave for Crailing. While he was still intent on sketching, 'this dinner matter hurried Mr Turner a little.' Soon the two men were off to collect their baggage and to hire a chaise, which was to take them to Crailing, and from there to Kelso (for Kelso Abbey had also been chosen for illustration in the *Minstrelsy*). They arrived at the Patons' shortly before six and remained only for the meal. They then set off for Kelso, which they reached at ten. After taking rooms at the Cross Keys Inn on the town square, they 'had a glass of Brandy & water apiece' and by eleven had gone to bed.

Cadell's plan had been to take leave of Turner here and return to Edinburgh. However, he had particularly enjoyed the companionship of this famous artist, and, as he had never been from Kelso to Berwick before, 'resolved to accompany Mr Turner round that way'.

The next morning, Wednesday, 10 August was fine, and, on rising Cadell learned that Turner had been out sketching the abbey by seven o'clock. Cadell went to meet him and the two men strolled back along the road from Jedburgh, crossed a bridge

54 J.M.W. Turner, *Kelso*. Watercolour, 1832, engraved for Sir Walter Scott, *Poetical Works* (1833–4). 3¼ × 5½ in; 8.3 × 14.0 cm. Private collection.

and climbed a slight rise, where Turner 'got a Capital Sketch' of the town, with the bridge and the abbey (**53, 54**). The two men then crossed the Teviot to the ruins of Roxburgh Castle, where Turner made a sketch of the few fragments that remained, taking another sketch as they retraced their steps to Kelso. They arrived at the Cross Keys for breakfast by ten. Although they had planned to post that morning to Berwick, they decided not to leave immediately, but to take the stage, which would depart at half-past two. The strain of the tour must have been beginning to tell on Turner.[1]

The stage which they caught travelled by Coldstream and Cornhill. Whether they journeyed on the outside of the stage by necessity or choice is not known, but it did provide them with a splendid view of the country through which they passed. They noticed Twizel Castle on the Till, a Gothic Revival building which Cadell had once suggested as a subject for illustrating *Marmion*, but which Scott had rejected as unsuitable, since it was such a bad example of 'modern Gothick'. Indeed, as they passed it, Cadell was obviously persuaded that Scott was right, since he noted in his diary that he had seen 'Mr [Francis] Blake's abominable Castle'. Later he wrote to Scott about this experience: 'I did laugh very much . . . when I saw it. You did quite right to abuse me as well as it – it is awful & shows how many folk talk of what they do not understand & most certainly no one *can* understand any place till they see it.'[2] The stage then approached Norham Castle, slowing down as the horses strained up the hill by the ruin. As they passed the castle, Turner is reputed to have taken off his hat and made a bow. On observing this strange act of homage, Cadell is supposed to have exclaimed, 'What the Devil are you about now?' 'Oh', was the reply, 'I made a drawing or painting of Norham several years since. It took; and from that day to this I have had as much to do as my hands could execute.'[3] While passing the castle, Turner made three quick, though not particularly accurate, sketches of the ruin (**55**). That he troubled to bring out his pencil and sketch book may have been a reflex action, since he considered the castle a kind of personal touchstone. Both Scott and Cadell had several times suggested it for illustration in the *Minstrelsy* and *Marmion*, and it may have been for this reason that Turner made his notations. In the end, however, the subject was rejected.

The stage reached the centre of Berwick at seven, pulling into

55 J.M.W. Turner, Norham
Castle. Pencil sketches, 1831,
'Abbotsford Sketch Book',
Turner Bequest, CCLXVII,
59a. $4\frac{3}{8} \times 7\frac{1}{4}$ in; 11.3 × 18.4 cm.
British Museum, London.

the King's Arms Inn, where Turner and Cadell found rooms.
After taking dinner, the two strolled a considerable distance
through the town, up the High Street, searching for an
appropriate place to take a view that was to illustrate Halidon
Hill in Scott's drama of that title. Turner made several sketches,
but the one that he considered the most suitable was taken 'out of
the Scotsgate in a field on the left hand side of the Dunse Road'
(56). Turner appears to have started several compositions, finally
outlining that which was to be developed the following morning.
Turner was pleased with the spot which he had chosen, and with

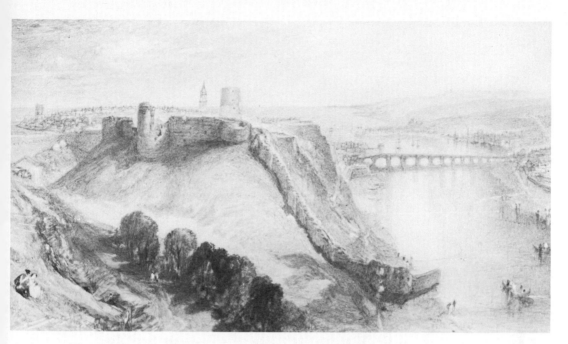

56 J.M.W. Turner, *Berwick-on-Tweed*. Watercolour, 1832, engraved for Sir Walter Scott, *Poetical Works* (1833–4). $3\frac{3}{8} \times 5\frac{3}{4}$ in; 8.6 × 14.6 cm. William P. Wood, Esq, West Grove, Pa, USA.

the double-page preliminary outline which he made, that included 'the old Castle, the Bridge and sea'. At nine o'clock the pair returned to the Inn, had a whisky and water nightcap and went off to bed.

Turner's rigorous pace was beginning to tell. It was arranged that they would be up by seven, so that the painter could finish his sketch from the Scotsgate before the departure of the Mail for Edinburgh at ten o'clock. To Cadell's dismay, Turner did not appear until nearly eight o'clock, when the two men quickly returned to the spot which Turner had fixed on the previous night. Turner completed his carefully detailed study in under an hour. The two were back at the King's Arms by nine, when Turner determined to delay his departure. He wished to make further sketches on the Edinburgh journey. He would be in the capital in two days, by Saturday the thirteenth. As arranged, Cadell took the ten o'clock stage and was back in Edinburgh by evening. The following morning he wrote to Scott, informing him of his return, and mentioning that Turner 'got very charming sketches of Kelso and Berwick' and that the artist had decided to delay his visit to Edinburgh in order to 'take a Castle or two on his own account'.[4] Turner had been especially anxious to record Innerwick Castle and Lord Tweeddale's castle at Yester, which he did, as well as to make a number of sketches of Haddington Church. As he had promised, Turner arrived in

Edinburgh on Saturday in the early afternoon.

Turner's visit to Edinburgh was enjoyable, profitable and brief. Cadell soon learned of his arrival, and for the first evening quickly arranged a dinner at which the painter was to be the principal guest. The party proved to be a pleasant one. Among those assembled was Robert Scott Lauder, a pupil of Turner's old friend, John Thomson of Duddingston. Because Turner was probably tired, not having fully recovered from the strain of his journey, the party did not last long, and the guests departed by half-past nine.

For the next day, Sunday, 14 August, no record of Turner's movements has come to light, but we do have information about the following day. As Turner was leaving for the north of Scotland on the sixteenth, it was necessary that he and Cadell first establish the sketching itinerary. At half-past eight on the morning of the fifteenth, Cadell called on Turner and together they strolled to the publisher's house on Atholl Crescent, where they enjoyed a leisurely breakfast. Their talk centred on subjects for illustration both in Edinburgh and in the north. At about ten,

57 J.M.W. Turner, Edinburgh from Blackford Hill. Pencil sketch, 1831, 'Abbotsford Sketch Book', Turner Bequest, CCLXVII, 7a–8. 4⅜ × 14½ in; 11.3 × 36.8 cm. British Museum, London. See Plate 58.

58 J.M.W. Turner, *Edinburgh from Blackford Hill*. Watercolour, 1832, engraved for Sir Walter Scott, *Poetical Works* (1833–4). 3⅜ × 5¾ in; 8.6 × 14.6 cm. In the collection of the Earl of Rosebery.

CCLXVII-8

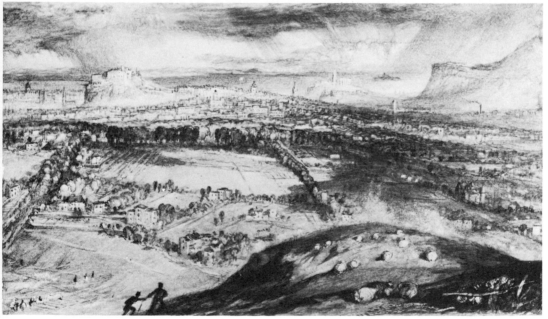

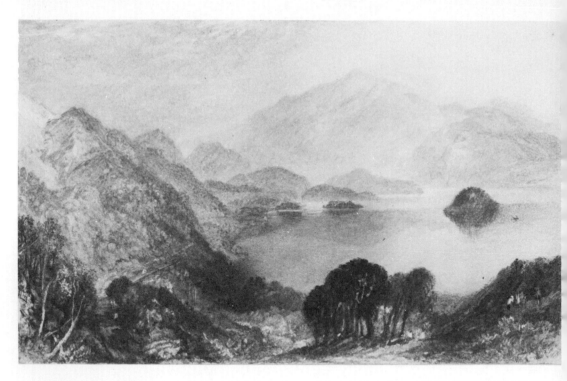

59 J.M.W. Turner, *Loch Katrine*. Watercolour, 1832, engraved for Sir Walter Scott, *Poetical Works* (1833–4). $3\frac{3}{4} \times 5\frac{7}{8}$ in; 9.5 × 15.0 cm. British Museum, London.

60 J.M.W. Turner, Loch Coriskin (or Coruisk). Pencil sketch, 1831, 'Stirling and the West Sketch Book', Turner Bequest, CCLXX, 38a. $8 \times 4\frac{7}{8}$ in; 20.2 × 12.4 cm. British Museum, London.

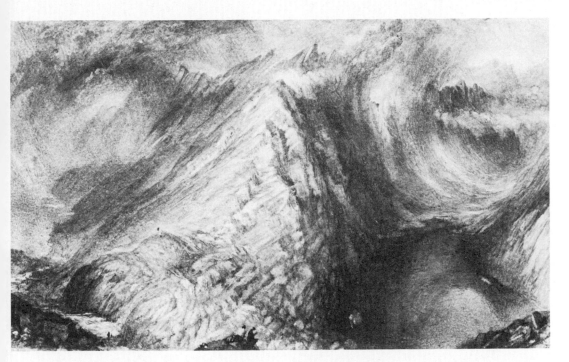

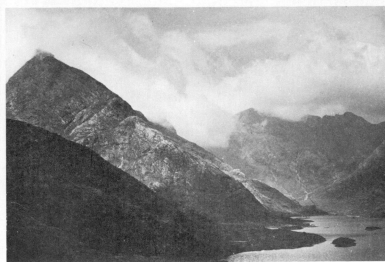

61 J.M.W. Turner, *Loch Coriskin.* Watercolour, 1832, engraved for Sir Walter Scott, *Poetical Works*, (1833–4). $3\frac{1}{2} \times 5\frac{5}{8}$ in; 8.9×14.3 cm. National Gallery of Scotland, Edinburgh.

62 Loch Coriskin (or Coruisk). Photograph.

Cadell summoned a carriage and the two set out for Blackford Hill, which had been selected to illustrate *Marmion*. From the beginning, a view of Edinburgh, taken from Blackford Hill, had been proposed for this volume. Indeed, Cadell had written of it to Scott: he thought it would make a splendid frontispiece. Lofty and steep, Blackford Hill forced Turner, weighed down by a heavy coat, an umbrella and sketch books, to seek Cadell's aid during the ascent. On reaching the summit, Turner was delighted and immediately began sketching an elaborate panoramic view (**57, 58**), covering two pages of the 'Abbotsford Sketch Book' and finished with careful detail.[5] The study took Turner well over an hour to complete. By one o'clock, the sketch was finished and Turner and Cadell descended the hill to Braid House, which was near by. Its appearance disappointed them. They then evidently drove to Cadell's business premises in St Andrew's Square, where they planned Turner's northern itinerary and discussed subjects which would be appropriate for *The Lady of the Lake* and *The Lord of the Isles*.[6] That evening Turner again dined with Cadell and guests, one of whom was the painter William Allan, who wrote to a friend later,

Turner was here the other day, he has been at Abbotsford, and by this time will be in the Island of Sky[e]. I believe he is to do something for Cadell, he told me that he had seen my picture of the Fair Maid of Perth in London, and said much in its favour, more than that I could not have expected from such a man as Turner. . . .[7]

The artist Watson Gordon had also been invited but was unable to attend.[8]

Turner left Edinburgh the following morning 'in good glee' on the Dunfermline Coach, bound for the more spectacular and dramatic scenery of the north.[9] He was certainly looking forward to this part of the tour. He had noted before he left London that, after he got as far as Loch Katrine, he would be reluctant to 'turn back without Staffa and Mull and all. . . .' And though he had decided when he first met Cadell that a tour of the Western Highlands and Isles would be too lengthy and exhausting (as he was also planning to visit the Continent) he had not wished to rule out the possibility altogether. Indeed, as we have seen, before he set out on this northern lap of his tour he had decided to go to the Highlands and Western Isles. Also he had arranged to visit his old friend and patron, H.A.J. Munro, at Novar

House near Evanton, north of Inverness.

The tour seems to have begun at Stirling, where Turner took a number of views of the castle that are contained in the 'Stirling and West Sketch Book'. From there he travelled west to Loch Ard, Loch Venachar and Aberfoyle. He also visited Loch Lomond, Loch Achray, Loch Katrine (**59**) and Loch Goil. He made studies of Loch Long and Inverary as well as Loch Fyne. He then proceeded, perhaps by sea, to Oban. (His route can be traced in the 'Loch Long and Loch Ard Sketch Books'.) Apart from views of Loch Lomond, Loch Achray and Loch Katrine (considered for *The Lady of the Lake*), there is little else in these sketch books that can be identified as being specifically intended for the 'Poetry'. Many westerly subjects considered for *The Lord of the Isles* are included in the two 'Sound of Mull Sketch Books'.

From Oban, Turner steamed to the Isle of Skye, where he took a small boat from Elgol across the choppy waters of the bay to the otherwise inaccessible Loch Coriskin (Coruisk) (**60–62**). This passage is recorded in the 'Stirling and West Sketch Book'.

The landscape at Coriskin was as spectacular, barren and treacherous as any Turner had met on this northern trip. He came close to being seriously injured here, for, in attempting to gain the best view of the loch, he lost his footing on its smooth and often wet stony slopes, and, 'but for *one* or *two* tufts of grass', he would have 'broken his neck'.

That Turner could have grasped so well the spirit of Loch Coriskin from the rough on-the-spot compositions that he made would seem impossible without the aid of a remarkable memory. It was a sublime *locus* that had deeply impressed itself on his mind; as he later remarked, it is 'one of the wildest of Nature's landscapes'.[10] When he came to prepare his finished watercolour, his recollection was undoubtedly intensified and coloured by what Scott had written of this stark, rock-girdled loch:

> ... rarely human eye has known
> A scene so stern as that dread lake,
> With its dark ledge of barren stone.
> Seems that primeval earthquake's sway
> Hath rent a strange and shatter'd way
> Through the rude bosom of the hill,
> And that each naked precipice,
> Sable ravine, and dark abyss,
> Tells of the outrage still.[11]

In the watercolour of this lake, Turner selects from the scene the same primal, convulsive and desolate qualities that Scott's lines describe. The drama of his viewpoint, high above the lake, is strengthened by the petrified eruptions of the lakeside's rocky peaks, whose jagged outlines are softened and obscured by the upward sweep of cloud and mist. Turner has exaggerated the form and structure of these spectacular geological formations; for him, as for Scott, they were a permanent record of the cataclysmic events that shaped the early history of the earth. In order to isolate and emphasize the lake below, Turner has given it a subdued surface and rendered it as ominously still. In this vast arena of natural forces, the artist has depicted himself as a spectator and a recorder, in order to provide the scene with a sense of scale. In its dramatic power, the watercolour of Coriskin must be considered one of the most sublime and striking designs that Turner executed.

The 'Poetry' sketches, such as those of Loch Coriskin, are not simply records of fact: they are expressions of Turner's experience of, and feelings for, a place. And while he was preparing the finished watercolours, such recollections, merging with the images that Scott's poetry evoked, provided Turner with his fundamental inspiration. The physical outlines of landscape were only the catalyst in a highly creative, synthetic activity, and the watercolours that resulted function not only as descriptions but also as receptacles of mood.

From Coriskin, Turner travelled to Tobermory and boarded the steamer, *Maid of Morven*, which plied between Staffa and Iona. Fortunately, some documentation survives which illuminates this particular lap of the northern tour. In a letter to the American, James Lenox, who had bought his famous painting *Staffa, Fingal's Cave*, Turner wrote of the experience several years later:

... a strong wind and head sea ... prevented us making Staffa until too late to go on to Iona. After scrambling over the rocks on the lee side of the island, some got into Fingal's Cave, others would not. It is not very pleasant or safe when the wave rolls right in. One hour was given to meet on the rock we landed on. When on board, the Captain declared it doubtful about Iona. Such a rainy and bad-looking night coming on, a vote was proposed to the passengers: 'Iona at all hazards, or back to Tobermoray.' Majority against proceeding. To allay the displeased, the Captain promised to steam thrice round the island in the last trip. The

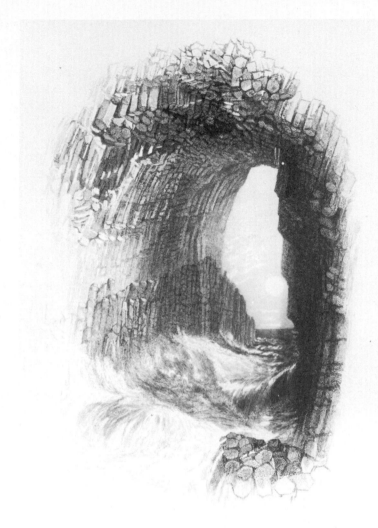

63 J.M.W. Turner, *Fingal's Cave, Staffa*. Vignette for Sir Walter Scott, *Poetical Works* (1833–4), Volume 10. Engraving on steel by E. Goodall, 1834. 4¾ × 3⅛ in; 12.0 × 8.0 cm. British Museum, London.

sun getting towards the horizon, burst through the rain-cloud, angry, and for wind; and so it proved, for we were driven for shelter into Loch Ulver, and did not get back to Tobermoray before midnight.[12]

Turner was certainly one of those who scrambled into Fingal's Cave, since his 'Staffa Sketch Book' contains views taken from the interior, from which he developed his illustration for the 'Poetry' (**63**). However, the experience of Staffa found its most eloquent expression in his *Staffa, Fingal's Cave* mentioned above, exhibited at the Royal Academy the next year (**64**). The entry in the catalogue included these lines from *The Lord of the Isles*:

> Nor of a theme less solemn tells
> That mighty surge that ebbs and swells,

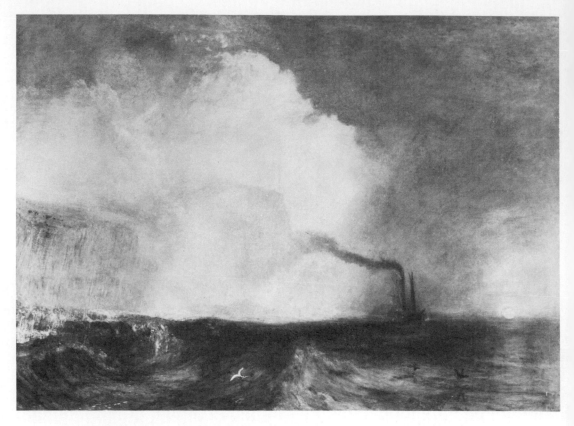

And still, between each awful pause,
From the high vault an answer draws ...

Scott's verses convey the sound of swelling and receding tide which echoes through Fingal's crystal-encrusted chamber; they also provide the natural cadence which Turner has transposed into painting, and from which he has orchestrated his grand vision of the landscape of the cave's exterior, of Staffa's cliffs, of its sea and sky. Reconstructed from sketches and from his memory of the event, Turner depicts the *Maid of Morven*, on which he was a passenger, valiantly steaming against the storm. This is Turner's first major canvas in which steam power, symbol of the Industrial Revolution and man's ingenuity, is pitted against the inexorable forces of nature.

After his adventures on Skye and Staffa, Turner returned to Oban. He was there on 2 September and then began a trip northeast to Evanton to see H.A.J. Munro.[13] On the way he made the sketches of Dunstaffnage Castle and of the deep valley of Glencoe which exist in the 'Staffa Sketch Book'. According to the 'Fort Augustus Sketch Book', Turner travelled from that place to Fort

William, taking a steamer up to Loch Lochy, the Caledonian Canal and Loch Ness (where he stopped at the Falls of Foyer), and then to Inverness. From there he journeyed to Novar House, near Evanton, to visit Munro.[14] Whereas he had originally thought of going to Glasgow to meet Cadell,[15] in the end he seems to have travelled to Aberdeen and then to have coached south to Edinburgh. He probably reached the capital by about mid-September.

By this time, Scott was preparing to leave for a winter in Italy, and he planned a final festivity in the house that had been the scene of numerous celebrations and parties in the previous years. He invited many old friends to share a last dinner with him, realizing that, because of the state of his health, there was no guarantee that he would ever see them again. Cadell was there on 17 September, having arrived the day before in order to complete arrangements for the work in hand, including the 'Poetry'. This morning, the day of the final festivities, Cadell found Scott in the company of three men: 'Willy' Allan the artist, Laidlaw, and a man whom Cadell had not met before. Scott, in good spirits, immediately introduced the stranger. 'Mr Cadell,' he said, 'I have more satisfaction in introducing this gentleman to you than the son of a Duke.' The stranger was Captain Burns, the son of Robert Burns. Cadell described him as 'a little man & blind of his left eye'.[16]

Cadell was then taken to the stables by Laidlaw to examine a bay pony which he had agreed to buy from Anne Scott. He was annoyed because Laidlaw asked for a sum which Cadell considered excessive: £26 5s.[17] Cadell's annoyance was considerable, and he was in no mood to hear the news which Burns then conveyed. It was about Turner, who had recently returned to Edinburgh.[18]

Turner had only just learned of Scott's imminent departure for Naples. According to Burns, he was both dismayed and irritated, since he believed that the trip would mean delays for, and perhaps even the stoppage of, a project which he had now come to believe was of major artistic importance. As a consequence, Turner openly announced his opposition to what he considered an unacceptable situation. When Cadell heard about Turner's scandalized protests, he began to seethe with indignation. Could the painter have so little regard for Scott's health and well-being? Despite Cadell's attempts to disguise his agitation from Scott, his

host perceived that something was amiss, and when Cadell suddenly left for Edinburgh during the morning, Scott fully realized that he was upset. After Cadell had gone, Scott must have interrogated Burns, for on the following day he wrote to his publisher,

I got a terrible alarm after you were gone yesterday. As I do not shake for the Bank of England[19] I had only to suppose that Mrs Caddell [*sic*] was unwell but afterwards learnd with pleasure that it was [only] some anxiousness of our Apelles Mr Turner who was howling like a dog in the high way who had lost his patron in a strange place.[20]

On the same day that he returned to Edinburgh, Cadell encountered Turner, but by now his temper had cooled and he was conciliatory towards the painter. After briefly discussing the northern lap of the tour with him at his office, Cadell invited Turner for dinner that evening, when they discussed the illustrations. Cadell noted in his diary that they 'went over all his & my journeying'. The two apparently patched up their differences, for Cadell went to bed 'well pleased' with their evening together.[21] Indeed, he felt somewhat embarrassed when he received Scott's letter, in which he was reminded of his fit of pique on the previous day. He had not intended that Scott should notice his agitation. He also regretted that Scott had learned the cause of Turner's perturbation, and was in turn upset, despite his efforts to treat the matter lightly. Cadell wrote,

I am sorry that Mr Turner should have annoyed you all so much – it was most absurd to be in such a pother – not withstanding I passed a most profitable evening with him going over all the subjects and fixing their various positions [in the volumes] he is great in his praise of [Loch] Coriskin & wishes to know if you prefer any one point more than another.[22]

In all probability Turner left Edinburgh by steamer for London the following day, 18 September, as he was apparently back in the capital by the twenty-third. The two-month tour had perhaps been too long and arduous for him, for he came home thoroughly exhausted and in indifferent health.[23]

7

The Conclusion of the 'Poetry' Business; Turner's 'Smailholm Gift'

> ... Fruit from a witherd Scottish thorn
> Time once there was alas but now
> That time returns not new again
> The shades upon the Dial cast
> Proceed but pass not back again. . . .[1]

> Sir Walter Scott

Shortly after Turner's return to London, Scott made arrangements to travel there, and to set out from there to the Mediterranean in an attempt to restore his health. Cadell made arrangements for the author's passage from London to Malta and from there to Naples. During the second week of September 1831, the publisher wrote to Captain Basil Hall, the travel writer and friend of Scott, and

mentioned among other things that the idea of getting Sir Walter a passage on board a King's Ship had been talked of – a hint was enough for the Captain – and lo, on Wednesday the 14th when I got my London letters there was one from the Captain to me enclosing one for Sir Walter narrating that he had gone at once to the Admiralty sent in his card to Sir James Graham – stated his object and at once got the offer of a passage on board the Barham of 52 Guns ... to sail in three weeks & that Sir Walter should be in London in a fortnight.

Captain Hall wanted Cadell to take this news directly to Abbotsford, and Cadell therefore immediately wrote to Scott

about the proposal, mentioning that he would come to Abbotsford shortly.

On 16 September Cadell walked through the front door of Abbotsford and went to look for Scott. He found him in the study. It was clear to him that the writer was not in the best of moods, but he raised the subject of Scott's going abroad in the *Barham*: 'What do you think of the Barham?' He was shocked when Scott indicated that he 'intended to decline it & handed a half written [letter] to me [Cadell] declining the ship'. Cadell immediately attempted to dissuade Scott from this course, but 'for a time', he noted, 'I did by no means succeed.' Scott was framing 'sundry excuses', but '[I] fought all this . . .', he noted, 'as stoutly as I could'.[2]

In the end, Scott capitulated. Having made the decision to go, and to travel on the *Barham*, he felt much easier. He was flattered and impressed that he should be going on a King's ship and that the arrangements had been so easily made. The fears about the trip which had previously filled his days at Abbotsford – the unfinished manuscripts, the possibility of another attack, a debt never to be liquidated, the thought of dying abroad – these doubts and worries now dissolved, as a new wave of faith and confidence washed over him. He would soon be his old self. Scott duly went to London, then to Portsmouth where he embarked in the company of his daughter Anne and his son, Major Walter Scott.

Turner's health, like Scott's, was not good, and the trip to Scotland in 1831 had physically weakened him. In December of that year he wrote to Cadell, noting a news report concerning Sir Walter's arrival in Malta. Apart from asking technical questions concerning the 'Poetry' illustrations, he remarked, 'I am glad to find (by the Times paper of today) that Sir Walter has arrived at Malta and by his own words "for myself I am *quite well* and heart-[w]hole like a Biscuit". For myself I wish I could say the same. . . .'

Turner wished to know the size proposed for the 'Poetry' engravings: were they to be the same as those in the 'Magnum' edition of the 'Waverley Novels' or were they to be of some other size? If he knew this, he could make his watercolour illustrations of the required dimensions; then the designs could be traced by the engraver directly on the plate, eliminating the usual labour required in reducing the design. In this way, he explained, he

could save the engraver's 'time and your Expense'. He also wanted to know if Cadell wished to receive drawings in 'succession', and 'according to your list'. Turner, however, did not dwell entirely on business; he thoughtfully concluded his letter with 'Compliments of the Season to you and Family'.[3]

Cadell was apparently prepared to accommodate the additional expense that reduction would involve, for the engravings that were produced (related, in size, roughly, to those for the 'Magnum' edition) are slightly smaller than the watercolour designs. From experience, Cadell must have known that even a limited reduction of the design on the plate would result in an engraved composition that appeared more compact and texturally richer, thereby enhancing considerably the aesthetic effect of the designs in the published volumes.

Cadell received a second letter from Turner in late February 1832, indicating that the artist had completed his first group of 'Poetry' watercolours: 'By the time you receive this I hope to have done six drawings and six Vignettes for Minstrelsy 1 2 3 4 [and] Sir Tristran [sic] and Rokeby. . . . I do hope you will not call me very idle since January.'

Turner apologized that he could not complete the remaining twelve watercolours for some time. He was too busy with other matters. The deadline for submitting canvases for the Royal Academy exhibition was 10 April, and so he must devote his time to preparing these. However, when he found time to complete Cadell's commission, should he post the illustrations to Edinburgh or await the publisher's arrival in London? He considered it unlikely that Cadell would come to London in the near future, because cholera had struck Edinburgh. Turner had been unnerved by the outbreak, which was reaching epidemic proportions, and wanted to know if there were any remedies: 'I will thank you to send me the paper which your medical-men printed as to treatment &c. or if any thing has been discovered during the progress of the disease in Scotland and your opinion is shown (contagious or Epidemic) from known [cases?].'[4]

Cadell's family did not escape it. The publisher's ten-year-old daughter, Emily, died from it on 24 February and Cadell delayed his visit to the south in consequence. He was of course also concerned for his own health, and decided to remain in Scotland until the general 'uneasiness' and 'uncertainty' of the time had passed.[5] He finally departed for London on 9 March, noting in

his diary for this day 'left Edinburgh this morning by Mail for London, [one of] the main objects of my journey [is] to put into various Engravers hands the half of the Designs by Turner for Scott's Poetry. . . .'[6]

At a few minutes before two on the afternoon of Monday, 12 March, Cadell knocked at the door of Turner's house in Queen Anne Street West. The cordial reception that he received was, however, somewhat clouded by Turner's revelation that he was preparing seventeen vignette designs for Murray's forthcoming edition of *The Works of Lord Byron*, which was to be issued in monthly parts.[7] Cadell was dumbfounded by the news, for which he was totally unprepared. He instantly explained how 'awkwardly I was situated, & that I must announce his Designs for the Poetry without a moments delay'. Cadell feared that this publication of Byron's works would jeopardize sales of the 'Poetry'. Turner understood his predicament and 'thought I [Cadell] was quite right'.[8]

When Turner displayed the twelve designs for the 'Poetry' which he had completed, Cadell felt much better. In a letter to Scott, who had now arrived in Naples, Cadell wrote, '[the Designs] are most beautiful. Mr Turner has done them all justice & I am in every way pleased with the way he has treated me. I [shall] put these designs into the hands of Engravers forthwith & before I leave.'[9] Cadell presented Turner with a cheque for £315 in payment for the twelve watercolours.[10] But he did not take them away with him, as Turner wanted to 'clean them'; also, Cadell had pointed out some errors, to correct which Turner would have to make some alterations on some of the costumes.[11] These changes were possibly concerned with the figures embellishing the vignette surrounds. Cadell was to return two days later to take the drawings to Moon, Boys and Graves the publishers and printers, in Pall Mall.

On Wednesday, 14 March, Cadell returned to Queen Anne Street, as promised. The twelve drawings had been cleaned and the corrections made. The two men 'jawed for an hour & a half'; then Cadell left with the designs.[12] At the beginning of the following week, these watercolours were on display at the premises of Moon, Boys and Graves, to announce the forthcoming publication of Scott's *Poetical Works*. But the exhibition of these watercolours, which was only brief, was also intended to provide an opportunity for the engravers (many of

whom Turner had advised Cadell to contact) to make their own choice of designs to engrave.

The next day, Cadell returned to Moon's to see the drawings, which had now been framed, and paid them a sum against the cost of printing the plates. Cadell was uncertain about Moon's, of whom he had had only slight experience. He found them a 'poor pinched folk – very – I must watch them & sharply too'.[13] Turner's drawings were probably being hung, or were in place, by 15 or 16 March.

On Saturday, 17 March, Cadell began the business of arranging for the engraving of the 'Poetry' watercolours. He went first to '[John] Pye [at] Cirencester S[t] saw him – then went to [Edward] Goodall on the Hampstead Road – saw him, both are to come to Pall Mall [Moon, Boys & Graves] to see the Turners & say what they can do. . . .'[14] On Monday, 19 March, at Pall Mall, Cadell 'wrote to [Henry] Le Keux [promising the engraver two designs still available] E. [Edward] Finden [the engraver] called while I was there – he looked as if he would have liked to have got one of the Turner's to do.'[15] In the evening, Cadell wrote to his wife about his success in finding engravers for the 'Poetry': 'I have got half of my Turners engaged for by First raters – I think I may make out the remainder tomorrow.'[16]

Indeed he did, and he gave a vivid account of the business of hiring these engravers: 'I have succeeded in engaging all the leading engravers such as Pye – [Robert] Wallis – Goodall, Le Keux to do Turners Views. . . .'[17]

The final selection of the 'Poetry' drawings for engraving was made two days later, on 22 March, at Pall Mall. Cadell noted, '[I] . . . had a talk with [James] Wil[l]more the Engraver who does Lochmaben (Vignette). . . . H. [Henry] Graves wrote a note to [Robert] Brandard the Engraver some time after my return he came and agreed for Jedburgh (Front) for £63 – to be ready in November. . . .'[18]

Before Cadell left London, he went once more to visit Turner, to discuss the execution of the second group of the watercolours for the 'Poetry', noting that he 'had a long jaw (fully an hour) with him – left a list of [the] 12 Designs wanted. . . .' That Cadell had some say in the presentation of the drawings is made quite clear by a note in his diary that he left a list containing instructions on 'how it would be most agreable [sic] to have them'.[19]

Cadell was back in Edinburgh in early April. He had not

anticipated making another journey to London that year, but another trip was necessary, for a letter from Charles, Sir Walter's son, changed his plans. On 14 June, the distraught Charles, who had accompanied his father to London, wrote to Cadell with melancholy news: 'My poor father has had another attack when on his way to Rotterdam & as Sir Henry Halford and Dr Holland consider him in danger we are very anxious that you should come to London without loss of time. . . .'[20] Cadell immediately packed and was on his way south by steamer on the sixteenth.

On the voyage to Malta in November 1831, Scott was accompanied by his daughter, Anne, and his son, Major Walter Scott. His health appeared to improve, and his spirits had continued to rally. On reaching the island in the latter part of the month, Scott began considering the book about the Knights of Malta that he had earlier discussed with Cadell. It would be entitled, *The Siege of Malta*. When the frigate *Barham* left Malta early in December 1831, Scott truly believed that his health had improved, but on his arrival at Naples it was plain to his son Charles, who met him, that he was far from well, and Charles was sorely distressed by his father's condition.

But Scott was in fact sufficiently well to become caught up in the constant round of social activities which the British community in Naples offered. Sight-seeing was one of the most important, and Scott found himself in the company of Sir William Gell, an archaeologist, with whom he visited many historic sites, including Paestum, Cumae, Pompeii and Posilipo. Scott continued to mend, convinced that he had shaken off that muddiness of mind that had earlier plagued him and which had prevented him from writing. Now he appeared to write with relative ease. The tale of the *Siege of Malta* seemed to flow from his pen. By the beginning of January 1832 the work was progressing rapidly: he had almost finished the second volume. By the end of the month, the manuscript was nearly completed. When he received letters from Scott, Cadell was heartened by the author's optimism and by the news of his vastly improved health. He would look forward to seeing the *Siege of Malta*. 'I shall print it,' Cadell had written, 'the moment it arrives & [shall] bring it out as soon as ready & most cheerfully place its value at your command. . . .'[21]

Scott – serene, and with a new confidence – now felt certain that his health was sufficiently restored for him to visit Greece

and make a return journey by way of Austria and Germany. This idea was eventually abandoned in favour of a route through Rome, Florence, Bologna and Venice, thence over the Alps to Germany, up to Holland and home. (On this return journey, Scott was accompanied by Anne and Charles. Walter had been recalled by his regiment.) Scott's spirits were reasonably buoyant and his health was still quite good until they reached Germany, when the strain began to tell. It rapidly became apparent that Scott was very unwell; when they reached Nijmegen, he was struck down by a devastating apoplectic attack from which he was never to recover. Anne and Charles immediately took him on board a steamer in Rotterdam and accompanied him to London.

When Cadell arrived in London on 18 June, he went directly to a room in the St James's Hotel, Jermyn Street, where the stricken author lay, but was not allowed to see him. Cadell recorded,

On the whole to-day it is clear that altho[ugh] Sir Walter is easier, he cannot, nor is it to be wished that he should recover – he has intervals of reflection, but the whole machine is shattered & gone it was thought imprudent that I should be seen by him ... I shall remain in town to await any event that may happen, & to converse & talk with Major [Walter] Scott & Lockhart as to future plans.[22]

In early July Scott was bundled on board the steamer *James Watt*, which carried him to Edinburgh (accompanied by his family and Cadell), and was then transported by carriage to Abbotsford. During this sad London visit, the publisher conferred again with Turner, who was then fully apprised of Scott's current condition.[23]

Turner had, in fact, known of Scott's state of health while he was at Abbotsford. That he believed then that the author's days were numbered is supported by the symbolism of the *Bemerside* vignette, which he executed in February 1832. When Turner was completing this and a number of other watercolours for the 'Poetry', Scott was in Naples, as Turner, of course, knew. He also knew that because of his illness, Scott might never see the 'Poetry' illustrations, nor know of the tribute which they contained. Because of the publishing schedule for the *Poetical Works*, it would have been impossible to send Scott any of the finished designs. The watercolours which Turner was preparing were first to be

exhibited briefly, and then immediately engraved. For this reason, Turner resolved to create a special drawing, which would contain a commemoration (similar, as we shall see, to that of the 'Poetry' designs) and which he would then send abroad to Scott. He duly painted a watercolour which was to be both a memento of Turner's Abbotsford visit and an expression of the artist's deep regard for, and admiration for, Scott.

This watercolour is the vignette of *Smailholm Tower*, currently in a private British collection (**65**). It is unlike the vignette watercolours prepared for the 'Poetry' in that it does not possess, as they do, a pictorial framework. However, in other ways this landscape possesses much of the character of the 'Poetry' designs. It contains (as they sometimes do) figures which are definitely identifiable, and it documents a particular event during Turner's stay in Scotland: the visit of the Abbotsford party to Smailholm Tower on Saturday, 6 August 1831. Turner represents the carriage departing from the scene, carrying Scott, Cadell and Turner, sated after a splendid lunch. In the distance looms the monument-like form of the tower, shrouded in mist. In the middle ground stands the farm of Sandyknowe, and the good farmer's wife can be observed, waving to the group as they leave. Cadell and Turner are viewed from the back, though Turner appears to be sketching the scene from the precise angle at which the original pencil sketch was taken.

Turner chose this particular occasion for his subject because it was one of the most memorable of his visit. Also, this was a place which occupied a very special place in the author's heart. Not only was Scott's family associated with its history, but, as a child, he had spent much of his time under the shadow of the great peel. The signal importance of Smailholm for Scott is documented by a note which Cadell made in his diary. After Turner had completed his sketches of the tower, Cadell recorded, 'Sir Walter was in great glee – he had evidently set his heart on Turner doing Smailholm & told Mr T[urner] that there was nothing he had more anxiously wished than that he (Mr T) should do that tower.'[24]

Scott was highly pleased to receive Turner's gift, which arrived in Naples in March.[25] It was fortunate that it arrived when it did. The stroke in June was to dull and confuse the author's mind so much that, by then, he would not have appreciated Turner's eloquent tribute.

65 J. M. W. Turner, *Smailholm Tower and Sandyknowe Farm*. Watercolour, 1832: the 'Gift' design. $7\frac{1}{2} \times 5\frac{1}{2}$ in; 19.1 × 14.0 cm. Private collection. See Plate 43.

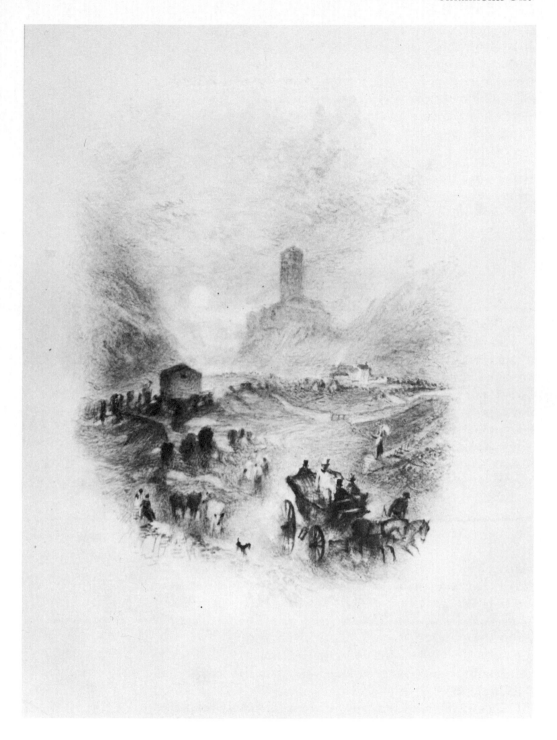

While in London, waiting to accompany Scott home, Cadell spoke with Lockhart about the value of Scott's 'Library Property', and possibly about the editing and the revising of the notes in Scott's works, including those for the 'Poetry', a responsibility which Lockhart had assumed in mid-March of this year, when Scott was still abroad. As we have seen, Cadell also found time to confer with Turner. In his travel diary for Wednesday, 20 June, he wrote,

Took a cab to Turners had a long & most agreable [*sic*] talk with him, it was most fortunate my going as he leaves town for Petworth tomorrow morning & will be absent some ten days, if I am in town at that time he thinks he will give me two drawings to take north, at any rate the whole [12] by August....[26]

After Turner's departure for Petworth, Cadell decided to see what progress was being made on the drawings which were in the hands of the engravers, and on 2 July he visited several of these. John Pye and his assistant Edward Webb were working on Mortham Tower (the *Greta and Tees*) and *Bowes Tower* respectively. The *Mortham* plate was under way and the two would be 'ready in time promised'. Edward Goodall had taken *Carlisle* and *Caerlaverock*, one plate of which was 'pretty far on', and both would be completed 'in good time'. James Willmore was just beginning his *Lochmaben* plate and Robert Brandard had only started *Jedburgh*, but would 'keep [to] his time'. However, Robert Wallis, who had selected *Kelso* and *Hermitage*, had 'nothing done – but fair promises'. Of him, Cadell wryly observed, 'Rather a doubtful blade this'.[27]

Cadell visited Turner on 5 July. 'I was glad', he noted, 'to find [he] had returned to town, had a long confab with him – he has the two drawings for the Lay ready – and promises the two for Marmion on Saturday at 10 making 16 [designs completed] out of 24.'[28] Before departing for Edinburgh, Cadell collected the two drawings for *The Lay of the Last Minstrel* (*Melrose* and *Newark Castle*) and the two for *Marmion* (*Edinburgh from Blackford Hill* and *Ashestiel*). He left the *Newark Castle* with Moon's (it was to be cut by W.B. Cooke), but took the remaining three back to Edinburgh, to be engraved there by John Horsburgh and William Miller.[29]

Cadell was in Edinburgh by 9 July, after having accompanied the stricken Sir Walter and his family on the steamer *James*

Watt.[30] Though Cadell did not go on with Scott to Abbotsford at that time, he did visit him on 24 July. He was dismayed.

I saw Sir Walter about 11 – he recognised me only for a moment & seemed to forget me as I went round his bed. I saw him frequently afterwards while he was being wheeled about in his chair before the door but he did not recognise me & seemed unconscious of all around him.[31]

Turner kept his word about the last of the 'Poetry' watercolours. On the afternoon of 2 August, Cadell received a packet containing the final eight designs.[32] After he had examined them, he arranged for three to be sent back to London for engraving, while the remainder were to be given to Miller, the Edinburgh engraver.[33]

Though Cadell was on the whole pleased with the progress of the 'Poetry' designs, there was one matter that still disturbed him. He had recently seen the first published part of Murray's *The Works of Lord Byron*, which Turner had illustrated, and wondered again if the 'Poetry' might suffer in competition with it. He thought that possibly his edition might appear too 'bald and ill got up' by comparison, since it was without the 'kind of annotations & . . . various readings which . . . with so much tact have been appended to Byron'[34] Yet Cadell knew it was too late to worry about such matters. In any event, the 'Poetry' should be assisted by coming in on the tide of the 'Magnum' edition of the 'Waverley Novels'. Further he had no doubt that the designs by Turner would make the project a success. 'The beauty of the Turner illustrations, & the general interest that would be attached to the Poetry soon after the death [of Scott]' would be sufficient to guarantee good sales. The demand for volumes after the author's death would 'more effectually cut up the large stock in hand'.[35]

By mid-August, Scott's health had deteriorated further. Lockhart, who had recently visited Abbotsford, relayed only gloomy news to Cadell, who, in turn, wrote to his younger brother, Hew Francis, who lived in Cockenzie, 'Sad, sad accounts from Tweedside, Lockharts letter . . . says it cannot continue above a few days, his strength decreases and he takes less food.'[36] Yet the flame of Scott's life flickered on. Towards the end of August, however, Lockhart was convinced that it would soon be over. The days of September began, and marched on, and

Scott continued to cling to life, though gradually his grip weakened: 'Nothing can be more heart breaking & spirit wearing than this scene, Mortification is now very largely developed in 3 or 4 different parts & when he dies he will be already more than half dissolved.'[37] Cadell wrote this letter to his brother on a bright, warm, autumn day, 21 September, the very day that Scott passed away.

With the completion of the *Poetical Works*, Cadell began planning for the *Prose Works*, which were to continue the new edition of the collected works. He was still anxious to acquire as many copyrights in Scott's works as possible, in order to obtain a comfortable living. He had been slowly accumulating them. As a result of the 1827 sale, he purchased, as we have seen, a half share of the copyrights in all of the 'Waverley Novels' from *Waverley* to *Quentin Durward* and in *Paul's Letters to his Kinsfolk*, and one-half of the copyright in the author's *Poetical Works*. In 1831, he bought a half share of the copyright in the *Life of Napoleon* and, as we shall see, he was able to buy from Scott one-half of the copyrights in all of the remaining, later novels (Scott, after his bankruptcy, had not relinquished them). After Scott's death, Cadell negotiated the purchase of the copyrights of 'all [of] his Prose Works and the [entire copyright of the] proposed Life [of Scott] by Lockhart'. Cadell confided to his diary: 'The completion of this arrangement [with the trustees and Scott's family] consolidates in me One Half of [the major works of] a great Library Property [which] makes me resolve to confine myself almost entirely to it.'[38] He planned to ensure the success of this venture by retaining Turner as his illustrator.

8 Turner's Tour of Scotland in 1831 : its Artistic Significance

Of the six Scottish trips which Turner made, the 1831 trip was artistically and historically one of the more important and the most fully documented. During this visit, which lasted altogether two months, the artist filled ten or eleven sketch books with landscape studies. Additional documentation exists in the form of journals of the Abbotsford visit, and of a subsequent tour to Berwick-on-Tweed and a visit to Edinburgh, kept by Cadell.

As Cadell was an especially careful and observant journalist, his diary entries establish with certainty that Turner employed several sketch books at once. When drawing a subject, Turner would often employ both large and small books. The large book was used mainly for more elaborate landscape studies, while the smaller one was usually employed for slight and rapid notations of detail, to record walking figures, or to document the essential shapes of a landscape as it was being sketched from a moving carriage.

Such insights into Turner's sketching methods are extremely valuable, for they provide a splendid indication of his graphic approach to nature at a point slightly beyond mid-career, in his 'expressive' phase. Although sketches for Scott's *Poetical Works* can be classified with those for the earlier *Provincial Antiquities* in so far as they display similar picturesque viewpoints, they do differ in other ways. In the *Provincial Antiquities* sketches, especially those dating from 1818, Turner was often more concerned with the detail and naturalism of his landscapes than

later, in 1831, when he began to make sketches for Scott's *Poetical Works*. In the earlier studies, Turner sought, through line, the more precise nature and quality of foliage, the subtle undulations of ground, and the crisp fenestration and detail of architecture. Such an intention is reflected as much in the careful way he examined his subjects as in his insistence on employing a needle-sharp pencil (see, for example, the illustrated sketch of Borthwick Castle).

If Turner's sketches for the *Provincial Antiquities* watercolours exhibit a progressive naturalism, they do so because, para-doxically, they cling to a tenet of the Picturesque: that the character of an object can best be pictorially recorded from certain form-clarifying and compositionally satisfying vantage points. For this reason, the sketches for the *Provincial Antiquities* watercolours tend to present, as has been noted, particular and composed viewpoints prepared for restatement in the final watercolours.

In sketches of the 1831 tour for the 'Poetry', the concern for the specific qualities of objects, their details and precise configura-tion, is less pronounced and occasionally lacking altogether (as, for example, in the pencil sketch of Carlisle, made for *Minstrelsy of the Scottish Border*). Turner has lost interest in the minutiae of landscape forms. Even outlines are more broadly interpreted. If sometimes these forms are treated in such a way as to diminish the apparent qualities of objects, they gain both in strength and forcefulness of design. The change in appearance is due to a fundamental shift in intention. Turner, as in the earlier *Provincial Antiquities* studies, seeks out different viewpoints from which to sketch his subjects; now, however, this is often not because he wishes to depict either the most usual or characteristic aspects of a subject (as in the *Provincial Antiquities* studies), but in order to expose initially as many of its facets as possible, so as to understand more fully its pictorial potential. By following such a procedure (documented in Cadell's 'Abbotsford Diary', the most illuminating of his journals, for Ashestiel and Newark Castle), Turner achieved a substantial grasp of the fullness and complexity of a place's three-dimensional personality, whether it be a single object or a larger, more inclusive, landscape. While any single preliminary sketch might not appear to convey adequate topographical content from which to develop an illustration, a group of such sketches, taken in concert, presented

a highly informative spatial record. This approach is at variance with that adopted in many of the *Provincial Antiquities* studies, for there it was often the individual sketch, elaborate and complete, which determined the composition and form of the finished watercolour. The method which Turner often adopted for the 'Poetry' illustrations, then, is a more creative approach to topography. By means of his well developed synthetic sense, he could now produce a composite image from the various viewpoints, and within the confines of his London studio was able to concoct remarkably 'fresh' and reasonably accurate views from what might appear to be rather meagre and inadequate raw material.

There is another difference between sketches for the *Provincial Antiquities* and those for the 'Poetry': the manner in which they relate to the format. In sketches for watercolours of the former, the arrangement of the image on the page is nearly always significant, while in those for the 'Poetry' it is often not. Sketches for the latter are in many instances less composed and are placed arbitrarily on the page. This is so because these sketches are essentially exploratory, since Turner does not necessarily see the page as a format to contain a composition.[1] True, Turner does occasionally fracture forms and provide dotted lines to suggest spatial extensions, thus containing a view that the page cannot otherwise accommodate. Yet when intent on exploring the fissures, the hollows and swells of topography, he extends the landscape psychologically beyond the bounds of the page. This apparent disregard for the page as 'format' is also evident when the artist overlaps studies. In these instances, what Turner is doing is gathering information. Completeness or incompleteness are not states that necessarily apply when describing these initial sketches. One may say that the pages from the 'Poetry' sketch books were mainly conceived as pictorial ideas rather than as pictorial statements.

If Turner's method of sketching landscape on his 1831 Scottish tour suggests that he considered and recorded nature in a more conceptual way than he had done on his Scottish visits of 1818 and 1822, then the watercolours made from the 1831 sketches confirm this approach: these watercolours are more abstract, both formally and in their meaning. For example, since Turner had been fully aware of Scott's deteriorating health and was deeply moved by his Abbotsford visit, he perceived that his

illustrations for the 'Poetry' might be considered as memorials. Many of these designs were developed from sketches made at Abbotsford, and they present several distinct but often interrelated levels of commemoration. Most clearly connected with the 'Poetry' is the commemoration of the past, achieved mainly by the introduction of ancient architecture, often in ruins. On another and more personal level, Turner celebrates his visit to Abbotsford as well as the genius of his host, Sir Walter Scott.

Ancient architecture, which is the subject of most of Turner's 'Poetry' illustrations, evokes an atmosphere that is decidedly wistful, since crumbling monuments serve as silent witnesses to the mutability of man and man-made things. There can be little doubt that, in commemorating the past, Turner consciously attempted to charge the landscape with a mood that was both authentic and consistent with that evoked in the 'Poetry'. When subjects for illustration were first being considered, Turner received from Cadell's London agent a copy of a previous edition of the *Poetical Works*, as well as a list of subjects tentatively proposed for illustration. This list included page references to these subjects described in the 'Poetry', and Turner was apparently supposed to decide on their suitability on the basis of the poetical descriptions. In this way, Turner's impressions of certain places or of architecture were coloured by Scott's poetic references to them. And as these descriptions are pregnant with historical association, it is perhaps not surprising that the watercolours which Turner eventually prepared should generate an 'historic presence' which marks them with a special character. But while the mood of 'historic presence' in Scott's poetry is usually achieved by a recreation of the atmosphere of an age, in Turner's landscapes the past is commemorated through a recognition that what has passed must be irredeemably lost to the present.

Turner is able to strengthen and amplify this historic presence by the particular relationships which he establishes between the tiny figures which populate these landscapes and ancient architecture. His architectural remains tend to be placed either in the deep middle ground or in the distance, while figures, on the other hand, usually occupy the foreground or near-middle ground. By locating architecture in a position somewhat remote from the figures, Turner perhaps intuitively illustrates Racine's observation, in his Preface to *Bajazet*, that 'people do not

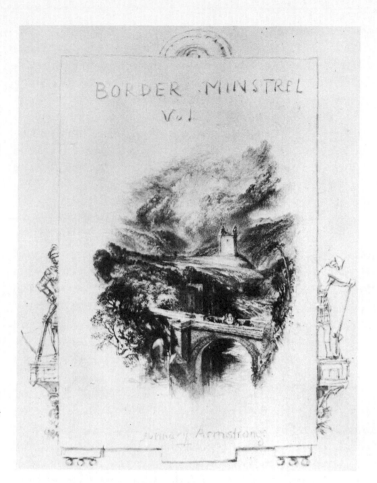

66 J.M.W. Turner, *Johnny Armstrong's Tower, Gilnockie.* Watercolour, 1832, engraved for Sir Walter Scott, *Poetical Works* (1833–4). $11\frac{1}{8} \times 8\frac{1}{8}$ in; 28.2 × 20.6 cm. Taft Museum, Cincinnati, Ohio, USA.

distinguish between that which is . . . a thousand years, and that which is a thousand miles away from them.'[2] In other words, by creating a physical gulf between figures and architecture, Turner is instilling a sense of temporal distance.

Temporal separation becomes more pronounced when an emotional gulf exists as well. Figures in many of these illustrations appear unaware of or indifferent to the architectural fragments which surround them, since these ruins play no part in either their lives or their thought. For example, the group of inhabitants in the view of Jedburgh Abbey remain oblivious of the stately ruin behind, while the cowherds and the lone fisherman in the Mortham Castle (the Greta and Tees) design concern themselves only with matters at hand. The figures in these views appear to be passing through the landscape, and therefore their indifference to their environment is amplified, and the implied brevity of their presence enhances their temporal isolation. What could better

demonstrate this isolation than the view Johnny Armstrong's Tower (**66**), in which the ruin provides the backdrop to a coach lurching across a bridge and speeding away?

If by establishing physical and emotional distance between architecture and figures there is a strengthening of the mood of historic presence, then the vignettes which constitute half of the 'Poetry' designs increase it even more. While the pictorial image of the vignette is released from the conventional sanctions of the rectangular format, yet it is not free of strictures. The vignette is by nature oval or circular, and its inner organization is necessarily determined by its shape. Components of the composition are consciously and strictly ordered, compressed and shaped according to the format. The result is a composition of abstract and centrifugal character. When architectural remains are the subject of the design, as they often are, they are located at the pictorial centre or visual pivot of the composition, serving as the dominant and most expressive element of the landscape. By this means, the aura of history enveloping the architecture is focused upon and intensified.

If the form of the vignette serves to intensify mood, the nature of the decorative borders originally intended for all the vignette illustrations equally serves to enhance it. Such a decorative device was considered by Turner to be essential to the pictorial logic of his vignette, and was intended to serve as an instrument of iconographic enrichment. These frames often embrace on their borders the actions of the dramatis personae of the poems, and therefore these figures, resplendent in ancient armour and costume, provide not only a link between the landscape view and the poetry, but strengthen the aura of historic presence which is such an important element of the illustrations as a whole.

The aura of historic presence which pervades the 'Poetry' landscapes also serves as an emotional background to yet another commemorative aspect of the illustrations: Turner's visit to Abbotsford.

In a number of landscape sketches and finished watercolours Turner has documented the events and personalities associated with his visit. The figures which he introduced into his pencil sketches were his personal memoranda, mnemonic aids to recall to mind the circumstances of a particular occasion. The figures embellishing the landscapes of the finished watercolours and the consequent engravings were introduced for a general audience as

decorative adjuncts; yet for Turner and that small circle with whom the artist was associated at Abbotsford, they were charged with a special, private significance.

In a pencil sketch of one of the doorways of Abbotsford (**67**), Turner has depicted two figures, one undoubtedly Scott, the other possibly Cadell or Laidlaw. In a sketch of Newark Castle (**68**), Turner records Cadell, sitting on a fallen tree, waiting for the artist to complete his study. A drawing of Smailholm Tower, a place intimately associated with Scott's childhood, documents an outing with the author. In this sketch, Cadell can be identified, having 'some long cracks with Sir Walter as he leant on my arm while Mr Turner made his sketches'.[3] To the left is Sir Walter's servant, James. In yet another study, Turner records Sir Walter leaning on James's arm.

Similar events are recorded in the finished watercolours. However, the groups of figures which occur in the watercolours are not the same as those that occasionally appear in the preliminary sketches for these. In spite of this, the watercolours are abundant in visual incident. In his view of Bemerside (**69**) Turner depicts that 'bon[n]y little lassie a Miss Mary Haig', with whom, Cadell noted, 'Sir Walter and I took a turn to where the house is more prominently seen but not so picturesque as where Mr Turner took his sketch.'[4] Since Turner did not record the figures for the watercolours in his preliminary studies, it is not surprising that, in the watercolours which were executed after his return to London, he could occasionally confuse and conflate different events, combining them in a single view. For example, in the published view, *Melrose*, one seems to find events and personalities representing two different outings in which the vale served as background (**70**).

The first of these outings took place on Saturday, 6 August, when Sir Walter, Cadell, Turner and the servant James were on their way to Smailholm Tower. The party halted briefly to enjoy the view of Melrose 'from the North side of the Tweed', and the artist 'pointedly put it to Sir Walter whether he would wish the Lay illustrated with the Melrose of the author or Melrose Vale the point we were then at, Sir Walter replied that he would leave that to the Painter – so that nothing was settled....'[5] On the way home that same day, a second halt was called, so that the artist could further examine the vale; Turner was 'greatly pleased with the turns of the Tweed about Old Melrose &

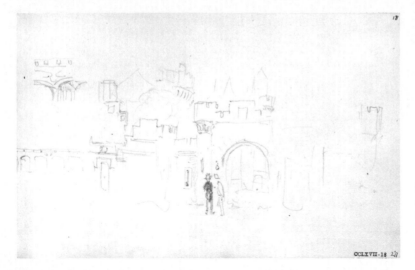

67 J.M.W. Turner, Abbotsford portal. Pencil sketch, 1831, 'Abbotsford Sketch Book', Turner Bequest, CCLXVII, 18. $4\frac{3}{8} \times 7\frac{1}{4}$ in; 11.3 × 18.4 cm. British Museum, London.

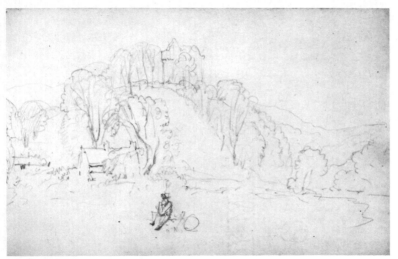

68 J.M.W. Turner, Newark Castle, with Robert Cadell, seated. Pencil sketch, 1831, 'Abbotsford Sketch Book', Turner Bequest, CCLXVII, 80. $4\frac{3}{8} \times 7\frac{1}{4}$ in; 11.3 × 18.4 cm. British Museum, London.

Gladswood and particularly so ... with the sun in the direction it now shone in'.[6] The second trip associated with the view took place on the following Monday, 8 August. On that occasion Turner made a sketch of the vale: 'We lost some time in getting across the Tweed to get this Sketch and it was half past 7 before [we] were in the gig for home – the View just taken was on the Drygrange road – at a small road leading to a farm house – before we left this spot we had dinner & it was very welcome. Sir Walter's boy attended us with a Basket of viands....'[7] On this outing, Cadell mentions only Turner, himself and Sir Walter's

boy. Yet Turner appears to have represented himself sketching, umbrella beside him, with Cadell and James, with one boy enjoying an evening meal and another boy in the cart.

In spite of such discrepancies as occur here between diary and watercolour, the 'Poetry' designs that include references to Turner's visit – especially those landscapes in which the artist commemorates the genius of Scott – are charged with symbolic significance. Since Turner knew as well as others much closer to Scott that the author's life was near its end, in his designs for the 'Poetry' he composed a tribute to him.

The context for the commemorations of Scott is established by the illustrations' architectural surrounds (in the style of traditional emblematic frontispieces and title-pages), originally planned to be published with all the vignettes. The form of these surrounds is clearly derived from contemporary funeral wall

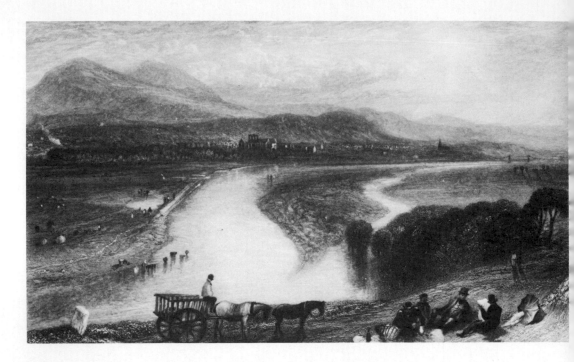

plaques or tablets, with their embellished tops and bracketed bases, and these surrounds therefore extend the commemorative importance of the designs still further. It may be significant that when the decision was made to eliminate from the engravings all but one of the surrounds, the one retained was that for the *Abbotsford* design, with its conspicuous references to Scott (**71, 72**).

Abbotsford was considered a memorial to Scott not simply because the author lived there (for Ashestiel, also illustrated, was another residence of his) but because it was the most widely celebrated of Scott's houses and the one most intimately associated with his final years. The surround of the vignette reinforces the concept of Abbotsford as a monument to Scott by presenting glimpses of the interior. On the left side of the surround, Turner represents the armoury, in which one of Scott's faithful hounds is sleeping. On the right side is Scott's study, with his desk and empty chair. That the author is not represented in these interior glimpses makes the mood more poignant and the commemorative element more pronounced.

But of all the 'Poetry' illustrations, *Bemerside* (**69**) must be considered the most explicitly commemorative, and, indeed, in this respect, the central illustration of the 'Poetry'. In the foreground of the view, Scott and Cadell accompany Miss Mary

70 J.M.W. Turner, *Vale of Melrose*. Frontispiece for Sir Walter Scott, *Poetical Works* (1833–4), Volume 6. Engraving on steel by W. Miller, 1833. $3\frac{3}{8} \times 5\frac{3}{8}$ in; 8.7×13.6 cm. British Museum, London. See Plate 50.

Haig, the daughter of the Laird of Bemerside. Before them, in the sunken garden in which they stand, is an assembly of objects which symbolically serves to celebrate Scott's artistic contribution and his place in history. In the centre of the garden stands a sundial round which the objects are arranged, and which is the key to the meaning which Turner wishes to impart. The essential message conveyed by the sundial is that life is brief. And, as if to be certain that this meaning is transmitted, the artist has added, near the base of the dial, a spilled crock. There can be little doubt that Turner wishes to stress Scott's mortality, for, resting against the podium which supports the sundial, is the author's portrait. Further, Cadell, on the right next to Scott, seems to be tugging at the author's arm and pointing to pots of flowers in a double row (symbolic of his passing years),[8] as if to remind the author of his advanced age and the imminence of death.

If Turner ponders Scott's mortality, he also provides solace. For next to Scott's portrait lies a volume of verses by Thomas the Rhymer. Emblematically, Turner seeks to place Scott's achievement within the context of the Scottish literary tradition by identifying him with the thirteenth-century bard. Not only had the two collected and preserved ancient rhymes as well as composed new ones, but Scott was responsible for editing and publishing Thomas's metrical romance of Tristram. As if further to underline Scott's literary achievement in the illustration, branches of laurel are placed beneath Scott's portrait, not only as emblems of his success and genius, but also of his immortality.

The *Bemerside* design is important in yet another respect, for this illustration is also a commemoration of Turner himself. The artist was certainly as conscious of his own mortality as he was of Scott's.

That Turner had become obsessive in his concern with death is quite understandable. He had not been well and the thought of mortality had been impressed even more deeply on his mind during his association with Scott at Abbotsford. Yet this concern for death was by no means recent. In 1829, his father, for whom he had a strong attachment, died. Then, only months later, Sir Thomas Lawrence was no more. Lawrence had been one of the first to notice Turner's budding genius and was also responsible for obtaining the artist's only Royal commission. With infinite sadness, Turner wrote to his painter friend, George Jones, in Rome,

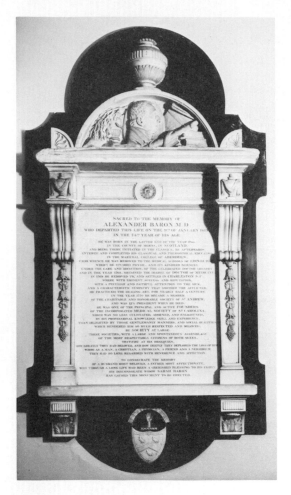

71 William Marshall, *Memorial to Alexander Baron (1745–1819)*. Marble. 90 × 45 in; 228.6 × 114.3 cm. First (Scots') Presbyterian Church, Charleston, USA. Reproduced by courtesy of the magazine *Antiques*. See Plates 72, 101.

72 J. M. W. Turner, *Abbotsford*. Vignette for Sir Walter Scott, *Poetical Works* (1833–4), Volume 12. Engraving on steel by H. Le Keux, 1833. 3¾ × 3½ in; 9.7 × 8.9 cm. British Museum, London. This view records the return of Turner and Cadell to Abbotsford on the evening of 8 August 1831.

73 J.M.W. Turner, *A Garden*. For Samuel Rogers, *Poems* (1834). Engraving on steel by W. Miller, 1834. 3¼ × 3⅜ in; 8.3 × 8.6 cm. British Museum, London. See Chapter 8, note 8.

Alas, only two short months Sir Thomas followed the coffin of [George] Dawe [the artist] to the same place. We then were the pall bearers. Who will do the like for me, or when, God only knows how soon; my poor father's death proved a heavy blow upon me, and has been followed by others of the same dark kind. However, it is something to feel that gifted talent can be acknowledged by the many who yesterday waded up to their knees in snow and muck to see the funeral pomp swelled up by carriages of the great....[9]

Turner, who had been upset by his father's death and by the passing of other acquaintances and friends, was now so conscious of his own mortality that the day after his father's funeral he put his signature to his first will. In 1831, shortly before the trip to Scotland to collect sketches for the 'Poetry', he made a second will.

In the later 1820s Turner spent considerable time at Petworth House in Sussex with his old friend and patron Lord Egremont. With his father's decease, however, he seems to have spent even more time there. He was drawn to Petworth not only by the generous hospitality of his host, but by the ebb and flow of guests, which may have helped to distract him from his deep melancholy and preoccupations with death. At Petworth, Turner kept

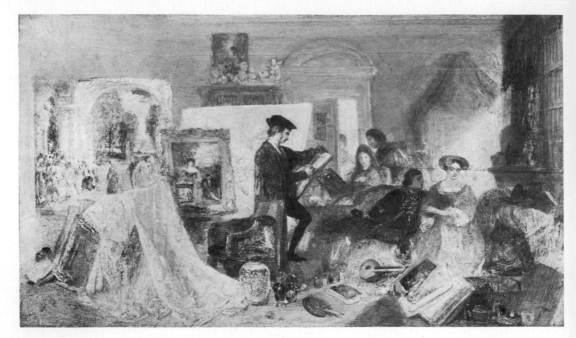

74 J.M.W. Turner, *Watteau Study by Fresnoy's Rules*. Oil on panel. Exhibited at the Royal Academy, 1831. 15¼ × 27¼ in; 40 × 69.5 cm. Tate Gallery, London.

himself busied with his art. He had been given a room for painting which he normally kept locked, but when he desired company, he often brought his paper and watercolours with him, sketching freely with the brush. It was at this time that he executed many of those broadly treated, liquid essays of almost uninflected colour, those luminous interiors associated with his Petworth sojourns.

Several large oil paintings were developed from the experiences of these Petworth visits. A very significant painting must be the *Watteau Study*: indeed, it is perhaps one of the most forceful autobiographical evocations in which Turner was to indulge (**74**). The subject of this painting, while explicitly Watteau, is also a representation of Turner himself. For the interior depicted is palpably that of Petworth, with its great round-pedimented doors. Further, Watteau is shown sketching groups of figures such as Turner himself had sketched in that great house. Turner greatly admired Watteau.[10] But he also believed that he, like Watteau, deserved a place in the pantheon of art. That this painting is concerned with Turner's reputation after death, and is a kind of self-commemoration, is suggested by the references to fame which it contains.

Placed atop a cupboard in the central background of the

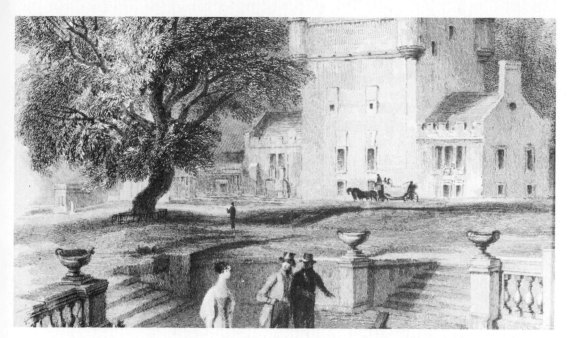

75 J.M.W. Turner, *Bemerside Tower*, for Sir Walter Scott, *Poetical Works* (1833–4). Detail of engraving on steel by J. Horsburgh, 1833 (Plate 69). British Museum, London.

composition are numerous statuettes, but immediately above the head of Watteau is what appears to be a representation of a winged figure of Fame, crowning a bust. A similar statuette stands to the right of Watteau on the mantelpiece of the fireplace. As if to be certain that this allegorical meaning is not overlooked, Turner reveals it openly, for, by spreading in the foreground symbols of the various creative arts (the palette, the book and the lute),[11] he means to imply that, through the arts, the genius of man can survive.

It was possibly the *Watteau Study* that provided inspiration for the iconography of the *Bemerside* illustration. While *Bemerside* provides a commemoration of Scott, as has been noted, it serves also as one of Turner. In this design, the artist himself is depicted (minute though he is) standing sketching before a great Spanish chestnut (**75**). The symbolic paraphernalia in the foreground, while part of the commemoration of Scott, function also as a memorial to Turner. Although the lute here is associated with the book of rhymes, since Scott believed in the natural connection between music and verse, the musical instrument, the book of rhymes and the painting of Scott are symbols of the arts, providing the means by which immortality for the creative artist can be secured. This meaning, then, seems to be essentially the

same as that conveyed in the *Watteau Study*.

There is yet another pictorial element associated with the artist's self-commemoration which occurs in *Bemerside*, and which strengthens the connection between this design and the *Watteau Study*.

Since the subject of the *Watteau Study* is concerned explicitly with black and white and their function in painting (that is, with the way in which they pictorially advance and recede and model form), then perhaps it is not surprising that Turner should have included in the right foreground a book of engravings, possibly after Watteau's own work.[12] What Turner seems to be suggesting is not only the efficacy of the black and white print, but its value as an instrument of artistic expression and its role in establishing and extending an artist's reputation and fame. That Turner believed in the importance of the print as an artistic expression and vehicle of artistic ideas there can be no doubt, and this suggests the growing importance which he attached to illustration, particularly after the recent great success of his designs for Rogers's *Italy* (1830), which had been engraved on steel and were therefore printed in large numbers for bigger editions than had been customary before. This was significant, since the wider the circulation of Turner's designs, the wider was the public's awareness of him as an artist. In the *Bemerside* design, a book or folio of engravings is shown, similar to that in the *Watteau Study*. What Turner seems to be stating, once more, is that engraving can assist the artist in securing his fame.

In conclusion, by investing his views for the *Poetical Works* with associative values and metaphors, Turner was able to enlarge their expressive potential and thus to increase their power to complement and mirror the mood of the verses that they illustrate. Indeed, through his designs, Turner was attempting to share Scott's poetical vision, while at the same time making important statements of his own. Though Turner's landscape designs for the *Poetical Works* must be considered highly personal, innovative and unusual in their complexity and depth of meaning, some of their qualities recur in his later designs for literature, such as those for Scott's *Prose Works* (1834–6) and Lockhart's *Memoirs of the Life of Sir Walter Scott* (1839).

9 Turner's Tour of Scotland in 1834; the 'Waverley' Commission; the *Prose Works*

As I have mentioned, after Scott's bankruptcy the copyrights of his novels, from *Waverley* to *Quentin Durward*, were put up for sale. With the agreement of Scott's trustees, Cadell and Scott had bought these copyrights and had shared all of them equally. Cadell then made plans for what proved to be the spectacularly successful 'Magnum' edition of the novels, published between 1829 and 1833. By 1830, the venture had become so profitable that Cadell approached Scott with the request to buy one-half of the copyrights of all the remaining novels, which the author had kept after his bankruptcy. Scott realized that Cadell was anxious to possess as many of the copyrights in his successful works as possible. He reasoned that if his publisher became a half-partner in the remaining novels, Cadell would thus acquire an extremely valuable property, and he resolved that 'with all my heart he must pay for it'.[1] But, in the end, Scott decided not to sell the copyrights. In his journal, he wrote candidly about his feelings on the matter:

I do not see clearly enough through this affair to accept this offer. I) I cannot see that there is wisdom in engaging Mr Cadell in deep speculations . . . unless they served him very much. I am in this respect a burnd child and I have not forgotten the fire or rather the furnace. II) I think the property worth more if publickly sold. III) I cannot see any reasons which should render it advantageous for me to sell one half of this property it being admitted at the same [time] highly judicious to keep the other half; this does not fadge. IV) as to the immediate

command of the money I am not pressd for it nor having any advantage by paying it a year or two sooner or latter [sic].[2]

Scott wrote to Cadell, informing him of his decision not to sell. The publisher accepted the refusal in a 'goodhumourd' manner. According to Scott, Cadell 'mentions what I am conscious of, the great ease of accompting if the whole is divided into two halves. But this is not an advantage to me but to them who keep the books and therefore I cannot be moved by it. . . . I do not fear that Mr Cadell will neglect the concern because he has not the large share of it. . . . He is . . . too honest a man.'[3]

Four months later, Cadell, still determined, made Scott a further offer of £10,000, and this time the author accepted. Cadell was jubilant and recorded, 'my most important business transaction during the year was the purchase in July & August from Sir Walter Scott & his Trustees of the half Copyright of all the Novels after Quentin Durward. . . .'[4]

Knowing that, with half of all the copyrights in the 'Waverley Novels' in his possession, he could greatly increase his profits from Scott's fiction, Cadell began to plan yet another special edition of the 'Waverley Novels'. Indeed, even before the first volumes of the *Poetical Works* were off the press, Cadell had already laid the groundwork for this new edition. To increase his profits he would again illustrate the novels; this time, Turner would be his illustrator.

However, Cadell discovered that he had competition for Turner's services. At the beginning of 1833, Edward Finden, the engraver and publisher, approached Turner and apparently asked him to prepare a set of designs illustrating Scott's 'Poetry', which he wanted to publish as a picture album with commentary.[5] Cadell soon learned of 'Finden's scheme' from Henry Graves of Moon, Boys and Graves, who, full of news, had come to Edinburgh on business. With firm control of half the copyrights of Scott's major publications, Cadell had envisaged Turner as being his chief illustrator for Scott's works and as being identified as such in the eyes of the public. If Finden should obtain the artist's services for his own set of illustrations of Scott's verse, this would undermine Cadell's own plans, since the simultaneous appearance of Finden's illustrations with his own edition could only have a detrimental effect on his sales.

Cadell was no fool. He acted swiftly and with decision. On the day that Graves visited him and spoke of Finden's proposal, the

publisher wrote to Turner, offering him a contract to illustrate a special edition of the 'Waverley Novels'.[6] Although he had long envisaged a worthy successor to the 'Magnum' edition, Cadell had probably not intended to begin work on it so soon. The 'Finden scheme', however, forced his hand. In order to dissuade Turner from accepting Finden's proposal, Cadell calculated that he would need to present a financially attractive alternative, and for this reason decided on a new, lavishly produced and fully illustrated edition of the 'Novels'. He forthwith offered to commission from Turner between thirty and forty illustrations for this projected edition, which he estimated would occupy thirty volumes in all. At the time Turner received Cadell's offer, he was probably not in a sufficiently composed state of mind to reply immediately. For he had been so distracted and so deeply upset by a dispute with another publisher, Charles Tilt, over the 'copyright' of some of his designs, that he was considering legal action. (See Appendix 1.) Turner eventually came to a decision; he accepted Cadell's commission and rejected Finden's.

Because of other commitments, however, Cadell did not wish to proceed immediately with his plans for the new edition of the 'Waverley Novels'. His reluctance may also have been due to the disappointment that he had been experiencing over the poor sales of Scott's works. For, when the first volumes of the *Poetical Works* appeared in the spring of 1833, the expected demand did not materialize. Despondently, Cadell recorded, '[I am] a good deal cast down ... about Poetry only 4200 sold on 1 May.'[7] Nor did the situation improve later in the year: even the sales of the lucrative 'Magnum' edition dwindled. '[This] year', wrote Cadell, 'I commenced the New Edition of the Poetry – its success was considerably below my expectations. I thought from 12000 to 15000 might sell but it has not come up to 8000 full, the Continuation of the Novels ... have not sold well. I do not expect to lose by them, but I shall gain little.'[8]

If the 'Waverley Novels' project was delayed, it was not forgotten. In the spring of 1834, Cadell was in London, to settle, among other things, the commissioning of Turner to prepare illustrations for the novels and, furthermore, for Scott's *Prose Works* and Lockhart's projected biography of his late father-in-law.

The year 1834 was a particularly busy one for Turner. He had prepared five paintings for the Royal Academy exhibition and was taking endless sketching trips. In May or June, he possibly

visited Oxford, to discuss illustrations with the editor of the *Oxford Almanack*, who was considering publishing a series of views of the city by Turner. In late July, after attending a council meeting of the Academy, he set out for the Continent. The purpose of the trip was to make sketches for his *Rivers of Europe* serial and the proposed special new edition of the 'Waverley Novels'. On the evidence of his sketch books, he appears to have gone first to Brussels, travelled to Liège, thence to Verdun and Metz, down the Moselle to Koblenz, and from there up the Rhine to Mayence. Finally he seems to have gone to Cologne, then to Aachen, over to Liège, then to Brussels and home. The tour probably took four or five weeks to complete.[9]

When Turner returned to his Queen Anne Street address early in September, he found a note from Lord Egremont awaiting him: he had been invited to visit Petworth House during the second half of the month. Lord Egremont had arranged for a group of artists to be there, including Turner's friends, Francis Chantrey, the sculptor, and C.R. Leslie, the painter. John Constable would also be at Petworth. But Turner, who had made other arrangements, was obliged to refuse Egremont's invitation, confiding that 'he was off to the North on a bookseller's job – that was a profound secret'.[10] However, he seems to have promised Egremont that he would visit Petworth on his return journey, at some time about the beginning of October.

Turner's mysterious undertaking was a trip to Scotland, financed by Cadell: essentially a sketching tour on which Turner was to make a great many studies for the publications that Cadell had discussed with him in the spring. Of prime importance would be the sketches for the new edition of the 'Waverley Novels', but, as mentioned above, Turner was also to take views for the *Prose Works* (especially the *Tales of a Grandfather*) and to make studies of places associated with Scott's life, which were to illustrate the proposed biography by Lockhart. The commissions for all of these projects were probably given to Turner by Cadell before the publisher went to London in early May, at which time the final arrangements would be concluded.

When Cadell had arrived in London, one of his first stops was at Turner's house. He knocked at the artist's door shortly before ten on the morning of Wednesday, 7 May, but no one appeared. Deciding that the 'old man was not up', Cadell scribbled a note on a card, saying that he would return later that morning, and

slipped it under the door. He then took a cab to the Lockharts' house at 24 Sussex Place, overlooking Regent's Park, and found the couple at breakfast. In the course of conversation, he mentioned that Turner would need to take a trip to Scotland to prepare the thirty or forty illustrations required for the new edition of the 'Waverley Novels', quipping that he would continue to commission the artist, 'as long as the said Mr Turner is alive'.[11] Lockhart suggested that a dinner meeting with Turner should be arranged, and this was tentatively fixed for the evening of Friday the ninth, subject to Turner's agreement. Lockhart's interest in the plates for the novels is understandable: he was, after all, the general editor of Scott's works, and had very definite ideas about illustration.[12] In any case, since Turner would also be making sketches for the proposed biography of Scott, Lockhart would inevitably and essentially be involved.

After leaving the Lockharts', Cadell returned to Queen Anne Street, where, at eleven a.m., he found Turner up. The two men discussed the matter of the illustrations, speaking briefly of the designs for the *Prose Works* and, specifically, of the *Tales of a Grandfather*. It was probably decided then that, of the twelve Scottish subjects planned for the *Tales*, four were to be completed immediately from sketches made on the 1831 tour. The remaining eight were to be developed from subjects to be sketched on the forthcoming trip. However, Cadell believed that details should be discussed later. With regard to the subjects for the 'Waverley Novels', he referred to his conversation with Lockhart and asked if Turner would join them two days hence, on the ninth. Turner hesitated, as he 'was to have left town on Friday', but Cadell 'persuaded [him] to accept of an invitation to dine with Lockhart on that day'.[13]

On Thursday, 8 May, Cadell visited Lockhart again, confirming the dinner engagement with Turner, and then, with an edition of *Tales of a Grandfather* under his arm, set out for Queen Anne Street, since he wanted Turner to search in the volumes for passages that might suggest themes for illustration. When Cadell arrived, he spoke only briefly with Turner about the designs and informed him that the next day he would call with a carriage at half-past five, to take him to the Lockharts'.

Cadell duly collected Turner the following afternoon, as arranged. When they arrived at Sussex Place, Turner no doubt expected to meet Mrs Lockhart, but she was not to be seen and,

though the dinner was prepared, it was set for the three men only. Apparently Sophia Lockhart had taken her dinner upstairs, so that the men could devote their evening to business matters. Cadell noted that the three of them accomplished a great deal and 'covered over all the Waverley Novels & the probable scenes to be described'.[14] But it is also likely that they discussed illustrations for *Tales of a Grandfather* and for Lockhart's proposed biography. Cadell was thoroughly satisfied with the meeting, noting that 'we had a most thorough evening of business'.[15]

After dinner, Turner and Cadell were taken by their host to meet Sophia, who was upstairs in the drawing-room. After salutations, Cadell was suddenly struck by her strange appearance and by what seemed to be her unusual behaviour. After his initial confusion, he was startled to realize that she was suffering from the effects of drink. According to Cadell, Mrs Lockhart 'had a tray before her & a bottle & hot water she admitted to Turner it was a drop of comfort – but I *deeply* regretted to notice at least *I think I could not be mistaken* that *she had been indulging. I think she was affected by it!* alas, alas.'[16] Turner's reaction to Mrs Lockhart's state is not recorded. But Cadell soon recovered from his shock and joined in the animated conversation. Indeed, he found the discussion to be quite an enjoyable end to the evening. He recorded, 'We jawed till $\frac{1}{4}$ to 11.'[17] On reflecting later on this London trip, he wrote,

I have broken the back of the main object of my journey & well it was that I came when I did as Turner is off to the country & had I delayed only one week I must have felt abundantly foolish to find the bird flown. I had almost daily meetings with him we had one great afternoons talk at Lockharts on Friday [the meeting described above].[18]

Cadell confidently noted, 'I think we shall succeed in getting the old boy [Turner] to come north [at] the end of this season.'[19]

On the morning after the Lockhart dinner, Cadell went again to Turner's house, to find him on the point of leaving town. They arranged that Turner should come to Scotland in late August or early September. The publisher concluded the meeting by presenting Turner with £25, that was 'to pay part of his French expenses';[20] this must have been an advance against the cost of Turner's visit to France during the summer, when he would make sketches for *Quentin Durward* and *Anne of Geierstein* in the proposed new edition of the 'Waverley Novels'.

Turner had returned from France by early or mid-August and had set out soon after on his journey to Scotland. He wrote to Cadell, informing him of this. Cadell began making preparations for the visit. He looked over Charles Tilt's *Landscape Illustrations of the Waverley Novels with Descriptions of the Views* (1832), with illustrations by such artists as J. D. Harding, George Barret, Peter De Wint, Richard Westall and George Cattermole, confiding to his diary that, by so doing, he would be better able to discuss subjects with Turner.[21] By 30 August he had sent a letter to Manchester for the artist to collect on his way north.[22]

Whether or not Turner received the letter is unknown. However, on the morning of 15 September he reached Edinburgh and, after taking a room at the Turf in South St Andrew Street, arrived at Cadell's house in Atholl Crescent. He found the publisher entertaining John Wood, the editor of Douglas's *Peerage*, at breakfast. The two men had just attended an early morning meeting of the committee which was preparing the great banquet for Lord Grey (Charles, 2nd Earl Grey) which was to take place that day.[23] Indeed, it was probably to be in time for this dinner that Turner arrived when he did. (As a member of the organizing committee, Cadell had secured Turner's admission.)

The celebration of Lord Grey's arrival in the capital was well under way by the time Turner appeared. Lord Grey, Whig Prime Minister from 1830 to 1834, had been responsible for securing the passage of the Reform Bill of 1832, despite the many obstacles that had been placed in its way. The Bill, providing almost uniform qualifications for suffrage, enfranchising many of the middle class and redistributing seats in Parliament, had had a profound effect on Scotland. As Scotland's representation at Westminster had been farcically small, the Bill was the means of giving her a more adequate voice. Passage of the Bill, therefore, had been extremely important to the Scots, and Grey went to Scotland after his resignation as Prime Minister in order to receive the thanks of a grateful nation. He had entered the capital to a glittering welcome. In his honour, an immense triumphal arch, surmounted by a giant thistle, had been raised, and over the centre of the arch hung a flag, jubilantly inscribed, 'Scotland Hails with Joy The Approach Of Her Patriot Grey'.[24] At either side of the arch fluttered two other flags: one displaying the word 'Liberty', the other, 'Reform'. The city was in a mood for

celebration, and it was recorded that Edinburgh 'never presented a more gay and joyous appearance not even when it was honoured with the visit of his late Majesty in 1822':[25]

In the history of Britain, no statesman has ever enjoyed a triumph so splendid and so unalloyed with any thing which could lessen its value to an elevated mind. Royalty itself, mere loyalty, could not draw such a tribute from the people of this country. Even the numbers assembled on Monday were greater than at the King's visit in 1822, and in the enthusiasm shown, there is no room for comparison between the two occasions.[26]

On the day of Turner's arrival, Cadell was understandably preoccupied by arrangements for the banquet, but he gave time to discussing the subjects for Turner's illustrations. He accompanied the artist to his office in St Andrew's Square, where the two men remained for most of the morning. At half-past eleven they left, Cadell going to his house, where he changed into clothes suitable for the great event. He then went to the Woods' for 'a comfortable mutton chop', after which he returned to Atholl Crescent by hired coach, collected his wife, and 'decked with ... ribbon' proceeded to the High School – which was to be the scene of the magnificent banquet – shortly before three.[27] There he concluded his part in the arrangements and may have helped supervise the arrival of the first guests, who were admitted at four o'clock.[28]

A great pavilion had been erected at the eastern end of the High School, designed by Thomas Hamilton, the School's architect. It had been elaborately decorated for the occasion by David Roberts, the celebrated London painter and former Edinburgh stage designer, and by David Hay, the Edinburgh decorator/painter.[29]

The evening was spectacularly successful. Six hundred guests crowded under the huge, richly decorated canopy to hear speeches and to eat and drink their fill. Cadell was well pleased by this dazzling celebration, noting later that 'the whole affair went off *admirably*'.[30] Turner was seated between two illustrious Scots scientists, Sir Charles Bell and Sir David Brewster. Brewster had not met Turner before, but had heard about him, and reflected later that he had 'exhibited none of his [reputed] peculiarities'.[31]

The next morning, Tuesday, 16 September, Cadell arrived

early at his office, to be joined by Turner, 'with whom', he noted, 'I was long occupied'.[32] They discussed the subjects of the designs which Turner was to prepare, particularly those for the 'Waverley Novels'. Turner then left, but returned later; and the conversation about the illustrations was resumed.[33] The following morning, Turner again appeared at Cadell's office, this time to plan a sketching itinerary. He remained for two hours, arranging for several short day trips from Edinburgh, a number of tours of the city and its environs and a long trip which was to occupy him for just over a week.[34]

On Thursday the eighteenth, Turner set out to make what were probably the first sketches for his commission. These appear to have been made for illustrations to the 'Waverley Novels'. He left on the very early coach for Lanark, probably to gather views for *Old Mortality*, and visited a number of sites, including Corra Linn and Douglas Castle.[35] From the garden of his country estate, Hailes (five miles from Edinburgh on the Lanark Road), Cadell watched for the coach (which would pass close to his house), hoping to hail Turner as he headed southward. He did see the coach lurch by, but, though it was near enough to call a greeting, he decided against it, since the artist, head pressed against one of the windows, 'was asleep and so [I] did not [wish to] disturb him'.[36]

Turner cannot have stayed long in Lanarkshire, for he seems to have returned to Edinburgh that evening to join the Lockharts at dinner. Lockhart was apparently anxious to discuss the proposed illustrations for his as yet unwritten *Life of Scott*, and asked if he might speak to Turner about them the next day, but Turner explained that he had a prior engagement to sketch Craigmillar Castle. Lockhart thereupon suggested that he might accompany him thither,[37] and the next morning the pair set out and, as they walked, apparently discussed the illustrations for the *Life*.[38] Turner thought that day would be his last in the city before he left on his extended tour.

We have, as yet, no documentation for this tour, which lasted slightly more than a week, since Turner was back in Edinburgh on Monday, 29 September. On the same day, he met Cadell, who accompanied him to Sir Walter Scott's former residence in Castle Street; this was the house that the author had been forced to sell at the time of his bankruptcy in 1826. After arranging Turner's itinerary, to be concluded by a dinner at Hailes, for the following

76 J.M.W. Turner, No. 39, Castle Street, Edinburgh. Pencil sketch, 1834, 'Stirling and Edinburgh Sketch Book', Turner Bequest, CCLXIX, 40a. $4\frac{3}{8} \times 7\frac{1}{4}$ in; 11.3×18.4 cm. British Museum, London. See Plate 101.

77 J.M.W. Turner, Sir Walter Scott's house, Prestonpans. Pencil sketch, 1834, 'Edinburgh Sketch Book', Turner Bequest, CCLXVIII, 86. $4\frac{3}{8} \times 7\frac{1}{8}$ in; 11.1×18.1 cm. British Museum, London.

day, the publisher departed, leaving Turner to sketch the house for an illustration to the *Life of Scott* (76). Turner spent the rest of the day sketching in the city, for Cadell had to attend a meeting of the committee set up to plan a monument to Scott, at which a design by Thomas Campbell, the sculptor, was to be discussed.[39]

The following morning, Cadell hired a carriage and drove to the Turf, where, before seven, he collected the artist, and they left for Prestonpans, which they reached at twenty minutes to nine. Cadell pointed out the house in which Scott lived as a boy of six, and Turner sketched it (77, 78);[40] this was yet another potential subject for an illustration to Lockhart's *Life*. After Turner had

78 Sir Walter Scott's house, Prestonpans. Photograph. Royal Commission on the Ancient and Historical Monuments of Scotland, Edinburgh.

completed his study of the house, the men drove on to Cockenzie, where they arrived at nine, to be greeted by the publisher's younger brother, Hew Francis, who lived there.

After a leisurely breakfast at which Hew Francis's son, John, joined them, Turner and the two Cadell brothers left on foot for Preston field. They 'walked to Rigginhead when T[urner] drew the *plain*',[41] a subject probably considered either for the *Tales of a Grandfather* or for the novel, *Waverley*. John Cadell met the three men at Meadow Mill with the carriage, and they went on to Preston Tower, which Turner also sketched.[42] After this, Cadell and Turner drove Hew Francis and his son back to Cockenzie, and then headed for Edinburgh, arriving at the Turf at a quarter past three, 'after a pleasant excursion'.[43]

For the dinner party at Hailes that evening, Cadell had invited John Wood, as well as two artists, Watson Gordon[44] and J.F. Williams,[45] both of whom were anxious to meet the celebrated Londoner. At a quarter to four, Cadell sent a coach to collect the guests and bring them to Hailes.

Until dinner was announced (at five), the guests walked together in the extensive woods which surrounded the property. Though we have no record of the conversation at dinner, we may reasonably assume that one of the topics was the proposed monument to Sir Walter Scott – a popular subject in this artistic

circle at the time. It was, of course, a matter which deeply concerned Cadell, for, as a member of the committee, he had been taking part in discussions over the past year which concerned possible sites for the as yet to be selected design. Turner himself was deeply interested in the proposal for the monument to Scott. He had been made a member of the committee for a Scott memorial in London, and was therefore intrigued by the plans for Edinburgh's commemoration of the writer. (See Appendix 2.) The guests 'jawed' until ten, and were then driven back to town.

The following morning, at eleven a.m., Turner arrived at Cadell's office, to discuss with him the choice of the remaining subjects to be sketched. They decided that Turner should spend that day in Edinburgh, making views of the city that might be suitable for the 'Waverley Novels' and the *Prose Works*. Cadell accompanied Turner to Heriot's Hospital, where the artist sketched views from the garden[46] (perhaps to illustrate *The Fortunes of Nigel*). Then they walked to the High Street, where Turner was to make sketches of the city from Castle Hill. Cadell must have left Turner just before the latter left to take further views of Edinburgh from St Anthony's Chapel(**79**): sketches that were eventually developed as an illustration for *Tales of a Grandfather*, in the *Prose Works*.[47] At three o'clock Turner reappeared at Cadell's office, this time to complete arrangements for the next day, his last in Edinburgh. Cadell, who had been expecting him, had prepared an itinerary that would take Turner south to Melrose – and specifically to Selkirk, for views for the *Surgeon's Daughter*, and to St Mary's Loch and Innerleithen, for views to illustrate *St Ronan's Well*.[48]

Turner left early the next morning, Thursday 2 October, and spent that day and the next sketching countryside he knew in the neighbourhood of Abbotsford, returning to Edinburgh on Saturday when he intended to leave Scotland.

On this last day in Edinburgh, Turner made a short jaunt to Calton Hill with Cadell, who wished to discuss the Scott memorial with him.[49] During his stay, Turner had almost certainly expressed his great interest in the proceedings of the Monument Committee, which had considered two styles of monument: a Gothic cross and an obelisk. During this conversation with Cadell, Turner may have indicated his preference for an obelisk. It is certain that Cadell discussed with

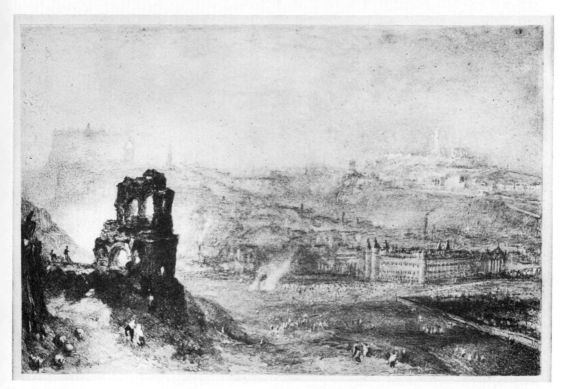

79 J.M.W. Turner, *Edinburgh from St Anthony's Chapel*. Watercolour, *c*.1834, engraved for Sir Walter Scott, *Prose Works* (1834–6). 3½ × 5¼ in; 8.9 × 13.4 cm. Indianapolis Museum of Art (gift in memory of Dr and Mrs Hugo O. Pantzer by their children).

him the siting of the monument, being especially anxious that Turner should give his opinion of one proposal, for a location on the north-east corner of Calton Hill.[50] Turner, however, seems not to have liked this site at all.

After this final meeting with Cadell, Turner left by coach to make the long trip south to Petworth in Sussex, where on arrival he was pleased to see his old friend Chantrey, as well as C.R. Leslie, the painter, and his family. Fortunately, Turner's presence was noted and recalled by Leslie's son Robert, who, in his *A Waterbiography*, refers to the painter and this visit.[51]

Turner's 1834 Scottish tour was his last. Surprisingly, after the painter returned from it with his harvest of sketches for the three Scott projects, Cadell did not raise the matter of commissioning those intended for the 'Waverley Novels'. As Turner usually prepared his illustrations for Cadell over the winter months, and had them ready when the publisher came to London in the spring, Cadell's silence in this particular could only mean that he was having second thoughts about launching the new edition of the novels.

Cadell's apparent unwillingness to proceed with the

commission must have disturbed Turner, who, on Cadell's advice, had declined Finden's offer, only to find himself without the promised commission after all. For someone who depended on illustrations for a portion of his livelihood, the loss of a commission of this size was serious. When, in late 1834 or early 1835, the publishing firm of Fisher and Co. offered to commission from him designs (**80, 81**) for G. N. Wright's *Landscape – Historical Illustrations of Scotland and the Waverley Novels*, he did not hesitate to accept.[52] Though Cadell must have realized that Turner's decision was fully justified under the circumstances, he may still have been annoyed by Turner's acceptance of the commission, and it may be for this reason that he changed his mind about his proposal to make Turner the principal illustrator of any future editions of Scott's works which he might issue. Indeed, by 1836, Cadell's dependence on Turner had considerably diminished. For example, in a letter of that year written in London, he noted, 'Altho[ugh] more than a week from home I have seen few faces . . . but with my main man [Lockhart] I have got through much – the others are trifling comparatively – still I must see them while I am here – Turner who for many years was [contacted] on my first day not yet either. . . .'[53]

Nevertheless, the 'Waverley Novels' project was still in Cadell's mind. He came to believe that it should follow the projected edition of the *Memoirs of the Life of Sir Walter Scott*, the manuscript of which, in 1836, Lockhart was bringing to a conclusion. Yet the publisher's ideas about illustration had been changing over the years. He now saw the proposed new edition of the 'Waverley Novels' quite differently from when he had first discussed illustrations for it with Turner some three years earlier. And by 1839, though little general progress had been made on the new edition of the 'Waverley Novels', Cadell's ideas in the matter of illustration had at last crystallized. He was convinced that this was 'the age of graphically illustrated Books',[54] and was anxious to increase the number of proposed plates. Indeed, only the year before, he had arranged for Turner to prepare twenty designs for a spectacular, lavishly illustrated single volume, *The Lady of the Lake*.[55] Further, the practice of allotting a separate page to each illustration no longer seemed to him to be desirable, primarily because it was no longer fashionable. He now proposed that the 'Waverley Novels' should be issued in a new style and format: they were to be fully illustrated, not by steel engravings,

80 J.M.W. Turner, *Ballyburgh Ness*. Watercolour, *c*.1835, engraved for Fisher's *Illustrations of the Waverley Novels* (1836–7). 3⅛ × 5⅛ in; 7.9 × 13.0 cm. Fogg Art Museum, Harvard University (Greville L. Winthrop Bequest). See Chapter 9, note 52.

81 J.M.W. Turner, *March of the Highlanders*. Watercolour, *c*.1835, engraved for Fisher's *Illustrations of the Waverley Novels* (1836–7). 3¼ × 5½ in; 8.2 × 14.0 cm. Tate Gallery, London. Based on a composition for the proposed 'Royal Progress'. See Plate 18, composition 16 (second row of sketches, left). See Chapter 9, note 52.

but by 'Wood Cuts from New Designs', which would be placed not only on separate pages allotted to them, but also on pages of text. And, following the growing trend towards cheap popular editions, Cadell intended to 'issue at the same time in Weekly Numbers & Monthly Parts a double column or peoples Edition'.[56]

As usual, Cadell had laid his plans with care. If, by 1839, he appeared to be in haste, it was not simply because the project had been dragging on for six years, but because the life of the copyright was running out not only on the 'Waverley Novels', but on all of Scott's works. Cadell calculated that, with an edition of the 'Waverley Novels' appearing within no more than two years, he could wring profit from the dying copyright and then sell: '[With] the consent of Sir Walter Scott's Testamentary Trustees got, I would sell the copyright of the entire work and divide the produce – the Trustees pocketing their share & R[obert] C[adell] taking advantage of the Sale of the Copyrights to sell off all his other matters & wind up & retire.'[57]

This new edition of the 'Waverley Novels' was planned to be as spectacular as possible: a final, extravagant issue of Scott's works by the Robert Cadell publishing house. And from the point of view of illustration this edition would represent, for the company, a radical departure. By the end of 1839, Cadell had definitely decided what to do: 'It is to be an Edition of the Novels with Wood Cuts profusely given and [combining plates] of the curiosities of Abbotsford, the Edition ... might be termed the Abbotsford Edition.' Indeed, this was what it was to be called.[58] In fact, the illustrations were to be a much more significant part of the production than had originally been proposed.

By the late 1830s and early 1840s wood engraving had become a popular medium for illustration, as can be seen in contemporary issues of *The Penny Magazine*, *The Illustrated London News*, *Punch* and, with increasing frequency, in illustrated books. The main aesthetic advantage of wood engraving was that it could be 'locked up' with type in the printer's forme, so that illustrations and text could be printed on the same page, thus providing an intimate design relationship which had not normally been possible when the medium was either copper or steel. As wood was relatively inexpensive to engrave, a publisher could embellish books much more lavishly. On the other hand, the quality of wood engraving at this time was not especially high, and not comparable with either steel or copper engraving.

In June of 1839 Cadell, who needed expert advice on the use, and cost, of wood engraving for illustrated books, had written to F.G. Tomlins, a London publisher who had issued several books which were profusely embellished with wood engravings. The new edition of the 'Waverley Novels' was to be in super-royal octavo format and would require the services of many artists and engravers. Tomlins explained that it was possible to find artists able both to create the designs and to cut them on wood, but he suggested that the better course was to select artists who would draw the designs directly on the wood blocks, and then engage two or three of the most eminent wood engravers to cut them.[59] He told Cadell that he must go to London or Paris in order to find wood engravers of the finest calibre; there were no such engravers in Edinburgh. Further, he warned Cadell that first-rate artists often thought it demeaning 'to draw for the wood and it requires also a considerable knowledge of technicalities & skill to produce the requisite effects'.[60]

In 1840, almost a year later, Cadell, now well informed on the subject of wood engraving, wrote to Turner, saying that the 'Waverley Novels' project could now proceed and that he wished Turner to be its chief illustrator. He also mentioned that the designs were to be engraved on wood. Turner wrote to Cadell, indicating that he could not accept the commission if wood engraving was to be the technique employed. Turner's response was, perhaps, predictable. He had spent his career developing techniques of copper and steel engraving which yielded effects equivalent to those created by his drawings. That he should have been opposed to wood was due not to lack of experimental zeal, but to his knowledge of the medium's limitations and of its association with inferior, mass-production, popular publishing. Cadell was upset by this rebuff. A business acquaintance, to whom he confided Turner's rejection of the commission, sensibly and perceptively observed that he was 'not surprised that the *Turners* would not be translated into wood they are far too delicate for that process'.[61] Cadell was not sufficiently stung by the artist's rejection to admit defeat. Good businessman as he was, he would not accept the artist's decision as final. That he believed Turner could have a change of heart is suggested by his visit to the artist at his house in the following year, 1841. However, despite the publisher's pleas, Turner remained adamant,[62] explaining that the quality of reproduction on wood was so poor that proofs

received as part payment would be worthless. Cadell noted in his diary that Turner 'will not boat for *wood*[,] he evidently calculates on proofs as part of his pay'.[63] Nettled and disappointed by the artist's response, Cadell decided that he must make other arrangements. As soon as he left Turner's, he strode off 'very cleverly to [Robert Scott] Lauder 35 Charlotte St Fitzroy Square & had a long jaw with him'. Lauder had previously been employed by Cadell as one of his illustrators of the famed 'Magnum' edition of the 'Novels'. Unlike Turner, Cadell noted, Lauder *'will work cheerfully'*.[64]

Cadell required a landscape artist of some eminence to replace Turner as the principal illustrator of the 'Waverley Novels', but Lauder, for all his ability, was not this. As a consequence, less than a week after his meeting with Turner, Cadell contacted Clarkson Stanfield, an artist who, after a brief career in Edinburgh, had established himself in London as one of the country's most capable landscape painters and who also had been one of his illustrators of the 'Magnum' edition. Stanfield, Cadell believed, would be an acceptable substitute. Cadell soon came to an agreement with Stanfield who, as Cadell was delighted to discover, charged less for illustrations than Turner. Further, he was entirely willing to visit Scotland to sketch the necessary subjects.[65]

Turner's rejection of the 'Waverley Novels' commission was the outcome of Cadell's determination to be up to date by insisting on wood engraving. Yet, in the event, the publisher was, ironically, to change his mind and have Stanfield's landscapes engraved on steel. Had Cadell been more sensitive to the limitations of wood engraving and to Turner's dilemma, we might now possess a set of designs rivalling the landscapes prepared earlier for G.N. Wright's *Landscape – Historical Illustrations of Scotland and the Waverley Novels*.

From the time Scott had first agreed to a new edition of his *Poetical Works*, he understood that this would be immediately followed by an edition of his *Prose Works*, uniform with the *Poetical Works* in size and design. The *Prose Works* was to be an edition of major significance; it was originally planned in twenty volumes. As with the *Poetical Works*, each volume was to be illustrated by a frontispiece and by a vignette on the title page, and Turner was to be given the commission. The complete *Prose Works* actually extended to twenty-eight volumes, although Turner's

contribution remained the same as at the outset: forty illustrations. These designs, completed between 1833 and 1835, were derived from three sources. First, there were those developed from sketches already in the artist's possession and made years before; second, there were those prepared from designs or engravings made after the works of other artists; third, there were those illustrations developed from sketches made specifically for the *Prose Works* – sketches which, in some cases, required Turner to make special excursions. But before discussing Turner's designs, I will outline the manner in which the concept of the published *Prose Works* developed.

When the new edition of the *Prose Works* was being planned in 1831, Cadell became obsessed with the idea of beginning the publication with the *Life of Napoleon*, of which he had bought half of the copyright in July of that year. Also, he believed that the *Life* was of sufficient interest and importance to attract a large reading public.

While making these plans, Cadell was also searching for a suitable person to undertake for him the editorial responsibility for Scott's works as a whole, including this new edition of the *Prose Works*. Before he went abroad, Scott himself had suggested to Cadell that someone should be employed to 'do the rough work in his absence'. Presumably the plan was to send Scott, for his final correction, the 'rough work' done by the editor. Unfortunately, however, Cadell had taken no steps to search for such an assistant at that time. Now that Scott had left, the matter was urgent, and Cadell decided to put the problem to Lockhart.

In March 1832 Cadell, who was in London, visited Lockhart and discussed with him his plans for the *Life of Napoleon*, its illustrations, and, in particular, his need of an editor to take charge of revisions of the notes to Scott's works. Cadell soon noted Lockhart's interest and was confirmed in his belief that 'Mr L[ockhart] . . . was the man [to be the editor]. I put it to him – the affair was settled in a moment, he is to consider the whole affair most fully – terms &c –.'[66] Cadell wrote to Scott,

I have had to lay before your son-in-law your idea of harnessing some clear headed hand to service the whole – you will recollect that George Hogarth was mentioned for this at a former day – but he is now far from books & far from the press – besides a better man occurred to me – no other than Mr Lockhart himself.[67]

Shortly thereafter Lockhart was appointed general editor of, and

adviser on, Scott's works, a position which he held until the late 1830s.

In August, only two months before Scott's death, Cadell wrote to Lockhart, raising the matter of the revisions of the notes for the *Life of Napoleon*: 'I wish your attention could be now steadily fixed on Napoleon, in two years he must be before the public, and [therefore] I will have to think of my illustrations very shortly....'[68]

While working with Scott, Cadell had been allowed considerable freedom in the matter of illustration. Indeed, Scott left most questions involving specifically artistic judgement to Cadell, maintaining that he himself 'knew little about art'. Accordingly, when the plans for publication of the *Life of Napoleon* were finally under way, Cadell wrote to Lockhart about the illustrations, as he had always done with Scott – asking Lockhart for his views on some points, but (on others) appearing to assume that his own views would be accepted. He asked Lockhart to decide what the frontispiece subjects should be of the nine volumes of the *Life*. Should they be 'in the shape of Portraits? Napoleon, Josephine, Desaix, Talleyrand, Massena?'[69] He thought that Lockhart should keep in mind vignettes of the 'great battles' for the title-pages which could add a great deal.[70] Cadell also expressed his view that, before he illustrated the *Life*, Turner (whom he regarded as the only possible illustrator to choose) should have on hand an adequate reserve of engravings and sketches on which to draw.[71]

Lockhart's answer took Cadell by surprise. While he might accept many of the publisher's suggestions, he was clearly intending to have a stronger voice in artistic matters than his father-in-law had had. He wrote that he could not entirely agree with Cadell's proposals: 'I think it would be very wise,' he observed, 'as portraits of the Napoleon people have been hackneyed, to give only *one* head – viz. his own – & embellish the [frontispieces of the] other volumes with localities.' Lockhart, who knew Turner's work, reminded Cadell of *Waterloo* which 'Turner painted . . . magnificently long ago'. Lockhart also wrote that Turner should prepare a view of 'Brienne where the Emperor was at school – & of Fontain[e]bleau where he resigned in 1814'. Further, there must be a view of Paris, and Lockhart also wrote of Turner's *Childe Harold's Pilgrimage*, which he had seen at the Royal Academy that very year, remarking on the magnificent

landscape which it displayed, although wrongly believing that this was a view of Rome.[72] As for the view of Paris, whether it should 'be the Seine with the Thuilleries [sic] – or a general view from [Montmartre?] he will judge best'. Lockhart cautioned Cadell, 'Let him know the design you have in [your] head & no fear for his [lack of] tact.'[73] In other words, Cadell was not to allow Turner to dissuade him from this plan.

Cadell was aware that such scenes as Lockhart proposed might require Turner to make a sketching trip to Paris, but he was prepared to accept the additional expense. He was determined that the *Life of Napoleon* should be beautifully illustrated, and he believed, as he had when he began discussing designs for the *Prose Works*, that the best results would be obtained by making fresh on-the-spot sketches. When Cadell put the matter to Turner, in correspondence, the painter replied that he would indeed need to go to Paris, if he was to prepare the particular views that Cadell suggested. However, fortunately for Cadell, Turner had to travel to France this year in any case to collect sketches for his proposed 'French Rivers' series, so that to go to Paris and its vicinity would cause him little inconvenience and would not be excessively expensive. Cadell sent Turner a list of the subjects required and gave him permission to purchase local illustrative material, such as prints, if sketches could not be made.

These arrangements were concluded in late August 1832. Turner left for France either at the end of the month or in early September, arriving in Paris by mid-September.[74] He remained in France for about four weeks, and while he was there may have learned the sad news of Scott's death, which occurred on 21 September.

Almost as soon as Turner returned to London, he wrote to Cadell, informing him of the success of his trip. He had been to Brienne, but was disappointed to find that the Ecole Militaire had been demolished. Fortunately, the Château was still in existence and he had sketched that, although he had had difficulty in locating Napoleon's residence on the Quai Conti (**82, 83**). While in Paris, he also made sketches of Bourrienne's lodgings on the Rue de Marais, and views of the Etoile, Paris from Père-la-Chaise (**84, 85**), Vincennes, Malmaison, St Cloud, Versailles, Rambouillet, St Germain and Fontainebleau. If a view of Compiègne was wanted, this could be sketched by someone else, since, Turner said, it was too far out of his way. He

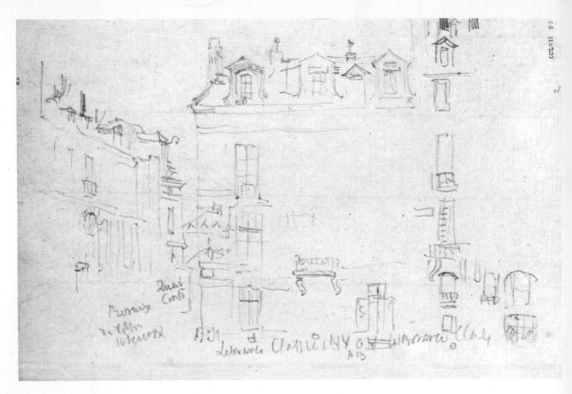

82 J.M.W. Turner,
Napoleon's Logement, Quai
Conti. Pencil sketch, 1832,
'Paris and Environs Sketch
Book', Turner Bequest,
CCLVII, 62. 4½ × 6⅞ in;
11.4 × 17.5 cm. British Museum,
London.

83 J.M.W. Turner, *Napoleon's
Logement, Quai Conti.* Vignette for
Sir Walter Scott, *Prose Works*
(1834–6), Volume 9. Engraving
on steel by J. Horsburgh, 1834.
4⅝ × 2¾ in; 11.8 × 7.0 cm.
British Museum, London.

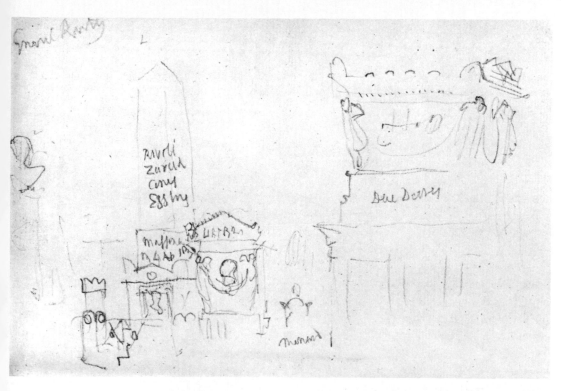

84 J. M. W. Turner,
monuments at Père-la-Chaise,
Paris, to Massena, Le Fabre and
others. Pencil sketch, 1832,
'Seine and Paris Sketch Book',
Turner Bequest, CCLIV, 24a.
$4\frac{1}{8} \times 6\frac{7}{8}$ in; 10.5 × 17.5 cm.
British Museum, London.

85 J. M. W. Turner, *Paris from
Père-la-Chaise*. Frontispiece for
Sir Walter Scott, *Prose Works*
(1834–6), Volume 14.
Engraving on steel by
W. Miller, 1835. $3\frac{1}{8} \times 4\frac{5}{8}$ in;
8.1 × 11.8 cm. British Museum,
London.

193

also noted that he had made studies from the great pictures of the battles of Marengo and Eylau, which had been painted to Bonaparte's order. Lodi, he believed, he could draw from a print in London, and he already possessed sufficient material for Waterloo. As for the portrait of Napoleon which was required, he had 'endeavoured to make some arrangements with a French artist who will write me word of the expense'.[75]

Cadell, who seems to have been quite satisfied with Turner's report of the trip, asked him to begin preparing the illustrations of French subjects which were required. He wanted Turner to complete the watercolours over the winter, telling him that he would be in London in the spring to collect them for the engravers.

By the time Cadell arrived in London in the next spring of 1833, he had already begun preparing the *Prose Works* for publication,[76] and fully expected that he would now be able to get the *Life of Napoleon* under way. However, this proved to be impossible, since Lockhart, who was supposed to have been attending to its editorial preparation, had apparently done nothing,[77] and Turner, on whom the publisher hitherto had always been able to depend, had over-burdened himself with other commissions during the winter and had not prepared any of the designs. A delay in publishing would involve great expense, and Cadell now wondered if it would be possible to begin his edition of the *Prose Works* by issuing the *Life of Napoleon* first.[78]

He was particularly disappointed that Turner had nothing prepared and wrote testily, 'He has not got *one* of the Napoleon drawings done – [I] pressed him hard for half next month & the remainder in August . . . a good deal arranged with this interview with Turner – [I] find that those on the spot have many advantages with Artists.'[79] It would appear that Turner responded to Cadell's entreaties, for he supplied him with at least half of the designs by the end of June, though Cadell did not receive the last illustrations until December.[80] In the event, Cadell could not afford to delay publication and consequently 'arranged so as to keep as much as possible to Chronological order. Dryden to commence with – the Swift – Lives of Novelists. . . .'[81] For all watercolours, Turner was paid twenty-five guineas each, as well as the costs arising from the Paris trip.

As he had originally planned to launch the *Prose Works*, and to stimulate sales of them, with the *Life of Napoleon*, Cadell was

anxious that its illustrations should be particularly attractive. It is probably for the same reason that the illustrations for the *Life*, unlike the groups of illustrations in other volumes of the *Prose Works*, have the unity of a series. The subjects resulting from Turner's 1832 French tour are the *Hôtel de Ville, Paris from Père-la-Chaise, Napoleon's Logement, Brienne, Vincennes, St Cloud, Mayence, Malmaison* and *Fontainebleau*. Of the remaining designs of this group, one, *The Bellerophon*, is based on engravings, while the others (*Venice, Milan, Verona* and *Field of Waterloo*) seem all to have been developed from sketches and drawings already in the artist's possession. Imbued with strong chiaroscuro effects, Turner's landscape subjects for the *Life* are highly dramatic, one quality which unites them as a series. And, like his other illustrations on steel, they are eloquent out of all proportion to their actual size. Through form and content, they provide a richness of observation and incident, and in several cases a psychological impact, that claims for them a special place among his published works. Like those for the other volumes of the *Prose Works*, they fall roughly into the three categories mentioned near the beginning of this section, but they also have a distinctive character.

Among the *Napoleon* designs which were developed from sketches and drawings already in the artist's possession, *Field of Waterloo* is based on early sketches of the battleground (**86**). Also the design was probably influenced by a watercolour of the same title, which Turner completed for Walter Fawkes, perhaps in 1819 (**87**). While the viewpoint has changed slightly, a similar dramatic sky hangs over the field and even the thunderbolt is repeated. However, one of the essential differences between the earlier watercolour and the design for *Napoleon* is that while the former illustrates Waterloo as it was on the day of the battle, strewn with bodies, the latter presents the field as it appeared years later. That is to say, Turner, as in most of his other illustrations for the *Prose Works*, wished to present only the ambience of an event, and not the event itself. The only pictorial reference he allows himself is the shattered tree stump to the left, beneath which are the scattered remnants of a human skeleton, mute testimony to the carnage of years gone by.

This approach to landscape is to be expected of Turner. For basic to an understanding of these landscapes must be the realization that the artist is presenting a 'topographical stage', for

which the text of the biography provides the actors and the action. Turner depends heavily on Scott's ability to tell a story, describe events, and develop both personalities and relationships in order to supply the necessary associative thoughts with which to animate his drawings.

The presence of associative values in the landscape illustrations of the *Prose Works* should not surprise us, since, as we have seen, they impregnate Turner's views in Scott's *Poetical Works*. Also, even from the earliest period of his career as an illustrator, Turner had prepared landscapes that were to serve as accompaniments to texts containing historic and geographical descriptions. In consequence, he knew that the iconographic significance of landscape was enriched by such texts, and, in the *Life of Napoleon*, landscape illustration and text are related in the same way, as the Introduction to the *Prose Works* makes quite clear. Here Cadell writes that the *Napoleon* engravings 'after Turner's drawings [are] of the places most strikingly *associated* with the history of that extraordinary man'.[82]

Yet Turner, with his great experience as an illustrator, was sufficiently hard-headed to know that landscapes alone were inadequate to guarantee the popularity of a biography. Therefore, in several illustrations he reinforces and enhances Scott's descriptions by introducing characters and events from the biography. He treats these figures, however, as relatively minute elements in the landscape, thus they are too small to be recognizable from their features. Their identification depends in a few instances on their clothing, but more often on the dramatic situation taken in conjunction with the topographical setting. Turner's interest in, and capacity for, figure painting or portraiture was limited, and it is at least partly for this reason that he sought the assistance of Scott's text, this time to enlarge the figures in the mind of the viewer and to provide descriptions of the physical and psychological characteristics on which, indeed, these illustrations largely depend for their effect.

For example, in his view of Fontainebleau (**88**) for the *Life of Napoleon*, Turner selected a most dramatic moment. Scott had written that in 1814 the allied forces invaded France and Paris was taken. As the allies believed that Napoleon's defeat and the end of the war were now in sight, they had to consider France's future; the alternative possibilities of a regency, or of the restoration of the Bourbons, were discussed. When Napoleon, in

86 J.M.W. Turner, *Field of Waterloo*. Frontispiece for Sir Walter Scott, *Prose Works* (1834–6), Volume 16. Engraving on steel by W. Miller, 1835. $3\frac{5}{8} \times 5\frac{1}{2}$ in; 9.2×14.1 cm. British Museum, London.

87 J.M.W. Turner, *The Battle of Waterloo*. Watercolour, *c*.1819. $11\frac{3}{8} \times 16$ in; 28.8×40.0 cm. Fitzwilliam Museum, Cambridge.

88 J.M.W. Turner, *Fontainebleau.* Vignette for Sir Walter Scott, *Prose Works* (1834–6), Volume 15. Engraving on steel by W. Miller, 1835. $3\frac{3}{4} \times 3$ in; 9.6 × 7.6 cm. British Museum, London.

temporary headquarters at Fontainebleau, sent his emissary Caulaincourt to Paris to subscribe to 'all ... [allied] demands', the allies knew that the end of the war was at hand. They also believed that, as long as Napoleon ruled France, there would be no lasting peace, and so Napoleon was informed by Caulaincourt that Paris would not entertain a treaty with him. However, Caulaincourt 'was of the opinion that the scheme of a regency by the Empress, as the guardian of their son, might ... be granted. Austria, he stated, was favourable to such an arrangement, and Russia seemed not irreconcilably averse to it. But the abdication of Buonaparte was a preliminary condition.' The news of the demand for abdication swept among the senior general staff, strengthening their belief that a march on Paris, which Napoleon had proposed, should not now take place. 'In their opinion the

war ought to be ended by this personal sacrifice on the part of Napoleon.' Assembled in his bedroom in the palace, these officers explained to the Emperor

the sentiments which they entertained . . . their opinion that he ought to negotiate on the principle of personal abdication, and the positive determination which most of them had formed, on no account to follow him in an attack upon Paris. . . . with considerable reluctance, and after long debate, Napoleon assumed the pen. . . .[83]

In his view of Fontainebleau, Turner might have chosen to represent this event in the palace. Yet such a scene, however well handled, would have been difficult for Turner to dramatize, especially in an illustration of such small scale. Consequently, it is not surprising that he selected instead a view of the exterior of Fontainebleau, where he could create a greater feeling for space, and chose to represent the psychological moment when the Emperor prepared to send his trusted envoys to Paris with the instrument of abdication. Turner, deeply aware of Scott's admiration for Napoleon, has represented the Emperor atop the grand entrance staircase of the palace. Here he depicts Napoleon as a tragic but heroic figure, standing apart from his senior staff in silence and isolation. The Emperor ponders his fate and that of his faithful officers and men. Caulaincourt and Ney, appointed to be the bearers of the document, are preparing to depart by coach. The extraordinary reduction in the size of the figures precludes the possibility of identification either from physiognomy or even dress; it is the location and the arrangement of the figures which provide the key. Turner, with an exquisite sense of theatre, has wrung from these minute figures the high drama and pathos of the event.

A second example of Turner's consummate skill in evoking dramatic mood by means of tiny figures can be found in another illustration from the *Life*: the *Bellerophon* incident (**89**). Scott writes that by July 1815, shortly after Napoleon's defeat at Waterloo, the British Admiralty had deployed many of its ships along the western coast of France, to prevent the possibility of Napoleon escaping by sea. One of the ships of this blockade, the British line of battle ship the *Bellerophon*, was instructed to cruise off Rochefort, and it was to Rochefort that Napoleon had fled, hoping to board a French vessel that would carry him and his family to safety in America. Behind him he had left his troops in

89 J. M. W. Turner, *The
Bellerophon, Plymouth Sound.*
Vignette for Sir Walter Scott,
Prose Works (1834–6), Volume
16. Engraving on steel by
E. Goodall, 1835. 3⅜ × 4⅜ in;
8.6 × 11.1 cm. British Museum,
London.

disarray – and his enemies; ahead of him he found his escape route blocked by the British fleet. What was he to do? He could either return to his troops and continue the fight, or surrender. He chose to surrender. Napoleon sent two of his most trusted men to negotiate terms with the captain of the *Bellerophon*, who could guarantee his safety only as far as the English coast; of his future beyond that, he could say nothing. As soon as Napoleon was taken on board, the man-of-war sailed for England. On 24 July *Bellerophon* arrived at Torbay; two days later the captain was given orders by the Admiralty to proceed to Plymouth Sound, where he received further instructions. Scott writes, 'The *Bellerophon* had hardly anchored, when orders came from the admiral, Lord Keith, which were soon after seconded by others from the Admiralty, enjoining that no one, of whatever rank or station, should be permitted to come on board. . . .'[84] Scott vividly describes the public's response to the news that Napoleon was aboard *Bellerophon*:

That frenzy of popular curiosity, which, predominating in all free states, seems to be carried to the utmost excess by the English nation, caused such numbers of boats to surround the Bellerophon, that, notwithstanding the peremptory orders of the Admiralty, and in spite of the efforts of the man-of-war's boats, which maintained constant guard round the vessel, it was almost impossible to keep them at the prescribed distance of a cable's length from the ship. They incurred the risk of being run down, – of being, as they might apprehend, shot (for muskets were discharged for the purpose of intimidation), of all the dangers of a naval combat, rather than lose the opportunity of seeing the Emperor whom they had heard so much of. When he appeared he was greeted with huzzas, which he returned with bows, but could not help expressing his wonder at the eagerness of popular curiosity, which he was not accustomed to see in such a pitch of excitation.[85]

Turner's pictorial translation of Scott's account is an accurate one: he has been able to evoke a mood which gives added poignancy to the plight of the Emperor, whose future was yet to be decided. He has also captured the very different, almost holiday, spirit of the boats, laden with curious onlookers, which mill round the hulking *Bellerophon*, the symbol of Britain's might. The man-of-war's crewmen in dinghies valiantly attempt to keep the area clear, their bustling activity being in strong contrast to the motionless figure of Napoleon on the ship's deck. As in the

Fontainebleau illustration, Turner has depicted Napoleon as but a speck, identifiable only from the location and the event. Yet Napoleon dominates, and indeed sets, the mood. Seen in silhouette, he is placed immediately against the base of the huge middle mast, which bisects the composition, and by this means the viewer's eye is directed to his figure. Silent and without emotion, Napoleon surveys the excited crowds, awaiting the decision on his fate.

Turner's collaboration with Cadell over the illustrations to Scott's *Life of Napoleon* must have been satisfying for the artist in that it permitted him to experiment with, and to vary, dramatic illustration. It was an involvement which in certain respects is deeply revealing. The published designs indicate, once more, Turner's dependence, as a landscape artist, on association. Moreover, because of the unique opportunity which the commission afforded him, he was able to show that his scrutiny of nature was not restricted to topography alone. His profound understanding of and compassion for man (but especially for a man above men) is revealed here in several of the designs. He has pictorially expressed – and, indeed, amplified in a very personal and original way – that sympathy for Napoleon which Scott himself has so frequently revealed in his biography.

Turning to the remainder of the illustrations for Scott's *Prose Works*, I should like first to consider the periods during which, as a whole, they were executed. Most of these can be determined with some accuracy. When carrying out large commissions for book illustration, Turner often prepared his designs in groups, and this was the case with most of those for Scott's *Prose Works*. From the point of view of the designs, the contents of the *Prose Works* can be classified into four groups.

The first comprises those illustrations occuring in Volumes 1 to 7. The first volume, *The Life of John Dryden*, contains a title-page vignette by Turner of the Dryden monument. Volume 3, the first part of the *Biographical Memoirs* (with accounts of the lives of eminent novelists, including Samuel Richardson, Horace Walpole, Tobias Smollett and Oliver Goldsmith), has a vignette of Dumbarton Castle. The fifth volume, devoted to *Paul's Letters to his Kinsfolk*, is introduced by Turner's *Brussels*, as frontispiece, and *Hougoumont*, as the title-page vignette. Volume 6 contains three essays, first published in the *Encyclopaedia Britannica*, entitled 'Chivalry', 'Romance' and 'The Drama'. To this volume Turner

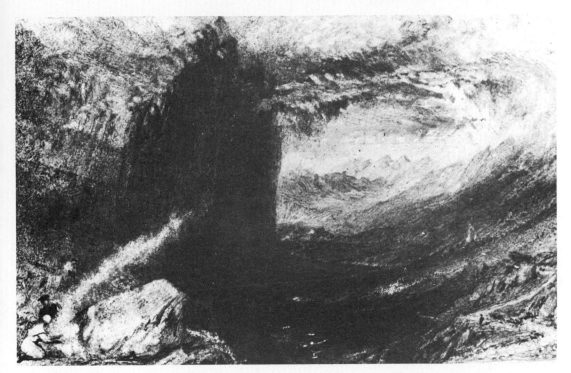

contributed the frontispiece, *Jerusalem*, and the vignette, *Shakespeare's Monument*. In the seventh volume, *The Provincial Antiquities and Picturesque Scenery of Scotland*, Turner's *Norham Castle* serves as the frontispiece and his *New Abbey, Dumfries* as the vignette.

Most of the designs prepared for this first group of illustrations were based on sketches and watercolours already in the artist's collection, such as *Dumbarton*, *New Abbey*, *Norham Castle*, *Brussels* and *Hougoumont*. On the other hand, *Jerusalem* was based on engravings after the work of other artists. The designs for the Dryden and Shakespeare monuments required sketches to be made specifically for them. All illustrations for this first group appear to have been executed 1833–4.

The nine central volumes (8 to 16) of the *Prose Works* contain the second group of illustrations. These volumes are occupied by *The Life of Napoleon Buonaparte* (discussed above), publication of which had to be postponed and for which the designs form perhaps the most interesting group; these, as we have seen, were prepared in 1833 and were developed mainly from sketches made by Turner on his special trip to Paris in 1832.

The third division of the *Prose Works* includes only two designs, *Chiefswood Cottage* and *Rhymer's Glen*, made for Volumes 18 and

21, containing Scott's *Periodical Criticism*. It is probable that the sketches for these vignettes were prepared during the Scottish tour of 1831, and the watercolours during 1833–4.

The fourth and final division, Volumes 22 to 28, contains designs for the *Tales of a Grandfather*. These views, taken in Scotland and France, are less homogeneous in date than those in the other three groups. The Scottish scenes (**90**, **91**) were partly developed from sketches made in 1831 (*Glencoe, Dunstaffnage, Fort Augustus* and *Inverness*) and in 1834 (*Edinburgh from St Anthony's Chapel* and *Craigmillar Castle*). Other Scottish illustrations for the *Tales*, such as *Stirling, Linlithgow* and *Killiekrankie*, may have been based on sketches made on earlier tours. In the *Tales* with French settings, the views of Rouen (**92**, **93**) and Château d'Arques were probably sketched on the Continental tour of 1832, while *Calais* and *Abbeville* may have been based on sketches made on tours taken during the mid-1820s. The illustrations for the *Tales*, both of Scottish and French subjects, appear to have been executed between 1834 and 1835.

The forty designs for the *Prose Works* are related to Scott's texts

92 J.M.W. Turner, Rouen. Pencil sketch, *c*.1832, 'Seine and Paris Sketch Book', Turner Bequest, CCLIV, 59a. 4⅛ × 6⅞ in; 10.5 × 17.5 cm. British Museum, London.

91 J.M.W. Turner, *Dunstaffnage*. Watercolour, *c*.1834, engraved for Sir Walter Scott, *Prose Works* (1834–6). 4¾ × 6 in; 12.1 × 15.3 cm. Indianapolis Museum of Art (gift in memory of Dr and Mrs Hugo O. Pantzer by their children).

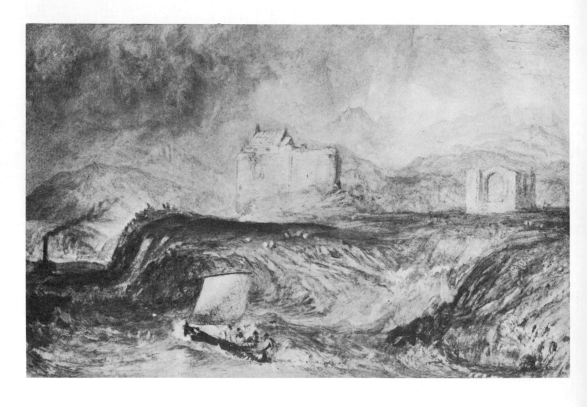

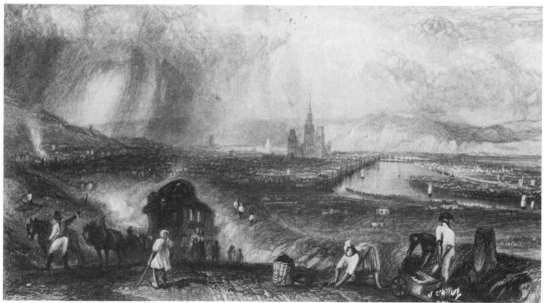

93 J.M.W. Turner, *Rouen –
Distant View.* Frontispiece for
Sir Walter Scott, *Prose Works*
(1834–6), Volume 27.
Engraving on steel by
W. Richardson, *c.*1836. $3\frac{1}{4} \times 5\frac{5}{8}$
in; 8.3 × 14.3 cm. British
Museum, London.

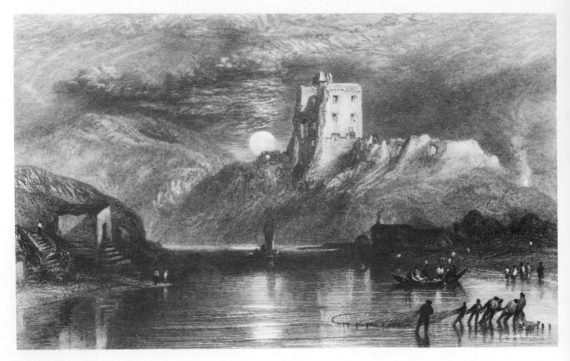

in various ways. There are those which are meant to represent a district, rather than specific places described or alluded to in the text. On the other hand, there are others which actually depict the places mentioned; some of these even include the historical characters whom Scott describes.

'The Border Antiquities', which is the introductory essay of Volume 7 (the *Provincial Antiquities and Picturesque Scenery of Scotland*) contains a frontispiece, *Norham Castle* (**94**), with a facing vignette plate, *New Abbey*. These designs are only associated with the text in a general way: the subjects serve as examples of Border architecture. Only Norham Castle is specifically mentioned in the text, and then only in a passing reference to its strategic and historical importance. However, there is another reason why these illustrations are appropriate. The ruins which they depict provide an atmosphere of romance. Introducing the subject of the essay, Scott observes that those

[frontier] scenes once the theatre of constant battle, ... defence, and retaliation, have been for two hundred years converted into the abode of peace and tranquility. Numerous castles left to moulder in massive ruins; fields where the memory of ancient battles still lives among the

94 J.M.W. Turner, *Norham Castle, Moonrise*. Frontispiece for Sir Walter Scott, *Prose Works* (1834–6), Volume 7. Engraving on steel by W. Miller, 1834. $3\frac{1}{2} \times 5\frac{1}{2}$ in; 8.8 × 14.0 cm. British Museum, London.

descendants of those by whom they were fought or witnessed.

Scott goes on to write of the history and traditions of the Borders and of 'the evidences of its existence [which] bear ... witness to the remoteness of its date; and he who traverses these peaceful glens and hills to find traces of strife, must necessarily refer his researches to a period of considerable antiquity.'[86] Therefore, both *Norham Castle* and *New Abbey* possess a general rather than a specific reference to the essay, yet they also provide an emotional relevance as well, reinforcing the atmosphere of romantic historicism which Scott, in the first part of the essay, sets out to evoke.

The vignette, *Dumbarton*, which embellishes the third volume (*Biographical Memoirs*) of the *Prose Works* has a more specific connection with the text than the landscapes for *The Border Antiquities*. The view of Dumbarton and the River Leven is meant to complement the frontispiece portrait of Smollett (not by Turner) on the facing page, since it illustrates the district with which Smollett's family was associated. Smollett's grandfather was a consistorial judge of Edinburgh, representing the Borough of Dumbarton in the Scottish Parliament. Indeed, Smollett himself was born near the banks of the Leven, and it was at the Dumbarton grammar school that he received his classical education. Even in his writings, Scott tells us, Smollett makes reference to the Vale of Leven, mentioning it 'not only in the beautiful ode addressed to his parent stream, but in the *Expedition of Humphrey Clinker*'.[87]

In other landscape illustrations for the *Tales of a Grandfather*, there is a similar specific relevance to the text. *Dunfermline* and *Edinburgh from St Anthony's Chapel*, which both appear in Volume 22, illustrate the reign of King Malcolm, who first resided at Dunfermline before moving to Edinburgh. When he did go to Edinburgh, he 'took possession [of it, as well as] the surrounding country'.[88] The views of these places, as with most of Turner's landscapes, are as the artist himself found them. Here, as in many other illustrations for the *Prose Works*, Turner depends on Scott to stimulate the imagination of his reader, to transport him into the past, to revive historical events and to transform the scene which the artist presents as he himself saw it.

This is also true of Volume 23 of the *Prose Works* (the second volume of the *Tales*) in which Stirling Castle is the subject of the

95 J.M.W. Turner, *The Rhymer's Glen*. Watercolour, c.1834, engraved for Sir Walter Scott, *Prose Works* (1834–6). 5 × 3¼ in; 12.7 × 8.3 cm. National Gallery of Scotland, Edinburgh.

frontispiece. This illustrates the reign of James V, to whom the castle was strategically important. The King 'prevailed on his mother, Queen Margaret, to yield up to him the Castle of Stirling, which was her jointure house, and secretly put into the hands of a governor whom he trusted'; it was then used by James as a protection against 'the wrath of the Douglasses'. Here, as in the two views previously mentioned, landscape and architecture serve to isolate a location rather than the event with which it is associated.

If, in some of the landscapes for the *Prose Works*, Turner represents the dramatis personae of Scott's histories (as, for example, in *The Life of Napoleon*), in others he alludes symbolically to the presence of the author and his family. For example, in two volumes of the *Periodical Criticism*, Turner celebrates the critical achievement both of Scott himself and of the writer's son-in-law, Lockhart. The title-page vignette, *Rhymer's Glen* (95), showing an area of wilderness on the Abbotsford estate, was chosen to illustrate Volume 21, probably because it contains Scott's critical reviews of books on landscape gardening

96 J.M.W. Turner, *Chiefswood Cottage*. Watercolour, *c*.1834, engraved for Sir Walter Scott, *Prose Works* (1834–6). 5½ × 3¾ in; 14.0 × 9.5 cm. National Gallery of Scotland, Edinburgh.

and because Turner may have wished it to be a tribute to Scott as a gardener and practitioner of the Picturesque, especially since Scott had practised his skills as a gardener in the Glen. As we have seen, Turner was also versed in the theory and practice of the Picturesque. (By the time Turner was employed by Scott, however, it was no longer an active principle of his art, though elements of its pictorial structure lingered on.) By associating his *Rhymer's Glen* vignette with Scott's skills as a gardener, Turner may also have intended it to illustrate specifically Scott's critical essay on Sir Henry Steuart's book, *The Planter's Guide* (1828). In this essay, after discussing the formal garden laid out in the immediate environs of an Elizabethan house, Scott wrote that, as the gardens extend from the house, they seem

to connect themselves with the open country. The inhabitants possessed the means, we must also suppose, of escaping from this display of ostentatious splendour to the sequestered paths of a lovely chase, dark enough and extensive enough to convey the idea of a natural forest, where, as in strong contrast with the scene we have quitted [that is, the

97 J.M.W. Turner, Chiefswood Cottage. Pencil sketch, 1831, 'Edinburgh Sketch Book', Turner Bequest, CCLXVIII, 52. 4⅜ × 7⅛ in; 11.1 × 18.1 cm. British Museum, London.

formal garden], the cooing of the wood-pigeon is alone heard, where the streams find their way unconfined. . . .[89]

Such a scene as Scott describes may have suggested to Turner the Rhymer's Glen, which Scott dearly loved. Turner's vignette not only represents the Glen and its rivulet, but alludes to Scott's presence by depicting a rustic seat with an open book near it and his walking-stick. By including these allusions to Scott, Turner, yet again, depends on association in order to create the pictorial equivalent of what has been referred to as Scott's 'humanized' landscape.[90]

Turner makes a comparable symbolic reference to Lockhart in the title-page vignette, *Chiefswood Cottage* (**96**, **97**), which appears in Volume 2 of the *Periodical Criticism* (Volume 18 of the *Prose Works*). Chiefswood Cottage was Lockhart's summer retreat on the Abbotsford estate. Moreover, the desk and inkpot, prominently displayed in the foreground, not only allude to his position as general editor of the famous *Quarterly Review* (for which Scott wrote so many of his critical articles), and to his singular skills as a critic, but also perhaps to his future authorship of Scott's biography, since Lockhart had been commissioned to write a life of Scott before Turner was asked to prepare this vignette (1833-4).

10 Turner's Illustrations to Lockhart's *Memoirs of the Life of Sir Walter Scott*

Those who were associated with Cadell could not have been surprised when, three years after Scott's death, he expressed some concern that Lockhart (**98**) had made little progress with the writing of his promised *Memoirs of the Life of Sir Walter Scott*. Cadell set great store by this projected biography, which was not only to be definitive (and a major addition to his publications of 'Scottiana'), but, as he had purchased the entire copyright (in 1832), also an important investment. In his diary at the end of 1835 Cadell wrote, 'Nothing required but Lockharts Life to make all my operations move in quick quick time – it is the *opus* of all others to benefit Sir Walter Scotts family & me most especially.'[1]

It had been two years earlier, in 1833, that Cadell and Lockhart had first seriously discussed the *Life*. Such, indeed, had been Cadell's confidence in the project that, when in London in May that year, he had published an announcement concerning the preparation of the biography in the newspapers – calculated, according to him, to 'keep off interlopers'.[2] The *Life* had originally been planned in a format uniform with the small volumes of the *Poetical Works* (twelve volumes) and *Prose Works* (intended to occupy twenty-eight volumes), which had been and were being illustrated by Turner. Cadell and Lockhart had decided that the *Life* should be ready for publication two years later (in 1835), in order to coincide with the appearance of the last volumes of the *Prose Works*.

Lockhart had promised to fling himself into the writing of the *Life*; nevertheless, Cadell, when on a visit to London in 1834, was disappointed to find that Lockhart had made little progress. Though Cadell now thought that the proposed deadline for publication could not be met, he resolved to keep to this schedule, in the hope of spurring Lockhart on. He had little knowledge, however, of the difficulties encountered by Lockhart in collecting and preparing his material; it was a task both laborious and time-consuming. Letters of enquiry had to be written, and Scott's correspondence was not only difficult to read but required careful transcription. Lockhart's delay, though unfortunate, was certainly explicable.

Cadell, however, was not interested in excuses, only in results. He pointed out to Lockhart that he must begin writing very soon. He also spoke to him about possible subjects for illustration, believing that the financial returns on the *Life* would be significantly increased if it included attractive designs. He persuaded Lockhart that a well-illustrated edition was desirable and that Turner should be the artist chiefly responsible for this aspect of the book. As we have seen, Turner visited Scotland during the late summer of 1834 to gather material for the *Prose Works* and for the proposed edition of the 'Waverley Novels', and also to sketch places considered appropriate for illustration in the biography.

When, in 1835, Cadell's deadline arrived and passed, his doubts were confirmed. Lockhart, who had assembled a vast amount of material but had had difficulty in synthesizing it, wrote to Cadell,

I now sit among a multitude of Collectaneana, hopping and peering, for hours sometimes, before I can settle the plan of the day's operations. Perhaps I may promise a volume of my own reminiscences of our intercourse and fireside talk. I never thought of being a Boswell, but I have a fair memory, and to me he no doubt spoke more freely and fully on various affairs than to any other who now survives. . . .[3]

Despite Lockhart's apparent efforts to produce a manuscript, Cadell believed that he was not working. By the beginning of 1836 he was deeply annoyed by 'Lockhart . . . lingering over the Life . . .'[4] and probably wrote to Lockhart telling him as much. For, only two weeks after making this observation, Cadell received a letter from Lockhart, assuring him that he had begun

98 Sir Francis Grant, *John Gibson Lockhart*. Oil on panel, date unknown. $12\frac{3}{4} \times 10$ in; 32.4×25.4 cm. Scottish National Portrait Gallery, Edinburgh.

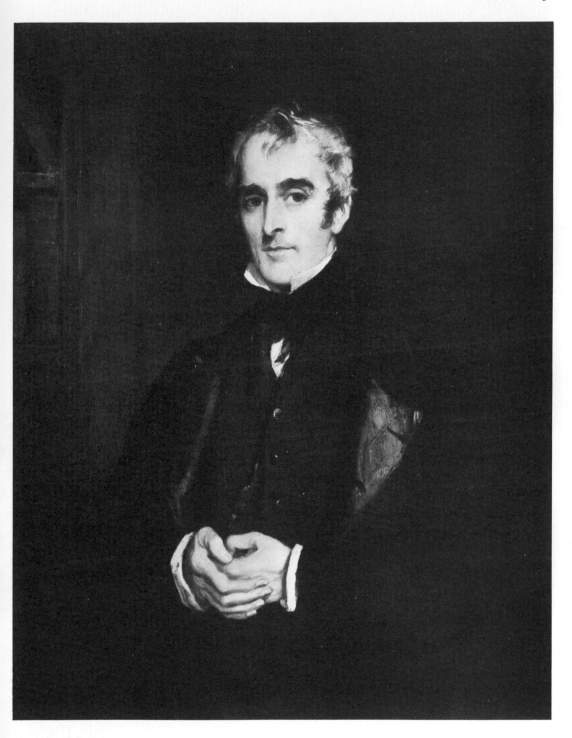

writing. Cadell was overjoyed: '[I am] to *commence* the Life forthwith – [he] wants £500 – nothing for a long time has given me so much pleasure as the prospect of the start of this....'[5] Cadell must have sought further assurances that the work was proceeding, for in March Sophia Lockhart felt compelled to write to the publisher about her husband's progress:

Knowing how anxious you are for the 'Life', I cannot help writing you a few lines to tell you it is fairly begun, and Lockhart [is] working as hard at it as ever you could wish. He has been arranging it so long in his mind that, now fairly commenced, he will not be long about it; and he has read to me, and continues to do so, what he writes, and I am much mistaken if anything in our time will come up to it in interest, style, or as a picture of manners just passing away.[6]

Less than a week after Lockhart announced to Cadell that the writing of the *Life* was under way, the publisher wrote to Turner about the designs, which were to be developed from sketches made on Turner's last trip to Scotland, in 1834.[7] While we have no information about the number of designs the artist had been asked to prepare, we do know that Cadell favoured a lavishly illustrated edition, with family portraits as well as landscapes by Turner. To his great disappointment, however, in October 1836, apparently some months after Turner had been given the commission, Lockhart decided against a fully illustrated *Life*.[8] Now there would be but a single plate: a portrait of Scott by Sir Henry Raeburn in the first of the seven volumes that were eventually published.

The blow was probably a heavy one for Cadell. Not only did he believe that drastically curtailing the number of illustrations would have an adverse effect on sales, but he would be forced to cancel his contract with Turner. However, he soon devised a scheme whereby he would not need to break the contract. He proposed that the intended illustrations (both landscapes by Turner and portraits) should be published independently in monthly issues. He suggested to Lockhart that this would be a lucrative alternative, and would, moreover, be a means of publicizing the *Life*. Lockhart seems to have agreed to the plan, but believed that if monthly issues of this kind were published, ideas for illustrations might be pirated by unscrupulous 'speculating cocknies' for their own annuals.[9] He therefore proposed that, instead of appearing in monthly instalments, all

the illustrations should be brought out together in an album at Christmas, thereby competing effectively with the other publishers' annuals. Cadell, however, preferred his own idea, considering that his '2/6 trick' (monthly issues) would be more profitable. He was sure that the illustrations, like those by Turner in *Finden's Illustrations of . . . Byron*, published in monthly parts by John Murray and sold by Charles Tilt, should be published by Tilt and himself, and he resolved to go to Tilt with his proposal.[10]

On 3 November 1836, full of optimism, Cadell arrived at the London publisher's premises, and was stunned when Tilt told him 'that [even] if he had the whole of the materials supplied to him he would not take the risk. The general conclusion we parted with was that it would not do. . . .'[11] Cadell, convinced of the profitability of his scheme, saw Tilt again four days later. His proposal was again turned down, and Cadell reluctantly abandoned the scheme.[12]

Presumably Cadell informed Turner of Lockhart's decision, and of his own failure to persuade Tilt of the profit to be made by publishing the plates in monthly issues. At that time (in early November 1836), Cadell must have instructed Turner not to proceed with his designs (though, as I shall suggest later, at least one of them had been completed). Although Cadell had planned initially to produce the *Life* to the size and design of his editions of Scott's poetry and prose, when it was first published (1837–8), it was larger in format and contained, as Lockhart had insisted, only one plate: a portrait of Scott. During 1837, when the first volumes of the *Life* appeared, Cadell, who at first was disappointed by the public's response, later expressed satisfaction with the swelling interest in the work. As he was intent on continuing to publish books by and about Scott in volumes uniform with those of the poetry and prose, he contacted Lockhart and received approval for a second edition in this format; with Lockhart's agreement, this was to include many illustrations, some of which would be by Turner. This second edition was to be a project, Cadell noted, that would keep him 'very busy for a good bit – and yield much good money'.[13] He was evidently keeping to his resolution to publish only Scott's works, 'no miscellaneous Bookselling'; his intention was to 'look upon the Life as laying a foundation for Ten Years incessant occupation'.[14]

In April 1838 Cadell came to London, 'principally to arrange

99 J.M.W. Turner, *Sandyknowe*
(or *Smailholm*). Watercolour,
1838, engraved for J. G.
Lockhart, *Memoirs of the Life of
Sir Walter Scott* (1839).
$8\frac{3}{4} \times 9\frac{1}{2}$ in; 22.2 × 24.1 cm.
Vassar College, Poughkeepsie,
New York. See Plates 40, 43, 65.

with Mr Lockhart for [this] . . . new Edition of the Life'.[15] Late in
1837 he had ordered illustrations to embellish this edition, and
since then he had received several which he now brought to
London.[16] Turner had executed at least one of these designs, and
Cadell wished to return it. He therefore called at Turner's house,
but the painter was out. While walking near St Paul's Cathedral
a few days later, he accidently 'found old Turner', and arranged
to visit him in several days' time.[17] On Tuesday, 5 May, Cadell
duly called on Turner and returned one of two designs of the
Smailholm Tower which Turner had sent to him. (The reason for
returning the design I shall attempt to explain later.) During his
visit, Cadell also commissioned from Turner a final illustration
for the *Life*: a 'splendid' *Abbotsford*.[18]

Although this second edition was not to be as lavishly
illustrated as the first was originally planned to be, yet each of the
proposed ten volumes (at first, twelve were envisaged) was to
contain a frontispiece and a vignette in the manner of the
volumes of the poetical and prose works. Few of the illustrations,
however, were to be landscapes: the majority were to be portraits
of Scott, his ancestors and his family.[19] Whereas Turner's share of
the projected illustrations for the first edition was to have been a

large one, only three of his designs appeared in the new edition. Probably the first of these to be completed was the vignette of Scott's Edinburgh house, 39 Castle Street, which may date from before November 1836, when Cadell presumably cancelled Turner's contract for illustrations for the first edition. The second illustration to be made for the *Life* was the vignette of Smailholm Tower and Sandyknowe Farm; it was probably completed in the early months of 1838. Turner's third and final design was the rectangular frontispiece, *Abbotsford*, prepared later in that same year.

In at least two respects these designs are a natural outgrowth of those which Turner had prepared years before for the *Poetical Works*. First, they are harmonious in appearance, specifically in their design and general style; second, they are similar in possessing symbolic significance.

The vignette *Sandyknowe* which was to be published (**99, 100**) was likely one of the two reported similar views of Smailholm sent by Turner to Cadell.[20] The second landscape was that which Cadell, when in London, returned to the artist, and which, I suggest, was the 'gift' watercolour that Turner had sent to Scott

in Naples in 1832 (see p. 148). Turner may have borrowed the 'gift' and used it both as an inspiration for the published illustration and as an alternative design, in the event that Cadell had not liked the one that he had prepared. There is certainly a general similarity between the two designs. While it is possible that they were developed independently of one another from the same rapid, on-the-spot sketch, the evidence of the watercolours themselves would suggest otherwise. Both are vignettes in form, and in both the tower looms impressively, like some huge monolith which dominates the landscape. Also, the two watercolours share a quality of mood. Further, Scott is the subject in each of them.

What happened to the 'gift' watercolour after Scott's death is not known, but it seems likely that by the time that Turner was about to consider the design of the vignette *Sandyknowe* (**99**) (that is, early in 1838), the 'gift' design was in Lockhart's possession. The 'gift' watercolour may have been among Scott's private possessions, and in October 1836 Cadell may have brought it from Abbotsford to London with a number of other drawings that were being considered as illustrations for the first edition of the *Life*.[21] When, shortly after, Lockhart decided against a fully illustrated edition, the 'gift' watercolour and the other drawings may have gone to the Lockharts. It is alternatively possible that, much earlier, the 'gift' design had found its way into the collection of Sophia Lockhart, who had in her possession some of her father's small personal mementoes. If the 'gift' watercolour was among them, after Sophia's death in 1837 it would probably have passed into Lockhart's possession, because of its pointed references to Scott. As Turner had visited the Lockharts in London on at least two occasions, and seems to have been sufficiently well acquainted with Sophia to have given her a present (as we shall see), it would not seem unusual for Turner to have borrowed the 'gift' design from her widower, the author of the book that he was about to illustrate. Cadell probably returned the 'gift' watercolour to Turner (if this was the design which he returned) because it was not required; Turner would then have returned it to Lockhart.

Just as the published *Smailholm Tower* (**100**) has links with the illustrations for the *Poetical Works* (through the 'gift' watercolour), so also does *39, Castle Street* (**101**), probably intended for the first edition of the *Life*. Like *Smailholm Tower*, it

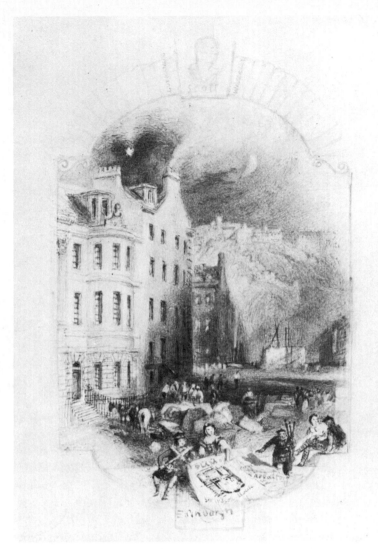

101 J.M.W. Turner, *No. 39, Castle Street, Edinburgh.* Watercolour, *c.*1836, engraved for J. G. Lockhart, *Memoirs of the Life of Sir Walter Scott* (1839). $5\frac{1}{2} \times 3\frac{1}{4}$ in; 14.1 × 8.3 cm. Pierpont Morgan Library, New York. See Plates 76, 105.

is in the form of a vignette. However, *39, Castle Street* has, in addition, an elaborate border, similar to those of the vignettes for the *Poetical Works*, and as in them (especially *Abbotsford* (**72**)), the surround emphasizes the commemorative function of the landscape.

Whereas Turner had restrained the commemorative element in the borders of the designs in the *Poetical Works*, because Scott was still living, in the border of *39, Castle Street* he expresses the commemorative aspects of his theme much more forcefully. Because Scott had been dead for several years by the time Turner produced *39, Castle Street*, the artist could make open use of the

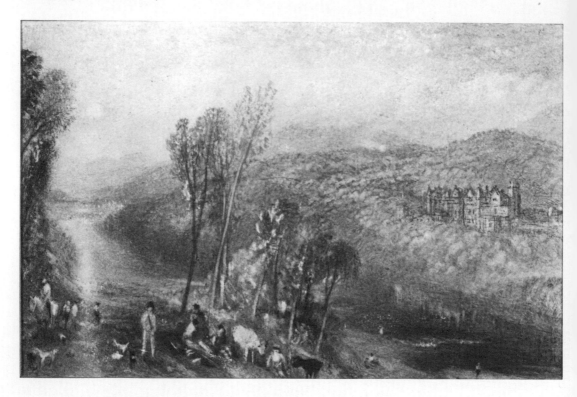

mortuary tablet patterns for the border. The keystone of the framing arch of the border shows a carved relief of Scott's head, while its supporting voussoirs hold volumes of his published works: both these features strengthen the association with contemporary mortuary tablets, with their sculpted likenesses and symbolic references to the deceased's occupation, personal attributes, and public achievement (**71**). Thus, the border of *39, Castle Street* (although absent from the published illustration) has a close affinity with those 1832 watercolours prepared for the *Poetical Works*, and suggests that *39, Castle Street* was not only the first of the three watercolours to be prepared, but was actually intended for inclusion in the first edition of the *Life*, and is therefore datable to 1836–7.

The third and final watercolour to be prepared for this new edition of the *Life* was a rectangular view of Abbotsford, completed later in 1838 (**102**). It, too, has links with the *Poetical Works*. While little documentation exists for this work, one clue, probably an important one, is provided by an entry in Robert Cadell's diary for May 1838; 'thru [*sic*] to Turner with whom I

102 J. M. W. Turner, *Abbotsford*. Watercolour, 1838, engraved for J. G. Lockhart, *Memoirs of the Life of Sir Walter Scott* (1839). $3\frac{3}{4} \times 5\frac{3}{4}$ in; 9.5×14.6 cm. Private collection.

arranged for a splendid Abbotsford for the Life'.[22] That Cadell describes the proposed design as 'splendid' may suggest either that Turner had decided how he would treat the subject and described his idea to Cadell, or that Cadell already knew the design which Turner was to use. It is possible that, like the illustration *Smailholm Tower* in the *Life*, the composition of *Abbotsford* was derived from an earlier unpublished design. This design may have been in the possession of Mrs Lockhart.

Turner had probably been in touch with the Lockharts mainly through Cadell, in connection with the illustrations for the first edition of the *Life*. These contacts must have taken place between 1834, when Turner began to assemble his material, and late 1836, when the plans for a fully illustrated edition were aborted. It seems that at some time during this period Turner presented Sophia Lockhart with an oil-painted souvenir, similar in intent to the watercolour of Smailholm Tower (the 'gift' watercolour), which he had given her father. This present was a tray (**103**), decorated with a painted landscape[23] which, in style, is not inconsistent with the artist's other oil paintings of the mid-1830s (if allowance is made for the fact that it follows the form of his watercolour illustrations and is executed on metal).[24] The tray painting represents a view of Abbotsford, drenched in a late afternoon light, as Turner may have remembered it. The scene is also commemorative, but in a posthumous sense: in the left foreground Turner has represented Scott himself. In this pictorial tribute the artist's memory of his association with Scott is revived: a warm association which he had recalled many times in his sketch books.

In the landscape of the 'Abbotsford Tray' Turner has eloquently established the appropriate mood for this unusual memorial; he has created a tenor of feeling shaped both by evocation and suggestion. The setting is tranquil; it is a vision of nature that is hushed and resonantly expectant. The golden lateness of the day, the stillness of the moisture-laden air, the gentle murmurings of the slowly drifting Tweed; these are aspects of the landscape which are conjoined in a potent and deeply moving combination, providing the necessary background for reflection.

Remarking on Turner's 'splendid Abbotsford' in 1838, Cadell may well have known of the existence of the tray, and would therefore have been in a position to comment on it.

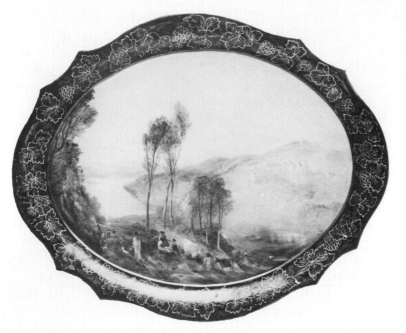

103 J.M.W. Turner, *Abbotsford*. Japanned metal tray, *c*.1836. Oval: 20 × 25 in; 50.8 × 63.5 cm. Indianapolis Museum of Art (gift in memory of Evan F. Lilly, with the hope that it will bring inspiration and beauty into the lives of others).

That the 'Abbotsford Tray' painting was not developed from the watercolour for the *Life* is suggested by several facts. There are subtle modifications of the topography, and of the arrangement of its elements, beyond those which would have been necessary to adapt the rectangular composition of the watercolour to the oval format of the tray. Also, the tray painting reveals evidence of *pentimenti*, and the under drawing (which is easily visible) exhibits a marked vitality – qualities that are not characteristic of a copy. But the most persuasive argument against the illustration in the *Life* being the source for the tray design, and in favour of the opposite contention, lies in Turner's treatment of the figures.

While those in the foreground of the small watercolour for the *Life* are quite indistinct, those on the tray are precisely represented and would have been immediately identifiable by Sophia and members of her family. On the tray, the standing figure to the left must be Scott; he is shown in a light suit and dark top-hat such as he is shown wearing in Turner's sketches made during his visit to Abbotsford, in the *Bemerside* vignette and in the 'gift' watercolour which Turner had sent to Scott. On the tray, to the right and behind the author are members of his immediate family. Anne and Sophia arc represented, as are probably their

104 J.M.W. Turner,
Abbotsford. Watercolour, *c*.1832.
3 × 5¾ in; 7.6 × 14.6 cm.
Hickman Bacon Collection.
See Chapter 10, note 25.

brothers, Walter and Charles, although it is possible that the two latter figures are Walter and Lockhart. If one examines the watercolour illustration for the *Life*, precise identification of this kind is impossible due to the small size and vagueness of the figures. It would seem likely, therefore, that this illustration was based on the design on the tray, rather than the reverse.[25]

I have suggested that Turner's designs for Lockhart's *Memoirs of the Life of Sir Walter Scott* can be linked with those for the *Poetical Works* both in a formal sense and in their commemorative element. At the same time, however, these illustrations are distinctive, possessing a pictorial cohesion which Turner could not possibly have achieved in the illustrations for the poetry. The most apparent of these unifying characteristics is the architectural subject which dominates each composition. While each of the three buildings represented is associated with Scott, they also possess, collectively, a metaphorical meaning, symbolizing, as they do, three periods in the author's life as well as the traditional 'Three Ages of Man'. Smailholm Tower is associated with Scott's childhood, 39 Castle Street with his middle years, and Abbotsford with his old age.

In the foreground of *39, Castle Street* two architectural plans are displayed. Above and in full view is a ground plan of the Castle

Street house; beneath it, and partly obscured, is a plan labelled 'Abbotsford'. Clearly, what Turner wishes to convey is the idea that Abbotsford and Castle Street shared a period of Scott's middle age. That Abbotsford occupied a shorter period, and played a less significant role, during his creative years, is suggested by the partly hidden plan. However, Abbotsford was not unimportant. The building of this house occupied much of Scott's attention from 1818 to 1822, when it was completed, and it became his favourite abode; indeed, after his bankruptcy, it was his only one. Therefore, the inclusion of the Abbotsford plan enriches the meaning of *39, Castle Street*, while it simultaneously establishes a link with *Abbotsford* (the third design).

The connection between *39, Castle Street* and *Smailholm Tower*, however, is quite different. In each illustration a star is showing. In *Smailholm Tower*, the star is suspended almost immediately over the head of the young Scott, who is attended by his nurse; it serves to foretell Scott's future fame. In *39, Castle Street*, on the other hand, the star, while in the same general position in the composition, is much higher in the sky. By showing it suspended over Scott's house, Turner indicates that the writer achieved fame during the middle period of his life. Indeed, as if to underline this meaning, Turner has drawn the star poised above a sculpted bust of Scott with which he has decorated the cornice of the writer's house. The moon (almost a half-moon), which balances the star on the right, metaphorically reinforces the suggestion that Scott's success is associated with his middle years.[26]

Astral imagery even extends to the third illustration, *Abbotsford*, which is associated with Scott's old age. Traditionally, a setting sun is considered symbolic of declining life. That it hovers above the head of the author, in a position comparable to those of the stars in the other two illustrations, suggests that it does indeed have this significance here. The sun in the landscape of the 'Abbotsford Tray' probably has the same meaning. Although *Abbotsford* is not, iconographically, the richest of the three illustrations for the *Life of Scott*, it catches the mood impressively. With this idyllic vision of Abbotsford, Turner concludes his pictorial trilogy.

Fully understanding the power of symbolism, Turner introduced into these three illustrations compositional elements which are profoundly significant both as reinforcements of the

underlying meaning of each picture and as expressions of his personal concern. *39, Castle Street* is the most compelling of the three allegorical designs, especially when its fuller significance is grasped. Its richly symbolic character effectively links it to the other two illustrations, giving the group a unity and depth of meaning that is quite remarkable. Although the symbols of *39, Castle Street* have a strong temporal significance in relation to Scott's middle years, they also have, like all symbols, timeless, independent existences. This is also true of another pictorial element introduced by Turner, relating to the proposed monument which was to be erected in Edinburgh to the author's memory, and whose design gave rise to a keen controversy in which Turner was briefly involved (see Appendix 2 for a full account).

In the background on the watercolour we see a block-like structure, covered with scaffolding, which obstructs the intersection of George Street and Castle Street. From the scale of the adjacent buildings, one can estimate this structure to be about fifteen feet high.[27] From its position, at the intersection of two streets, one may reasonably conclude that it represents a massive monument, either being erected or being dismantled. Strangely enough, no record exists of a monument at this location until 1878,[28] and there is no indication of it in Turner's original, on-the-spot sketch. It is therefore probable that, in this work, Turner is proposing a site for the Scott monument and is depicting the base as being already under construction.

Turner probably saw the report, published in 1835, of the Sub-committee entrusted with the responsibility of recommending both a site and a suitable design for the monument. With regard to the design, some members favoured a Gothic cross (such as was eventually adopted), others an obelisk, such as the architect W.H. Playfair had proposed in his submitted design. In the *39, Castle Street* watercolour, Turner has represented a base resembling that in the Playfair design, thereby reaffirming pictorially the preference for the obelisk which he had already expressed to Cadell, who was on the Sub-committee.

Many locations for the monument in Edinburgh had been discussed. Most members of the Sub-committee had favoured a site in George Street, near Charlotte Square.[29] Although the report makes no reference to a site at the intersection of Castle Street and George Street, such as is indicated by Turner, his was,

nonetheless, a sensible suggestion, since Scott's home was near the corner of George Street. That Turner did not actually represent an obelisk in the watercolour suggests that he was tactfully aware of the rift within the Sub-committee on the matter of the design.

The engraving of *39, Castle Street* (**105**) was not made until after February 1838,[30] when George Meikle Kemp's Gothic cross was pronounced the winning design for the Scott monument, which was sited in due course in Princes Street.[31] It is significant that the block-like form, present in Turner's watercolour, does not appear in the published illustration. Its absence poignantly symbolizes Turner's dashed hopes, as well as the hopes of those who shared his wishes. In the engraving, all that remains at the site is a furiously burning brazier, added for compositional balance but having no special meaning. *39, Castle Street* is the central illustration, both in a sequential and in a symbolic sense, in Turner's three designs for the *Life of Scott*.

The placing of these three illustrations among designs by other artists, which was their fate in the *Life*, was certainly not what Turner had envisaged. In the publisher's failure to keep them together, their rich pictorial symbolism has been lost, and their significance generally obscured.

As an illustrator of books by and concerning Sir Walter Scott, Turner had had the opportunity of becoming acquainted with the writer, and, over the years, of gaining an extensive knowledge of his writings. Viewing the commissions for Scott illustrations first as a challenge, and later almost as his privileged preserve, Turner discovered them to be a means of investigating the nature of illustration and a fertile ground for experimentation. The designs made during Turner's initial collaboration with Scott, for his *Provincial Antiquities*, are primarily descriptive, though they were not painted for a text: rather, the text was developed round them. While Turner's later book designs for works by, or about, Scott are of necessity descriptive, they are more richly varied in form and are clearly more symbolic; thus they relate more sympathetically and subtly to the distinctive texts which they illustrate. On another level of interpretation, they provided Turner with a platform for public and personal commemorations of Scott.

This enlarged expressive ingredient of Turner's later Scott

105 J.M.W. Turner, *No. 39, Castle Street, Edinburgh*, for J. G. Lockhart, *Memoirs of the Life of Sir Walter Scott* (1839). Engraving on steel by W. Miller, 1839. 4⅜ × 3⅜ in; 11.1 × 8.6 cm. British Museum, London. See Plate 101.

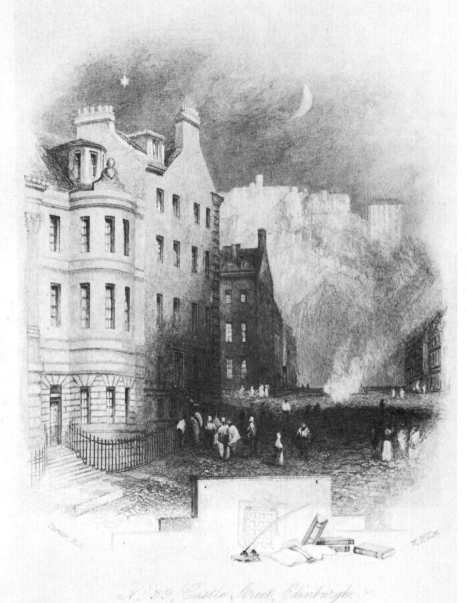

LIFE
OF
SIR WALTER SCOTT, BAR.T
VOL. IV.

N.º 39, Castle Street, Edinburgh.
The town Residence of Sir Walter Scott, for upwards of Twenty-five Years.

EDINBURGH: PUBLISHED BY ROBERT CADELL.
AND WHITTAKER & Cº LONDON.
1839.

illustrations is common to all of his designs for literature prepared during the 1830s. These designs were all engraved on the more durable steel plates, which meant that bigger editions of the books containing Turner's designs were published, and his illustrations therefore received wider distribution, with a resulting further enhancement of his artistic reputation. Perhaps partly because these designs were reaching a wider audience, Turner decided to increase their expressive capacity in order to 'elevate' them and to give them a special artistic status: some appear to contain symbolic configurations, derived from his contemporary oil paintings; others, in which grand, apocalyptic forces are drawn into small focus, anticipate those forms of his later paintings. Probably Turner did not consider his book illustration in isolation from the rest of his art; it is only in the perspective that time brings that one can examine and assess this role, and understand it, in a way that he could not.

Although Turner, as a British landscape artist of the Romantic period, was not alone in his sensitivity to the writings that he illustrated, he did explore the illustration's expressive potential in a unique way. He endowed book illustration with a new significance and assigned to it a responsibility of uncommon authority. W.G. Rawlinson, one of the earliest champions of Turner's engraved work, has provided a remarkably fitting assessment of his capacity in this field:

Leaving Turner's oil paintings apart, I am convinced that no one can make a study of his engraved work – and still more of the hundreds of drawings and thousands of sketches on which that work was founded – without being profoundly impressed with the sense of his power. Notwithstanding occasional faults of taste apparent to every one, his work is stamped with those rare qualities of 'infinity', of poetry, of mystery, of mastery over every form and aspect of Nature, which are to be found in conjunction, only in the very greatest artists of all times and all schools.[32]

Appendix 1

The Turner-Tilt Affair

When it became apparent that Scott's *Provincial Antiquities and Picturesque Scenery of Scotland* would never become a paying proposition, the copper plates and the remaining stock of published numbers were sold. The plates were bought by the engraver and publisher W. B. Cooke, who probably hoped to reissue them. This he never did, and they were sold to Charles Tilt, the Fleet Street bookseller and publisher, for £110.

By 1833, Tilt had published several successful illustrated books on the prose works of Sir Walter Scott. The earliest was the two-volume *Landscape Illustrations of the Waverley Novels with Descriptions of the Views* (1832), which was followed by a three-volume work, *Landscape Illustrations of the Novels of the Author of Waverley; with Portraits of the Principal Female Characters* (1833), and *Portraits of the Principal Female Characters in the Waverley Novels; to which are added Landscape Illustrations of the Highland Widow, Anne of Geierstein, Fair Maid of Perth, Castle Dangerous* (1833). This last work was apparently considered to be the third volume of the first book mentioned: *Landscape Illustrations. . . .* After the publication of these books Tilt decided to launch a new related work, to be entitled *Illustrations: Landscape, Historical, and Antiquarian, to the Poetical Works of Sir Walter Scott Bart*, which was to contain landscape illustrations by well-known artists, including David Roberts, A. W. Callcott, Copley Fielding and J. D. Harding.[1] These designs were to be accompanied by an historical and descriptive text by one Mr Moule. Turner was offered a share of the designs, but rejected the offer; one reason he gave was that he had already prepared landscapes for Cadell to illustrate Lockhart's edition of Scott's *Poetical Works* (1833–4).

Because Tilt was convinced that illustrations by Turner would increase the sales of his proposed book, 'it was determined [by Tilt] to copy on a smaller scale', on steel plates, three of Turner's engraved designs from the *Provincial Antiquities: Roslin Castle, Crichton Castle* and *Tantallon Castle*. Turner objected strenuously to the plan to copy engravings made after his watercolours, and, during the early months of 1833, he paid for repeated advertisements in various newspapers, informing the public that these prints had 'NOT been engraved from his Drawings or touched by Mr Turner'.[2]

Turner's objection to Tilt's proposal is understandable, and in certain respects was justifiable, despite Tilt's repeated assertions to the contrary. When Tilt bought the copper plates of Turner's illustrations in the *Provincial Antiquities*, he had purchased only the right to print further impressions from them (though not according to Turner); he did not have the right to make new plates from the impressions of the old plates. Indeed, the Engraving Copyright Act of 1766 states that the law protects only those 'making an engraving from the original work [of art]'. Thus, Tilt was wrong in believing that he could

consider the engravings in the *Provincial Antiquities* as 'originals'. However, Turner was opposed not only to what he considered the illegality of this procedure, but to the creation of an inferior standard of engraved image. From his broad experience, Turner knew that if the engraver made a copy from an engraved image, the results could not help but be inferior. The engraver would lose qualities of the original watercolour and, through misinterpretation, create distortions of it. Thus, it was for the above reasons that Turner sought to prevent Tilt from 'continuing to do what ... [he, Turner] considered to be an act of great unfairness'. The following extract from *The Times* of 16 October 1833 gives an account of Turner's charge against Tilt, which was heard at Mansion House by the Lord Mayor. The Lord Mayor suggested that since the dispute could not be settled at this hearing, then Turner should apply for an injunction at the Court of Chancery. This Turner does not appear to have done, and Tilt's book containing his three designs was published in the spring of the following year (1834), despite Turner's protests:

... Yesterday Mr Tilt, the print-seller of Fleet-street, appeared before the LORD MAYOR, without being summoned, to meet the charge of Mr Turner, the celebrated artist. Mr [John] Martin [the editor of the proposed book] and other gentlemen of high professional character attended.

The LORD MAYOR said that Mr Turner had applied to him to interfere, to prevent Mr Tilt from continuing to do what the former considered to be an act of very great unfairness. The matter certainly was not within his jurisdiction, but he did not confine himself to the strict limits of his magisterial duties in cases which were brought before him, and as he felt for the honour of his fellow-citizen, he frequently took cognizance of accusations and imputations for the purpose of rendering other proceedings unnecessary.

Mr Turner stated that he had been employed by Sir Walter Scott to paint illustrations of the antiquities of Scotland, and engravings had been made on copper from his labours. Mr Tilt had got hold of these engravings, and procured a professional man to engrave from them on a smaller and steel plate, and published copies as illustrations of Sir Walter Scott's works, attaching to each copy his (Mr Turner's) name as the original artist. Now, such a mode of carrying on trade was disreputable, inasmuch as the plagiarism was calculated to deceive the public and to diminish the reputation of the painter, and necessarily his profits. Mr Turner produced copies from the original plates and copies of the imitations, and submitted to the Lord Mayor that the latter were likely to prejudice him in the estimation of the discerning part of the public. Mr [Augustus] Callcot[t] another Royal Academician and a gentleman of very great eminence, was subjected to similar treatment, so that it became a matter of necessity to check a practice which threatened to fasten upon painters the blunders and want of genius so manifest in the attempts of others.

The LORD MAYOR asked what the custom of the trade was?

Mr Turner said that the moment the plate had been used for the specified number of copies there was an end of it, and it could be no longer used in any way against the interest and consent of the artist. The plates he objected to had never been done from his drawing, although his name was attached to them. The gentleman who had engraved 'Rosslyn Castle' for Mr Tilt had, very properly, upon being appealed to, refused to assist in continuing the deception, and it was only reasonable to expect that Mr Tilt would not, under the circumstances, fill up the place of that engraver, in justice to the whole profession.

Mr Tilt said that Mr Turner was never more mistaken in his life than in supposing that there was anything illegal or unfair in what he complained of. Mr Turner had been one of those in whom the property in the plates from his drawings was vested, and as soon as the plates had done their work the proprietors thought proper to sell them to the highest bidder, which he (Mr Tilt) happened to be. As the property in the article was thus regularly transferred, he certainly had a right to do as he pleased with it. He considered the copyright as vested in him. He had purchased the plates openly; he had informed Mr Turner of his intention; there had been no mystery or concealment; and as to the imputed injury to the reputation of the artist, that was a point on which a difference of opinion might and did exist.

The LORD MAYOR. – Did you buy the copperplates as old copper or as plates?

Mr Tilt said that the value of the plates as old copper could not exceed 50s., and he had given for them [£]110.

The LORD MAYOR. – I wish to know why, if the plates were done with – if, as has been said, they had done their work, and could not be fairly applied to any use of art – they were not destroyed, instead of being sold? (A laugh).

Mr Turner. – They were sold without my consent.

The LORD MAYOR. – But the sale is not disputed; it was sanctioned by your partners in the work.

Mr Martin said that he had called upon Mr Turner and Mr Callcot[t] and told them what was about to be done. Mr Callcot[t] did not offer the slightest objection, admitted that the purchaser of the plates had a right to do as was stated, and only hoped that his reputation might not be allowed to suffer by the new plates: upon being assured that every care should be taken, he was perfectly satisfied. Mr Turner, however, refused to consent, although assured that if he objected to the impressions they should be at once put behind the fire. He had also been requested to retouch the illustrations, but nothing could reconcile him to the circumstance.

Mr Turner. – I don't see why an artist should retouch without remuneration. But how could I retouch copies when the originals are in the possession of Sir Walter Scott's executors?

Mr Tilt. – The fact is, I made offers to Mr Turner, in conjunction with other artists, but he refused, as he could not get the whole job to himself. I wished for a division of the labour and profits, but Mr Turner wished to monopolize, and would not give a share to his brother artists. He knows he has not a leg to stand upon, or he would not resort to this mode of complaint. I am proprietor of the plates, and I dare him to the test of our claims in a court of law or equity.

Mr Turner. – I intend to try the case on its merits in another place.

The LORD MAYOR. – I regret that this affair cannot be settled amicably by me: and all I can say is, that an application for an injunction from the Court of Chancery is the only mode I can recommend.

Mr Tilt. – Mr Turner knew perfectly well that I would not relinquish my right, and I am ready to meet him.

Mr Turner. – I trust, however, that the public will be put in possession of the way in which these things are done, that works by other persons are foisted upon them as the works of distinguished men.

Mr Tilt. – Oh, Mr Turner, you ought to let your brother artists have a little slice. (Laughter.)

Appendix 2

The Scott Monument

Early in October 1832, only days after Scott's death, a meeting of 'Friends and Admirers' was held in Edinburgh, at which it was resolved that a committee should be set up, composed of 'Noblemen and Gentlemen', who would consider 'the best means of testifying by some public and permanent mark, their respect for his memory'.[1] In the event, two committees were formed, one from Edinburgh, the other from London, to consider the building of a public monument in Scott's memory in Edinburgh. Notices were distributed throughout England, Ireland and the Colonies, as well as in Scotland, advocating the setting up of local committees and machinery for the acceptance of subscriptions. The debate over the design of the Edinburgh memorial, like the jury's choice of design for the new Parliament Buildings in London, throws much light on nineteenth-century taste. The efforts to select a suitable design began in 1833 and only ended in 1838, when George Meikle Kemp was chosen to erect the monument in the Gothic Revival style that now graces Princes Street Gardens (**106**).

As a result of their appeals, the committees in Edinburgh and London quickly raised considerable funds. However, the London committee, which had originally pledged to support the erection of an Edinburgh monument, changed its mind and decided that its collected funds should be employed to relieve the financial straits of the Scott family, who still carried the considerable burden of Sir Walter's debt.[2] Despite repeated efforts to revive the London committee's interest in the Edinburgh memorial, the London group remained determined to use their money to help to liquidate Scott's debt. The differing objectives of the two committees had the unfortunate effect of discouraging further public donations to either body.[3]

Cadell was made a member of the Edinburgh General Committee's Sub-committee, which was formed on 28 November 1833 and whose sole task was 'to Report to the General Committee on the most eligible plans and site [for a monument] within the City of Edinburgh'. The designs were to be limited 'to a Monument purely architectural, or including a statue as part of the design, in preference to one entirely sculptural'.[4]

On examining the designs which were eventually submitted,[5] the Sub-committee found agreement difficult, especially concerning the style of the monument to be erected. Indeed, full agreement was never reached, for the Sub-committee split into two opposing factions, one preferring an obelisk design, the other favouring a Gothic cross.[6]

Cadell was probably responsible for bringing Turner into the fray. Although Turner's admiration for great men, such as Scott and Napoleon, was often reflected in his art, on this occasion he expressed his continued respect for Scott's

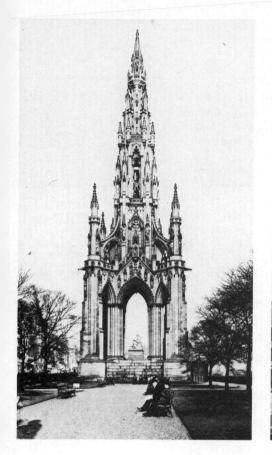

106 George Meikle Kemp, the Scott Monument, Edinburgh. 1840–46. Photograph taken *c.*1910. Royal Commission on the Ancient and Historical Monuments of Scotland, Edinburgh.

107 W. H. Playfair, *Proposal for a Monument to Sir Walter Scott.* Pen and brown wash. Signed and dated 1835. 16¼ × 11⅜ in; 41.3 × 29.0 cm. Royal Commission on the Ancient and Historical Monuments of Scotland, Edinburgh.

memory by also involving himself in discussions concerning the erection of the Scott monument. In October 1832, on his return to London from a trip to France, where he had made sketches for Scott's *Life of Napoleon*, he found a letter (probably sent on Cadell's recommendation) inviting him to join the London Committee which had been formed to find a way 'to perpetuate the memory and talent of Sir Walter Scott'. Delighted, he immediately wrote to Cadell: 'I ... found among my Letters one proposing to place my name on a Committee ... answer to be addressed to W.F. Scott MP John Street, Berkeley Square which I have done with the word YES. Now do tell me something about it immediately if you please by post.'[7]

Turner's interest in the London Committee was, however, short-lived; after this body had decided to devote its funds to a different objective, so increasingly did the painter focus his attention on the activities of the Edinburgh General Committee. As one of its members, Cadell had presumably kept Turner informed of its proceedings before the artist's 1834 tour. Turner was certainly fully informed by the autumn that year, when he visited Edinburgh to sketch subjects for the *Prose Works*, the proposed new edition of the 'Waverley Novels' and the still unwritten Life of Scott. It was at this time that invitations were extended to artists and architects to submit designs for the monument. Thus, Turner was at the centre of activity; even if he was not himself asked to submit a design, he was certainly consulted by Cadell both about the style to be adopted for the monument and its possible setting. Cadell had been pondering the question of the style as far back as the spring of 1833, when he had been in London, getting the production of the *Prose Works* under way. While in London, he decided to drive to 'Mr Britton 17 Burton St ... about *Monuments* and pillars and crosses'. That the purpose of this visit to Britton was to consider the memorial to Scott is proved by a second visit to Britton two days later, when Cadell 'had a talk ... about a [?Gothic] Cross as the most appropriate monument to Sir Walter Scott in Edinburgh'.[8] When appointed to the Sub-committee later that year, he exhibited the same zealous enthusiasm to select what in his view was the most fitting type of monument. However, Cadell, who had originally embraced the idea of a cross (presumably a Gothic cross), had by the autumn of 1834 become one of the most vociferous contenders for the obelisk.

There is every reason to believe that Cadell's change of mind was due to Turner, who was convinced that the only style of monument suitable for commemorating Scott would be an obelisk, and one of 'commanding size'. Also, it seems probable that Turner made a sketch of the type of memorial that he had in mind, for, while he was with Turner in Edinburgh in the autumn of 1834, Cadell acquired a 'drawing' or 'sketch' of an obelisk that he was anxious to show to the architect, W.H. Playfair.

Can it be fortuitous that the design submitted to the Sub-committee in January 1835 by W.H. Playfair (**107**) was of an Egyptian obelisk, and that this would be of 'commanding size', being two hundred feet high and supported on a granite base forty-four feet high? By late 1835, the Sub-committee had narrowed its choice to Playfair's obelisk and a Gothic cross designed by Thomas Rickman (**108**). Rickman's cross was to be 'eighty-five feet in height or one hundred if desired to be built of Craigleith stone rising from a granite base, comprehending a colossal Statue of Sir *Walter Scott*'.[9] Many members favoured

the Rickman Gothic cross.[10] There was, however, a clamorous minority, led by Cadell, who repeatedly stated their preference for the obelisk. Cadell, who spoke eloquently in support of the obelisk, considered Turner's opinion on the matter so important that he insisted on its being recorded in the Sub-committee's report, published late in 1835: 'An obelisk of commanding size was strongly recommended as the only suitable monument for the purpose, by that eminent artist MR TURNER, whose opinion in matters of taste is deserving of the greatest weight. . . .'[11]

In the hope of eliciting opinions from the General Committee, the Sub-committee did at least agree that the designs of the two contenders should be displayed at the Royal Institution, and this was done before the General Committee met on 11 December.[12] Cadell inspected the drawings on the tenth, but his opinion remained unchanged. Of the meeting on the following day, he jotted tersely in his diary, 'great Battle'.[13]

Clearly, each faction of the Sub-committee had planned its own strategy. The published report of the Sub-committee, recommending the Rickman design, was read out. However, an opponent then moved that 'Mr Playfair's design for an obelisk be adopted'. Before the General Committee could debate the matter, the Rickman faction of the Sub-committee proposed another motion, recommending the Gothic cross.[14] Predictably, Cadell had a great deal to say both against the proposal for a Gothic cross and in support of the obelisk: 'I spoke more at length than any other & fully as well as I expected myself. . . .'[15] Because of the lack of unanimity, the General Committee proposed a new competition, details of which would be worked out by the Sub-committee at a January meeting.

Some members of the General Committee, who opposed the obelisk, did not respond favourably to the portion of the report which contained Turner's opinions, nor did they favour the support given to his views by the artist on the Sub-committee, William Allan, regarding the attitude of these painters as artistic interference. One member of the General Committee could not refrain from remarking,

A Monument in this Country, erected to a Native of this Country, with its adjuncts or ornaments, ought to be an edifice which tells at once what it is – An Egyptian Obelisk gives no such information. The decoration of the City from without, is manifestly what has operated upon the minds of the two very eminent painters, whose opinions were imparted to us at the Meeting and the Obelisk as they state it may no doubt form a very pre-eminent and distinguished decoration, but it does not disclose to the spectator that it is monumental, until near approach enables you to see the relievos and read the inscription. . . .[16]

Another member also registered his irritation:

I can hardly doubt that you are against the monst[rous] obelisk . . . which would be as high as the eaves of the George Street houses, throwing the adjacent houses into utter insignificance or appearing in itself a hugely disproportion'd erection – some stress is laid on the opinion of Artists, more I confess than I think it is worth, I mean Painters & Turner in particular as stated by Cadell (who has taken up the obelisk in the odious & intemperate manner that is usual with him) to have recommended such an obelisk as *the only* suitable monument to Sir Walter Scott. Now what I should like would be, not to have the opinions of Painters as to the *suitability* to Sir W. Scott, which we can ful[l] as well or

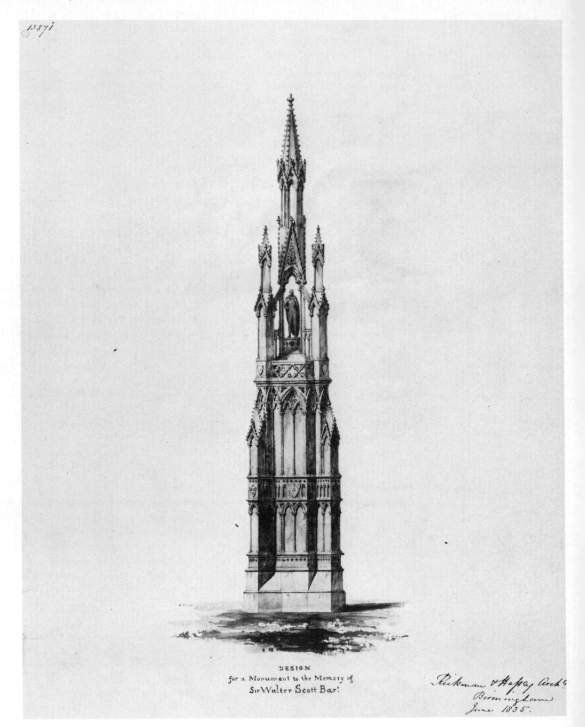

DESIGN
for a Monument to the Memory of
Sir Walter Scott Bar.[t]

better ourselves – but what is the opinion of men of Taste as to the effect of a Gothic structure in connection with modern houses.... What is Turner's own opinion tho' not very good in stone & lime....[17]

David Hay, the Edinburgh decorator/painter, an opponent of Rickman's design, reported the result of this meeting to the artist David Roberts, a friend of his, whose own designs had been rejected earlier by the Sub-committee: 'Playfair, I believe has retired from the contest, so we [in the end] shall likely have a black figure under a canopy like an umbrella or a blackbird in a wicker cage....'[18]

At a meeting on 12 January 1836, the Sub-committee agreed to advertise for designs 'in which the combination of a statue with architecture [was] indispensable'.[19] During the summer fifty-five designs were received, '22 of which were Gothic structures, 11 statues more or less combined with architecture, 14 Grecian Temples, 5 Pillars, one obelisk and one fountain'.[20] These were assembled in one of the rooms of the Royal Institution; Cadell examined them in September, but was disappointed.[21] He inspected them again in November,[22] in preparation for a meeting of the General Committee in December.

When the General Committee next met on 16 December, it was decided that five members of the Sub-Committee, including Cadell and William Allan, should make an initial selection of designs, from which the General Committee would select three to be awarded prizes.[23] At a meeting on 21 December, the five members from the Sub-committee made their selection, from which the General Committee duly made its choice. The first prize was won by Rickman, who had submitted a reworked version of his earlier design; the second was won jointly by Charles Fowler, an architect, and A. W. Leiver, a sculptor; and the third was awarded to George Meikle Kemp (who had competed under the pseudonym of 'John Morvo') for a Gothic cross, containing an effigy of the author.

Despite the fact that three awards had been made, some members of the Sub-committee still expressed dissatisfaction, this time because of the poor quality of the winning submissions and probably also because they were all Gothic crosses. Indeed, the feeling within the pro-obelisk faction of the Sub-committee was so intense that some members wished to go before the General Committee. Although evidence conflicts on the point, it appears that the Sub-committee's inability to reach a consensus was raised at a meeting of the General Committee on 3 January 1837, when a resolution was passed that 'none of the designs was considered worthy of being adopted'.[24] Little progress was made that year.

Renewed efforts were made to arrive at a solution at a meeting of the General Committee on 19 January 1838, when it was decided that the members should re-examine all the designs which had been submitted and establish new priorities for prizes. The first prize now went to the cross submitted by Kemp, who had obtained third prize in the earlier competition; the second was given to a design for a cross by a Mr Bell; the third, to one by a Mr C. N. Wilson, and the fourth prize, for yet another cross, to a competitor whose name has not been recorded.[25] At a meeting on 2 February, the Sub-committee considered the four prize-winning designs and decided in favour of Kemp's Gothic cross, which, according to his proposal, was to contain an effigy by the sculptor 'Mr [John] Steele [Steell]'. Cadell strongly opposed the decision, but was 'outvoted

108 Thomas Rickman and Hassey, *Design for a Monument to the Memory of Sir Walter Scott, Bart.* Watercolour. Inscribed and dated June 1835. 14 × 11 in; 35.5 × 27.9 cm. Collection of the Duke of Buccleuch.

hollow'. His grief is expressed in this short outburst in his diary: 'Mr Kemp's plan and some poor Statue by Steel[l] is to commemorate Sir Walter Scott!!'[26] But the battle was far from over.

On 5 February, Thomas Hamilton, the architect, called unexpectedly at Cadell's office in St Andrew's Square. He had come to inform the publisher that his design for a church, which had been prepared years before and submitted to the Town Council of Edinburgh, had served as the basis of Kemp's design. Hamilton asserted that Kemp had not only seen his design, but had held the plans in his hands. Cadell now saw his opportunity to strike a mortal blow against the Kemp design. Excitedly he took both Hamilton's account and his plans to William Allan; then he gave his information to the other members of the Sub-committee who supported the obelisk.[27] Finally, he brought the matter to the attention of the full Sub-committee on 28 February, hoping to discredit Kemp's proposal. Since Cadell was the leading opponent of the Kemp design, many members must have been suspicious of his motives; at any rate, they refused to discuss the matter further. Sadly the publisher noted in his diary, 'Mr Kemps plan [was] approved of by a majority of the Committee & a Report [is] to be made accordingly to [the] larger Committee – Allan & I the Minority....'[28]

Having failed to sway the Sub-committee, Cadell privately printed a letter opposing Kemp's design and sent a copy of it, together with evidence of Kemp's plagiarizing of Hamilton's design, to each member of the General Committee.[29] The letter contained a devastating attack on the Sub-committee, which Cadell accused of lacking professionalism in selecting the design of a man as ill qualified as Kemp. His appointment, the publisher contended, appeared to be based on so-called and questionable 'native genius'. Not only was he 'unheard of' as a professional, but the Sub-committee had failed to provide any 'specimen of what he [had] done in architecture, not even the erection of a cow-house'.[30]

Cadell believed that the Sub-committee's decision had been manipulated. He noted that the last meeting of the Sub-committee had been 'managed with good theatrical effect', but added that 'an experienced eye could observe that there had been a rehearsal before an inner circle'.[31] Kemp's design was supposed to have been based on Antwerp Cathedral, but Cadell declared, preparing to fire a final and decisive volley, that Kemp's Gothic cross had been copied from Hamilton's design for a church. In short, Kemp's design was a '*plagiarism*'.[32]

At a meeting on 19 March, the General Committee discussed Cadell's letter. However, the publisher's attack on the conduct of the Sub-committee lost rather than won him support. When the final meeting of the General Committee took place on 6 April, it was not without heat. Cadell spoke of it as the 'grand *battle*' in which old lines were still clearly drawn.[33] But Kemp's design was still upheld, and Cadell recorded that his side had been defeated by twenty-one votes to ten.[34]

Cadell (who sincerely believed, as did Turner, that an obelisk was the only suitable style for a monument to Scott) was aggrieved. However, he resigned himself to the situation and noted, '6 or 7 of our troops went away [before the vote] & some did not attend ... we are soundly beaten.' However, he was also somewhat relieved: '[I am] glad this affair is settled it was a burden on me.'[35]

No record survives of Turner's reaction to the General Committee's final

choice of design for the Scott memorial in Edinburgh. He had remained very much in the background of the controversy, though it was his opinion which indirectly seems to have caused the deep cleavage within the Sub-committee. He was, however, to make one more statement about the monument, and this he did in the illustration *39, Castle Street*, for Lockhart's *Life of Scott*, which is discussed in Chapter 10.

Appendix 3

The Selection of the Subjects illustrated in

Lockhart's Edition of Scott's *Poetical Works*

The discussions which took place over the choice of illustrations for Scott's *Poetical Works* are highly illuminating. (For an account of the discussions which centred on Volume 7, *Marmion*, see pp. 85–6.) The selection of subjects can be traced through several references to lists; the first tentative list was Cadell's and dates from 17 March 1831 (MS 3917, fol. 75). It was revised on 19 March (MS Acc. 6080, MSS 2–10; MS 3917, fol. 99). This was the list the publisher sent to Scott for perusal and amendment. It was returned to Cadell and a copy with Scott's revisions was posted to Turner on about 1 April (MS 920, fols 15–16v, MS Acc. 5188, Box 2 (diary), 1 Apr. 1831). This final, amended March list was the authoritative one, but it underwent constant changes. Some were made on 12 July (MS 1752 (typescript), p. 326v) and others on 29 July (MS 3918, fols 204v, 205). Still further revisions took place on 1 August, only a few days before Turner arrived at Abbotsford. On 6 August, after Turner's arrival, additional amendments were made when the artist's views were taken into account (MS Acc. 5188, Box 1). A penultimate list, made on 17 September by Cadell and Turner, is reasonably close to the arrangement and choice of subject-matter eventually published (MS Acc. 6080, MSS 2–10, 'Memoranda and Calculations'). For a list of the subjects published, see the end of this Appendix.

The eight views illustrating the four *Minstrelsy* volumes (which would open the *Poetical Works*) were to include castles and abbeys drawn from the areas near the western, central and eastern Border. The subjects proposed for the west were to be taken by Turner on his way northwards to Abbotsford. The western subjects considered were Carlisle Castle, Lochmaben Castle, Caerlaverock Castle, Lincluden and New Abbey; from the central and eastern Border, Kelso Abbey, Jedburgh Abbey, Hermitage Castle, Roxburgh Castle, Norham Castle, Johnny Armstrong's Tower of Gilnockie, Dryburgh Abbey, Smailholm Tower, Newark Castle and Cessford Castle were proposed. In early March, after Cadell had begun the task of drawing up a list of subjects, Scott recommended for the *Minstrelsy* the 'very striking Smailholm Tower', near the abode of his childhood. Hard by, he noted, there were Newark Castle, 'although somewhat hacked', and other possible subjects, 'Cessford castle, Hermitage castle & many very fine [ones?] besides' (MS Acc. 5131, fol. 43, 13 Mar. 1831, W.S. to R.C.). Later Scott was to observe, 'The more we can get in my neighbourhood the better.' (Ibid., fol. 140v, 1 Aug. 1831.) With the exception of Newark Castle, all of these subjects appeared on the final March list as suitable for the *Minstrelsy*.

On the final March list, it was tentatively proposed that the first volume of the *Minstrelsy* should show Kelso as the frontispiece; either Smailholm Tower or Roxburgh Castle was suggested for the vignette. For Volume 2, Jedburgh, 'with river in foreground', was proposed for the frontispiece, and Norham Castle '&

Tweed' (a subject which Turner had previously taken) was suggested for the vignette. Dryburgh Abbey '& Tweed' was proposed as the frontispiece to Volume 3, with Cessford Castle considered for the vignette. The fourth and final volume was to be illustrated by a view of Carlisle (this was Scott's suggestion, though he would have preferred it as the illustration for *The Lady of the Lake*) as the frontispiece and either Hermitage Castle (Cadell's suggestion) or Lochmaben Castle (Scott's suggestion) as the vignette.

On 12 July, Cadell suggested other subjects for the *Minstrelsy*. For the fourth volume he proposed Caerlaverock Abbey, Lincluden and New Abbey as possibilities (MS 1752 (typescript), fol. 326v, 12 July 1831). He did not seem enthusiastic about Scott's suggestion of Carlisle. However, Carlisle appeared as the frontispiece on the 29 July list, and Lochmaben Castle was once more designated for the vignette. No mention was made of Hermitage Castle, which on the March list had been suggested, together with Lochmaben Castle, as possible views for the vignette. Scott was dissatisfied and was prepared to discard many subjects which Cadell had suggested, and with which, indeed, he himself had originally been in agreement. As a consequence, the publisher, in frustration, reduced the number of certain subjects from eight to four: Carlisle, Caerlaverock, Lochmaben and Hermitage. On the very day that Cadell did this he received another communication from Scott, undermining still further the existing list of *Minstrelsy* subjects. Scott indicated dissatisfaction with Hermitage and suggested that it should be replaced by Johnny Armstrong's Tower of Gilnockie. Caerlaverock and New Abbey, which had been suggested by Cadell on 12 July, were now described by the author as being 'stuffd in without propriety' (MS Acc. 5131, fol. 140v, 1 Aug, 1831, W.S. to R.C.). Some time before, Cadell had ventured to suggest Douglas Castle and Bowes Tower, but Scott would not hear of them (ibid., fol. 144v, 1 Aug., W.S. to R.C.). Scott then reinstated Hermitage (ibid., fol. 144, 3 Aug. W.S., to R.C.) and proposed Bemerside. This latter Scott suggested on 3 August, only a day before Turner's arrival.

Two days after Turner arrived, a revised list was prepared; this included many of the artist's suggestions (MS Acc. 5188, Box 1, 6 Aug. 1831). The list reaffirms Scott's choice of Carlisle for the frontispiece, but to Volume 1 of the *Minstrelsy*. The vignette was to be Johnny Armstrong's Tower. For Volume 2, Caerlaverock was designated as the frontispiece, and Lochmaben as the vignette. For Volume 3, Hermitage was to serve as the frontispiece, while the vignette would be Jedburgh. For the fourth and final volume of the *Minstrelsy*, the frontispiece was to be either Dryburgh Abbey or Kelso, and the vignette was to be Smailholm Tower. The penultimate order of the *Minstrelsy* illustrations was established on 17 September. The only changes occurred in the third and fourth volumes. In Volume 3, Jedburgh became the subject of the frontispiece and Hermitage that of the vignette. In Volume 4, Dryburgh was replaced by Kelso as the frontispiece (see MS 3919, fol. 2v, 1 Aug. 1831, R.C. to W.S.).

The fifth volume of the *Poetical Works* was to be devoted to *Sir Tristrem* and the illustrations were to depict views on the central Border. On the final March list, Scott had proposed Coldingnose Castle as the frontispiece and the cascade in Rhymer's Glen as the vignette (MS 920, fol. 16, 19 Mar. 1831). On the 6 August schedule, Coldingnose, which was not favoured by Turner, was dropped in

favour of Bemerside, another subject which he did not particularly like. The choice of vignette remained Rhymer's Glen, though the bridge rather than the waterfall was to be the main subject. By 17 September, however, Cadell and Turner decided that Dryburgh Abbey was to be the frontispiece and Bemerside the vignette. Rhymer's Glen was now dropped altogether as a subject for the 'Poetry' (MS Acc. 6080, MSS 2–10).

The sixth volume, containing *The Lay of the Last Minstrel*, was, according to the final March list, to have a view of Melrose Abbey by moonlight as frontispiece, while Abbotsford was contemplated for the vignette. Roslin had been proposed earlier by Scott, who had not liked Cadell's choice of Ravensheugh Castle (MS Acc. 6080, MSS 2–10). But Roslin was only briefly considered, as the publisher must have reminded Scott that Turner had already published this subject in the *Provincial Antiquities*. It was then decided that Melrose Abbey and Abbotsford would be the most appropriate combination of subjects for the *Lay*, and, indeed, these were the subjects on which Cadell and Scott were probably agreed from March to 6 August. However, only a day or two after the 6 August list was drawn up, a change of mind occurred, perhaps due to Turner. Two views of Melrose Abbey were suggested for this volume: one of the Abbey, from close quarters, which would be the vignette; another, a distant view of the Abbey overlooking the vale of Melrose, which was proposed as the frontispiece. By 17 September, Turner and Cadell decided against both Abbotsford and Melrose for the vignette and proposed instead Newark Castle, the subject eventually published.

The Lady of the Lake, the major poem introducing the eighth volume, was to be illustrated by north-westerly subjects. On the final March list, a number of views had been proposed: the Trossachs, Benvenue or Loch Katrine as frontispiece, and several subjects, including Loch Lomond, Beala-nam-Bo and Inch Cailloch, for the vignette. On the 1 August list, the subjects had been reduced to the required two. Loch Katrine was proposed as the frontispiece and Benvenue was to be the vignette. However, Turner was not altogether happy about these subjects, for on the 6 August list they were considered as being only tentative. Cadell wrote that the illustrations for this volume must 'depend on Scenes [? taken] but Trosacks & Benvenue with Loch Lomond half way up Ben Lomond' (MS Acc. 5181, Box 1). By 17 September the frontispiece proposed was 'Island Lake' (? Inch Cailloch), while Loch Achray, Trossachs and Benvenue were suggested for the vignette (MS Acc. 6080, MSS 2–10, 'Memoranda and Calculations').

The major poem of the ninth volume was *Rokeby*. Cadell had suggested Mortham Tower as frontispiece. Scott insisted that the frontispiece should be Barnard Castle and that Mortham would be more appropriate as the vignette. This was the arrangement established on the final March list. However, on the 1 August list, changes were made. Cadell now proposed Bowes Tower as the frontispiece and a scene on the Greta as the vignette. He pointed out to Scott that he did not feel Mortham would be acceptable since this place had been illustrated earlier by Turner for his 'Yorkshire' views (see p. 30); it would not do, he said, to have a repetition of 'what the same Artist has already done – in this matter the great object is originality by Mr Turner' (MS 3919, fol. 1v, 1 Aug. 1831, R.C. to W.S.). Scott continued to insist that Mortham was 'absolutely necessary'. The setting was particularly beautiful, he noted, 'with

the curious monument [Mortham Tower] adjacent picturesquely situated between two tall trees' (MS Acc. 5131, fol. 140, 1 Aug. 1831, W.S. to R.C.). Bowes Tower, Scott agreed, was 'fine', but it 'would not so well connect with the subject [Rokeby]. . . .' (ibid.) He reminded Cadell of the importance of selecting illustrations suited to the poetry: 'You are aware that it is from the happy adaptation of the works of an artist to the poetry that the public will judge that the illustrations have been actually designed for the publication.' (ibid.) A compromise solution was reached on the 6 August list, Mortham Castle was to be the frontispiece; Bowes Tower was to be the vignette. This combination of subjects appears on the 17 September list (MS Acc. 6080, MSS 2–10).

The Lord of the Isles was to be the poem to introduce the tenth volume. On the preliminary March list (MS Acc. 6080. MSS 2–10), a number of subjects from the Western Isles was suggested: Artornish (Ardterinish) 'with a thunder storm', Mull Sound, Strathnardill and Dunskye (Dunskaich), Staffa and Loch Ranza. Scott added to these possible subjects Loch Coriskin, the 'finest or wildest' of the landscapes on Skye. On the final March list (MS 920, fols 15v, 16) Staffa was replaced by Loch Coriskin. However, Scott was neither sure that Turner would have the time to sketch these subjects from this northern part of Scotland, nor convinced that they were absolutely necessary. On 22 April, he noted that 'highland scenes' would 'lead him [Turner] too far, [and] put him to inconvenience and delay, time perhaps too long', and he recommended that, for these subjects, 'we will either get copies, or find substitutes so we will have the whole capable of being fitted up within the time you propose' (MS Acc. 5131, fol. 77v, 22, 23 Apr. 1831, W.S. to R.C.). By August, however, it was almost certain that the northern tour would take place, and so Loch Coriskin was selected for the frontispiece, while either a scene from Staffa or McLeod's Maidens would serve for the vignette. However, there was still some doubt, since Cadell made a note that these were *possible* subjects, probably depending again on the availability of time or even on the weather. The only change indicated by 17 September was the elimination of McLeod's Maidens as an alternative to a view on Staffa (MS Acc. 6080, MSS 2–10.)

The eleventh volume was to feature *The Bridal of Triermain* and was to illustrate subjects on the south-westerly 'English Road'. On the preliminary list (MS Acc. 6080, MSS 2–10), Skiddaw and Penrith Table were proposed as subjects for the frontispiece, but no subject was suggested for the vignette. On the final March list, Namworth Castle and the Castle Rock of St John were proposed for the latter. By 1 August, Skiddaw was tentatively selected as the frontispiece. The suggestions for the vignette, however, were reconsidered: either the Castle Rock of St John or the Penrith Table was now suggested. Scott complained that Penrith Table, originally proposed by Cadell for the frontispiece, could not be connected with the poetry, although he conceded that it might be adapted 'as the place of combat' (MS Acc. 5131, fol. 144, 3 Aug. 1831, W.S. to R.C.). On the 6 August list, Skiddaw was confirmed for the frontispiece and Penrith Table for the vignette (MS Acc. 5188, Box 1). These subjects remained on the September list (MS Acc. 6080, MSS 2–10). Penrith Table was published as 'Mayburgh'.

On the final March list, the twelfth and last volume, devoted to the *Dramas*, was to include Berwick-on-Tweed as the frontispiece and Auchendrane as the vignette (MS 920, fols 15–16v, 19 Mar. 1831). On 29 July, Berwick remained as

the frontispiece, but Cadell suggested that the vignette might be either 'Fast Castle or Pease Bridge . . . a substitute for a Border Castle – of which there may be [now] too many – but I throw out this for your Consideration – these two . . . would illustrate the Eastern Border – as Carlisle and others illustrate the western & Jedburgh & Roxburgh the middle' (MS 3918, fol. 205v, 29 (?31) July 1831, R.C. to W.S.). On 1 August, probably as the result of Scott's major, unexplained objection to his proposals, he admitted that the subjects for the *Dramas* now left him 'wholly at sea . . .' (MS 3919, fol. 4, 1 Aug. 1831, R.C. to W.S.). By 17 September, it was agreed that the subject of the vignette should be Abbotsford (MS Acc. 6080, MSS 2–10).

The subjects and their order as published differ little from the selection and order established by 17 September, though the few changes are worth noting. Johnny Armstrong's Tower, which had been proposed as the vignette to Volume 1 of the *Minstrelsy*, was published as the vignette to Volume 2, and the vignette to Volume 1 showed Smailholm Tower. Caerlaverock, which in September was still being proposed as the frontispiece to Volume 2, was published as the frontispiece to Volume 4. Jedburgh, proposed as the frontispiece to Volume 3, finally appeared as the frontispiece to Volume 2, and its former position was eventually occupied by a view of Kelso. The vignette to Volume 3, as published, was Lochmaben. Hermitage Castle, which had been proposed as the vignette to this volume, became the vignette to Volume 4. These were the changes which took place in the *Minstrelsy* volumes. Fewer changes occurred in the remainder of the volumes. For Volume 8 (*The Lady of the Lake*), the frontispiece eventually selected was Loch Katrine; the vignette, Loch Achray. Mortham remained the frontispiece of Volume 9 (*Rokeby*), but it was combined with a view of the confluence of the Greta and the Tees. The final change occurred in Volume 10 (*The Lord of the Isles*) where the 'view on Staffa' finally published was Fingal's Cave.

Subjects illustrated in Lockhart's Edition of Scott's *Poetical Works*

Volume	Frontispiece	Vignette
1 *The Minstrelsy of the Scottish Border*	Carlisle	Smailholm
2 As above	Jedburgh	Johnny Armstrong's Tower
3 As above	Kelso	Lochmaben
4 As above	Caerlaverock	Hermitage Castle
5 *Sir Tristrem*	Dryburgh	Bemerside
6 *The Lay of the Last Minstrel*	Melrose	Newark Castle
7 *Marmion*	Edinburgh	Ashestiel
8 *The Lady of the Lake*	Loch Katrine	Loch Achray
9 *Rokeby*	Junction of Greta and Tees	Bowes Tower
10 *The Lord of the Isles*	Loch Coriskin	Fingal's Cave
11 *The Bridal of Triermain*	Skiddaw	Mayburgh
12 *Dramas*	Berwick-on-Tweed	Abbotsford

Appendix 4

Periods of Use of some Sketch Books

in the Turner Bequest (British Museum)

Number	Description	Years Employed
CCLIV	Seine and Paris	1832
CCLVII	Paris and Environs	1832
CCLXIV	Rokeby and Appleby	1831
CCLXV	Berwick	1831
CCLXVI	Minstrelsy of the Scottish Border	1831
CCLXVII	Abbotsford	1831
CCLXVIII	Edinburgh	1831, 1834
CCLXIX	Stirling and Edinburgh	1834
CCLXX	Stirling and the West	1831
CCLXXI	Loch Long	1831
CCLXXIII	Staffa	1831
CCLXXIV	Sound of Mull (I)	1831
CCLXXV	Sound of Mull (II)	1831
CCLXXVI	Fort Augustus	1831

Notes

Publications listed in the Bibliography are cited in the Notes by author's name and short title only. All MSS cited are in the possession of the National Library of Scotland unless it is otherwise stated.

CHAPTER 1

1 William Gilpin, *Observations relative to Picturesque Beauty made in the year 1776, on Several Parts of Great Britain; particularly the High-lands of Scotland*, 2 vols, London, 1789.
2 Ibid. I, p. 84.
3 Ibid. I, p. 52.
4 Scott, *Letters*, XI, pp. 459–61.
5 Finberg, *Life*, p. 73.
6 Ibid. p. 76.
7 British Museum, Add. MS 50118, fol. 24, 24v, 16 Jan. 1811, J.M.W.T. to John Taylor (editor of the *Sun*). I am grateful to Dr John Gage for reminding me of this reference to Scott's poems in the Turner Mss.
8 Thornbury, *Life*, p. 130.

CHAPTER 2

1 *Works*, XXI, p. 11; see also Herrmann, *Ruskin and Turner*, pp. 96–7 (79).
2 Ziff, 'J.M.W. Turner on Poetry and Painting', p. 196. The passage was transcribed by Ziff from Turner's notes in his copy of Opie's *Lectures on Painting* (p. 62), published in London in 1809.
3 Ziff, op. cit. p. 197. This quotation is taken from the 'Perspective Sketch Book' (Finberg, *Complete Inventory*, CVIII, pp. 287–91), pp. 48a, 49, 49a, 50a, 51a, 52a. The italics are mine.
4 Richards, *Philosophy of Rhetoric*, p. 93.
5 Finberg, *Complete Inventory*. The engraving is a view of Friar's Bridge (1780) after a watercolour by M.A. Rooker.
6 This drawing in the Bequest is not listed in Finberg's *Complete Inventory*.
7 Gilpin, *Observations on Cumberland and Westmore-land*, 2 vols, London, 1786. Turner made copies of at least two aquatints from this work, *Dacre Castle* and *Dovedale*, both of which are found in Vol. II. Unfortunately, these drawings, once in the Turner Bequest, seem to have been lost. See Finberg, *Complete Inventory*, I, D, H.
8 Finberg, *Complete Inventory*, I, E.
9 In Turner's second lecture for the Royal Academy (dated by J. Gage *c*.1810) the artist observed, 'It is inevitably [?] allowed that Engrav[ing] is or ought to be a translation of a Picture for the nature of each art varies so much in the means of expressing the same objects, that lines become the language of colors [which is] the great object of the engravers study. . . .' British Museum, Add. MS 46151, A, fol. 16v); see also Gage, *Colour in Turner*, p. 196.
10 I have benefited from reading Ivins's *Prints and Visual Communication*.
11 Victoria and Albert Museum, MS 86 FF. 73, fol. 89.
12 Ibid.
13 After having seen Pye's rendering of his *Pope's Villa*, Turner was determined that the engraver should translate more of his work. Pye was therefore presented with the famous *Temple of Jupiter* for engraving. The results were 'so gratifying to Turner that he offered to paint a companion picture for the express purpose of engraving'. While Pye was certainly given other works by the artist to engrave, his commissions from this quarter were not overabundant. As Pye himself recalled, 'I should have starved on Turner'. (Ibid.)
14 In early nineteenth-century England, the form of the vignette was often considered to be 'poetical', and thus the most suitable compositional framework within which to create 'a sort of midsummer-night's dream where Fancy,

unrestrained by time and place, indulges in the revelry of fairy fiction' (Landseer, *Lectures*, pp. 115–16). Turner possessed a copy of this work (Falk, *Turner*, p. 257).

15 A discussion of the significance of Turner's use of the three primaries can be found in Gage, *Colour in Turner*, pp. 106 ff.

16 See Finley, 'Two Turner Studies: A "New Route" in 1822', pp. 385–90.

17 Rawlinson, *The Engraved Work of J.M.W. Turner*, I, li.

18 Thornbury relates that Cyrus Redding recalled that he once met Thomas Campbell, the poet, who noted that he '"had gone to a great expense for Turner's drawings, to be engraved for my illustrated poems". (I forget the number he said, for each of which he had paid twenty-five guineas). "I was also told not to mind the expense; the drawings would sell, being Turner's, for what I had paid for them, as soon as the engravings were finished. They could not be disposed of at anything like the price. It was said they were not in his best style; in short, I thought I should be compelled to keep them. One day I saw Turner, and told him what had occurred, and that I had hoped to make something of them. I added, in joke, that I believed I should put them up to auction. Turner said, feeling annoyed, I suppose, at my remark, 'Don't do that; let me have them.' "I sent them to him accordingly," said the poet, "and he has just paid me for them." I think Campbell said twenty guineas each, but I am not sure of the sum, my recollection failing me about the precise amount. I could not help saying, "Turner does this because he is tender about his reputation; he will not have them in the market."' (Thornbury, *Life*, p. 233.) Cadell had paid Turner £1312.10.0 for fifty designs for the *Prose Works* and *Poetical Works* and sold them for £700, so that the actual cost of his designs was about £612, or approximately £14 per design rather than 25 gns, which they initially cost. (See MS Acc. 5188, Box 3 [diary] 17 Mar. 36.) When he calculated the cost of the illustrations by Turner for a new edition of *The Lady of the Lake* in 1838 (see Chapter 9, note 56), Cadell, while being charged £525 for twenty designs, expected them to bring him £250 when resold; therefore their actual cost to him would have been slightly more than £13 each.

1 For discussion of this project see Finley, 'J.M.W. Turner's Proposal for a "Royal Progress"', pp. 27–35.

2 MS 3889, fol. 217, 20 Oct. 1818: E. Blore to W.S.

3 MS 3134, No. 172 (1818).

4 Ibid.

5 Ibid.

6 Ibid.

7 Ibid.

8 Whitley, *Art in England, 1800–1820*, pp. 291–2. See also E. Blore's letter to W. Scott: 'Turner I believe is about starting for Scotland for [the] purpose of preparing his Drawings ...' (MS 3889, fol. 217, 20 Oct. 1818).

9 See Finberg, *Complete Inventory*, pp. 478–87 (CLXV, CLXVI, CLXVII). See especially CLXVI, p. 70a.

10 Thornbury, *Life*, p. 130; Lockhart, *Peter's Letters to his Kinsfolk*, II, p. 290; Baird, *John Thomson*, pp. 52–3; Napier, *John Thomson*, pp. 304, 542. Napier is probably incorrect when he states that Turner first visited the Manse in Duddingston in 1822 (Ibid. p. 301).

11 Fraser, *The Works of Horatio Macculloch*, p. 24.

12 Ibid.

13 Schetky, *Ninety Years of Work and Play*, pp. 108–9.

14 Ibid. p. 109.

15 According to the *Provincial Antiquities* contract (MS 3134, No. 172), there were to be regular meetings of the proprietors, at least 'once every six months and oftener if necessary'. Since at least half of the proprietors (Turner, Thomson, Lizars and Scott) were in or near Edinburgh for about two weeks in November, it seems likely that a meeting was held during that period.

16 MS 965, fol. 62, 30 Apr. 1819, W.S. to J. Skene; Skene, *Memories*, pp. 108–9. The year is erroneously given as 1823. Skene had enquired of Scott about the wisdom of employing Turner as the illustrator of Robert Stevenson's *An Account of the Bell Rock Lighthouse* (Edinburgh, 1824). Despite Scott's negative reply, Turner was commissioned and prepared a watercolour, based on a sketch by Skene, which served as the frontispiece to the work (*Memories of Sir Walter Scott*, p. 109); Finberg,

Life, p. 257. See also Turner's letter to Stevenson regarding the drawing (MS 785, fols 9–10, 8 July 1819).

17 Finberg, *Life*, p. 254.

18 MS 3029, fol. 3, 28 Oct. 1818, W.S. to E. Blore.

19 Ibid. fol. 5, 22 Jan. 1819, W.S. to E. Blore.

20 Ibid.

21 MS 3890, fol. 25, 25 Jan. 1819, E. Blore to W.S.

22 Ibid. fol. 25v.

23 MS 3893, fols 35, 35v, 10 Aug. 1821, E. Blore to W.S.

24 Ibid. fol. 36.

25 Ibid.

26 Scott, *Provincial Antiquities*, vol. 1, p. 85.

27 MS 3029, fols 9v, 10, 15 Nov. 1820, W. Lizars to E. Blore.

28 Ibid. fol. 7, 5 Feb. 1819, W.S. to E. Blore.

29 See Finley, 'J.M.W. Turner's Proposal for a "Royal Progress"', p. 31. In a private communication, Dr Gage has kindly brought to my attention Turner's letter of 3 Dec. 1823 to J.S. Schetky, published in Miss Schetky's *Ninety Years of Work and Play*, p. 129 ff., in which the artist refers to an abandoned series of engravings that Dr Gage believes are probably related to the unfinished oil paintings (which may not be *modelli*, as I have suggested in the article just cited). It should perhaps be mentioned that at this time (1822) Turner may have come in contact with James Skene, whose drawings of the Bell Rock Lighthouse formed the basis of one of the artist's designs (see note 16, above) and who on this occasion may have provided some fundamentals concerning theories of light and colour which still engaged Turner's attention. Indeed, Turner seems to have been experimenting with optical ideas in certain watercolours which he prepared almost immediately after this 1822 trip (see Finley, 'Turner: An Early Experiment with Colour Theory', pp. 357–66, and 'Two Turner Studies: A New Route in 1822', pp. 390–96).

30 Finley, 'J.M.W. Turner's Proposal for a "Royal Progress"', p. 32, n. 22.

31 MS 3896, fols 195, 195v, 13 June 1823, E. Blore to W.S.

32 MS 3029, fol. 34, 16 June 1823, W.S. to E. Blore.

33 Ibid.

34 Whitley, *Art in England 1821–37*, p. 248. The following watercolours were hung in the 'oaken frame': *Borthwick Castle; Edinburgh High Street; Crichton Castle; Heriot's Hospital, Edinburgh; Linlithgow Palace; Edinburgh from the Calton Hill; Roslin Castle (Hawthornden)* and *Tantallon Castle*. These watercolours were in the possession of Ralph Brocklebank by 1886; see Royal Academy of Arts catalogue, Winter Exhibition, London, 1886, p. 51.

35 MS 3029, fols 34, 34v, 16 June 1823, W.S. to E. Blore.

36 Ibid. fols 36, 36v, 37, 37v, 1 July 1823, J. Thomson to E. Blore.

37 MS 3893, fols 155, 155v, 16 Nov. 1821, E. Blore to W.S.

38 MS 1708, fols 136, 136v, 10 July 1823, E. Blore to G. Cooke.

39 MS 3899, fol. 218v, 25 Nov. 1824, E. Blore to W.S.

40 The new publishers' imprint appears in the two-volume work.

41 MS 3917, fol. 186v, 2 Apr. 1831, J. Thomson to W.S. See also Scott, *Journal*, p. 463, 25 Apr. 1828, concerning Scott's attempt to dispose of proofs.

42 MS 786, fols 104, 104v, 2 June 1828, J.M.W.T. to J. Thomson; see also MS 3917, fol. 186v, 2 Apr. 1831, J. Thomson to W.S.: '... I have had no connection with the concern [the *Provincial Antiquities*] for years past. I was advised to sell out – and Turner conducted the Transaction for me – If he has made good his threat of visiting you he will have furnished you I doubt not with good information as well as safe counsel...'

43 MS 3917, fol. 270v, 20 Apr. 1831, J.M.W.T. to W.S. Cadell was responsible for converting Scott's copies into cash (MS Acc. 5188, Box 7 (diary), 16, 18 June 1831).

44 Rawlinson, *The Engraved Work of J.M.W. Turner*, I, p. 107.

CHAPTER 4

1 Scott, *Letters*, XI, p. 197 (6 June 1829), W.S. to J. Gibson (the agent for Scott's trustees).

2 MS 3915, fol. 217, 28 Dec. 1830, R.C. to W.S. See also MS 3919, fol. 41, 18 Aug. 1831.

3 15 Jan. 1831, W.S. to S. Rogers, in Scott, *Letters*, XI, pp. 459–61.

4 For example, see W.S. to C. Tilt (14 May 1830), Edinburgh University La III, 585[26]. Scott wrote to Tilt, the publisher, 'I . . . very ungraciously left unacknowledged your present of the Landscape illustrations of Waverley. I pretend no Knowledge of art so my opinion ought to go for nothing. But I think they are very beautiful and sincerely hope they will serve [?] the purpose of the artist and publishers.' See also MS Acc. 5131, fol. 43, 13 Mar. 1831 (W.S. to R.C.) and fol. 55, 30 Mar. 1831. Scott had a reputation for lacking any artistic sense. C.R. Cockerell noted in his diary of 1824 that 'Sir W. Scot[t] who knows nothing of painting was praising a composition of Marmion by an amateur – saying it was wonderful & that it was by a *man of fortune and family* appealing to Nasmith [*sic*] who replied that it was so well it might have been done by a Duke.' See entry following 13 June 1824. Skene, on the other hand, believed that Scott had very firm ideas about the arts, including painting: 'Sir Walter considered the main end and object of painting, music and poetry to be in that respect the same; that the powers of each of them rested not in furnishing the subjects of imagination, ready dressed and served up, so much as in those happy and masterly touches which gave play to the imagination, and exerted the fancy to act and paint for itself by skilfully leading it to the formation of lofty conceptions and to the most pleasing exercise of its own attribute. Hence the superior effect to most minds of an ingenious sketch, where a dexterous and clever hint gives being to beauties which the laborious details of painting could never portray.' (Skene, *Memories*, pp. 63–4.) Indeed, because of Scott's interest in art, he became associated with the Royal Academy in London, and in 1827 was 'elected Antiquary to the Institution . . .' (Whitley, *Art in England 1821–1837*, p. 128). Further, as a youth Scott studied oil painting, though he observed, 'I could make no progress either in painting or drawing. Nature denied me correctness of eye and neatness of hand. . . .' (Ibid. pp. 244 ff.)

5 15 Jan. 1831, in Scott, *Letters*, XI, pp. 459–61. Rogers replied on 4 Feb. 'Happy should I be if I thought the Picture-book I sent you, could give any pleasure at Abbotsford; & still happier if it would induce you to lay your scenes in Italy & to transport *us* thither, though you will not go yourself. I am sorry to learn that you are not so well as we wish you to be. I have been ill myself, but am now nearly recovered, though not what I was before – I have indeed no right to expect it.' (MS 3916, fols 224, 224v, 4 Feb. 1831.)

6 MS Acc. 5188, Box 1 (diary), fol. 85v, 3 Feb. 1831. The 'Poetry' was certainly discussed again while Scott was still in Edinburgh on 6, 8 Feb. (Ibid. fols 87v, 90–90v.)

7 Ibid. Box 2 (diary), 24 Feb. 1831.

8 British Museum, Add. MS 50118, fol. 24.

9 These drawings were part of a series of watercolours displayed in cases at Farnley Hall, illustrating the poems by Lord Byron, Scott and Moore. In addition to the watercolours commemorating the poetry of Scott, there was a frontispiece to the series, one design inspired by Byron, *Tis Greece but living Greece no more*, and another, *Lalla Rookh*, from Moore. Reference to this series can be found in a manuscript catalogue of Turner's paintings and watercolours 'in the possession of F.H. Fawkes Esq. of Farnley Hall, Otley, Yorkshire A.D. 1850' (Victoria and Albert Museum, MS 86 EE 38). The Poet Series occurs on pp. 6v, 7, with a note that 'All drawings [are] of 1822.'

10 MS Acc. 5188, Box 2 (diary), 5 Mar. 1831.

11 MS 3917, fol. 30, 7 Mar. 1831, R.C. to W.S.; MS Acc. 5188, Box 10 (not foliated), 7 Mar. 1831, R.C. to W.S. (copy).

12 MS 3917, fol. 30, 7 Mar. 1831, R.C. to W.S. See also Scott, *Journal*, p. 648. Scott comments that the price that Turner is charging 'is cheap enough considering these are the finest specimens of art going' (14 Apr. 1831).

13 MS 3917, fol. 30, 7 Mar. 1831, R.C. to W.S.; MS Acc. 5188, Box 10 (not foliated), R.C. to W.S. (copy).

14 MS Acc. 5131, fol. 43, 13 Mar. 1831.

15 MS 3917, fol. 69, 14 Mar. 1831, R.C. to W.S. Cadell actually approached Skene for advice on 17 March; see MS Acc. 5188, Box 2 (diary).

16 MS 3917, fol. 69, 14 Mar. 1831, R.C. to W.S.

17 MS Acc. 6080, Box 1, 2–10 (not foliated), 19 Mar. 1831; MS 3917, fol. 75, 17 Mar. 1831; R.C. to W.S. The planning of the 'Poetry' volumes had begun at least as early as the end of December 1830

(see letter R.C. to W.S., 28 Dec. (MS 3915, fol. 216), and the subject was raised again in February 1831. Scott was in Edinburgh during January and early February (see Scott, *Journal*, p. 723, n. 11). On 2 February Scott 'went to stay with Cadell at 16 Atholl Crescent' (ibid.), and it was at this time that author and publisher began seriously to discuss the new edition of Scott's poetry. Indeed, it seems that discussions began on the day following Scott's arrival (MS Acc. 5188, Box 1, fol. 85, 3 Feb. 1831).

18 MS Acc. 6080, Box 1, MSS 2–10 (not foliated), 19 Mar. 1831. On Cadell's MS the author has added, 'Here as few fetters as possible be put upon Mr Turners genius and that although the Author & Publisher suggest their opinions yet the Artists opinions must be finally referred [?] to as the ultimate choice of subjects both respecting the choice of subjects & mode of treating them.'

19 MS 3917, fol. 75, 17 Mar. 1831, R.C. to W.S.

20 See Scott, *Journal*, pp. 646, 648 (9, 14 Apr. 1831).

21 MS 3917, fol. 99, 19 Mar. 1831, R.C. to W.S.

22 Ibid. fol. 240, 13 Apr. 1831, R.C. to W.S.; MS Acc. 5188, Box 2 (diary), 1 Apr. 1831. This was the eleven-volume edition of the *Poetical Works*, with dramatic figure compositions by R. Smirke for the frontispieces and landscape vignettes by Alexander Nasmyth for the title-pages. The inclusion of plates of the dramatis personae and views in this edition may have led Turner to combine the two types of subject in his vignettes for the new edition; see Chapter 8, p. 159.

23 MS 3917, fol. 69, 14 Mar. 1831, R.C. to W.S.; MS Acc. 6080, Box 1, MSS 2–10, 19 Mar. 1831; MS 3917, fol. 142, 28 Mar. 1831, R.C. to W.S.

24 MS Acc. 5131, fol. 43, 13 Mar. 1831, W.S. to R.C.

25 Ibid. fol. 47v, 20 Mar. 1831, W.S. to R.C.

26 Ibid. fol. 140v, 1 Aug. 1831, W.S. to R.C.

27 MS 920, fols 15–16v, [19] Mar. 1831.

28 MS 3917, fol. 142, 28 Mar. 1831.

29 MS Acc. 5131, fol. 49, 22 Mar. 1831, W.S. to R.C.

30 Ibid. fols 55, 55v, 30 Mar. 1831, W.S. to R.C. Scott believed that the views prepared by Turner should relate more closely to the text than did the vignette landscape designs by Alexander Nasmyth for the eleven-volume edition of 1821, 1830. See ibid. fol. 47v, 20 Mar. 1831.

31 Ibid. fol. 49, 22 Mar. 1831, W.S. to R.C.

32 Ibid. fol. 71, 16 Apr. 1831, W.S. to R.C.

33 Ibid. fol. 71v.

34 Ibid. fol. 77, 22, 23 Apr. 1831, W.S. to R.C. (written by Anne Scott).

35 Ibid. fol. 49, 22 Mar. 1831, W.S. to R.C.

36 MS 3917, fol. 142v, 28 Mar. 1831, R.C. to W.S. Cadell was confident that he understood Turner's art, and did not hesitate to inform Scott of what he believed were the artist's limitations: '. . . one thing I may remark Turners line is not suited for the Windows of Abbeys or minute architectural details – indeed [if asked to undertake work of this sort] he would decline it.' (MS 3919, fols 2, 2v, 1 Aug. 1831, R.C. to W.S.)

37 MS 3917, fol. 142v, 28 Mar. 1831, W.S. to R.C.

38 Scott, *Letters*, pp. 493–4. See also MS 3917, fols 142v, 143, 28 Mar. 1831, R.C. to W.S. Cadell had spoken to the agent for Scott's trustees about the same matter: 'I had an accidental opportunity a few days ago of mentioning to Mr John Gibson the transaction with Turner, he stared, & began to doubt the efficacy of engravings. I took some trouble to open his eyes – and proved most clearly that the whole plates of the Novels are paid by the Sale of 2000 books – and that all the imitators . . . are following the very same course. I have been more particular in alluding to this, as I am fresh from the calculation of the results, and I am convinced that 5000 less of the Novels would have sold without the plates – the same as to the Poetry – or, 4/-p[er] Vol could only have been asked.'

39 Ibid. fol. 142.

40 MS Acc. 5131, fol. 55, 30 Mar. 1831, W.S. to R.C.

41 Ibid.

42 MS Acc. 5131, fol. 52, 26 Mar. 1831, W.S. to R.C.

43 Ibid. fol. 55, 30 Mar. 1831, W.S. to R.C.

44 Ibid.

45 MS 3917, fols 240, 240v, 13 Apr. 1831, R.C. to W.S.

46 MS Acc. 5131, fol. 67, 15 Apr. 1831. Extract published in Scott, *Letters*, XII, p. 11.

47 See Scott, *Journal*, p. 648, 14 Apr. 1831; MS 3917, fol. 292, 25 Apr. 1831, R.C. to W.S.; ibid. fol. 270, 20 Apr. 1831, J.M.W.T. to W.S.

48 MS Acc. 5131, fol. 67, 15 Apr. 1831.

49 Ibid.

50 MS Acc. 5131, fols 67, 67v.

51 Ibid. fol. 55v, 30 Mar. 1831.

52 Ibid. fol. 71, 16 Apr. 1831. See also Scott, *Journal*, p. 649.

53 MS Acc. 5131, fol. 71, 16 Apr. 1831, W.S. to R.C. See also Scott, *Journal*, pp. 648–9. Scott noted that Turner's 'mode of Drawing is to take various drawings of remarkable corners and towns and stick them all together. He can therefore derive his subjects from good accurate drawings so with Skene's assistance we can equip him. We can put him at home in all the subjects.' (14 Apr. 1831.)

54 MS Acc. 5131, fol. 71, 16 Apr. 1831, W.S. to R.C.

55 MS Acc. 5188, Box 2 (diary), 19 Apr. 1831; ibid. Box 1, fol. 96.

56 Ibid. Box 1, fols 96–96v, 19, 20 Apr. 1831; also Box 2 (diary), 19 Apr. 1831. Cadell wrote to Scott a week after the latter's stroke, 'It is with great pleasure I hear you are continuing to gain strength, but above all things do not overdo – do not strain or exhaust yourself. . . . For any sake keep in mind how little we will all look, were any thing to befall you – but *I know* that that day will be far removed if you will take but common care of yourself, Dr Abercrombie assures me that health and long life are insured to you if you will just follow out the instructions laid down to you.' (MS 3917, fol. 292, 25 Apr. 1831.)

57 MS 3917, fols 270, 270v, 20 Apr, 1831, J.M.W.T. to W.S. After reading Turner's letter, Cadell informed Scott that he knew of steamers visiting Staffa, a service 'which would facilitate this part of the plan very much.' (Ibid. fol. 292v, 25 Apr. 1831.)

58 MS Acc. 5131, fols 77, 77v, 22, 23 Apr. 1831 (copy).

59 Ibid. fol. 144v, 3 Aug. 1831, W.S. to R.C.

60 MS 1752 (typescript), p. 345, 1 Aug. 1831, W.S. to R.C. 'Mr Turner is unquestionably the best judge of everything belonging to art.' (Ibid. p. 343.)

61 MS 3919, fol. 1v, 1 Aug. 1831, R.C. to W.S.

62 Turner had published *Norham Castle* in the *Liber Studiorum* (1816) and the *Rivers of England* (1824).

63 MS Acc. 6080, Box 1, MSS 2–10 (not foliated; sheet dated 19 Mar. 1831). Cadell was thinking of illustrations which Turner had completed for the

Provincial Antiquities (1826); see Chapter 3.

64 MS Acc. 5131, fol. 128, 18 July 1831, W.S. to R.C.

65 Ibid. fol. 140v, 1 Aug. 1831, W.S. to R.C.

66 MS 3919, fols 2v, 3, 1 Aug. 1831, R.C. to W.S.

67 MS Acc. 5131, fol. 144v, 3 Aug. 1831, W.S. to R.C.

68 See Cadell's references to the Field of Flodden (MS 3919, fol. 3, 1 Aug. 1831, R.C. to W.S.).

69 'Twizell [*sic*] Castle as it now stands is a most detestable sample of modern Gothick with which Sir Francis Blake Delavel replaced what in my recollection was a genuine castle of moderate size. There is only one thing fit to draw at Twizell & that is the old bridge which consists of a beautiful Gothick arch ribbd beneath and I think pointed [?] which would make an exquisite vignette but for God's sake no castle. Even the wise man who built the hulk is now blocking out from his eyes what cost him £50,000 to deform the silver tide with.' (MS Acc. 5131, fols 140v, 141, 1 Aug. 1831.)

70 Ibid. fol. 145, 3 Aug. 1831, W.S. to R.C.

71 See MS 1752 (typescript), p. 283, 2 May 1831, W.S. to R.C.; MS 3918, fol. 46, 16 May 1831, R.C. to W.S.; ibid. fol. 51v, 18 May 1831, R.C. to W.S.

72 MS Acc. 5188, Box 2 (diary), 25 May 1831. Cadell indicated that he received a letter from Turner on this date.

73 See MS Acc. 5131, fol. 88, 2 May 1831, W.S. to R.C.

74 MS Acc. 5188, Box 1, fols 97v–98v, 2, 3 June 1831.

75 Ibid. Box 7 (diary), 11 June 1831.

76 Ibid. Cadell wrote to his wife of his first impressions of Turner, 'He is a very common looking person . . .' (Ibid. Box 15, (not foliated), 11 June 1831, R.C. to wife). See also letter from J. Mylne to Mrs Cadell: 'Tell Robert that I forgot the description he gave me of Turner – except that he is a little man – and that I am sure I cannot have seen him – as anything I met with at all in the shape of a Gentleman, was very tall. . . .' (Ibid. 29 Aug. 1831.)

77 MS Acc. 5188, Box 7 (diary), 13 June 1831.

78 Ibid. Cadell had later planned to meet Turner at Glasgow (MS 3919, fol. 41, 18 Aug. 1831, R.C. to W.S.)

79 MS 3918, fols 109–109v, 15 June 1831.

80 MS Acc. 5188, Box 2 (diary), 30 June 1831. Cadell apparently promised Scott that he would

visit Abbotsford on his return journey, but, as he eventually decided to return to Edinburgh by sea, he wrote to apologize to the author for the change in plan. 'I could not well manage', Cadell wrote, 'to take Abbotsford on my way back as I took advantage of steam from Liverpool, but as I have a good deal to say to you I think I must trot out by Blucher [coach] one of these days.' (MS 3918, fol. 142, 1 July 1831, R.C. to W.S.)

81 Ibid.

82 MS Acc. 5188, Box 1, fols 99–99v, 6 July 1831.

83 MS 1752 (typescript), p. 326, 12 July 1831, R.C. to W.S.

84 MS 3918, fol. 192v, 25 July 1831.

85 MS 1752 (typescript), p. 326, 12 July 1831, R.C. to W.S.

86 MS Acc. 5131, fol. 122v, 15 July 1831.

87 MS 3918, fol. 192, 25 July 1831, R.C. to W.S. See also Turner's letter to G. Cobb (British Museum, MS 50119, fol. 16, 21 June 1831).

88 It was Cadell's original intention to write to the artist both at Penrith and Carlisle. See MS Acc. 5188, Box 2 (diary), 25 July 1831.

89 MS 3918, fol. 192, 25 July 1831, R.C. to W.S.

90 MS Acc. 5131, fol. 134, 27 July 1831, W.S. to R.C.

91 MS 3918, fols 205v, 206, 29 (? 31) July 1831.

92 MS Acc. 5131, fol. 140, 1 Aug. 1831, W.S. to R.C. As early as March, Scott had advised Cadell that 'some canvassing will be necessary and the painter must be taken into the council...' (Ibid. fol. 49, 22 Mar. 1831.)

93 Ibid. fol. 140, 1 Aug. 1831. As early as 20 March, Scott informed Cadell that the scenery of the illustrations should be related to the poems. (Ibid. fol. 47v.)

94 Ibid, fol. 141, 1 Aug. 1831, W.S. to R.C.

95 MS 1752 (typescript), p. 352, 3 Aug. 1831, W.S. to R.C.

96 MS Acc. 5188, Box 15 (not foliated), 5 Aug. 1831, R.C. to wife.

97 Ibid. Box 1, 4 Aug. 1831, ibid. Box 2 (diary), 3 Aug. 1831.

98 MS Acc. 5188, Box 1, fol. 102, 4 Aug. 1831.

99 Ibid. Box 15 (not foliated), 6 Aug. 1831, R.C. to wife.

100 MS 3918, fol. 146v, 2 July 1831, J. Skene to W.S. Skene was deeply concerned about the state of Scott's health and suggested that the trip would

be useful only 'without *personal* fatigue'. But if this was possible, then, he was convinced, the trip 'would be of great benefit[;] the change of air, of scenes and of living certainly does wonderfully infuse new vigour into most constitutions and I have no doubt that both Anne and yourself would be equally benefited....' (Ibid. fols 146v, 147.)

101 MS 1752 (typescript), p. 356 (copy), 15 Aug. 1831, W.S. to Mrs Thomas Scott (wife of the paymaster of the 70th Regiment). The original MS is in the Huntington Library, San Marino, California, USA.

102 Ibid. p. 365, (?) August 1831, W.S. to son, Major Walter Scott: 'Mr Cadell seems very desirous I would suffer him to cram a thousand pounds into my pocket & promise him a diary or something of that kind. This will make expences [*sic*] light....'

103 Scott was reluctant to leave Abbotsford and a great deal of still unfinished writing. At least as late as 15 August, he was still unenthusiastic about the trip. 'Dr Abercrombie talks of my going to Naples this winter but I think there are reasons very likely to keep me at home.' (MS 1752 (typescript), p. 356 (copy), W.S. to Mrs T. Scott.)

104 MS 5188, Box 1, fol. 103, 4 Aug. 1831; ibid., Box 15 (not foliated), 6 Aug. 1831, R.C. to wife.

CHAPTER 5

1 Cadell remarked, 'Turner himself was vastly pleased to find me here – and no less so Sir Walter so that it has been a capital tryst how long I may be here I know not but I fancy it must be some days....' (MS Acc. 5188, Box 15 (not foliated), 5 Aug. 1831.)

2 Ibid. Box 1, fols 103, 103v, 4 Aug. 1831.

3 Ibid. fol. 104, 5 Aug. 1831.

4 'We went to Ashestiel, Sir Walters residence when he wrote Marmion & the Lady of the Lake to ascertain if it would do as a vignette for Marmion in place of Flodden.' (Ibid. Box 15, 6 Aug. 1831.)

5 Ibid. Box 1, fol. 104, 5 Aug. 1831.

6 Ibid. fol. 104v, 5 Aug. 1831.

7 Ibid. fol. 105, 5 Aug. 1831.

8 Ibid.

9 Ibid.

10 MS Acc. 5188, Box 1, fol. 105v, 5 Aug. 1831.

11 Ibid.

12 MS Acc. 5188, Box 1, fol. 106v, 6 Aug. 1831.

13 Ibid. fol. 107v, 6 Aug. 1831.

14 Ibid. fol. 106v, 6 Aug. 1831.

15 Ibid.

16 Ibid.

17 MS Acc. 5188, Box 1, fol. 107, 6 Aug. 1831.

18 Ibid.

19 Ibid.

20 MS Acc. 5188, Box 1, fol. 107v, 7 Aug. 1831.

21 Ibid. fol. 108, 7 Aug. 1831.

22 Ibid.

23 MS Acc. 5188, Box 1, fol. 108v, 7 Aug. 1831.

24 Ibid.

25 Ibid.

26 Dryburgh Abbey was continually raised as a possible subject for illustration in the *Minstrelsy*. When Scott suggested the family Mausoleum, or 'Aisle', at Dryburgh as a possible subject, Cadell objected. He did not wish to be reminded of Scott's mortality, 'one thing I rebel against,' he declared, 'even against you – we will have no Aisle at Dryburgh – No – No – No – many years I trust will come before that is engraved – we will have the house of the Living Bard – I protest against the Mausoleum – Dryburgh Abbey we may have – but we will have no admission of the Mortality of the Author of the Lay!!' (MS 3919, fol. 2v, 1 Aug. 1831.) Although Cadell protested against designs which alluded to the author's mortality, in the event the 'Poetry' illustrations did just that.

27 MS Acc. 5188, Box 1, fol. 109, 8 Aug. 1831.

28 Ibid.

29 Ibid.

30 Ibid. This crossing of the Tweed is depicted in Turner's finished vignette design, *Abbotsford*.

31 MS Acc. 5188, Box 1, fol. 109v, 9 Aug. 1831.

32 Turner was probably first made aware of the associative values in landscape when he consulted travel guides written by, or under the influence of, William Gilpin, in which association plays an important role in enhancing landscape descriptions. However, Turner would also have encountered the association of ideas through his knowledge of Richard Payne Knight's *Analytical Inquiry into the Principles of Taste* (1805), possibly of Uvedale Price's *An Essay on the Picturesque, as Compared with the Sublime and the Beautiful* (1794–8), (Gage, 'Turner and the Picturesque' II, p. 76), of

the poem by Mark Akenside, *Pleasures of Imagination* (1744), (Ziff, 'J.M.W. Turner on Poetry and Painting', pp. 197, 202, 206) and possibly of Samuel Rogers's *Pleasures of Memory* (1792), which Turner was later to illustrate (see Chapter 8, n. 8.) Scott, who believed deeply in the importance of the historical values of landscape, knew most of these works. In his library (see Cochrane's *Catalogue of the Library at Abbotsford*) Scott possessed Akenside's *Poems* (in *Works of the English Poets* . . ., 21 vols, 1810, XIV; Cochrane, p. 42), Price's *Essays on the Picturesque* (1810 ed.) (Cochrane, p. 202) and Knight's *Analytical Inquiry* (1818 ed.) (Cochrane, p. 153). Scott had also read Knight's famed poem *The Landscape* (1794) and had corresponded with Price (see Allentuck, 'Scott and the Picturesque').

33 MS Acc. 5131, fol. 146, 10 Aug. 1831, W.S. to R.C.

34 MS 1752 (typescript), p. 366, (?) August 1831, W.S. to his son Major W. Scott. Scott also informed his son that he had 'been showing M[r] Turner the Country'. He also declared that, 'He [Turner] is very active and civil although I have heard the contrary reported. . . .' (Ibid.)

35 See MS Acc. 5188, Box 1, fol. 110.

36 Ibid. fols 115, 115v, 6 Sept. 1831.

CHAPTER 6

1 MS Acc. 5188, Box 1, fol. 111, 10 Aug. 1831.

2 MS 3919, fols 39a, 39av, 12 Aug. 1831. See also MS 1752 (typescript), p. 345, 1 Aug. 1831, W.S. to R.C.

3 Thornbury, *Life*, p. 139.

4 MS 3919, fol. 39a, 12 Aug. 1831.

5 Finberg, *Complete Inventory*, II, p. 857 (CCLXVII, pp. 7a, 8). Turner was so captivated by the scene (showing Cadell assisting him to the top of the hill), that he decided that he would keep it as a memento. See a letter by W. Miller, the engraver, to R.C.: '. . . The Plate of Edinburgh is advancing when a Proof is ready to send to Turner, I shall remember to send the Drawing as it appears he wishes to have it allways' [*sic*]. (MS 10994, fol. 81, 15 June 1833.)

6 MS Acc. 5188, Box 2 (diary), 15 Aug. 1831.

7 Fitzwilliam Library, Cambridge, MS 4–1949, 31 Aug. 1831, William Allan to John Burnet.

8 MS Acc. 5188, Box 2 (diary), 15 Aug. 1831.
9 MS 3919, fol. 41, 18 Aug. 1831, R.C. to W.S.
10 Scott, *Poetical Works*, X, p. 111, n. 7.
11 Scott, *The Lord of the Isles, Poetical Works*, X, pp. 109–10.
12 As quoted by Finberg, *Life*, pp. 332–3.
13 Boston Public Library, MS E9.1.107, 2 Sept. 1831, J.M.W.T. to E. Finden. I am grateful to Dr John Gage for bringing this letter to my attention.
14 Munro eventually purchased many of Turner's illustrations to Scott. At the patron's death Munro had thirty-seven of them in his possession. (William Frost, *A Complete Catalogue of the Paintings, Water-Colour Drawings, Drawings and Prints in the Collection of the Late Hugh Andrew Johnstone Munro, Esq., of Novar, at the Time of his Death deposited in his Home, No. 6. Hamilton Place, London ...*, [London], 1865, p. 123, nos 63–99.)
15 MS 3919, fol. 41, 18 Aug. 1831, R.C. to W.S.; MS Acc. 5188, Box 7 (diary), 13 June 1831.
16 MS Acc. 5188, Box 1, fol. 120, 17 Sept. 1831.
17 Ibid. fol. 120v.
18 It seems possible that Burns may have met Turner at one of John Thomson's Duddingston parties. Indeed, William Bell Scott refers to a party held at Duddingston in 1831, at which Turner was a guest. Scott refers to public disturbances over the Reform Bill taking place in Edinburgh at the time of the party; since these disturbances occurred in September, the party must have taken place just before Turner returned to London. (W.B. Scott, *Autobiographical Notes*, I, p. 84).
19 That is 'As I am not easily perturbed'.
20 MS Acc. 5131, fol. 196, 18 Sept. 1831.
21 MS Acc. 5188, Box 2 (diary), 17 Sept. 1831.
22 MS 3919, fol. 155, 19 Sept. 1831, R.C. to W.S.
23 Thornbury, *Life*, p. 245; Finberg, *Life*, p. 333.

CHAPTER 7

1 MS 2208, fol. 4, [1832]; as quoted in Johnson, *Sir Walter Scott*, II, p. 1233. Incidentally, Johnson's account of Turner's visit to Abbotsford contains inaccuracies. For example, Johnson states that 'almost all August went by with no word of Turner's arrival, but near the end of the month he turned up and Cadell brought him out to Abbotsford'. As we have seen, Turner arrived there alone on 4 August. Also, Johnson repeats the fictional accounts in Lockhart's *Life* of the visit to Dryburgh Abbey of Turner and Scott and of their lunch at Bemerside with the Haigs (*Sir Walter Scott*, II, p. 1190).
2 MS Acc. 5188, Box 1, fols 116v, 117, 16 Sept. 1831.
3 MS Acc. 5188, Box 10 (not foliated), 22 Dec. 1831, J.M.W.T. to R.C. See Finley, 'Turner and Scott's "Poetry"'.
4 Ibid. Box 10 (not foliated), 25 Feb. 1832, J.M.W.T. to R.C.; Box 2 (diary), 27 Feb. 1832; Finley, 'Turner and Scott's "Poetry"', pp. 740–42.
5 On 3 March, Cadell wrote Turner about the cholera epidemic. On 26 January he had recorded news of the first outbreak in Edinburgh. (MS Acc. 5188, Box 2, (diary).)
6 Ibid. Box 7 (diary), 9 Mar. 1832.
7 This was John Murray's edition, *The Works of Lord Byron ... and his Life* (by Thomas Moore), ed. John Wright, 17 vols, London, 1832–3. Most of Turner's illustrations for this were based on the designs of other artists. The edition's format must have impressed Cadell, for he thought of including annotations in Scott's *Poetical Works* like those of the *Byron*. (MS Acc. 5188, Box 15 [not foliated], 3 Aug. 1832, R.C. to J.G. Lockhart [copy]; ibid. 5 Aug. 1832, J.G.L. to R.C.)
8 MS Acc. 5188, Box 7 (diary), 12 Mar. 1832.
9 MS Acc. 5188, Box 10 (not foliated), 15 Mar. 1832, R.C. to W.S. See also MS 5317, fol. 138, 15 Mar. 1832; ibid. fols 136–137v, 2 Mar. 1832, R.C. to W.S.
10 MS Acc. 5188, Box 7 (diary), 12 Mar. 1832.
11 Ibid.
12 MS Acc. 5188, Box 7 (diary), 14 Mar. 1832. On the following day Cadell saw the Turner designs in the frames prepared for them. (Ibid.)
13 MS Acc. 5188, Box 7 (diary), 15 Mar. 1832.
14 Ibid. 17 Mar. 1832.
15 Ibid. 19 Mar. 1832.
16 Ibid. Box 15 (not foliated), 19 Mar. 1832, R.C. to wife.
17 Ibid. 24 Mar. 1832. Cadell 'called at John Pye's ... [was] a good while with him bargaining – he does the Design for Rokeby (Mortham) for £84 – and Webb the young man who was ... with him and of whom he speaks so highly does Bowes Tower for £35.10/- from John Pye ... drove to Goodall,

who undertake[s] two Frontispieces (Carlisle Castle & Caerlaverock) and two Vignettes (Johny [*sic*] Armstrong and Smallholm [*sic*]) John Pye gives his own Front. by 1 Dec – Webb, sooner – Goodall gives one every two months & completes the whole by 1 January he charges £73.10/- for the Frontis. & £36.15/- for the Vignettes ... next ... to ... Cooke a nice good humoured fat fellow whom to do one Vignette to charge not under £25 & to leave to me whether it will when done stand £30 – our next (I think now that we took Wil[l]more first I mean before Cook[e] but am not certain) turn was to J. Wil[l]more nr the Polagon, he will probably undertake both a Frontispiece and Vignette & is to come on Thursday at 10 to see the Designs, our next trot was to Wallis, Penton Street (30) Pentonville a most agreable [*sic*] gentlemanly person – he thought he should be able to take in hand a Frontispiece & Vignette but is to be at Pall Mall [Moon, Boys and Graves] by 4 o'clock to see the Drawings ... returned to Pall Mall by 4 ... Mr [W.B.] Cooke called Wallis also by appointment – when he made his election for Kelso as Frontispiece and Hermitage as Vignette – the Front. ready in Oct the second shortly after Christmas both in his best style the price of the Frontispiece £63 – the Vignette £31.10/- Cooke is to get his either from the 12 now being exhibited or out of the next 12....' (MS Acc. 5188, Box 7 (diary), 20 Mar. 1832.)

18 Ibid. 22 Mar. 1832.
19 Ibid. 21 Mar. 1832.
20 Ibid. Box 10 (not foliated), 14 June 1832, Charles Scott to R.C.
21 MS 5317, fol. 126v, 17 Dec. 1831.
22 MS Acc. 5188, Box 7 (diary), 19 June 1832. Cadell was anxious to discuss with them his proposal for an advance, by him, to pay off Scott's creditors. He himself was to benefit by this arrangement. See Johnson, *Sir Walter Scott*, II, pp. 1268–70.
23 Ibid. Box 7 (diary), 20 June 1832.
24 Ibid. Box 1, 6 Aug. 1831.
25 'I have got an esquisse of Old Smailholm Tower from the pencil of Mr Turner' (6 Mar. 1832, W.S. to Mrs H. Scott of Harden, in Scott, *Letters*, XII, p. 44.)
26 MS Acc. 5188, Box 7 (diary), 20 June 1832.
27 Ibid. 2 July 1832.

28 Ibid. 5 July 1832.
29 Horsburgh and Miller had earlier been promised two watercolours shown at the Moon, Boys and Graves exhibition in March: respectively, *Bemerside* and *Dryburgh*. On 12 April Cadell received these watercolours in Edinburgh (Ibid., Box 2, diary).
30 Ibid. 9 July 1832.
31 Ibid. 25 July 1832.
32 Ibid. (diary), 2 Aug. 1832.
33 Cadell had arranged with Miller to execute the Turner designs as early as 14 January (Ibid.).
34 Ibid. Box 15 (not foliated), 3 Aug. 1832, R.C. to J.G. Lockhart.
35 Ibid. It should be observed that three of the drawings for the *Poetical Works* (*Loch Achray*, *Newark Castle* and *Ashestiel*, appearing respectively in *The Lady of the Lake*, *The Lay of the Last Minstrel* and *Marmion*) were to be engraved again, as illustrations for the same poems, for a three-volume 24-mo edition published in 1835.
36 MS Acc. 5381, Box 60 (1) (not foliated), 22 Aug. 1832, R.C. to H.F. Cadell.
37 Ibid. 21 Sept. 1832, R.C. to H.F. Cadell.
38 MS Acc. 5188, Box 2, following entry for 31 Dec. 1832.

CHAPTER 8

1 There are, of course, the very finished sketches, such as those of Edinburgh from Blackford Hill and the study of Bemerside. These can be classified with the sketches for the *Antiquities* in so far as they emphasize a single viewpoint and are conceived as essential armatures for the finished watercolours.
2 Cited by Fry, *Characteristics of French Art*, p. 25.
3 MS Acc. 5188, Box 1, fol. 106v.
4 Ibid. fol. 107.
5 Ibid. fol. 106v.
6 Ibid. fol. 107.
7 Ibid. fol. 109.
8 This meaning is also conveyed by Turner in an illustration prepared for Rogers's *Poems* (1834). In the vignette for 'Pleasures of Memory', the artist depicts an old man standing motionless, contemplating an array of potted plants (**73**).
9 As quoted in Finberg, *Life*, pp. 319–20, 21 Jan. 1830.

10 Ruskin related that Turner, when aged, informed the Rev. William Kingsley that 'he had learned more from Watteau than from any other painter'. (Quoted by Gage, *Colour in Turner*, p. 240, n. 59.)

11 Turner was perhaps as intrigued by an analogy between art and music as he had been by that between art and poetry. No doubt his association with George Field, the colour theorist, encouraged him to consider these relationships. See Lindsay, *J.M.W. Turner*, pp. 110–11.

12 In the Royal Academy exhibition of 1831, Turner's *Watteau Study* was accompanied by lines from Du Fresnoy, indicating the pictorial efficacy of white and black. See Gage, *Colour in Turner*, p. 92; Lindsay, *J.M.W. Turner*, pp. 108–9, and especially, Finley, '*Ars Longa, Vita Brevis*: the *Watteau Study* and *Lord Percy* by J.M.W. Turner', *Journal of the Warburg and Courtauld Institutes* (forthcoming).

CHAPTER 9

1 Journal, p. 611 (5 Sept. 1830).

2 Ibid. p. 638 (13 Mar. 1831).

3 Ibid. (14 Mar. 1831).

4 MS Acc. 5188, Box 2 (diary), following entry for 31 Dec. 1831.

5 Ibid. 2 Feb. 1833.

6 Ibid.

7 MS Acc. 5188, Box 2 (diary), 3 May 1833; MS Acc. 5381, Box 60 (1), 15 May 1833, R.C. to his brother H.F. Cadell.

8 MS Acc. 5188, Box 2 (diary), entry following that of 31 Dec. 1833.

9 See Finberg, *Life*, p. 348. Finberg suggests that Turner was in Oxford in July; as noted, he may also have been there earlier, possibly in May or June.

10 Shirley, *The Published Mezzotints of David Lucas*, p. 123. See also Finberg, *Life*, p. 348, n. 1.

11 MS Acc. 5188, Box 7 (diary), 7 May 1834. Cadell may have been referring obliquely to remarks in a recent review in the *Morning Chronicle*, concerning exhibitions of Turner's watercolours in London: his views of the Seine shown at Moon, Boys and Graves's galleries and his illustrations to Byron at Colnaghi. 'Observing that many of the drawings at Colnaghi's had been bought by a Mr

Griffith, he [the reviewer] earnestly recommended that gentleman to make haste to sell them; "while Mr Turner is alive is the time to strike, while the iron is hot," he said, for fashions change, watercolours fade, and Mr Turner's "multiplying steam-power, perpetually at work in these matters, is prodigious".' (Quoted by Finberg, *Life*, p. 346.)

12 Lockhart seems to have agreed that Turner should be the designer. Although Cadell and Scott probably decided in 1831 that Turner should illustrate *The Miscellaneous Prose Works*, it was not until the summer of 1832 that specific reference to Turner as their illustrator is made. See below note 72, and Finley, 'Two Turner Studies: ... Turner's Illustrations to Napoleon', pp. 391–2.

13 MS Acc. 5188, Box 7 (diary), 7 May 1834.

14 Ibid. 9 May 1834.

15 Ibid.

16 Ibid.

17 Ibid.

18 MS Acc. 5188, Box 15 (not foliated), 11 May 1834, R.C. to wife.

19 Ibid. Box 7 (diary), 9 May 1834.

20 Ibid. 10 May 1834.

21 Ibid. Box 3 (diary), 21 Aug. 1834; Charles Tilt, *Landscape Illustrations of the Waverley Novels ...*, 2 vols, London, 1832.

22 MS Acc. 5188, Box 3 (diary), 30 Aug. 1834.

23 Ibid. 15 Sept. 1834.

24 M'Gregor, *Report*, p. 3.

25 Ibid. p. 15.

26 *Scotsman*, 17 Sept. 1834.

27 MS Acc. 5188, Box 3 (diary), 15 Sept. 1834.

28 *Scotsman*, 17 Sept. 1834.

29 M'Gregor, *Report*, p. 16.

30 MS Acc. 5188, Box 3 (diary), 15 Sept. 1834.

31 Thornbury, *Life*, p. 139, n. 1.

32 MS Acc. 5188, Box 3 (diary), 16 Sept. 1834.

33 Ibid.

34 MS Acc. 5188, 17 Sept. 1834.

35 See Finberg, *Complete Inventory*, II, T.B. CCLXIX ('Stirling and Edinburgh Sketch Book').

36 MS Acc. 5188, Box 3 (diary), 18 Sept. 1834.

37 MS 1594 (J.G. Lockhart diary), 18 Sept. 1834.

38 Ibid. 19 Sept. 1834.

39 MS Acc. 5188, Box 3 (diary), 29 Sept. 1834.

40 Finberg, *Complete Inventory*, T.B. CCLXVIII ('Edinburgh Sketch Book'), p. 86.

41 MS Acc. 5188, Box 3 (diary), 30 Sept. 1834.

42 Finberg, *Complete Inventory*, T.B. CCLXVIII, p. 83.

43 MS Acc. 5188, Box 3 (diary), 30 Sept. 1834.

44 Sir John Watson Gordon (1788–1864) had been invited by Cadell to meet Turner when the artist was in Edinburgh in 1831. See Ibid. Box 2 (diary), 15 Aug. 1831.

45 James Francis Williams (1785–1846).

46 MS Acc. 5188, Box 3 (diary), 1 Oct. 1834.

47 Finberg, *Complete Inventory*, T.B. CCLXIX, p. 88a.

48 MS Acc. 5188, Box 3 (diary), 1 Oct. 1834. See also, for example, Finberg, *Complete Inventory*, T.B. CCLXVIII, pp. 33, 34.

49 It was at this time that Cadell paid Turner £40 for expenses associated with his visit, and £105 for four designs which the artist had brought north with him. (MS Acc. 5188, Box 3 (diary), 1 Oct. 1834.)

50 Ibid.

51 Leslie, *A Waterbiography*, p. 57. See Finberg, *Life*, pp. 348–50.

52 Little is yet known of Turner's association with Fisher on this project. Fisher was determined to produce another work like Tilt's successful *Landscape Illustrations of the Waverley Novels*. (Cadell himself was aware of the Tilt work when he planned his new edition of the 'Novels'; see note 21 above.) Turner's association with Fisher was not entirely satisfactory, apparently because of some disagreement over the advertising of the volume. As a consequence, Turner seems to have severed his connection with Fisher, but not before having completed six designs: *Col. Mannering*, *Hazelwood and Smugglers*; *Ballyburgh Ness*; *'It's Auld Ailie hersell'*; *Wolf's Hope*; *Loch Leven Castle* and *Edinburgh Castle − March of the Highlanders*. The last-named was derived from one of the planned paintings of George IV's visit to Scotland in 1822. See Finley, 'J.M.W. Turner's Proposal for a "Royal Progress"', p. 31. In 1836 the artist mentioned to Cadell his difficulties with Fisher and the reasons for breaking his association with him. The publisher observed, 'I see the old boy is tender on these matters'. (MS Acc. 5188, Box 7 (diary), 8 Nov. 1836.) It seems possible that Turner had completed more than six watercolours for the *Landscape − Historical Illustrations of ... the Waverley*

Novels before he severed his association with Fisher. A seventh might be *Kenilworth* (of approximately the same size as Turner's six published designs), which is described in Armstrong, *Turner* (p. 260), and was dated by Armstrong 1830–35. Armstrong stated that it represented 'the reception of Elizabeth by Leicester' before Kenilworth Castle. The full moon behind the castle was reflected in the water (of the moat?), and the fireworks which announced the Queen's arrival lit up the castle, wreathing it in smoke. Armstrong's description of the watercolour suggests the subject of the Kenilworth design by T. Allom which was published in Wright's book (op. cit., II, opp. p. 34).

53 MS Acc. 5188, Box 15 (not foliated), 1 Nov. 1836, R.C. to wife.

54 This Cadell states in his 'Notice' prefacing the Abbotsford Edition of the 'Waverley Novels', published in 1842–6.

55 MS Acc. 6080, 2–10 (not foliated), 18 June 1838. For these twenty designs Turner was to charge £26.5.0. each. Cadell seems to have first raised the issue of this proposed illustrated edition with the artist on 24 May 1838 and had favourable reactions from him. Two days later Cadell again called on Turner, and had a further and final 'jaw with him about the Lady of the Lake illustrations' (MS Acc. 5188, Box 7 (diary)). The project was unaccountably abandoned. Perhaps at about this time or slightly later Turner came into possession of a set of Scott's 'Waverley Novels'. He probably acquired them to help him determine the subjects of his proposed illustrations; see Falk, *Turner*, p. 259.

56 MS Acc. 5188, Box 2 (diary); before 1 Jan. 1839.

57 MS Acc. 5188, Box 4 (diary), 1839, introductory inscription.

58 Ibid., concluding remarks. See inscription following entry for 31 Dec. 1839. Cadell envisaged this new publication as being '*a double column edition ... uniform with Murrays Byron ...*' (Ibid. Box 4 (diary), 17 Sept. 1839). Cadell also planned for a group of portraits such as appeared in the edition of Byron (ibid. 5 May 1840). Lockhart was in favour of decorative woodcuts in Cadell's publications at least as early as 4 August 1832 (ibid. Box 15, not foliated). Scott would also have approved of Cadell's proposal. (See his letter to Blore concern-

ing the embellishment of the *Provincial Antiquities*, MS 3029, fol. 7, 5 Feb. 1819; also Chapter 3, note 28, above.)

59 MS Acc. 5188, Box 11 (not foliated), 29 June 1839, F.G. Tomlins to R.C.

60 Ibid.

61 MS Acc. 5188, Box 11 (not foliated), 6 May 1840, J.G. Cochrane (former editor of the *Foreign Quarterly Review* and cataloguer of Scott's library at Abbotsford, 1838) to R.C.

62 MS Acc. 5188, Box 7 (diary), 6 June 1841.

63 Ibid.

64 Ibid. Despite Turner's refusal to contribute designs to this edition, Cadell eventually borrowed several of his watercolours from private owners and had them engraved on wood. Cadell borrowed *Abbotsford*, *Dryburgh Abbey* and *Caerlaverock Castle*, all designs prepared in 1832 for Scott's *Poetical Works*. At that time the *Abbotsford* watercolour was in the collection of B.G. Windus (MS Acc. 5188, Box 4 (diary), 5 May 1840). Cadell also borrowed one of the Turner watercolours from Abbotsford which had been prepared for the *Provincial Antiquities*: *Heriot's Hospital, Edinburgh from the West Bow*. Unfortunately, only a small segment of this design was engraved. Turner's fear concerning reproduction by wood was well founded, for the engraved designs are not successful.

65 Ibid. Box 7 (diary), 12 June 1841.

66 Ibid. 14 Mar. 1832.

67 MS 5317, fol. 138, 15 Mar. 1832, R.C. to W.S. See also MS Acc. 5188, Box 10 (not foliated), 15 Mar. 1832, R.C. to W.S.; ibid. Box 15 (not foliated), 24 Mar. 1832, R.C. to wife.

68 Ibid. Box 15 (not foliated), 3 Aug. 1832, R.C. to J.G.L. (copy).

69 Ibid. A year before, Scott had written to Cadell, 'As you are at so much trouble about ornaments [do] you not think it would be worth while to reengrave heads of the principal persons.' (MS 1752 (typescript), p. 363, 30 Aug. 1831.)

70 MS Acc. 5188, Box 15 (not foliated), 3 Aug. 1832, R.C. to J.G.L. (copy).

71 On 5 July 1832, Turner had informed Cadell that in order to complete the 'Vignettes for Napoleon ... he [Turner] ... would require materials' (Ibid. Box 7, diary).

72 Ibid. Box 15 (not foliated), 15 Aug. 1832, J.G.L. to R.C. In a private communication, Mr

Martin Butlin has suggested that Lockhart may have been thinking of Turner's *Rome from the Vatican*, since there is nothing in the background of *Childe Harold's Pilgrimage* which suggests Rome. This is an entirely reasonable suggestion. Yet, there is no indication that Lockhart knew *Rome from the Vatican*. As he had visited the Royal Academy only a few months before and seen *Childe Harold's Pilgrimage* there, one must assume that it is to this painting that he refers.

73 MS Acc. 5188, Box 15 (not foliated), 15 Aug. 1832, J.G.L. to R.C.

74 MS Acc. 5188, Box 2 (diary), 17 Sept. 1832.

75 I suspect that this unknown French artist may be J.B. Isabey (1767–1855), whose full-length portrait of Napoleon was to grace the first volume of the *Life of Napoleon* which appeared two years later. Isabey was a devoted friend of Delacroix, and it may have been on this visit to France that Turner was introduced to Delacroix. Delacroix later wrote of his meeting with the English painter, 'I remember having received him at my studio just once, when I was living on the Quai Voltaire.' (Delacroix lived there between January 1829 and October 1835.) 'He made only a middling impression on me: he had the look of an English farmer, black coat of a rather coarse type, thick shoes – and a cold, hard face.' (Delacroix, *Journal*, p. 458.)

76 During January, Cadell had been 'busy with sundry calculations' about Sir Walter Scott's *Prose Works*, and 'had been considering the sequence of illustrations' and written Turner about his preparation. See MS Acc. 5188, Box 2 (diary), 4, 8, 26 Jan. 1833.

77 Ibid. Box 7 (diary), 7 May 1833.

78 Ibid.

79 MS Acc. 5188, Box 7 (diary), 8 May 1833. Cadell wrote to his brother Francis about the matter: 'I have been a good deal worried with my artist folk. Turner my great man *had done nothing*. If I had not come [to London] the fat would have been in the fire – but I shall get something from him soon –' (MS Acc. 5381, Box 60(1) (not foliated), 15 May 1833).

80 MS Acc. 5188, Box 2 (diary), 2 Dec. 1833.

81 Ibid. Box 7 (diary), 10 May 1833.

82 Scott, *Prose Works*, I, p. 3. The italics are mine.

83 Ibid. XV, pp. 198 ff.

84 Ibid. XVI, p. 106.

85 Ibid. p. 107.

86 Ibid. VII, p. 4.

87 Ibid. III, p. 118.

88 Ibid. XXII, p. 38.

89 Ibid. XXI, p. 94.

90 Allentuck, 'Scott and the Picturesque', p. 188.

CHAPTER 10

1 MS Acc. 5188, Box 3 (diary), entry following 31 Dec. 1835.

2 Ibid. Box 7 (diary), 10 May 1833.

3 Lang, *Life and Letters of . . . Lockhart*, II, p. 90 (16 June 1835).

4 MS Acc. 5188, Box 3 (diary), before 1 Jan. 1836.

5 Ibid. 14 Jan. 1836.

6 Lang, *Life and Letters of . . . Lockhart*, II, p. 114 (4 Mar. 1836).

7 MS Acc. 5188, Box 3 (diary), 20 Jan. 1836.

8 Cadell noted in his diary on 28 Oct. 1836, 'Lockhart [was] in great glee [I] had a great talk [with him.] [The] *Life* [is] to be [in] *6 Vols!* & [will contain] *little illustration*.' (Ibid. Box 7, diary.)

9 MS Acc. 5188, Box 15 (not foliated), 1 Nov. 1836, R.C. to wife.

10 Ibid. Box 7 (diary), 1 Nov. 1836. The title of Finden's book varied. The first volume, published in 1833, was entitled *Finden's Illustrations of the Life and Works of Lord Byron*. The second and third volumes, published in 1833 and 1834 respectively, were entitled *Finden's Landscape and Portrait Illustrations to the Life and Works of Lord Byron*. The author of the text of all three volumes was W. Brockedon.

11 Ibid. 3 Nov. 1836.

12 Ibid. 7 Nov. 1836.

13 Ibid. Box 3 (diary), before entry for 1 Jan. 1838.

14 Ibid. before entry for 1 Jan. 1837.

15 Ibid. Box 7 (diary), 24 Apr. 1838.

16 Ibid. Box 3 (diary), 17 Apr. 1838.

17 Ibid. Box 7 (diary), 5 May 1838.

18 Ibid. 8 May 1838.

19 MS 1555, fols 65v, 66, 11 Oct. 1837, R.C. to Sir Walter Scott (Scott's son).

20 MS Acc. 5188, Box 7 (diary), 8 May 1838.

21 Ibid. Box 3 (diary), 12, 21 Oct. 1836.

22 Ibid. Box 7 (diary), 8 May 1838.

23 In Sophia Lockhart's London diary of 1836 (MS 1596), used as an appointment book, a solitary entry (for 29 February) refers to the proposed visit of a 'Mr Turner' at 3 o'clock in the afternoon. If this reference is indeed to the artist (who was in town at the time), then it is possible that this was the occasion on which the tray was presented. A former owner of the tray, Thomas Craig-Brown, stated that it was in the possession of Sophia Lockhart. There seems to be no reason to dispute this statement. Others that he made, however, can probably be dismissed. For example, he asserted that the tray was presented during the artist's 1831 visit to Abbotsford, but this is not supported by the documentary evidence of the Cadell diaries. I am deeply grateful to Mr Kurt Pantzer, who kindly brought Craig-Brown's statement to my attention and provided me with a copy of the document (now in the possession of the Indianapolis Museum of Art).

24 I am grateful to Mr Martin Butlin, who first drew my attention to the stylistic relationship between the tray and Turner's illustrations. The general form of the tray and its decoration were not unusual for certain ceramic table services. See, for example, the oval fruit-dish of Chamberlain Worcester used in 1822 at the dinner held at Hopetounhouse when Raeburn was knighted. (Boase, pl. 27a; Finley, 'J.M.W. Turner's Proposal for a "Royal Progress"', p. 28.)

25 There is an unfinished watercolour of Abbotsford by moonlight (**104**) that compositionally resembles both the *Life* illustration and the landscape of the 'Abbotsford Tray'. Superficially, this work appears to be more closely related to the *Life* design, because of its rectangular form and similar scale. However, I suggest that in fact it provided the inspiration for the Tray. Probably begun in 1832 as a 'Poetry' illustration, this unfinished rectangular design was set aside when Turner realized that he had been commissioned to prepare a vignette landscape. He seems to have made the same error with another subject, Lochmaben, which had been commissioned as a vignette but which he also prepared initially as a rectangular design. (The above discussion concern-

ing the 'Abbotsford Tray' and the *Abbotsford* for the *Life* is an expansion of information which I originally provided for, and which was published in, the catalogue, *The Paintings of J.M.W. Turner* by Martin Butlin and Evelyn Joll (Yale Center for British Art, London/New Haven, 1977).)

26 The symbolic content of this watercolour extends further. For example, the kilted figures represented commemorate Scott's nationalism and, most particularly, his diplomatic success in bringing George IV to Scotland in 1822.

27 In my article 'Kindred Spirits in Scotland', p.245, I suggested that the structure, in relation to nearby figures, appeared to be about 20 or 30 feet high. Dr Alistair Rowan, however, in a private communication, has rightly pointed out that a more accurate estimate of the size can be calculated by comparing the structure with the adjacent houses on George Street.

28 The sculpture at the intersection is of Dr Thomas Chalmers (1780–1847), by Sir John Steell (1804–19). See Rupert Gunnis, *Dictionary of British Sculptors 1660–1851*, London, 1953, p.370.

29 MS 1631 (published report dated 17 Nov. 1835), fol. 30v.

30 MS Acc. 5188, Box 3 (diary), 2 Feb. 1838.

31 On 17 December 1838, the Committee (with Lord Melville presiding) 'agreed that the site at the foot of St David Street, within the East Princes Street gardens at the place where power to erect a theatre was reserved was the best site of those which might be obtained....' (MS Adv. 23.3.15 (Castle, 'Manuscript History'), p.32.) I am grateful to Mr Alan S. Bell for bringing this MS to my attention.

32 *The Engraved Work of J.M.W. Turner*, I, lxix.

APPENDIX I

1 Information concerning Tilt's illustrated publications, with commentaries on Scott's prose and poetical works, was sent to me by Dr James C. Corson, to whom I am most grateful.

2 Finberg, *Life*, p. 344.

APPENDIX 2

1 *Edinburgh Evening Courant*, 6 Oct. 1832.

2 See MS Adv. 23.3.15 (Castle, 'Manuscript History', pp. 7–8).

3 MS 965, fols 286v, 287 (Skene's Reminiscences).

4 MS 1631, fol. 29 (published report dated 17 Nov. 1835).

5 By the early months of 1834, the Sub-committee had contacted 'several eminent Artists & Architects who being given general specifications, a list of suitable sites and an indication of funds available [some £6,000] were asked to submit proposals.' (Ibid., fol. 29v.) We know from Cadell's diary of some of the artists and architects contacted. The architects Thomas Hamilton and W.H. Playfair were approached, as well as Thomas Campbell, the sculptor. Possibly only one design was submitted in this year: a model by Campbell, which the Sub-committee examined on 29 September. While no evidence has been found to establish that Hamilton produced a design, Playfair certainly did. By the end of January 1835 he submitted a proposal for an obelisk to be situated at the west end of Princes Street, one of the locations mentioned in the invitation (MS Adv. 23.3.15, Castle, op. cit. pp. 13–14). However, these were not the only artists and architects asked to submit designs. Among the others were Edward Blore (architect, artist and engraver) and David Roberts (the landscape painter and designer of the canopy for the dinner given in honour of Earl Grey, see p. 176).

6 The published report (MS 1631) outlines the main arguments raised by both factions. Those in favour of the obelisk design insisted that 'for the sum of money subscribed [£6,000], no Gothic Structure of sufficient magnitude can be erected in Edinburgh, in any situation, that would not be paltry and subdued amid the heavy masses of our houses, — no prominent feature in the Town, especially from a distance, can be attained by it.... [For a monument to the memory of Sir Walter Scott] should be one of the most prominent objects in the city, if possible, above all others, as the memorial of an individual who has done so much for the fame and name of his country, and for the city of his birth....' (Ibid., fols 31, 31v.) Another argument put forward by those in support of the obelisk was that the Gothic design would be 'perishable', 'its tinsel ornaments, will ere long

decay by the hand of time', and there would be 'no funds wherewith to keep them in repair'. Further, the 'tracery and fret work, together with the minute subdivisions of a Gothic pile' could never inspire the 'impression of dignity and perpetuity' such as could be inspired by the 'severe and grand' character of the obelisk. In addition, while the character of an obelisk seemed to be in harmony with the architectural environment of Edinburgh, the decorative Gothic style seemed 'peculiarly unsuitable' (loc. cit.). Though it might be true that the obelisk might have no 'proper *historical* character', such as a Gothic cross would possess, yet, since its effect was principally achieved by means of its magnitude and proportions, it 'might be introduced without impropriety, among buildings of any age or description; and, in point of fact, has generally been introduced without any regard to the *congruity* of the surrounding structures'. A Gothic monument also required open space and should be surrounded by small or moderately sized buildings. In Edinburgh, 'its effect would be wholly lost'. An obelisk, being of greater size and of suitable proportions, would, on the other hand, stand out as an important landmark of the city. Further, at a site where George Street meets Charlotte Square, it 'would form the best and most appropriate termination to the series of monuments of eminent persons with which George Street and St Andrew's Square are already decorated, (MS 1631, fol. 31v).

Unconvinced, the supporters of the Gothic monument still believed that their design was the more appropriate. But, like the supporters of the obelisk, they were not advancing positive aspects of their own proposal so much as pointing out negative aspects of the opposition's design. They argued, for example, that the obelisk was not authentic in construction, that 'it is a composite building, formed of ordinary materials; and the fine association of durability and grandeur connected with these ancient monolithic monuments would be completely destroyed'. They also objected to the proportions and size of the proposed obelisk: 'In the most ancient form of Obelisks, a certain proportion was always observed between the height and that of the buildings with which they were connected; and when these stupendous

granite shafts came to be transplanted for the decoration of Rome, the same principle was observed; nor did the Romans ever dare to invade the ancient simplicity or natural dimensions of the obelisk, even at a time when, in the ordinary decline of taste, and degradation of art, they strove to give disproportionate grandeur, by preposterously exaggerating the dimensions of their monuments. Accordingly, there is no instance of a *built* obelisk now existing in any part of Italy.' (Ibid. fol. 32v.) The supporters of the Gothic monument therefore argued that the authentic obelisk was a monolith, and, while a modern construction might not be from a 'single stone', it ought at least to be of 'such dimensions as are consistent with the appearance of being so', and this provision the Playfair proposal did not, in their view, satisfy. A further argument against the obelisk was that such a size as proposed would 'entirely fail in producing the effect expected from it, in the distant views of the town', for, they stated, 'To produce a good effect, an Obelisk must be viewed from its base to its apex; and when merely seen in its upper portion over the roofs of houses . . . it would disappoint expectation.' In addition, the supporters of the Gothic monument were persuaded that the obelisk, the once 'venerated form', had been 'vulgarized' by being raised for all kinds of occasions, without regard for its special character. That is to say, it was felt that, because of its size, it had been found suitable for incorporation into large buildings, and could now be seen architecturally associated with the increased number of 'manufacturing establishments' which were 'now overspreading the land' (Ibid. fol. 33). The obelisk had therefore become hackneyed, and for this reason alone such a form would be inappropriate for commemorating the name of Sir Walter Scott, whose monument 'ought not only to be distinguished, but if possible, unique' – such as a magnificent Gothic structure would be.

An especially telling argument raised against the obelisk was that it possessed neither 'in style, character, aspect or history, any association whatever with Scotland, or the illustrious Scotchman proposed to be thereby commemorated'. The Gothic style was plainly more appropriate to this country, since it was not 'so

foreign a style, as that of Egypt' (Ibid. fol. 34). Even 'the accomplished author of the *Aegyptiaca* [William Richard Hamilton, 1777–1859] ... has expressed himself as decidedly opposed to an Obelisk as a Monument to SIR WALTER SCOTT, although all his predilections might have been expected to be in favour of that style' (Ibid. fol. 33v). (The work referred to was published as *Remarks on Several Parts of Turkey. Part 1. Aegyptiaca; or Account of the Antient and Modern State of Egypt, as obtained in the Years 1801, 1802 ...*, London, 1809. According to the *Dictionary of National Biography*, the 'most important of its contents is his [Hamilton's] transcript of the "Greek Copy of the Decree on the Rosetta Stone", with a translation in English'.) Sir Walter Scott himself, asserted the supporters of the Gothic cross, had 'often expressed his wonder that, in raising monuments to the memory of illustrious Britons, we should confine ourselves to copying the styles of Rome, Greece, and Egypt, to the neglect of that grand and more appropriate [Gothic] architecture of which our forefathers have left us such admirable specimens. He has been frequently heard to express his conviction, that, in sublimity, no effort of art could surpass a fine Gothic structure. ...' (Ibid. fols 33, 33v.) Gothic structures are beautiful in their outline, 'capable of the greatest enrichment – of being raised to the most commanding altitude – exclusively associated with the events, eras, and characters which occupied the genius of the man [Sir Walter Scott] whose memory it is desired to honour. ...' (Ibid. fol. 33.)

7 MS 1555, fol. 75, 24 Oct. 1832, J.M.W.T. to R.C. See Finley, 'Two Turner Studies: ... Turner's Illustrations to "Napoleon"', pp. 392–3.
8 MS Acc. 5188, Box 7 (diary), 13, 15 May 1833. Just how deeply Cadell felt about the monument to Scott is reflected in a letter written only a month or so after the author's death: 'I cannot allow any measure whether for the benefit of the family of my deceased friend: a Monument in Edinburgh, or one at Melrose, to be undertaken without being among the foremost to lend a helping hand in the most efficient of all ways. ...' (MS Acc. 5188, Box 15, (not foliated), 6 Nov. 1832, R.C. to J.G. Lockhart.)
9 Both designers had chosen a site at the west end of George Street, where it meets Charlotte Square,

one of nine locations recommended by the Sub-committee: '1st. The space in the Lawnmarket bounded on the East by St. Giles Church, on the South by the Signet Library and on the West by the County Hall. 2nd. The west end of Princes Street top of the Lothian Road opposite to St. John's Chapel. 3d. Foot of David Street on the brink of Queen Street Garden. 4th. The open space at the Head of Leith Walk, at Piccardy Place. 5th. Upon the elevated rocky angle of the Calton Hill at the north east corner facing Leith Walk. 6th. West end of George Street at Charlotte Square. 7th. Centre of Charlotte Square. 8th. Centre of Moray Place. 9th. Randolph Crescent ...', (MS Adv. 23.3.15, John Castle, 'Manuscript History', pp. 13–14). Playfair's proposal for an obelisk (submitted in January 1835) was probably of the same design, though it was to be situated at the west end of Princes Street, another location favoured by the Sub-committee (see note 5).
10 One of the members of the General Committee was convinced that by putting forward the idea of a statue with the proposed Gothic structure, the proposal was 'a good deal [planned] with the view of helping get rid of the obelisk'. (MS 1631, fol. 37, 26 Nov. 1835, G. Forbes to J.G. Lockhart.)
11 MS 1631, fol. 31v (published report), 17 Nov. 1835.
12 Playfair decided that his design did not look as well as it might, when compared to Rickman's, whose design 'was done pretty large, and in colours. Playfairs was a small bister drawing. The visitors of course thought most of the large coloured one. So Mr P[layfair] got his outlined on a large piece of canvas and asked me [David Hay] to dash in a skye [*sic*] for him, a day or two before the general meeting, in order that this might have as imposing an appearance as Rickman's' (Victoria and Albert Museum, London, MS 86 JJ 16, 17 Dec. 1835, D.R. Hay to David Roberts.)
13 MS Acc. 5188, Box 3 (diary), 11 Dec. 1835.
14 MS Adv. 23.3.15, Castle, op. cit. pp. 16–17. See also Cadell, *Letter to ... Duke of Hamilton*, pp. 4, 5.
15 MS Acc. 5188, Box 3 (diary), 11 Dec. 1835.
16 MS 1631, fols 38, 38v, copy of letter from William Adam to Lord Melville, 30 Dec. 1835. See Scott, *Some Unpublished Letters*, pp. 172–81.

17 MS 1631, fols 36, 36v, 26 Nov. 1835, G. Forbes to J.G. Lockhart.

18 Victoria and Albert Museum, London, MS 86 JJ 16, 29 Dec. 1835, D.R. Hay to D. Roberts. Despite Hay's remarks, Playfair was still an active contestant at this juncture.

19 MS Adv. 23.3.15, Castle, *op. cit.* pp. 17, 18.

20 Ibid. pp. 18, 19.

21 MS Acc. 5188, Box 3 (diary), 10 Sept. 1836.

22 Ibid. 30 Nov. 1836.

23 MS Adv. 23.3.15, Castle, *op. cit.* p.19.

24 Ibid; MS Acc. 5188, Box 3 (diary), 3 Jan. 1837.

25 Victoria and Albert Museum, London, MS 86 JJ 16, fol. 2, 21 Jan. 1838, D.R. Hay to D. Roberts.

26 MS Acc. 5188, Box 3 (diary), 2 Feb. 1838. This was John Steell (1804–91).

27 Ibid. 19 Feb. 1838.

28 Ibid. 28 Feb. 1838.

29 Cadell, *Letter to . . . Duke of Hamilton*, p. 5. On 2 March, Kemp wrote to his brother, 'There is a bookseller of the name of Cadell [who] has written a long pamphlet against Gothic, with a view to get the whole money, nearly seven thousand pounds, into the pockets of Chantrey the sculptor. There is to be a meeting of the large committee on Monday the 19th inst. against which this said bookseller is mustering all his forces with a view to overturn the decisions of the select committee....' (Bonnar, *Biographical Sketch of George Meikle Kemp*, p. 96.)

30 Cadell, *Letter to . . . Duke of Hamilton*, p. 8.

31 Ibid.

32 Cadell, *Letter to . . . Duke of Hamilton*, p. 9.

33 MS Acc. 5188, Box 3 (diary), 6 Apr. 1838.

34 Ibid.; MS Adv. 23.3.15, Castle, *op. cit.* p. 28.

35 MS Acc. 5188, Box 3 (diary), 6 April.

Selective
Bibliography

Manuscripts

The Cadell Papers, Sir Walter Scott's correspondence and John Castle's *Manuscript History of the Subscription for the erection of the Sir Walter Scott Monument* are in the National Library of Scotland, Edinburgh

Articles, Pamphlets and Books

Allentuck, Marcia, 'Scott and the Picturesque: Afforestation and History', *Scott Bicentenary Essays*, ed. Alan S. Bell, Edinburgh/London, Scottish Academic Press, 1973, pp. 188–98

Anonymous, *A Descriptive Catalogue of Drawings by J.M.W. Turner, R.A. expressly made for his Work now in Course of Publication, of 'Views in England and Wales' and also for Sir Walter Scott's 'Poetical Works' now privately exhibiting at Moon, Boys and Graves'; 6, Pall Mall*, London, June 1833

Armstrong, Sir Walter, *Turner*, London/Manchester/Liverpool, Thomas Agnew, 1902

Baird, William, *John Thomson of Duddingston, Pastor and Painter. A Memoir, with a Catalogue of his Paintings . . .*, Edinburgh, Elliot, 1895

Boase, T.S.R., *English Art 1800–1870*. 'Oxford History of English Art', Oxford, Clarendon Press, 1959

Bonnar, T., *Biographical Sketch of George Meikle Kemp, Architect of the Scott Monument*, Edinburgh, Blackwood, 1892

Butlin, M., and E. Joll, *The Paintings of J.M.W. Turner*, 2 vols, London/New Haven, Yale Center for British Art, 1977

Cadell, Robert, *Letter to His Grace the Duke of Hamilton and other Noblemen and Gentlemen, the Committee appointed by the Subscribers for a Monument in Edinburgh to the Memory of Sir Walter Scott*, Edinburgh, Constable, 1838 *Particulars and Conditions of Sale of Copyrights, the Property of the late Robert Cadell, Publisher, Edinburgh . . .*, Edinburgh [1851]

Cochrane, J.G., ed., *Catalogue of the Library at Abbotsford*, Edinburgh, Maitland Club, 1838

Crawford, Henry J., *Turner's Sketches and Drawings of Stirling and Neighbourhood*, Stirling, A. Learmonth, 1936

Delacroix, E., trans. Walter Pach, *The Journal of Eugène Delacroix*, New York, Grove Press, 1961

Falk, B., *Turner the Painter: his Hidden Life*, London, Hutchinson, 1938

Finberg, A.J., *A Complete Inventory of the Drawings of the Turner Bequest*, 2 vols, London, H.M.S.O., 1909

The Life of J.M.W. Turner, R.A., 2nd ed., London, Oxford University Press, 1961

Introd. Lawrence Gowing, *Turner's Sketches and Drawings*, New York, Schocken Books, 1968

Finley, Gerald E., 'Turner: An Early Experiment with Colour Theory', *Journal of the Warburg and Courtauld Institutes*, XXX, 1967, pp. 357–66

'J.M.W. Turner and Sir Walter Scott: Iconography of a Tour', *Journal of the Warburg and Courtauld Institutes*, XXXV, 1972, pp. 359–85

'Kindred Spirits in Scotland: Turner and Scott', *Connoisseur*, 183, August 1973, pp. 238–47

'Turner and Scott's "Poetry": New Evidence', *Burlington Magazine*, CXV, 1973, pp. 740–42

'Two Turner Studies: A "New Route" in 1822, Turner's Colour and Optics; Turner's Illustrations to "Napoleon"', *Journal of the Warburg and Courtauld Institutes*, XXXVI, 1973, pp. 385–96

'J.M.W. Turner's Proposal for a "Royal Progress"', *Burlington Magazine*, CXVII, 1975, pp. 27–35

Fraser, A., *The Works of Horatio Macculloch ... with a Sketch of his Life*, Edinburgh, Elliot, 1872

Frost, William, rev. Henry Reeve, *A Complete Catalogue of the Paintings, Water-Colour Drawings, Drawings and Prints in the Collection of the late Hugh Andrew Johnstone Munro, Esq., of Novar at the time of his death, deposited in his house, no. 6, Hamilton Place, London*, [London] 1865

Fry, Roger, *Characteristics of French Art*, London, Chatto and Windus, 1932

Gage, John, 'Turner and the Picturesque (II)', *Burlington Magazine*, CVII, 1965, pp. 75–81

Colour in Turner: Poetry and Truth, London, Studio Vista, 1969

Gilpin, William, *Observations relative chiefly to Picturesque Beauty, made in the year 1772, in several parts of England; particularly the mountains and lakes of Cumberland and Westmoreland*, 2 vols, London, 1786

Observations relative to Picturesque Beauty, made in the year 1776, on Several Parts of Great Britain; particularly the High-lands of Scotland, 2 vols, London, R. Blamire, 1789.

Gordon, Catherine, 'Illustration of Scott', *Journal of the Warburg and Courtauld Institutes*, XXXIV, 1971, pp. 297–317

Gowing, Lawrence, *Turner: Imagination and Reality*, Museum of Modern Art, New York, 1966, exhibition catalogue

Gunnis, Rupert, *Dictionary of British Sculptors, 1660–1851*, London, Odhams, 1953

Herrmann, Luke, *Ruskin and Turner*, New York/Washington, Praeger, 1968

Holcomb, Adele M., 'Scott and Turner', *Scott Bicentenary Essays*, ed. Alan S. Bell, Edinburgh/London, Scottish Academic Press, 1973, pp. 199–212

'J.M.W. Turner's Illustrations to the Poets', unpublished Ph.D. thesis, University of California, Los Angeles, 1966

Ivins, William Mills, Jr, *Prints and Visual Communication*, London, Routledge, 1953

Johnson, Edgar, *Sir Walter Scott: The Great Unknown*, 2 vols, London, Hamish Hamilton, 1970

Landseer, John, *Lectures on the Art of Engraving*, London, 1807

Lang, Andrew, *The Life and Letters of John Gibson Lockhart . . .*, 2 vols, London, Nimmo, 1897

Leslie, Robert Charles, *A Waterbiography*, London, Chapman and Hall, 1894

Lindsay, Jack, *J. M. W. Turner: A Critical Biography*, London, Cory, Adams and MacKay, 1966

Lockhart, John Gibson, *Peter's Letters to his Kinsfolk*, 3 vols, [Edinburgh], 1819
Memoirs of the Life of Sir Walter Scott, 2nd ed. 10 vols, Edinburgh, Cadell, 1839

M'Gregor, S., *Report of the Speeches at the Dinner to Earl Grey, at Edinburgh, on Monday, 15 September 1834*, 2nd ed., Edinburgh, 1834

Napier, Robert W., *John Thomson of Duddingston, Landscape Painter. His Life and Work . . .*, Edinburgh, Oliver and Boyd, 1919

Omar, M., *Turner and the Poets*, London, Greater London Council, 1975, exhibition catalogue

Rawlinson, W.G., *The Engraved Work of J. M. W. Turner, R.A.*, 2 vols, London, Macmillan, 1908, 1913

Richards, Ivor Armstrong, *Philosophy of Rhetoric*, New York/London, Oxford University Press, 1936

Ruskin, John, ed. E. T. Cook and A. Wedderburn, *The Works of John Ruskin*, 39 vols, London, Allen, 1903–12

Schetky, S. F. L., *Ninety Years of Work and Play, Sketches from the public and private career of J. C. Schetky . . .*, Edinburgh/London, 1877

Scott, Sir Walter, *Provincial Antiquities and Picturesque Scenery of Scotland . . .*, 2 vols, London, J. and A. Arch, 1826
Ed. J.G. L [ockhart], *Poetical Works*, 12 vols, Edinburgh, Cadell, 1833–4
The Miscellaneous Prose Works of Sir Walter Scott, 28 vols, Edinburgh, Cadell, 1834–6
Ed. J.A.S. Symington, *Some Unpublished Letters of Sir Walter Scott*, Oxford, Blackwell, 1932
Ed. H.J.C. Grierson, *The Letters of Sir Walter Scott*, Centenary Edition, 12 vols, London, Constable, 1932–7
Ed. W.E.K. Anderson, *The Journal of Sir Walter Scott*, Oxford, Clarendon Press, 1972

Scott, William Bell, ed. W. Minto, *Autobiographical Notes of the Life of William Bell Scott . . . and Notices of his Artistic and Poetic Circle of Friends, 1830 to 1882*, 2 vols, London, Osgood and McIlvaine, 1892

Shirley, Andrew, *The Published Mezzotints of David Lucas. After John Constable R.A. a Catalogue and Historical Account*, Oxford, Clarendon Press, 1930

Skene, J.S., ed. B. Thomson, *Memories of Sir Walter Scott*, London, John Murray, 1909

Stevenson, Robert, *An Account of the Bell Rock Lighthouse . . .*, Edinburgh, 1824

Thornbury, Walter, *The Life of J. M. W. Turner, R.A. . . .*, London, Chatto and Windus, 1877

Whitley, William T., *Art in England, 1800–1820*, Cambridge University Press, 1930
Art in England, 1821–1837, Cambridge University Press, 1930

Ziff, J., 'J. M. W. Turner on Poetry and Painting', *Studies in Romanticism*, III, No. 4, Summer, 1964, pp. 193–215

Index